# Alejandro Xul Solar

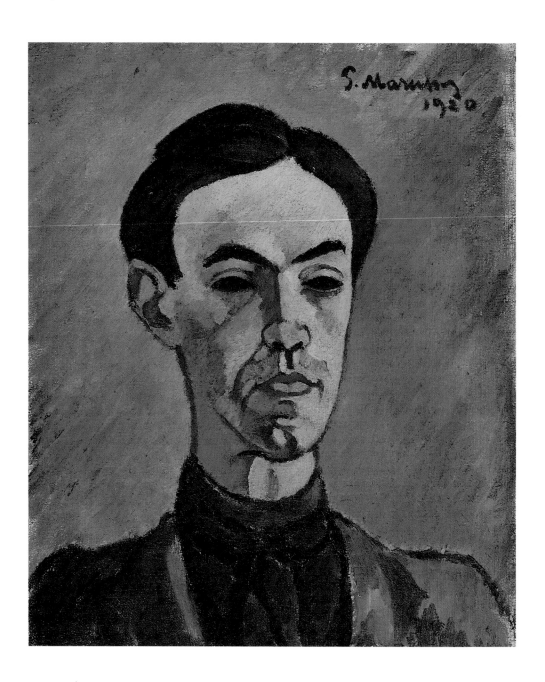

Figure 1. Piero Marussig
Portrait of Xul Solar, 1920
Oil on canvas, 50 x 40 cm
Museo Xul Solar

Mario H. Gradowczyk

# Alejandro Xul Solar

Ediciones ALBA
Fundación Bunge y Born
Buenos Aires
Distributed by
Harry N. Abrams, Inc., Publishers

**Coordination:**

Fundación Bunge y Born

Patricia Artundo and Marcelo Pacheco (Art Consultants)

**Design:**

Mario H. Gradowczyk, Karina Esther Hadida and Mariana Saddakni

**Photographs:**

Caldarella & Banchero

**Translation:**

Jason Wilson

Copyright © 1994 by Ediciones ALBA
Printed in Italy

First published by
Ediciones ALBA, Buenos Aires, 1994

ISBN 0-8109-3982-7 (Abrams)
Distributed in 1996 by Harry N. Abrams, Incorporated, New York
A Times Mirror Company

# Contents

The publication of this book on Xul Solar coincides with the one hundred and tenth anniversary of the birth of Bunge y Born. During these eleven decades the group, as well as creating work and opening new paths in industry, has demonstrated its interest in education, health, scientific research and Argentina's cultural and artistic development. These areas of concern have been especially active through the Bunge y Born Foundation, and its companies, in this case S. A. ALBA.

This work summarises this effort in community action, and celebrates a great artist's work, whose extraordinary creative richness encompassed not only painting but also astrology, religions, inventions, language, music, chess, architecture and the applied arts. Such a range cannot be understood through traditional stylistic categories.

Lastly, this book acknowledges the work of a man with a long career that was as quiet and austere as it was methodical and fecund. At all times he remained faithful to principles and ideals with which our organization also identifies itself.

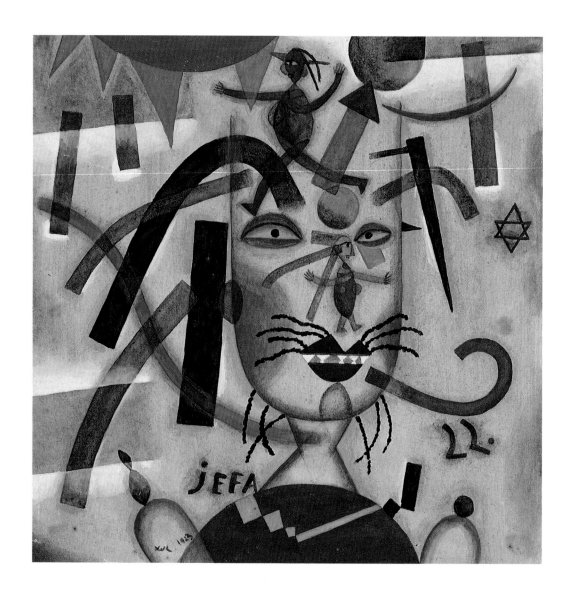

1. *Jefa* (*Female Chief*), 1923
Watercolour on paper, 26 x 26 cm
Museo Xul Solar

# Alejandro Xul Solar

Mario H. Gradowczyk

# Prologue

*Painting has one foot in architecture and
the other in dreams.*
Octavio Paz

When he was young Alejandro Schulz Solari had decided to invent a world for himself and his brothers so that he had a place from which to create and realize a universe of feelings and visions that he had perceived, and also express his yearnings, beliefs and inner life. Xul travelled a long road transforming his fantasy into reality, through successive stages, without ever betraying his initial aims. We perceive this world in his paintings and other works.

This study describes that journey and the many ways Xul structured his visions, images, languages, texts, games, architectures and designs. This is Alejandro Xul Solar's illuminated world.

Rafael Squirru pointed out in his analysis of Xul's personality that there remained the possibility of going deeper into the artist's style. I have tried to approach the artist from this point of view, using unpublished material and verifiable biographic details.

The presentation follows a chronological order and integrates a thorough study of the different periods in his paintings, the main source of information on the artist, with historical data. The possibility of including a large quantity of reproductions has facilitated this analysis, which attempts to place Xul not only within a local perspective but also within the greater context of the avant-garde art of this century.

However, the break-down of the chapters and sections allows for a separate analysis of specific aspects, like, for example, Xul's architectural work to which he had devoted some forty-five years, but which has not awoken much interest in critics or specialists until very recently.

Xul Solar's artistic activity covers a key cycle in the history of Argentine art, as it moves from the start of the 1910s to the 1960s, that is, from the appearance of the European avant-garde to the eruption of neo-figuration. It is significant that Xul, despite the quality and coherence of his work, has not awoken a greater following nor influenced the generations that succeeded him.

Resulta significativo que, pese a la calidad y coherencia de su producción, Xul no haya despertado mayores adhesiones ni influido en las generaciones inmediatamente posteriores.

El cubismo llegó al país de la mano de Emilio Pettoruti apenas en 1924; unos años después Antonio Berni advirtió las características "subversivas" del surrealismo europeo e hizo de éste un punto de partida de su realismo social, mientras Juan del Prete desarrollaba un repertorio de formas no figurativas. Años más tarde surgió el grupo Orión, más ligado a la pintura fantástica que a los rigurosos esquemas del movimiento surrealista, según lo señala Aldo Pellegrini. Y poco tiempo después, en la década del cuarenta, aparece el primer movimiento significativo de avanzada: son los jóvenes artistas nucleados alrededor del Movimiento Arte Concreto-Invención; a partir de entonces irrumpe en la escena argentina esa incesante búsqueda de lo nuevo, de mundos inexplorados.

Xul, aunque siempre estuvo abierto y dispuesto a compartir con otros sus cosmogonías, resultó para la mayoría de sus contemporáneos un personaje solitario, un excéntrico, tal como fuera caracterizado en novelas-clave de Arlt y Marechal. Sólo en un entorno muy pequeño, que compartía sus preocupaciones más esotéricas y sus investigaciones sobre las religiones y el lenguaje, Xul encontró apoyo y fue Jorge Luis Borges quizá su mayor interlocutor, a la medida de sus aspiraciones cósmicas.

Los cambios actuales experimentados por nuestra sociedad son lo suficientemente significativos como para aventar prejuicios e interpretaciones parciales. La obra de Xul, que hoy se admira en su Museo de la calle Laprida, ha sido exhibida en los últimos años en Buenos Aires y en salas tales como las del Museo de Arte de Indianápolis, la Hayward Gallery y Courtauld Art Galleries de Londres, el Centro Georges Pompidou de París, el Museo Real de Bellas Artes de Amberes, el Museo Ludwig de Colonia, el Museo Nacional de Estocolmo y el Museo de Arte Moderno de Nueva York. Se cumple así la idea fundamental de Xul: su arte es su mayor contribución para su país y el mundo.

Las visiones de Xul adquieren hoy una refrescante presencia, invitan a la reflexión e inspiran nuevas ideas, nuevos pensamientos, nuevas creaciones. A medida que nos aproximamos al nuevo siglo, quizás el mundo del artista esté más cerca y comprendamos, entonces, que Xul y su mundo son sólo uno.

# Acknowledgements

The making of this book has been made possible thanks to the generous support of the Fundación Bunge y Born, and its company, S. A. Alba. I would like to acknowledge the dedication of Ricardo Esteves, former director of Bunge y Born, who supported the project from its conception, and of María Luisa Herrera Vegas, secretary general of the Fundación Bunge y Born, whose organizational ability carried the project through.

I am very grateful to the Fundación Pan Klub who opened their photographic archives and Xul Solar's documents to me, especially its founding members Martha L. Rastelli de Caprotti -curator of Xul's house-, Natalio Jorge Povarché and Carlos N. Caprotti, for their constant help. The Rachel Adler Gallery in New York collaborated with great efficiency in obtaining a great amount of the reproduced material in the hands of foreign collectors.

The Paul Klee Foundation in Berne offered information that was of extreme interest in my research. The Fine Arts Museums in Berne and Leipzig, the Kröller-Müller in Otterlo, the Ludwig Museum in Cologne, the State Gallery of Modern Art in Munich, Bild-Kunst in Bonn and the Metropolitan Art Museum and the Guggenheim Museum in New York granted me the rights to reproduce photographic material of European avant-garde artists used as points of reference in placing Xul Solar's work in a wider context.

I would also like to thank Professor Christopher Green, curator of the exhibition held in the Galleries of the Courtauld Institute in London, who allowed me to evaluate Xul Solar's architectural work in its totality.

Conversations held with Micaela Cadenas de Schulz Solari (Lita Xul Solar) have for a long while brought me close to Xul's universe. I would like to emphasise the way my wife Felisa, who shared my commitment with Xul's world, provoked thought about the mystical and esoteric aspects.

Lastly, Rita Veneroni's opportune suggestions, Jason Wilson's excellent English translation, Christopher Green's revision and acute comments from Lil García Benitez and from Diego my son, contributed to a greater clarity of the text.

**2.** *Nido de fénices (Phoenix Nest)*, c. 1914
Oil on board, 22 x 26.5 cm
Private collection, Buenos Aires

# 1. Longings and Despair

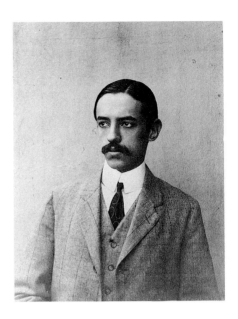

Figure 2. Alejandro Schulz Solari (Xul Solar). Photograph taken before his journey to Europe

In the notebook[1] written by Lita Xul Solar you can find some clues to Xul's childhood and youth. There are details about his father Emilio Schulz Riga (1853-1925), a German from Riga, and about his mother Agustina Solari (1865-1959), an Italian from Rovereto. There is a reference to his name, date and place of birth:

> *Oscar Agustín Alejandro, 14th of December, 1887, at twenty minutes past eleven on a Wednesday, a nice day, in San Fernando, the Province of Buenos Aires, General Alvear street, junction with 11th of September.*

There are further references to his sister Sara's birth in 1890, who died four years later; to illnesses, to typhoid at five years old, to nose and throat operations; to primary studies in a French school and in another English school; to secondary studies in the National College -North section- and in the private del Plata College; to learning the violin; to his first short-term job in the National Prison, where his father worked as an engineer; to his joining the Faculty of Exact Sciences to study architecture; to buying a piano; to being employed by the Buenos Aires Municipality which he abandoned after three months because *all day long he had nothing to do, and a friend who did not mind this inconvenience took over.*

A photograph at the time (figure 2) reveals a very tall and slim young man with olive skin, a moustache, and inquisitive and penetrating eyes. Behind that reserved expression hid a distraught and possessed person who had written revealing autobiographical texts and poems[2] between October 1910 and February 1912.

There is also a shortage of facts for this period. Xul mentions the existence of 12 paintings, and one dramatic and musical poem -now lost-, the hope of a job that did not materialize, his admiration for a young girl at a concert, a courtesan, illness, weeping, pride, failure, love, chains, battle, sadness, death -and life-, stiffled desires, loneliness, deceit, spiritual aspirations, brothers and sisters, sons and daughters, the world, sparkling glimpses of his sufferings and illusions.

In May 1911 he wrote, distressed:

> *How long will this go on for! Today another rejection; again I*

1. Micaela Cadenas de Schulz Solari (Lita Xul Solar), Hand-written notebook that contains a copy of notes made by Clorinda Solari in a notebook with her own comments, Archives of the Fundación Pan Klub Museo Xul Solar, Buenos Aires, 38 pages.

2. Oscar Alejandro Schulz Solari, Hand-written notebook titled *Beginning in the Spring of 1910*, without page numbers. The opening text: *October 1910* was published in *Xul Solar Catalogue of the Museum's Artworks*, Fundación Pan Klub Museo Xul Solar: Buenos Aires, 1990.

*see my failures and the sad loss of my dreams. Each time the desire for my first drama is more vivid, long scream, howl of hatred, ferocity, mistaken love, restless mysticism and piercing spite. I still have to wait two or three days! But won't I suffocate in this bitter and mortal mood that springs from my spited, restless love? I feel that this wood of sharp points pierces and oppresses me. How long have I been bleeding? Day after day, week after week, months and already two years with the same torment, and my imagination isn't enough: I need the world. How sad, how tragic are the tight embraces of a spectre, the love for a cloud! Alone, I will have to fill my immense deserts, but I do not know for whom, or what is the point of such colossal work if the world doesn't benefit from it at all. Oh, faced with an outrageous sunset, embracing another soul, the great change of death!*

Six months later it continued like this:

*I find comfort in my pride, and scorn for my chains. Like a pelican I want to tear my breast apart to give it to those eternally displaced, to redden with its blood those permanently satisfied. As in prayer I raise my spirit for my first son. Am I not threatened by early death? My first paintings, at least 12 of them, and my dramatic and musical poem, will at all hours be my obsession, and so that my life may not be useless and wretched, will also be my legacy if I soon pass the great precipice. Peace and love! What is the meaning of my ever-increasing breakdowns, that make me long for deep sleep, total oblivion, final death. Dazzling light, colours never seen, harmonies of ecstasies and of hell, unheard-of sounds, a new beauty that is mine, innumerable children, will allow me to forget all the pettinesses that stiffle me. If my damaging sorrows are due to labour in childbirth, I am pregnant with an immense, new world!*

Already by that time son and work were synonyms for Xul.

The existential tone of those texts points to a personality that thrives on challenge, a visionary rabidly opposed to the canons reigning in the Buenos Aires of his time. Unrestrained images burst up from his guts, and he expressed them in a direct and unaffected language.

In his writings Xul established a polarity between impossibility,

despair, illness, exhaustion, and his almost unattainable aspiration to give birth to this *immense, new world*.

The duality that existed between his longing to create and his emotional instability, between his aspirations and his achievements, was one experienced by other young iconoclastic poets before him -I'm thinking of Arthur Rimbaud and Isidore Ducasse, the Count of Lautréamont- and goes back to the essential concept of Being, and the dichotomy established between good and evil, a painful struggle only resolved in Xul's maturity.

The new French poetry was possibly sufficiently well-known in the River Plate for Xul to find in it a source of inspiration. Lautréamont was introduced by Rubén Darío[3] -the renovator of poetry in Spanish- who suggested that

> *it would not be wise to let young souls converse with that spectral man, be it for reasons of literary bizarreness or for the taste of a new delicacy.*

Allow me to point out that the image of the pelican[4] as used by Xul also appears in *Les Chants de Maldoror,*[5] but his texts are essentially angelic and lack that revulsion that dominates the *Chants* and that shocked the Nicaraguan poet Darío.

Xul's passion for creation is expressed in a direct vocabulary, without superfluous embellishments, and reflected in his nervous and personal calligraphy. It would be pointless to think that Xul lived an isolated life, devoted to cultivating his inner world, to struggling with his anaemia, to creating his inner visions, and indifferently contemplating the social and political conflicts that at that time were shaking his country, partially provoked by the accelerated growth of immigrant European workers. And if the Centenary of the May Revolution was celebrated with pomp in 1910, one must not forget the strikes, workers demonstrations led by anarchist and socialist groups, bombs, murders and the inevitable reactions of the xenophobic nationalists (*bandas patrióticas*).

Secular society resisted the advance of the new social realities, and turned to discriminatory practices, and an authoritarianism that manipulated politics, and employed electoral fraud. Official culture was devoted almost exclusively to the zealous preservation of local cultural traditions reflected in *gaucho* themes, and reports concerning the internal struggles between political bosses that petered out by the end of the nineteenth century. It rejected the new currents of cultural and artistic thinking to prevent it taking hold of the young, and if

3. Rubén Darío, *Los raros*, Buenos Aires, 1896, p. 111.

4. A coincidence cannot be avoided as the image of the pelican has important symbolic connotations that Xul was aware of. Christian iconography identifies the pelican with Christ; it is a symbol used by alchemists and secret societies like the Rosicrucians who adopted it as an emblem.

5. Isidore Ducasse, Le Comte de Lautréamont, *Les Chants de Maldoror*, Ediciones Viau: Buenos Aires, 1944, p. 36 ("First Canto", 12).

possible to paralyse the social conflicts generated by immigration being transferred to cultural expressions, or being directly used as a means of revolutionary action on the masses.

Already by the time of the Centenary, recently arrived Europeans in Buenos Aires outnumbered the native born. This tremendous increase required a sustained growth of industrial productivity to satisfy worker consumption that lead to the modernization of the country.

Only the modernist values represented by the poetry of Rubén Darío found timid followers. The poet Leopoldo Lugones, at that time militant in socialist circles, was one of them. On the other hand, the plastic arts and architecture clung to a dogged academicism, outrightly rejecting the European avant-garde.

The young who were avid for novelty had to travel to Europe to complete their education. They had to seek patronage from politicians and established artists to win the sought-after scholarships, as was the case of Emilio Pettoruti, or have their own means. It is apt to recall that Jorge Luis Borges, Victoria Ocampo and many others, studied in Europe, usually accompanied by relatives.

It would be inconceivable to locate Xul in this Argentine culture sustained by an idyllic evaluation of the past, and on the other hand alien to his own family's cultural identity. Perhaps only Martín A. Malharro[6] might have been a figure to take as an example, and more for his non-conformist attitude towards his milieu than for any formal discoveries in his painting, had he not died in 1911.

At twenty-four years of age, Xul felt isolated and threatened by a city that he deemed *wretched*, and misunderstood by his friends who reproached him for lacking a sense of reality. Anguished to the point of despair, and after a failed attempt to travel to Australia, he one morning decided to *found a new religion based on art, and to create a world for my followers*. By the afternoon that illusion had vanished.

In his last note, dated February 1912, he wrote:

*This same night I already repent of my weakness, and have progressed somewhat in the plan for my poem. Let spiritual forces protect me! Pallor to unhappy human life, and scorn for the sorrows and despair of our mortal condition in favour of the sublimity of eternal harmonies! Vital nectar!*

6. Martín A. Malharro (1865-1911), Argentine painter and print-maker of limited means. He travelled to Paris in 1895 and joined the Impressionists. His show in the Witcomb Gallery in Buenos Aires in 1902 generated violent and aggressive reviews because he endorsed Impressionism whose apparent *subversive* content puzzled important sectors of Buenos Aires's cultural life at the time.

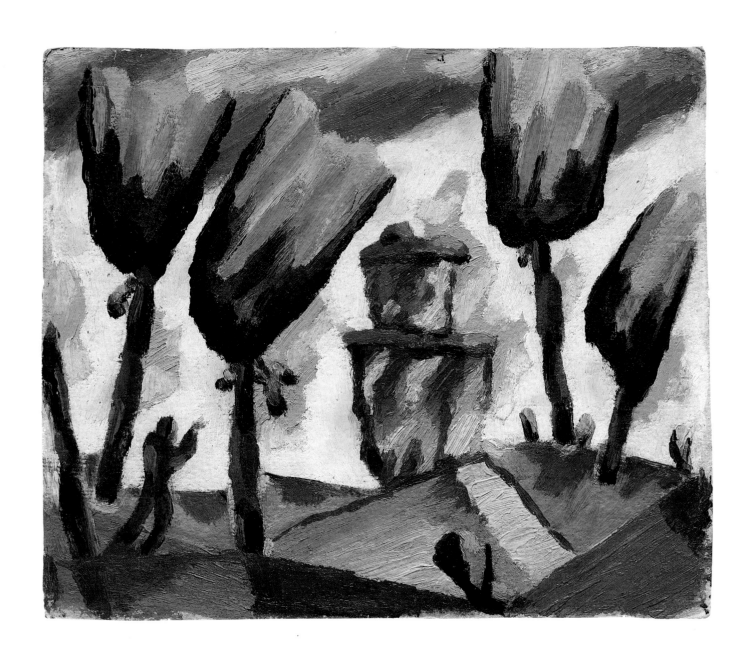

3. *Paisaje con monumento*
(*Landscape with Monument*), c. 1914
Oil on board, 22 x 27 cm
Private collection, Buenos Aires

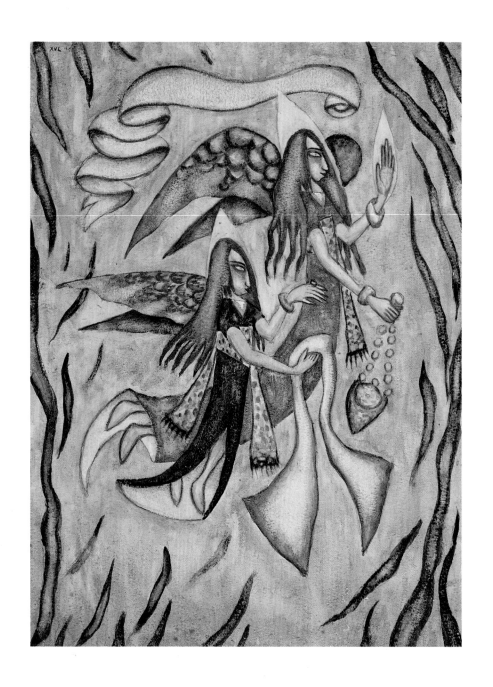

4. *Dos anjos* (*Two Angels*), 1915
Watercolour on paper, 36 x 27 cm
Museo Xul Solar

# 2. Twelve Years in Europe

In January 1912 Xul wrote:

*I have been preparing myself to go to Europe with enough money to last for a month, and I have swung between hope, the desire to struggle, rest and complete despair. Un matin nous partons, le cerveau plein de flamme, le coeur gros de rancune et de désir amers.*

A few months later Xul overcame the psychic dramas overwhelming him, as well as those states of mind that changed like the tides. On the 5th April 1912, with scant material resources, and prepared for any eventuality, Xul boarded the English ship *England Carrier*, bound for Hong Kong. He worked his passage. Nevertheless at the end of April 1912 he had to disembark in London.

Xul stayed in Europe for twelve years where he consolidated his artistic and spiritual formation. London, Paris, Florence, Milan and Munich were some of the artistic centres where he lived for long periods.

Soon after his arrival, his mother Agustina, and his aunt Clorinda, decided to travel to Europe to keep Alejandro company. At the time he was staying in Turin. They left Buenos Aires for London in April 1913. After a short tour of Paris the three of them took up residence in Zoagli, a small Italian village situated in the region of the Riviera di Levante hills, with a magnificent view over the Mediterranean, and close to San Pietro di Rovereto, the Solari family's place of origin. It is a familiar area of Italy where the two sisters had studied, and an appropriate place for them to await, in each other's company, for the return of the young artist from his prolonged and mysterious absences. The proximity of Genoa, vital centre of communications with other important European cities, played its part in this choice.

In the meantime his father stayed in Buenos Aires. He worked as an engineer in the National Prison, and with Germanic efficiency, contributed to the maintenance of the three of them.[7]

Zoagli became the vital centre from where Xul outlined, on a European map, the paths to be followed in his quest for spiritual

7. In the Fundación Pan Klub archives there is a meticulous monthly accounting of Emilio Schulz Riga's expenses in Buenos Aires for the months of September and November 1913, which was sent to his family in Zoagli.

and artistic confirmation, nourished by the love and dedication that his aunt, mother and father offered him, and counterbalancing any possible misfortunes or risks or depressions or anguish.

To illustrate the path followed, it is fitting to locate this young man in the context of his generation. Xul's idiosyncrasies were different to those of the young Argentines who were later to renew Argentine culture, and who were occasionally sent by their parents to Europe to ensure their cultural formation according to their vocation, their economic means, and social position. His self-confidence, contrasted with his pronounced shyness and adaptability, allowed him to overcome adverse material conditions, and to achieve a rapid assimilation of what was happening. He was aided by his command of German, English, Italian, French and Spanish.

What is known about those travels? Of his first stay in London I have picked on an anecdote narrated by Osvaldo Svanascini which Xul liked repeating.

*Being in London, and already without any means, he lodged in a house owned by the Salvation Army to shelter the homeless. On waking up in the morning he found himself with the sum of fifty pounds in his pocket. The surprise was shrouded in mystery. However, in the same place the London police had arrested a Frank the Sylph that very morning. He was a murderer and thief who the night before had been involved in a theft, and made a lot of money. The dilemma between thinking that the money had been a celestial gift or that the delinquent had planted it in the artist's pocket to rescue it later, was something that kept Xul guessing as he was addicted to the most impossible speculations, especially if these defied reality.*[8]

The Argentine poet Francisco Luis Bernárdez offered his view of how Xul Solar looked:

*In the Paris of 1926 and 1927 that for me practically amounted to Montparnasse or, if we want to be more precise, to the café called La Rotonde on the corner of that Boulevard and Raspail, you could recall the figure of a young Argentine, part painter and part astrologer, whose dreams tended to blend in a friendly way with the others who floated about the tables. He was Xul Solar. He was tall enough to stand out anywhere. He wore a beret, and a huge striped sky-blue and white poncho which made him look like a large living flag that wrapped him up in a*

8. Osvaldo Svanascini, *Xul Solar*, Ediciones Culturales Argentinas: Buenos Aires, 1962, p. 33.

*nostalgic emotion evoking the River Plate. Beside Picasso, who could still be seen there at that time, near the most daring artists of the time, and especially Modigliani, who was his friend and confidant, our compatriot was already behaving in the way that would distinguish him in our eyes. I mean that already then, during the First World War, he would reveal himself as free, disinterested, unattainable, strange, tender and mysterious, as much in his life (always somewhat secretive) as in his art that he practised with that dedicated innocence of an amateur, not because he lacked a personality but because of an excess of purity, a holy terror of ever falling victim to the slightest professional shortcomings.*[9]

## An Expressive Symbolism

Xul first visited Paris in March 1913. He returned a year later, and stayed until the end of August 1914 by when the Great War had already erupted. He returned again for nine months in January 1915.

Paris was at the time an epicentre for avant-garde art, and Cubism was the great movement of the day. It was based on a French pictorial tradition and counted Braque, Picasso, Gris and Léger amongst its outstanding figures. However, the new abstraction stood out, upheld by Kupka's spiritualism and Delaunay's studies on colour, the starting point for Klee's paintings. Matisse asserted his subtlety with an impeccable display of plane geometry and colour. Everyone admired and studied the formal and expressive features in the sculpture and objects that anthropologists and traders brought back from African and Pacific Ocean colonies, and, to a lesser degree, from the Americas.

The arrival in Paris of De Chirico's metaphysical art, and works by Italian futurists like Boccioni, and Severini; the exhibition of Russian artists like Chagall and Malevich, and news about the spread of German Expressionism, which influenced artists like Modigliani and Soutine, confirmed the degree of excitement lived in that city.

In addition to this feverish activity there was the presence of informed North American and Russian collectors, interested not only in Impressionism but in all the avant-garde currents, which lead to the demand for novelty.

9. Francisco Luis Bernárdez, *Xul Solar*,
Clarín, Buenos Aires, 30th January 1969.

23

The development of new forms of literature and poetry, a new philosophy, advances in music, and the arrival of the Russian Ballet, new expressive means like photography and cinema, provided further reasons why Parisian life was clearly fascinating[10] for anyone who came from such a limited artistic place as Buenos Aires.

As he threw himself into the new artistic experiences Xul Solar would possibly have asked himself the following questions: Could he canalise these overlapping energies? What medium should he use to make his dreams real, and how could he achieve his yearned-for transcendence?

His first paintings were small-scale landscapes, painted in oil on board, and clearly expressive like *Nido de fénices* (*Phoenix Nest*, plate 2) and *Paisaje con monumento* (*Landscape with Monument*, plate 3), close to the Expressionistic landscapes of Wasily Kandinsky. These works are neither signed nor dated, but the title of one of them, *Meudon*, a town close to Paris, suggests the period[11] between 1913 and 1914. Only some twenty paintings from this period are known.

To express his feelings and visions Xul preferred to paint in watercolours and tempera. He used small sheets of paper which he later mounted on fine coloured cardboard. By framing them in this way he enabled his paintings to stand out, and thus amplify the work's field of vision. Xul's technique was quick and direct, and related to his expressive needs, closer to how a monk acts in the solitude of his cell than to how the artists of the period worked.

An analysis of Xul's watercolour *Entierro* (*Burial*, plate 5) which he started at the end of 1912, and of which two other versions exist,[12] allows us to study his complex thought at that time. The theme is startling. A procession of mystical characters escorts two funeral bearers[13] carrying the dead person in his shroud along a narrow path

10. In a post card sent by Xul to his father on the 20th May 1913 he wrote: *We are now boarding for Italy, happy with Paris and myself enchanted with the Russian art of ballet. The company that performed it is going to Buenos Aires and I recommend you see it, and hear it as the music is unique. Paris is perhaps the most complete city.*

11. There may be some paintings done in Buenos Aires among these works.

12. The first is exhibited in the Xul Solar museum in Buenos Aires and reproduced in *Xul Solar Catalogue of...*, op. cit., p. 52; the second in Alejandro Xul Solar, Catalogue to the exhibition held in the Rachel Adler Gallery, with a text by Mario H. Gradowczyk, New York, 1991, fig. 1. Both are in tempera.

13. In a letter written in Italian, possibly sent to his mother and aunt and received on the 8th November 1912, Xul wrote: *Here's an idea for a tempera painting that I have started, a funeral march, light green, blueish brown, blurred red, black and light violet*, and he drew a sketch.

Figure 3. Arnold Böcklin
The Island of the Dead, 1880
Oil on wood, 80.7 x 150 cm
Museum der bildenen Künste, Leipzig

Figure 4. Jan Toorop
Fatality, 1893
Coloured pencils on paper, 60 x 75 cm
State Museum Kröller-Müller, Otterlo

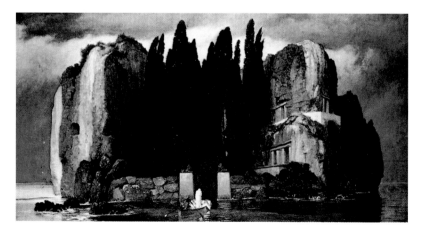

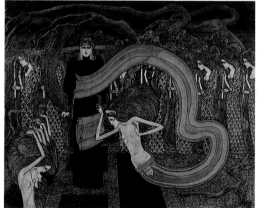

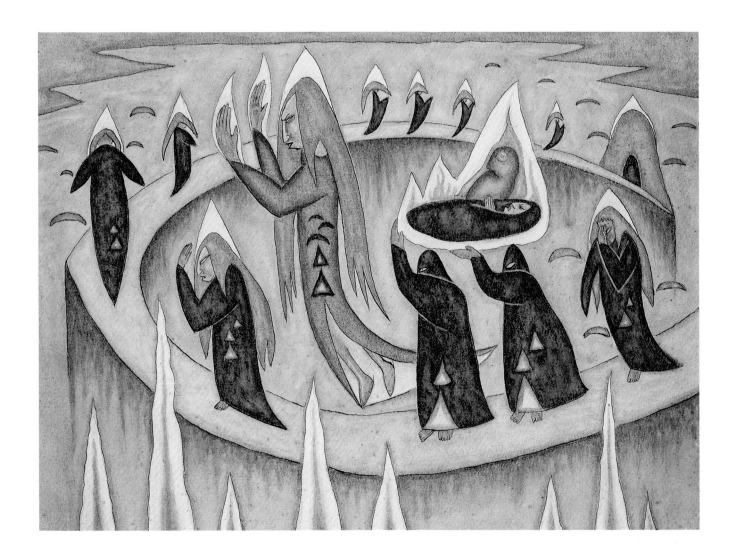

5. *Entierro (Burial)*, 1914
Watercolour on paper, 27 x 36 cm
Private collection, Buenos Aires

14. Two figures are homotopically equivalent when there is a continuous deformation (homotopy) between one and the other, that is, a continuous transformation from one to the other that allows for shrinking, rotations, etc, but not tearing apart.

above a precipice. While the dead man's soul leaves his body in the shape of a foetus, the figures in the procession, with fiery coloured haloes, slowly turn themselves into more stylised geometrical shapes in order to become a burial mound at the end of the path.

In this version the angel without wings leads the procession, levitating above the path. The tongues of fire that rise to the sky impart a dramatic and obsessive tone. The light is abstract, indefinable, without shadows. This sense of unreality contributes to the mystery that emerges from the image. Could it be completely fortuitous that the composition responds to a division of the plane that follows the golden rule? This is a geometric proportion used by the Cubists, and especially by Juan Gris, with spiritual and aesthetic resonances going back many centuries.

The rigorous application of a continuous homotopy[14] that transforms the escorts into a burial mound is a sign of Xul's inventive

imagination, anticipating by almost fifty years the computer-aided homotopic drawings of **Systems Art**.

This extraordinary image symbolises the separation of the soul from the dead man as the first stage in reincarnation. This vital concept in spiritualist thinking in Europe at the end of the nineteenth century was adopted by Xul, though it had existed in ancient religions since time immemorial.

If *Entierro* is compared with one of Böcklin's most famous symbolist works, *The Island of the Dead*, there is a surprising affinity of theme, and the presence in both paintings of a massive central feature, island or gorge. The use of similar colours is also noteworthy. However, Xul's planar treatment of the theme, and its impeccable geometric resolution, lack that grandiose Wagnerian element practised by many of the Symbolist painters of the nineteenth century. Xul here sided with painters like the Dutchman Jan Toorop. In his pastel *Fatality* (figure 4) symbolic elements like the band which is transformed into a female person, the procession, and the serpent, all suggest a spiritual ordering very close to Xul Solar's own.

In another work *Anjos* (*Angels*, plate 6) Xul painted four angels in flight. Their serene look and attitude allude to *avenging angels*,[15] possibly on some mission to punish. Even if we cannot be sure which kingdom they belong to, it is easy to guess who they are punishing by the 1915 date of the work.

The angels are treated as planar forms and their silhouettes are highlighted by ink in expressive lines that limit the coloured planar shapes. Line and colour complement each other in a harmonious form, and the picture plane changes into a space where his dreams can live.

Both scenes connect with the kind of angelic worlds experienced by a mystic like Swedenborg, who Xul had been reading at the time. Choice of colour is not haphazard for in both works Xul used a dual colour range; blue and its gradations, and gold, the colour of flames. The duality between a cold and a hot tone leads us to meditate on problems like life and death, and heaven and hell, symbolised there. The colour used to paint the main angel's clothing in *Entierro* coincides with Swedenborg: *the (angels) of high intelligence wear bright clothes like flames.*[16]

Xul's skill in being able to draw a synthesis, his firm outlines and planar images, allowed him to articulate his own pictorial style in a short time. Xul affirmed himself in a known style: Symbolism. This art movement assigned meaning to forms, without being completely

15. Malcolm Godwin, *Ángeles una especie en peligro de extinción*, translated from the English by Carmen Geronès and Carles Urritz, Robin Books: Barcelona, 1990, p. 114.

16. Emanuel Swedenborg, *El cielo y sus maravillas y el infierno* (*Heaven and its Wonders and Hell*), preceded by an interview with Jorge Luis Borges, and an introduction by Helen Keller. Translated from the English by Christian Wildner, Editorial Kier: Buenos Aires, 1991, pp. 106 and 178.

Figure 5. Fernand Khnopff
Sleeping Medusa, 1896
Pastel, 72 x 28 cm
Private collection, France

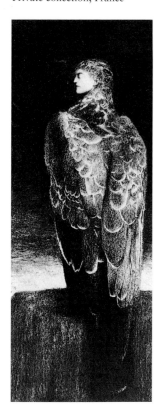

6. *Anjos* (Angels), 1915
Watercolour on paper, 28 x 37 cm
Private collection, New York
Courtesy Rachel Adler Gallery

17. Edward Lucie-Smith, *Symbolist Art*, Thames and Hudson: London, 1977, p. 54.

18. Quoted by Robert L. Delvoy, *Le Symbolisme*, Editions Albert Skira: Geneva, 1982, p. 82.

specific or literal. This is a world of suggestion, of ambiguity, of mystery, of what cannot be grasped, of what lies beyond. In Edward Lucie-Smith's words, *a reaction not only against moralism and rationalism, but also against the crass materialism which prevailed in the 1880s.*[17]

Symbolist art had to be idealist, symbolic, aesthetic and thus decorative, according to Albert Aurier's definition:[18]

*for decorative painting, as conceived by the Egyptians and primitives, is nothing but a manifestation of art that is simultaneously subjective, synthetic, symbolist and ideal.*

Few artists in that movement entirely fulfilled Aurier's definition, apart from the following, Jan Toorop (1858-1928), Mikalojus

19. See Mario H. Gradowczyk, catalogue for the Rachel Adler Gallery, op. cit.

20. Xul Solar, *Explica*, prologue to the catalogue *Pinties y dibujos*, Galería Van Riel Sala V, Buenos Aires, 1953.

21. Jorge Luis Borges, *Conferencia en la inauguración de la exposición Xul Solar en el Museo de Bellas Artes de La Plata en 1968*, republished in *Xul Solar Catalogue of...*, op. cit. By underlining the Jewish component in the German Expressionist movement, Borges highlighted the symbolic and cabbalistic elements in the aforementioned movement.

Figure 6. Romolo Romani
Lust, c. 1905
Pencil on paper, 47 x 61.5 cm
Musei Civici d' Arte e Storia, Brescia

Ciurlionis (1875-1911), and Romano Romani (1884-1916). Most of the so-called Symbolist artists expressed themselves allegorically, that is, in purely imaginative and rational representations, without managing to establish a visual connection with those archetypes located in the collective unconscious, according to Jung, and that transcend the meaning of the image. Allegory converts an image into a purely explanatory document which can be read rationally, and thus becomes banal.

Xul discovered in Symbolist art a way of representing images generated by his unconscious. If we take into account the time passed between the most active period, 1880-1910, in Symbolist art, and the period under discussion, it could be argued that Xul's pictures correspond to a tardy symbolism. However, we should point to the presence of another crucial component in his works, namely, their expressiveness, which confers on this first period, running from 1914 to 1918, a decisive importance in terms of his future mystical and aesthetic development.

In a previous work[19] we have called this period **Expressionist-Symbolist** in order to underline the presence of this other component in his art. The comparison between Xul's angels and the one painted by Fernand Khnopff (figure 5) illustrates this difference.

It is worth pointing out that here the term **Expressionist** is open to several interpretations, although Xul did not include this movement amongst his classifications of twelve pictorial styles or schools.[20] Borges linked Xul with *German Expressionism, better put, Judeo-German*,[21] and given the spiritual empathy that existed between the two this opinion should not be dismissed.

If the word Expressionist was meant to define a style, it would be hard to justify a definition that included such a wide range of artists, from Willendorf's Venus to the upside-down figures of the contemporary German artist Georg Baselitz. For the purpose of this essay, and following Borges's lead, Expressionism was a movement that erupted as a reaction by a group of intellectuals and artists faced with the rise of a new concept of the State in the Germany of the end of the century. This concept was upheld by the old Prussian aristocracy, and rooted in the new state's institutions, and in the army. An aggressive capitalism was structured in cartels, and clusters of workers gathered together round the most reformist sectors of the social democrats.

According to Etiennette Gasser:

*Expressionist art was conceived as a struggle to express the*

Figure 7. Xul Solar. Drawing included in his letter of November 1912 illustrating by heart an abstract work reproduced in the book *Der Blaue Reiter*, possibly Kandinsky's *Composition number 5*

22. Etiennette Gasser, *L'Expressionisme et les événements du siècle*, Pierre Cailler Editeur: Geneva, 1967, p. 36.

23. Jean Chevalier et Alain Gheerbrant, *Dictionnaire des Symboles*, Robert Laffont/Jupiter: Paris, 1982, p. XVIII.

24. Xul referred to *Der Blaue Reiter*, Piper and Co: Munich, May 1912, with reproductions and texts by the group artists.

25. See note 13.

Figure 8. Mikalojus Ciurlionis
Sonata of the Stars, 1908
Tempera on paper, 73.5 x 62.5 cm
Ciurlionis Museum, Kaunas, Lithuania

*feelings of a young generation, and to be understood by all those who did not conform.*[22]

In Expressionist art, the artist brings out the totality of his being, and the objective reality of the world is transformed according to his inner dictates. The measure of anguish, and unfulfilled yearnings in Xul's early texts, revealed his affinity with Expressionism.

Xul depicted in his Expressionist-Symbolic paintings a vision from his inner being. Substituting the objective world with psychic images he blended elements that might appear contradictory: love-hate, sacred-profane, idyllic-perverse, life-death, death-resurrection; and he did this through mechanisms that emerged from the unconscious in spontaneous, emotive and passionate ways.

At the same time Xul incorporated a Symbolism that allowed him to put his youthful aspirations into practice. Symbolism asserted the self through its veiled quality,[23] as changeable, unifying what is contradictory, as pedagogic and therapeutic, by the way it resonated in the world, for its function of transcendence, and by the way it transforms the energy liberated by dreams, and by symbols. This way of thinking was revealed in a letter written by Xul towards the end of 1912:

*I have bought myself a book **Der Blaue Reiter**[24] dealing with the most advanced art of the **fauves** (wild beasts), **Futurists** and **Cubists**. These paintings shock the bourgeois for there is no nature, just lines and colours. For example, like this [Xul here includes an ink drawing reproduced in figure 7] if I remember it properly because I am writing from a "trattoria". I do not think I like it very much, but I am relieved because I realize how alone, without outside influences, I have worked, within a tendency that will predominate in the most elevated art of the future. I also see how I will easily stand out from these new artists because I have a better sense of both composition and colour than most of them. At the moment I have few commissions, but enough, until I leave for Paris where everything will favour me.*[25]

The ethnic characteristics of the personages Xul painted have faces that are similar to the Egyptians of the old kingdoms, although they may perhaps derive from Pre-Columbian codexes, and are archetypal images lodged in the collective unconscious, waiting to be released by those who need them, and can spiritually connect with them. This

7. *Otra ofrenda cuori*
(*Another Heart's Offering*), 1915
Watercolour on paper mounted on card,
image: 21 x 12 cm; card: 28.5 x 15 cm
Private collection, Buenos Aires

26. Emilio Pettoruti, *Un pintor frente al espejo*, Solar/Hachette: Buenos Aires, 1968.

would explain the affinity between Xul's work and that of other Symbolist artists in contact with mystical and extra-terrestrial worlds as shown in the works reproduced in figures 3, 4, 6, and 8.

Xul did not solely work with a world of angels. *Ofrenda cuori* (*Heart's Offering*, plate 8) suggests a symbolism concerning the sacrifice for love, treated with colours that underline the tragedy. It is not known whether the offering of the lover, whose profile emerges from a chalice, will achieve his aim or not. The woman's gaze is as impenetrable as her body. It hides behind the jet-black, wavy hair that appears much later in Xul's sacred mountains, and in *Cuatro plurentes* (*Four Multiple Entities*, plate 141).

The fire-coloured triangular auras, the image of a bird that hides behind the loved one, and the sun in the background, signal the cosmic character of the harsh scene.

In *Otra ofrenda cuori* (*Another Heart's Offering*, plate 7) the theme is treated differently. It is not possible to know who will receive the offering which the supplicant -all heart- invokes from a feminine angel and from a bird with a woman's face. The fire-coloured aura is perhaps explained by the heart, crucial organ in the human body, and according to alchemy, the image of the sun inside man.

In July 1916, master of his expressive means, Xul moved to Florence, cradle of the Renaissance, and where the Futurist movement played an active role. There he met Pettoruti who has recounted[26] how he first met Xul Solar, and further anecdotes, that because of the publication date, cannot be verified in relation to Xul. It is a commonplace to complain about the reliability of artists' and writers' memories in their autobiographies.

That year Xul decided to sign his work Xul Solar, apparently to simplify the phonetics of his surname, but that conceals a recondite meaning. Xul back to front reads Lux which refers to measuring luminous intensity. Schulz Solari thus turns into the **intensity of the sun**, source of cosmic light and energy, a symbolism which Xul clearly intuited.

This equivalence between his name and the **sun** would explain the presence of the solar disc, or a sector of it, in so many of his paintings. It is a way of asserting his presence in his work, and a subtle signal that the artist, from his pictorial plane, also recognizes the contemplator's gaze.

A similar case seems to be that of Isidore Ducasse, the Franco-Uruguayan poet whose pseudonym, Count of Lautréamont (allegedly taken from a character in a popular novel by Eugène Sue), was

8. *Ofrenda cuori* (*Heart's Offering*), 1915
Watercolour on paper mounted on card,
image: 30.5 x 9.5 cm; card: 33.4 x 12.6 cm
Museo Xul Solar

27. Georges Emmanuel Clancier, *De Rimbaud au Surréalisme. Panorama critique*, Pierre Seghers Editeur: Paris, 1953, p. 30.

interpreted by Georges Emmanuel Clancier according to an occult sense as being *L'autre est Ammon* (the other is Ammon), and Ammon is the Sun King, the king of the gods of Egyptian religion, *and may be the sign of the temptation of the demiurge who animates or ignites what is real.*[27] This identification with the sun in both artists, wouldn't it imply an irrepressible urge to turn themselves into the vital source of energy of their own worlds?

## Asserting the Images

After his second baptism, Xul worked even harder. He left Florence in March 1917, and returned to Zoagli. He had by then mastered the techniques of watercolour and gouache, and found his own images. His ambitions were beginning to get fulfilled. At the same time he continued his researches and readings of occult texts, of esoteric sciences, and of the history of religions. He studied books by contemporary authors like Madame Blavatsky and Rudolf Steiner, by old mystical teachers like Jakob Böhme and Emanuel Swedenborg, and by William Blake, the English poet and painter with mystical inclinations.

He became interested in communication problems, due as much to his relationship to an expanding industrial society, as to the possibilities they offered for the propagation of the transcendental and mystical content of his thinking. He shyly began to develop his plan for the creation of a new language for America, structured on Spanish, with words in Portuguese, German and English. His objective was to facilitate the integration of the Americas, and he named this language **neocriollo** (neo-creole), or **neocreol**. There are evident references in Xul's paintings that confirm his Pan-Americanism. Love for his country exceeded the sheer excentricity of his way of dressing that in Paris had identified him as an Argentine.

*Man-tree* (plate 10) is another significant painting from this period. The face of the person inserted inside the tree trunk shares the same expressiveness as that of other German Symbolists, like Alfred Kubin (figure 9).

The inscription ANDRODENDRO marks one of his first attempts to integrate his images with words in order to communicate more effectively. That word, written in his new language, reads "Man-tree"

31

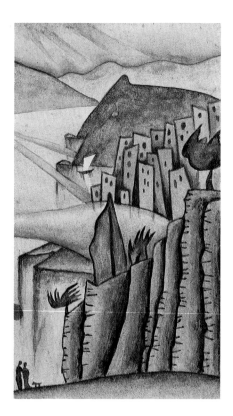

9. *Casas (Houses)*, 1918
Watercolour on paper, 21 x 12 cm
Private collection, Buenos Aires

28. Wasily Kandinsky, *Concerning the Spiritual in Art,* Dover: New York, 1977, translation of *Über das Geistige in der Kunst.*
29. Kandinsky's first abstract, or non-figurative painting, was signed in 1910.
30. Wasily Kandinsky, *Concerning...*, p. 53.

Figure 9. Alfred Kubin, Death's Bride, c. 1900
Ink and watercolour on paper, 30.4 x 21.1 cm
Albertina collection, Vienna

if one takes into account that ANDRO and DENDRO are the roots of such words. Other possible interpretations like *man-tree-fossil* or *man/inside tree* are the kind of games with which Xul surprised and confused the less informed.

Nature also suggested interesting pictorial themes to him. Plants, insects, landscapes, cities, lakes and mountains are some of his favourite subjects and motifs. This gaze outwards should make us ponder in the light of his later successful paintings when Nature ceased being his protagonist, and instead the human being -his spiritual life- dominated in the pictorial plane.

Plants and geometricized insects, as in the work *Bichos* (*Insects*, plate 10), turn later into stripes, ribbons and simpler geometric shapes. Mountains become places devoted to meditation, lakes become watery areas, and cities mythical places. Nature for Xul Solar became contingent to where gods, men and women, create, construct and inhabit fantastic architectural dwellings, embued with ancestral spirits. Nature as an abstract feeling has no reason to be.

Xul sheltered behind his paintings, without trying to make contact with European artistic circles in a straightforward or direct way. He continued studying, and analysing in depth the progress made in those years. He shared similar spiritual aspirations, transcending the formal aspects of painting, with the artists gathered around the group *Der Blaue Reiter*, led by Wasily Kandinsky and Franz Marc, as his first European paintings reveal (plates 2 and 3). He read Kandinsky's influential book *Of the Spiritual in Art*[28] where he formulated the spiritual basis to abstract painting:[29]

*The work of art is born of the artist in a mysterious and secret way. From him it gains life and being. Nor is its existence casual and inconsequent, but it has a definite and purposeful strength, alike in its material and spiritual life.*[30]

This view of art is very different from the one expressed by the Cubist painters, keen on researching how to achieve a fragmentation of forms, spreading them across the canvas, and simultaneously emphasizing the object's appearance.

It is worth remembering that in Paris Xul had the chance to visit the "Salons des Indépendants", as well as the "Salon d'Automne", and of getting into touch with other sources of abstract art like the pure art proposed by Robert Delaunay who was a great influence on the German Expressionist artists Marc and Macke, both victims of

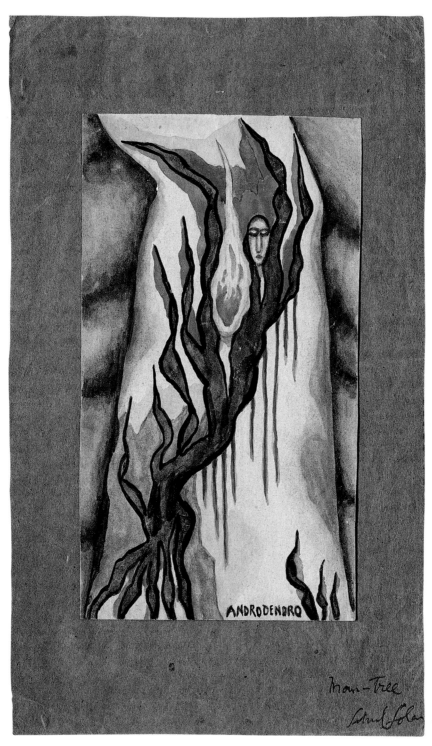

10. *Man-tree*, 1916
Watercolour on paper mounted on card,
image: 22.2 x 12.6 cm; card: 33 x 18 cm
Museo Xul Solar

11. *Bicho* (*Insect*), 1919
Watercolour on paper mounted on card,
image: 12 x 12 cm; card: 19 x 16 cm
Private collection, Buenos Aires

31. Guillaume Apollinaire, *Les peintres cubistes*,
translated into English by Edward Fry, New
York/Toronto, 1966, p. 117.
32. Christopher Green, *Towards a New Art -
Essays on the Background to Abstract Art 1910-
1920*, The Tate Gallery: London, 1980, p. 166.
33. Kupka exhibited his most important work in
the Autumn Salon. In 1912 they were: *Amorpha,
Fuge à deux couleurs*; the following year,
*Localisation de mobiles graphiques, I et II*.
34. See *The Spiritual in Art: Abstract Painting,
1890-1985*, Los Angeles County Museum of
Art, Abbeville Press: New York, 1986.

Figure 10. Robert Delaunay
Simultaneous Windows (2nd Motif, 1st Part),
1912. Oil on canvas, 55 x 46.5 cm
Solomon R. Guggenheim Museum, New York

the war, and on Paul Klee who, recommended by Kandinsky, paid him a visit in 1912.

Apollinaire called that art "Orphic", a term with several connotations that also suggested the musicality transmitted by the interplay of colour planes. He defined it thus:

*Orphism is the art of painting new structures with elements which have not been borrowed from the visual sphere, but have been created entirely by the artist himself, and been endowed by him with fullness of reality. The works of the orphic artist must simultaneously give a pure aesthetic pleasure; a structure which is self-evident; and a sublime meaning, that is, a subject. This is pure art.*[31]

Robert Delaunay, the most representative artist of that tendency, established chromatic relationships between the different colour planes that divide the pictoric plane. According to Christopher Green:

*He wanted to isolate the fundamental components of optical experience (prismatic colours), put them together in vigorous new arrangements and make us see for ourselves, therefore, the very essence of all such experience...*, that is *the connection between his painting and nature was left unbroken.*[32]

However, his practice of abstract painting only lasted a few years. Frantisek Kupka[33] followed a different route. He reached abstraction after having passed through a Symbolist phase, the same as Kandinsky, Malevich, Mondrian and Arp, the result of a profound spiritual development.[34]

Xul started a process that would lead him to develop new means of expression to explain his inner life, or communicate the visions received from beyond death. Xul was aware that modernity was not a transitory phenomenon, a fashion, but that it was rooted in deep structures of knowledge.

Significant changes began to appear in his paintings. In his *San Francisco* (*St. Francis*, plate 12), for example, painted in 1917, the symbolic handling of the saint is similar to the one used in earlier works, but the forms obey more purified geometrical schemes, and the image develops with a play of lines, planes and transparencies, and a construction of nature that suggests an incipient graphic automatism. The image of the serpent appears for the first time.

12. *San Francisco* (*St. Francis*), 1917
Watercolour on paper, 37 x 23 cm
Museo Xul Solar

35. The idea of extending the image in the painting to the frame was used by symbolist artists like Toorop, and Futurists like Balla and Severini.

36. The 1918 dates of these works were allocated by Lita Xul Solar, and both were signed Shul Solar.

37. In most cultures the moon is the feminine-**yin**, and fulfils a passive role as it reflects the light of the sun which is masculine-**yang**, and active. See Chevalier-Gheerbrant, *Dictionnaire...* op. cit., p. 892.

In 1918 he dropped the more realist and esoteric features, and incorporated freer, schematic, geometrical shapes, with expressive connotations. He increased the range of colours, and employed coloured card, on which he mounted his works, like a virtual exterior space. At times, the motif expands[35] towards this mount and shafts of light, and lines and forms give shape to fields of energy. These fields grant an extra source of energy to the image, as in *The Wounded Sun* (plate 13) and *Worshipped Face* (plate 14), first works[36] of this new phase.

The sun, represented by a feminine figure with a circular aura that emerges from a black cloud, is hit by an arrow shot by an archer standing on a platform lit by moonlight. It may seem odd that Xul changed the sexes of the **sun-moon** duality,[37] but in nomadic and pastoral civilizations like the Dogon in Africa, the mountain people of South Vietnam, and the Japanese, this duality is inverted, just as Xul suggests. In German the word moon is masculine, and sun is feminine.

To shoot the sun down with an arrow is to destroy the source of heat that dries and kindles the earth, according to some Oriental cultures. It is an invocation to rain which precipitates from clouds inhabited by the sun. Birds, trees without leaves, and the shadow projected by the moon, represent the earth. The thick, horizontal line symbolises the temple from where the archer makes his invocation.

This is a plausible explanation of the symbolism Xul conceals in the term **wounded sun**. Perhaps a secondary reading suggests his unconscious desire to invert the roles played by the sexes in modern society.

The end of the Great War in November 1918 accelerated profound structural changes. The break-up of empires, the strengthening of communism in Russia, revolutionary uprisings in Germany, and the creation of new countries, were some of the facts that disturbed socio-political and economic life in Europe. This commotion was also reflected in the world of art and culture.

The Dada movement appeared in Zurich in 1916, and spread its subversive ideas to Berlin, Cologne, New York, Barcelona, Hanover, reaching Paris towards the end of the war. Dada was the means chosen by a handful of avant-garde artists and pacifists to express their opposition and disenchantment with a society in crisis. They denounced an art that was **modern** in form only, that did not propose to resolve the essential contradictions of society. That resolve was the group's most important ambition.

Tristan Tzara wrote:

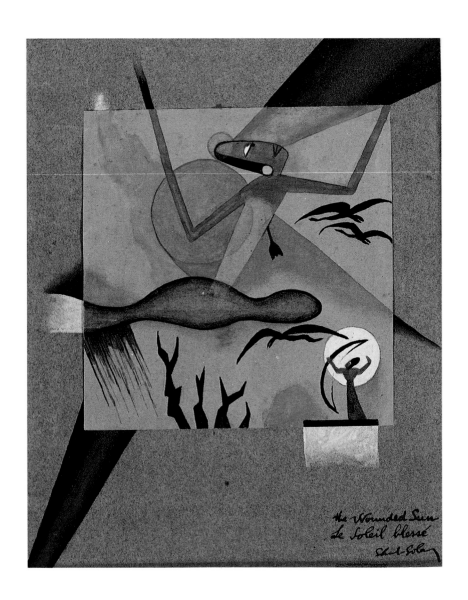

**13.** *El sol herido* (*The Wounded Sun*), 1918
Watercolour on paper mounted on card,
25 x 21 cm
Private collection, New York
Courtesy Rachel Adler Gallery

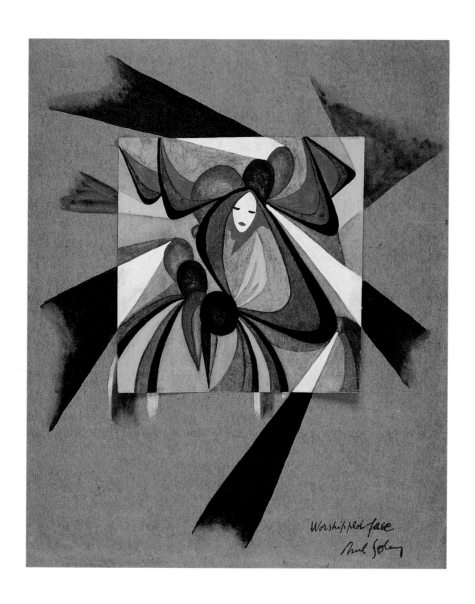

**14.** *Cara idolatrada* (*Worshipped face*), 1918
Watercolour on paper mounted on card,
25.1 x 20.8 cm
Private collection, Buenos Aires

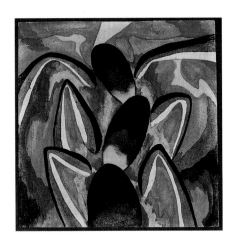

15. *Ritmos (Rhythms)*, c. 1918
Watercolour on paper mounted on card,
image: 11.9 x 11.9 cm; card: 19 x 16 cm
Private collection,
courtesy Rachel Adler Gallery

38. Tristan Tzara's prologue to Georges
Hugnet, *La aventura Dada*, Ediciones Júcar:
Madrid, 1973, p. 13.

39. F. Kupka, *Manuscript II*, p. 28, in
*Frantisek Kupka (1871-1957). A
Retrospective*, Margit Rowell, The Solomon R.
Guggenheim Museum: New York, 1975, p. 77.

Figure 11. Frantisek Kupka
Amorpha, Fuge for Two Colours, 1912
Oil on canvas, 211 x 220 cm
National Gallery, Prague

*Not in vain has Dada proclaimed that it was not modern. Far
from declaring itself part of the old game, Dada sought novelty
via a movement free of prejudices, negating, in this sense, all
formal and illustrative researches.*[38]

The **no** to conformism, the **no** to war, the invented language,
disconcerting affirmations, the recognition of freedom in artistic
forms, social protest, the identification of humour as a valid mode of
expression, are all fundamental ideas upheld by Dada artists.

Even though Xul did not actively participate in this movement, he
knew about it, and partly shared its intentions. Changes noted in the
pictorial representations of Xul's vision can be explained within that
context. The certainty of new modes of expression posed a
formidable challenge, like the imperative to build a world for for his
real ambitions. Enough anachronisms! The crisis of modern society
determined that myths be left behind. The powerful influence of the
reality in which he lived proved unassailable.

It is noteworthy that Xul did not depict his works as pure plastic
events, guiding himself by the rules of composition. Instead he
reflected images that appeared to him as unitary visions, and which
could not be modified. According to Kupka's explanation:

*In our inner visions, the different fragments which float in our
heads are coherently situated in space. Even in remembered so-
called representative images of organic complexes, they are so
strangely situated that the painter ... who would wish to
project them would have to go even beyond the fourth
dimension. Some parts penetrate each other; others seem
completely detached, disconnected from the organism to which
they are supposed to belong. The same is true of purely
subjective visions where only fragments, plexuses of forms, or
colours are given. Before we can seize them and set them
down, we must draw lines between them and establish a
structural coherence. But often they will never form a coherent,
logical or intelligible whole.*[39]

The kind of elements that constitute the visionary images is unique
to each artist. For Kupka they are bands and geometric forms; for
Kandinsky, spots of colours and images of objects that fade and
dilute until they lose their original form; for Arp, organic forms,
linked with the genesis of man and nature; for Mondrian, grids
reminiscent of tree shapes; for Delaunay, multiple coloured planes;

38

16. *Ritmos* (*Rhythms*), c. 1919
Watercolour on paper, 15 x 15 cm
Private collection,
courtesy Rachel Adler Gallery

for Malevich, absolute whiteness, or supreme blackness. The originality of each artist can be gauged by the singular character of the forms used to register his visions.

During this period Xul painted images that could not be assimilated to known elements, which indicates a greater opening of his subconscious. An obsession with hieratic symbolism yielded to other forms, other geometries, like the one seen in *Ritmos* (*Rhythms*, plates 15 and 16),⁴⁰ and in his designs for tapestries (plates 24 and 25). But Xul's visions are peopled by mythological beings, and his incursion into abstraction only lasted a short time.

## First Architectures

All over Europe during the period between 1917 and 1919, the idea of utopia took a greater and greater hold. After the carnage of Verdun, the chance of a rapid victory in the war for either of the sides had vanished. Artists, intellectuals, soldiers, and workers dreamt of a world without wars, hunger and strikes, with a better distribution of wealth; a world where men and women's intimate desires might manifest themselves, free of limitations and discriminations. Xul perceived that this new world was closer for him and his fellows. And this world had to be built, so Xul the **architect** emerged; furniture had to be designed by Xul the **designer**; Xul the **communicator** had to communicate with men and women to raise their spiritual level; Xul the **linguist** had to invent a new language to ease that communication; Xul the **artist** had to express in images the visions captured or generated by his unconscious; and Xul the **poet** had to reveal his inner world.

When Xul moved to Milan⁴¹ in September 1917 he worked in that city's Argentine consulate, but dropped the job after two months. Another phase in the course of his development began in that city where he stayed until August 1918, marked by his interest in architecture. Perhaps the imposing architecture of the Duomo, enveloped in autumn mist, unleashed a series of designs that he named *Bau* (*Building*) or *Estilos* (*Styles*), though I think his interest is more linked to the strengthening of one of his major ambitions, namely, the construction of communal buildings intended for culture and worship in his new world.

40. There's an oil painted on board by Xul called *Multipodos* whose image is similar to *Rhythms* (plate 12).

41. Xul returned to Zoagli in August 1918, and wrote a postcard with an image of Milan's Duomo to his father: *I am thinking of staying a few months and painting landscapes here. In all, it didn't go too badly for me in Milan, but always missing my country. Lets hope that peace is at hand in order to fly far off and see and learn new things, and not return such an ass as when I left, even if a bit older* (see figures 12 and 13).

39

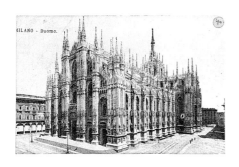

MILANO - Duomo.

Figures 12 and 13. Postcard from Xul Solar to his father sent around August 1918 with Milan's Duomo on the back

42. Kenneth Frampton, *Modern Architecture: A Critical History* (3rd edition), Thames and Hudson: London, 1992, p.64.

Figure 14. Bruno Taut
Design for a Building for Offices and Businesses (not carried out), 1921

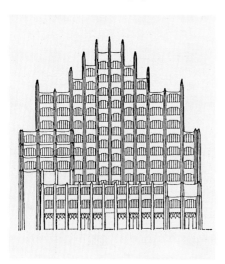

From his first landscapes to his latest *Grafías* (Ideographs) Xul has recorded his visions in order to make them didactically accessible. At the same time he has proposed concrete features that will give shape to the unique world he set out to create. Because of this, architecture as an all-encompassing activity could not remain excluded from Xul's mental world. As a young man he had begun studying architecture in the Faculty of Exact Sciences and which he had soon given up. It is possible that the strict academic expectations of those times proved to be incompatible with both his ambitions and motivations. But his obsession with architecture as a link between man, nature and the cosmos did not take long to resurface.

Xul developed his first architectural projects (plates 17 to 22) in Milan and Zoagli while in the middle of transforming his imagery. He propounded an architecture of Expressionistic characteristics and symbolic features, mixed with typological aspects like arches and filigrees in facades with Neo-Gothic qualities. At a first glance those projects might appear to be cathedral façades, influenced by Milan's Duomo [*Estilos* 3 (*Styles* 3), plate 17]. Some remind us of romantic castles designed and built for the extravagant Ludwig II of Bavaria. Behind these façades, and the suggestive decorative elements surrounding them, there are other connotations linked to Xul's expressive development in this critical moment of his integration with the avant-garde, while he struggled to rid himself of his psychic limitations in order to participate in the new postwar Europe which he envisaged as an ideal society, perhaps in the utopian sense glimpsed by reformist German Social-Democrat thinkers.

These buildings gave expression to his conception of the cosmos and his mystical thoughts, at the same time the decorative features used strengthened the symbolic contents. There are structural forms that have been conceived within a rationalist structural framework, in the manner of Villet-le-Duc,[42] like the one applied by Gaudí in the Church of the "Sagrada Familia", that can be observed in *Estilos* 3. What is surprising is the marked ascending character of the structural supports (columns) that taper towards the sky, and are placed in the forefront of the building. On these hang the canopies which as they are protective structures, perform as utilitarian and functional elements. On a second plane the treatment of this other part of the building suggests another architectural function. All this is highlighted by a brilliance of colouring and a fine play of shades and transparencies that only watercolours allow.

In *Catedral (Cathedral*, plate 19) the presence of cavernous apertures, that underline the contradictory asymmetry of the lateral

**17.** *Estilos 3 (Styles 3)*, 1918
Watercolour on paper, 19.9 x 24.9 cm
Private collection, Buenos Aires

41

18. *Proyecto (Project)*, 1918
Watercolour on paper, 19.5 x 24.5 cm
Private collection, Buenos Aires

Figure 15. Bruno Taut
Alpine Architektur, 1919, plate 14

buildings, has required the use of complex support structures that combine circular and ogee arches to fill out the voids. They are quite removed from the intuitive structural rationalism applied in *Estilos*.

The strange symbols used in the details: medallions with serpents, capitals with human or geometric shapes, friezes, curtains, do not correspond to the familiar shapes used by Art Nouveau architects and designers or by Gaudí. They are products of Xul's hermetic world.

In no way did these projects become nostalgic mementoes of the period when Gothic cathedrals were built, but they were Xul's first attempt to materialize **Volksbauen** (buildings for the people), a place where the masses could congregate, and from there work towards that new and utopian world dreamed-up in his Buenos Aires nights. They could be included in the *Worringerian* concept of **Gesamtkunstwerke** (integral work of art).

Xul added a dose of mystery to the Expressionist and Symbolist aspects of his first architectures which combined his conception of the cosmos, his ingenuous and restless expressive ways, his personal symbols, and his Dadaist humour in ways that were typically unconventional and identify him. This interest in developing communal buildings was later reflected in further projects and paintings which culminated with his Lettrist constructions in 1954 (plates 154-158).

42

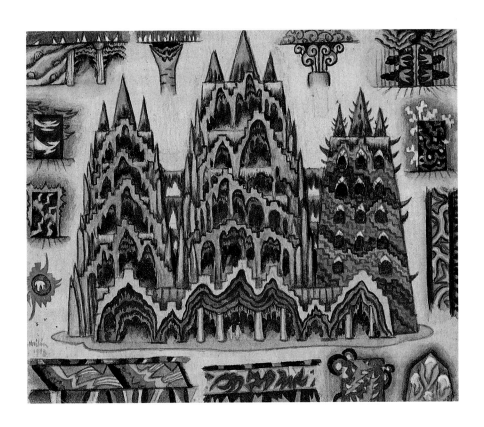

19. *Catedral (Cathedral)*, 1918
Watercolour on paper, 20,5 x 25 cm
Private collection, Buenos Aires

43. Taken from Iain Boyd Whyte, *Bruno Taut and the Architecture of Activism*, Cambridge University Press: Cambridge, 1982, p. 61.

44. See Iain Boyd Whyte, *The Crystal Chain Letters Architectural Fantasies by Bruno Taut and his Circle*, The MIT Press: Cambridge, MA, 1985.

With this group of works Xul aimed to join in the rebuilding of the postwar world, and without being aware of it, supported Adolf Behne's claim, published in 1919:

> *The mission of architecture, he wrote, should be to unite all arts in order to create an ultimate statement of unity: unity of man with man, of man with nature, and man with the cosmos.*[43]

In order to insert Xul into the historical context of Expressionist architecture, we would have to determine how far his works were influenced by Bruno Taut and his group, integrated around the so-called *Gläserne Kette* ("Crystal Chain"),[44] active between December 1919 and December 1920. This group had emerged after an exhibition of visionary architectural schemes called "Exhibition for Unknown Architects" in convulsed postwar Germany, that was a strong attack both on classic architecture and incipient modernism. Bruno and Max Taut, Hans and Wasily Luckhardt, Hermann Finsterlin, Hans Scharoun and Walter Gropius, amongst others, participated in that group. The title adopted contained an obvious reference to the pioneer crystal architecture proposed by Paul

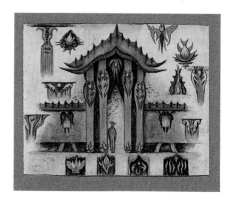

20. *Estilos (Styles)*, c. 1918
Watercolour on paper mounted on card,
23.6 x 28.4 cm. Private collection

21. *Egipto (Egypt)*, 1918
Watercolour on paper mounted on card,
19.4 x 14.8 cm. Private collection

45. P. Scheerbart, *Glasarchitektur*, Berlin, 1914.
46. Bruno Taut, *Eine Notwendigkeit*, Der
Sturm, vol. IV, n. 196/7, 1914, pp. 174-175.
47. Bruno Taut, *Alpine Architektur*, Hagen,
1919, and *Die Stadtkrone*, Jena, 1919.
48. *Ruf zum Bauen*, Ernst Wasmuth: Berlin,
1920. This publication contained reproductions
of fantastic architectures by the greater part of
the members of the *Crystal Chain*.
49. Another group of architects, headed by
Virgilio Marchi, declared themselves Futurists,
and their first designs, dating from 1919, are
more linked to Expressionism and fantastic art.
50. John Russell Taylor, *Visions from the
Human Melting Pot*, The Times, London, 8th
January 1994, p. 14.

Scheerbart,[45] developed by Bruno Taut, and a paradigm for the
German Expressionist, or *Activist*, architects.

There is no evidence of a connection between Xul and those
architect-artists, given that the majority of the architectonic fantasies
of the Activists were created between 1919 and 1920, and the first
ones done by Xul were dated 1918, indicating where they were
painted. We could speculate about Xul having read the first article
published by Taut,[46] and being informed about the mystical and
spiritual material attributed to the glass constructions, as hinted by
the transparent dome in one of his projects (plate 19). However,
Taut's books[47] first appeared in 1919. Furthermore, the show of the
"Unknown Architects" appeared without a catalogue, and Xul did
not acquire *Ruf zum Bauen*[48] in Munich before 1921. In terms of
what was happening in Italy, it doesn't look as if Xul had become
interested in the ideas of a Futurist architecture, supported by the
concepts of modernism and of the cult of the machine, and
represented at its start[49] by Saint' Elia, killed in the war.

Both Xul and the German Activists had been nourished by a
mystical conception of the cosmos firmly established in Europe at the
beginning of the century and they shared a world of archetypal forms
immersed in the collective unconscious. From there, different
expressive currents emerged which, by searching for absolute purity,
lead to the birth of abstract art. These common aims, within the
context of German and European economic, political and social
realities, served as the initial germ for the architectonic utopias of
both the Activists and Xul. But Xul's concrete realizations were
independent, and responded to his own individual will. A
confirmation of this can be seen in the similarity between Bruno
Taut's unbuilt design in 1921 (figure 14) and *Estilos 3*, carried out in
1918.

However, there is no chance of mistaking Xul's designs with the
fantastic and utopian designs by the "Crystal Chain" group. From a
strictly pictorial view, Xul's images, *tiny in size, but vast in scale*,[50]
relate more to the plastic arts. Also, although Xul's designs for
façades and architectural details survive, there are no known designs
of architectural interiors. Nevertheless, his architectures are upheld
by a structural logic that, although complex, makes them
constructable and habitable. It is here that an essential characteristic
in Xul's thinking first appeared: subverting utopias by turning them
into realistic possibilities.

At the same time Xul also designed objects for domestic use like
jugs, coffee pots, urns, and sofas, that combined Expressionistic

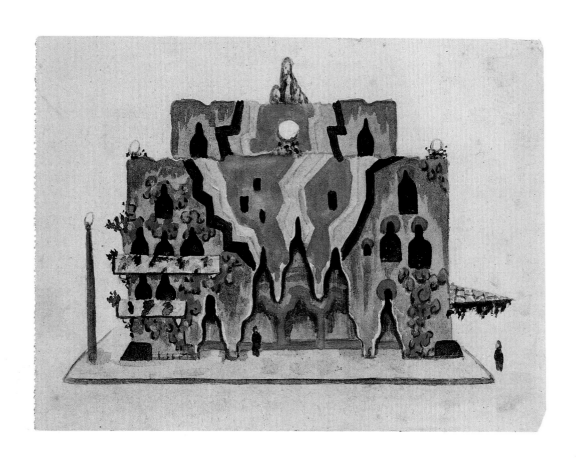

**22.** *Bau* (*Building*), c. 1918
Watercolour on paper, 12 x 16 cm
Private collection, Buenos Aires

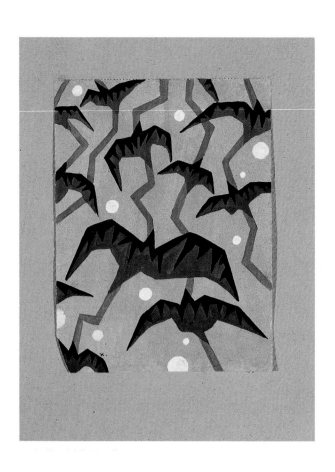

**23.** *Tapiz* (*Tapestry*), 1918
Tempera on paper mounted on card,
image: 16 x 12 cm; card: 22 x 16.8 cm
Private collection, Buenos Aires

**24.** *Tapiz* (*Tapestry*), 1918
Tempera on paper mounted on card,
image: 16 x 12 cm; card: 22.6 x 17 cm
Private collection, Buenos Aires

25. *Tapiz* (*Tapestry*), 1918
Tempera on paper mounted on card,
image: 14 x 11 cm; card: 18.6 x 15.2 cm
Private collection, Buenos Aires

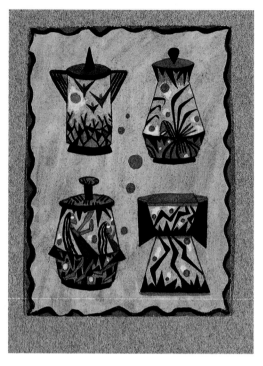

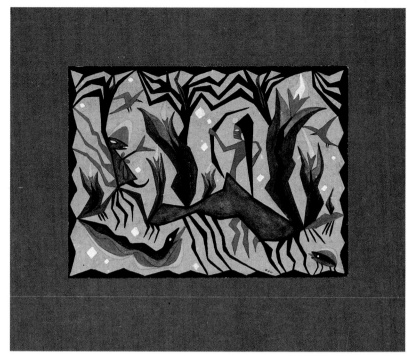

26. *Frascos (Jars)*, 1918
Watercolour on paper mounted on card,
image: 16.2 x 11.9 cm; card: 19.4 x 14.5 cm
Private collection, Buenos Aires

27. *Flechazo (Arrow Shot)*, 1918
Watercolour on paper mounted on card,
image: 15 x 21 cm; card: 25.3 x 30 cm
Private collection, Buenos Aires

Figure 16. Hans Poelzig
Great Theatre, Berlin, 1919

characteristics with anticipations of the Art Deco period. Sometimes Xul applied images in his design taken from his paintings, as can be seen by comparing *Flechazo* (*Arrow shot*, plate 27) with the objects from plate 26.

While his expressive means matured, his designs also evolved, and attained purer geometric shapes like those in plates 43 and 44. None of these designs were carried out, but back in Argentina he did decorate glasses with stylised faces.

A series of set designs, possibly for the theatre, were also part of Xul's new world. The similarity between his design (plate 28), whose origin lay in his 1918 architectures, and Hans Poelzig's theatre (figure 16) reinforces the underlined concepts.

## The Plasticist-Expressionist Paintings

The change in Xul's way of painting became settled. His new images were intimately linked with the difficulties he experienced breaking with his Expressionist-Symbolist style. In a series of oblong-shaped small works, mainly done in 1919 as diptychs, it is noticeable how by

28. *Escena teatri* (*1*) [*Theater Scene* (*1*)], 1920
Watercolour on paper mounted on card,
image: 15 x 21 cm; card: 21 x 25.4 cm
Private collection, Buenos Aires

29. *Escena* (*Scene*), c. 1924
Watercolour on paper, 25 x 32.5 cm
Private collection, Buenos Aires

continuous and painful meditation he tried to reconcile his connection with angelic worlds and spirituality with more spontaneous and direct images, without resorting to archaisms, and in harmony with the avant-garde ideals he also shared. That is why we coin the term **Plasticist-Expressionist** to characterize the works up to 1923.

From then on his visions were crowded with steep mountains and passes that are difficult to climb. His images retained the planar character of his earlier period, but were more schematic, and highlighted by more vivid colours. To attain his desired expressive mode Xul introduced in his works short texts written in incipient *neocriollo*. These first **verbal paintings** expressed a confessed desire to deepen his creative process in accord with his own developing inner life, and revealed his psychic shortcomings and insecurity. His obsession with these markedly vertical supports confirms the mystical feeling of elevation that such shapes suggest, as **ladders** towards light, towards heaven.

Behind his **verbal paintings** lay conflicts that characterized the initial phase of this new period, his aim to create and prove his own strength, his unrestrained desire for liberation, his yearning to find transcendence, and his own insecurity. They thus have a deep autobiographical meaning. Here we should refer to his precarious economic situation, and his direct dependence on his mother and aunt, affectionately called *mamás* (mothers) and *chatas* in his letters, for all three were supported by a solicitous father in Buenos Aires.

The diptychs exalted this rhythm, alternating between his changing moods, and reiterated that polarity between the desire to create and the impossibility of carrying it out, as seen in his previous writings.[51] The diptych: *Subo os alcanzaré mais ke alas tengo* (*I Climb and Will Reach You but What Wings I Have*, plate 30) and *Probémonos las alas también nos* (*Lets Try on the Wings Too*, plate 31) serve as an example. Painted in 1919, Xul practiced drawing with schematic forms, and the aura of the personages and birds are integrated into planar shapes.

This group of works revealed Xul's urge to attain superior levels of consciousness, as well as the doubts and fears that emerged. In the first image he asked the anguishing question: Will I be ready to attain plenitude? While he answered in the second that he was willing to take the risk. The use of colour in *Probémonos ...* suggests a possible transmutation from man to bird. Birds fly tirelessly through Xul's work of this period, and they *symbolize spiritual states of mind, angels, higher states of being.*[52] By aiming them at heaven Xul directed his prayers to reach that longed-for angelical state.

51. See note 2.

52. Chevalier-Gheerbrant, op. cit., p. 695.

Figure 17. Paul Klee
*Once Emerged from the Gray of Night...,*1918/17
Watercolour and pen drawing in India ink over pencil on paper, cut into two parts with strip of silver paper between, mounted on board, 22.6 x 15.8 cm. Kunstmuseum, Bern
© VG-BILD-KUNST, Bonn, 1994

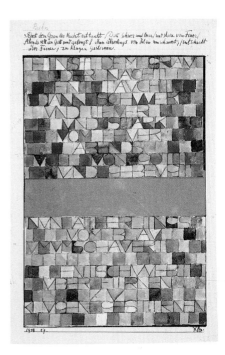

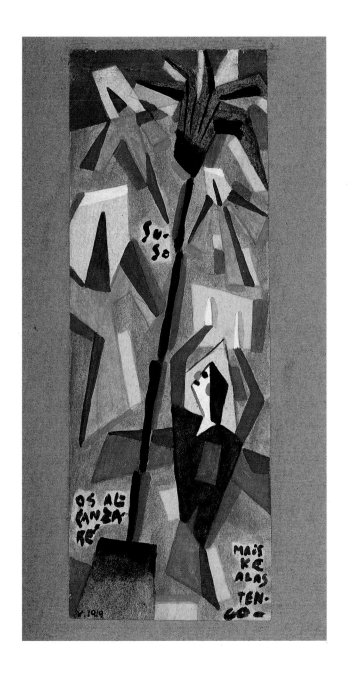

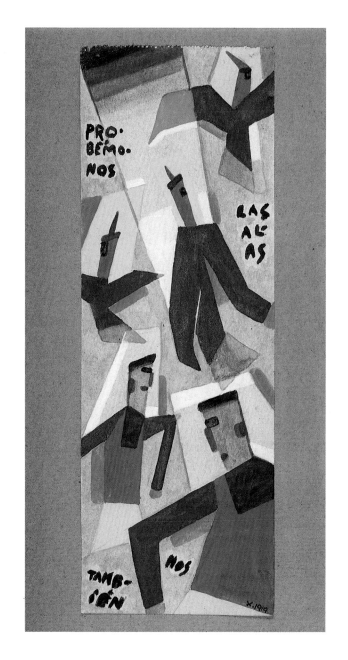

30. *Sube, os alcanzaré, mais ke alas tengo*
(*I Climb and Will Reach You but What Wings
I Have*), 1919
Watercolour on paper mounted on card,
image: 21 x 7.5 cm; card: 29.4 x 11.8 cm
Private collection, Buenos Aires

31. *Probémonos las alas también nos*
(*Let's Try on the Wings Too*), 1919
Watercolour on paper mounted on card,
image: 21 x 7.5 cm; card: 29.4 x 11.8 cm
Private collection, Buenos Aires

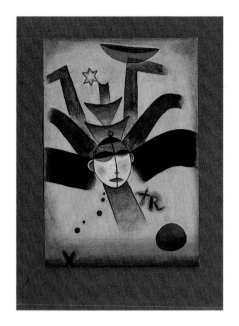

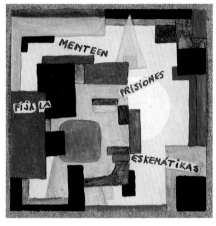

32. *Pupo (Pupo)*, 1918
Watercolour on paper mounted on card,
image: 21.5 x 15.5 cm; card: 24.5 x 18.3 cm
Museo Nacional de Bellas Artes, Buenos Aires

33. *Fija la mente en prisiones eskemátikas*
(*Fix the Mind on Schematic Prisons*), c. 1919
Watercolour on paper mounted on card,
image: 10.5 x 10.6 cm; card: 16.8 x 13.7 cm
John P. Axelrod Collection, Boston
Courtesy Rachel Adler Gallery

53. Archives of the Fundación Pan Klub
Museo Xul Solar, Buenos Aires.

Xul continued his progress, as seen in the series *Troncos* (*Trunks*). The final version (plate 34) was based on a drawing where the coloured planes assert the composition. The scene is suggestive, the tree trunks form conical structures and appear as mythical beings dancing rhythmically in front of a bird, while a sun and moon illuminate the strange landscape. A serpent creeps silently between branches, or roots, whilst another serpent peeps out from its hiding place. Both represent the primordial force of nature. The polarity between the bird as symbol of the celestial world and the serpent as symbol of the mysteries of the terrestrial world transfers the purely visual perception of the work to a superior plane.

As his pictorial techniques improved, the declamatory texts incorporated into his watercolours disappear, until more hermetic meanings are reached, as observed in *Fija la mente en prisiones eskemátikas* (*Fix the Mind on Schematic Prisons*, plate 33). The profile of a face made from a juxtaposition of planes is painted with colours so pure that it stands out from the geometric shapes surrounding it. Its expressive rigidity evokes Assyrian *bas-relief* images. The three basic shapes of the **circle**, **square** and **triangle** on the right of the face are paradigms of Geometry, as well as symbols of the three vital elements in the universe: **heaven**, **earth** and **fire**, and were adopted as a starting point for art of this century.

In that work Xul not only produced a pictorial achievement, but also established his position in front of an art consecrated to the representation of free-forms in the plane, namely **abstract art**. Geometry is a science that helps to free the mind, and clinging to it only helps to imprison the mind.

In 1919 Xul made several short trips to Milan, and then moved to London where he remained about six months. Xul underwent a profound crisis, also fed by the anxieties he felt emanating from the troubled postwar situation in Europe. London was then the main spiritual centre in Europe, and the interest some English circles professed for mysticism and magic did not leave Xul indifferent, as he was interested in occult philosophies, and oriental cultures and religions.

What he did in London remains a mystery. All that is known from that period are a few notes, along with poems, texts and linguistic analyses.[53] A text written on the 28th of March 1920 confirmed his anguish:

*Its reaching the limit. Weeks (months) blocked in my creative yearnings [creaji anhelo], impurities (belt, fran) read vagante)*

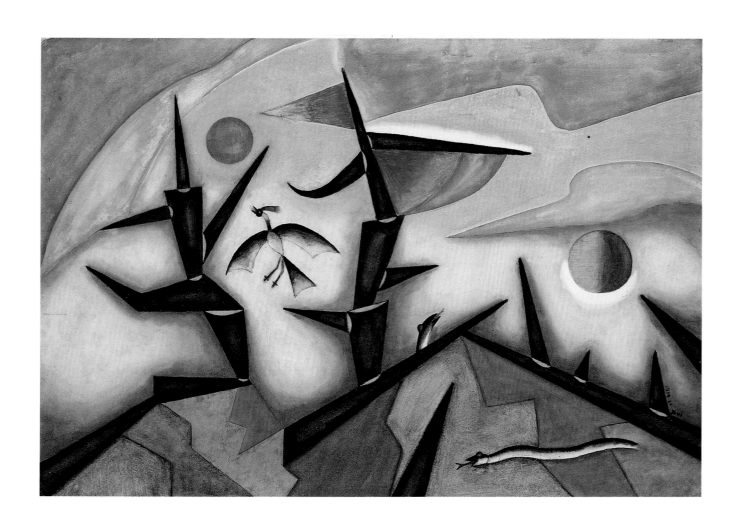

**34.** *Troncos* (*Trunks*), 1919
Watercolour on paper, 31.7 x 46.8 cm
Eduardo and Teresa Costantini Collection,
Buenos Aires

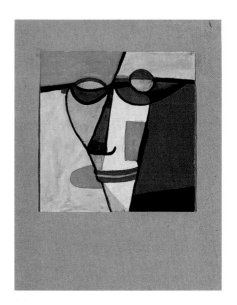

35. *Cara (Face)*, c. 1919
Watercolour on paper mounted on card,
image: 10.5 x 10.5 cm; card: 17.7 x 14.4 cm
Private collection, Buenos Aires

54. Piero Marussig (1879-1937) was one of
the founders of the Novecento Italiano group.

55. Xul told his father about this exchange
from Rome (postcard dated 7th June 1921).

56. Arturo Martini (1889-1947) one of Italy's
greatest sculptors of this century. On
Thursday 2nd May 1991 two New York
galleries, the Philippe Daverio and the Rachel
Adler Gallery, both located in the Fuller
Building, opened at the same time, and
independently, the first one-man exhibitions
of these two artists in New York city.

57. E. Pettoruti, op. cit., p. 136.

58. This incident has been interpreted as Xul
not wanting to sell his paintings. (See Daniel
E. Nelson, *Xul Solar: World Maker*, *Latin
American Artists*, The Museum of Modern
Art, ed. Waldo Rasmussen, with Fatima
Bercht and Elizabeth Ferrer, New York,
1993, p. 47.) But in fact, Xul's question was a
kind of Dadaist test of the collector's
intentions, as Xul wanted, and needed, to sell
his works.

59. Lita Xul Solar has decided on the dates of
the majority of the undated works.

*[vagante] the club in my house etc. I am sickened by myself and
all this (Little and many days renders tomorrow? [Poca y. i
muchos días da mañana?]*

In May 1920 Xul returned to Milan and made contact with Italian
artists. Piero Marussig[54] painted a magnificent portrait of him (figure
1). It is now in the Xul Solar museum, exchanged for a watercolour.[55]
Mario Buggelli, Director of the Galleria Arte, invited Xul Solar to
exhibit his works with Arturo Martini's sculptures.[56] The exhibition
took place in Milan at the end of 1920 and included 46 watercolours,
20 oils and 4 temperas. Amongst the most significant works were
*Entierro (Burial)*, *Anjos (Angels)*, *The Wounded Sun, San Francisco*,
his first architectures, and design motifs. The catalogue included a
text by Pettoruti.

The following anecdote[57] best illustrates Xul's disconcerting and
Dadaist personality. A well-known collector decided to buy two of his
watercolours. Xul complained: *How can such a prominent collector
as you buy such trash?* The show closed without a single sale.[58]

# A Season in Munich

A new trip to Munich where he arrived in October 1921 allowed Xul
to make direct contact with the works of the German Expressionists
and Paul Klee. He stayed in Munich for two years. To start with he
enrolled at the *Münchener Kunstwerkstätte* (Applied Arts Workshop
of Munich), situated at 21 Hohenzollern street.

Xul was motivated by the atmosphere in that city, and his
production increased while his oblong watercolours dedicated to his
inner life were left behind. He assimilated the modernist ideas
developing at the same time in other European cities in what is
unmistakably a personal style. Xul mastered his expressive means
with total freedom; had matured as an artist, and launched himself
into more accomplished compositions.

It is not possible to define one theme as characteristic of such a
rich and productive period, but there is evidence of a sort of rare
unity. Take *Tres y sierpe (Three and Serpent*, plate 38), a watercolour
painted in 1921,[59] as representative of one of his main obsessions; the
plurality of being. Three women's faces with spectral gazes

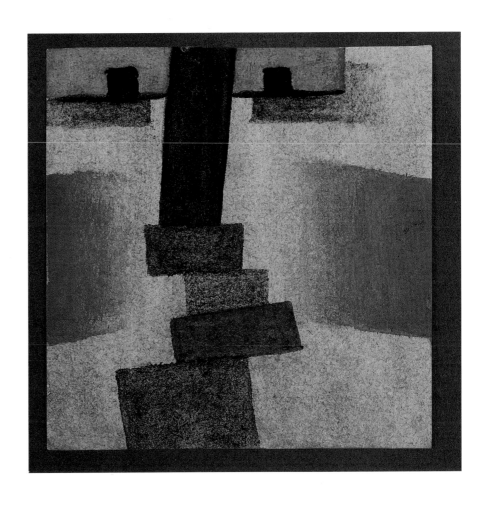

36. *Cara (Face)*, c. 1919
Watercolour on paper mounted on card,
image: 10 x 10 cm; card: 15.3 x 13.3 cm
Private collection, New Orleans
Courtesy Rachel Adler Gallery

contemplate us from the painting. They are constructed by juxtaposing planes that are balanced by warm and cold tones. These disturbed and suggestive faces express amazement, surprise, expectation, and fear. How remote those morbid and vexed feminine faces, possessed by occult forces, painted by the Symbolists at the end of the century turn out to be!

The rectangular planes that defined the faces illuminate the shapes with their transparencies. Xul established chromatic relations with glaring dissonances that reflected his expressive energy, and gave the work a sense of barbaric beauty, a beauty that responded to canons from strange imaginary worlds, far from the lyric and harmonic colour modulations on the pictorial plane cultivated by the Orphic painters like Delaunay, and that Paul Klee analysed in depth while at the Bauhaus.

The five X's are distributed over the image to compensate for the empty space, and at the same time, indicate the presence of the artist. The serpent drawn as a flat ribbon with its gold-coloured aura

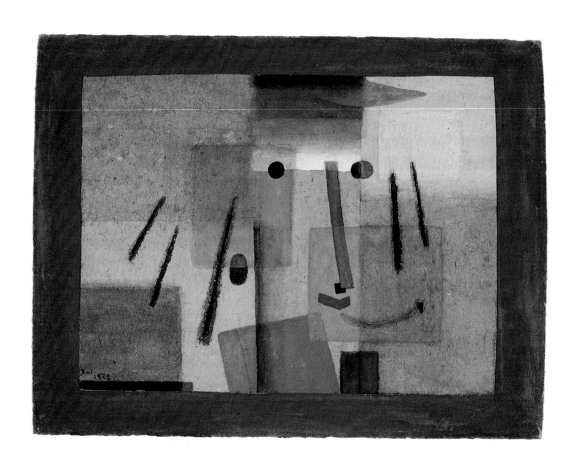

**37.** *Máscara con visera*
(*Mask with Visor*), 1923
Watercolour on paper mounted on card,
image: 14 x 19 cm; card:17.8 x 23.5 cm
Private collection, Paris
Courtesy Rachel Adler Gallery

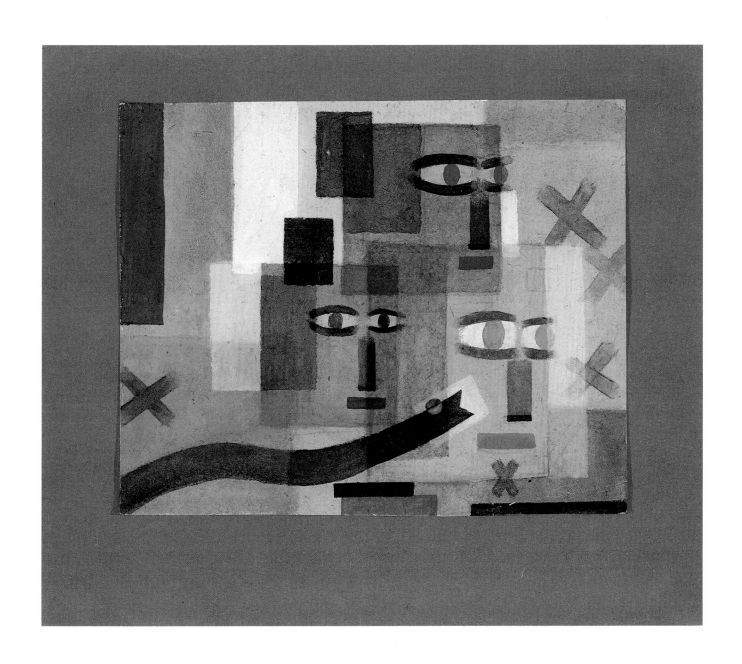

**38.** *Tres y sierpe* (*Three and Serpent*), 1921
Watercolour on paper mounted on card,
image: 15.6 x 19.7 cm; card: 22.3 x 26.1 cm
Private collection, Buenos Aires

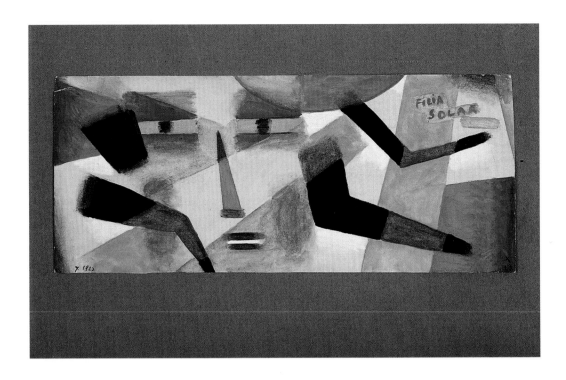

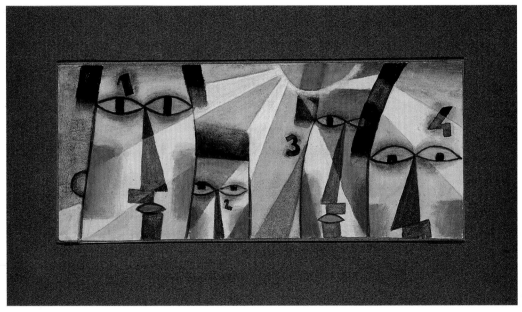

**39.** *Filia solar* (*Daughter of the Sun*), 1922
Watercolour on paper mounted on card,
image: 10 x 23 cm; card:17.2 x 30.3 cm
Private collection, Buenos Aires

**40.** *Los cuatro* (*The Four*), 1921
Watercolour on paper mounted on card,
image: 10.1 x 23.9 cm; card 17.4 x 30 cm
Eduardo and Teresa Costantini Collection,
Buenos Aires

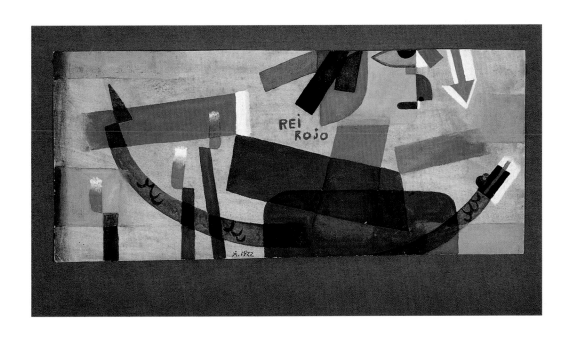

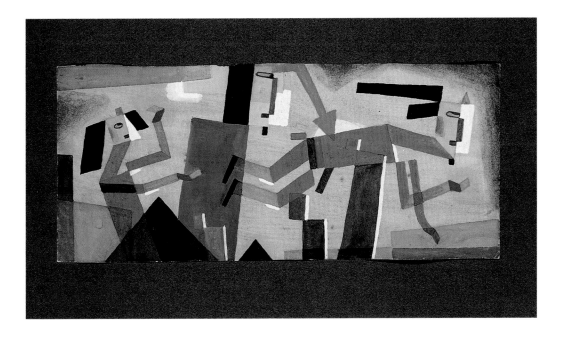

41. *Rei Rojo* (*Red King*), 1922
Watercolour on paper mounted on card,
image: 11 x 25.7 cm; card: 17.6 x 30 cm
Private collection, Belgium
Courtesy Rachel Adler Gallery

42. *Los tres* (*The three*), 1923
Watercolour on paper mounted on card,
image: 11 x 25.8 cm; card: 17 x 30 cm
Eduardo and Teresa Costantini Collection,
Buenos Aires

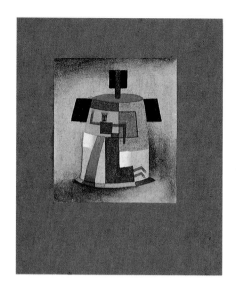

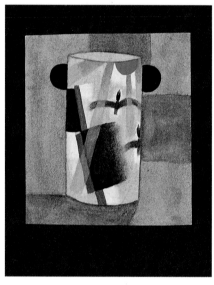

43. *Pájaro* (*Bird*), 1918
Watercolour on paper mounted on card,
image: 10.9 x 9.8 cm; card: 16 x 12.6 cm
Private collection, Buenos Aires

44. *Casi vuelo* (*I Almost Fly*), c.1919
Watercolour on paper mounted on card,
image: 11 x 9.8 cm; card: 19.8 x 17 cm
Private collection, Buenos Aires

60. Postcard to his mother from Kelheim,
dated 3rd July 1922.

61. Postcard to his mother from Kelheim,
dated 7th July 1922.

62. Julio Casares, *Diccionario ideológico de
la lengua española*, Gustavo Gili: Barcelona,
1982.

reminds us that this image emerges from the terrestrial plane, and belongs almost permanently to Xul's world.

An analogous treatment can be seen in *Máscara con visera* (*Mask with Visor*, plate 37). He painted further faces: *Filia Solar* (*Daughter of the Sun*, plate 39) and *Los cuatro* (*The Four*, plate 40) that reflect that sensation of bewilderment and mysterious unreality. When referring to his work of that period Xul wrote: *I am doing fantastic work*,[60] and four days later he wrote: *I am painting scarecrows*,[61] which in a dictionary means: *anything that instils fear by its figure or representation.*[62]

The feminine images sometimes reveal a certain dose of tenderness. The subtle and inviting gaze of a face made up in the oriental fashion, situated in the foreground [*Espero*, (*I wait*), plate 45], suggests an evening out of delicious intimacy, lit up by two candlesticks that flank the scene.

Xul mastered the plane that he worked with stripes, arrows, bands and ribbons painted with joyful colours that run in all directions, and surround and integrate the central motif of the work. *Pollo* (*Chicken*), reproduced in plate 46, is an example of Xul's technique. The watercolour is applied to give intensity of hue to the planes that make up the forms. In the areas defined by the intersection of those planes, Xul used similar but softer and more transparent colours. The distribution of these intersections on the pictorial plane balances the central image's expressive force and the peripheral stripes. The work's total image, lightened by the virtual fragmentation of the forms, appears to be suspended on the pictoric plane.

There are forms that Xul transforms into signs like those clouds painted with halos that he later repeated in other paintings (plate 51). The presence of the omnipresent solar disc that identifies Xul reinforced the iconic quality of the image.

His idea of encircling the central figurative motif with geometric elements has points of contact with that short transitional period in Kasimir Malevich's art that elapsed from the end of his Cubist-Futurist period up to his Suprematism. It's the period called "anti-logic", between 1913 and 1914. The anti-logic works show the contradictory juxtaposition of realist images over Cubist or non-figurative outlines. They include geometric shapes, a fish, a playing card, words and letters (figure 18). This technique of violent confrontation of realist images with pure geometric forms corresponds to a

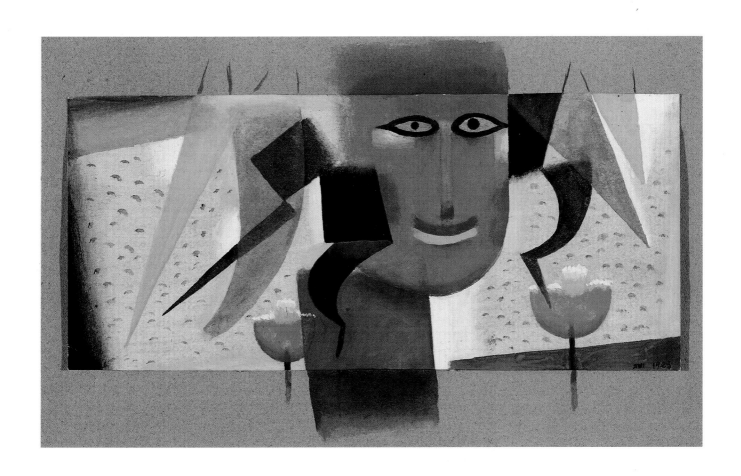

45. *Espero* (*I wait*), 1923
Watercolour on paper mounted on card,
16.7 x 27.8 cm
Private collection, Buenos Aires

61

*return to the exploration of the limits of the meaning of an image that must lead Malevich to the elimination of that other component of the picture*[63]

as the next step. That is how Malevich reached Suprematism. Instead Xul used that same confrontation to highlight his visions, and he represented them with a new language that not even his own Symbolist-Expressionism, nor other proposals put forward by the avant-garde, could satisfy.

The process used by Xul to define the central motif is rooted in Expressionism, and is related to the works of the artists of the *Die Brucke* movement, like Erich Heckel and Max Pechstein (figure 26). But the result is different. The Expressionists nervously distorted, deformed and exaggerated the surrounding reality. Xul employed a more schematic structure for drawing the human forms, animals and plants in his central motif, and his expressivity was more contained.

The elongated forms adopted for painting these works are the right ones to integrate stripes, semi-circles and figures with the central motifs, which are also boosted by the energy transmitted by the geometric shapes surrounding them. The juxtaposition of both energy fields generated a far stronger energy.

Xul resolved in a different way the intersections between figures. The Suprematists superimposed the colour planes one over the other as if working with collages to create a spatial effect of layers of colour, as seen in Malevich's oil painting (figure 21) or in Kudriaschev's watercolour (figure 19) while Xul painted intersections with appropriate tonalities. These changes of tonalities lightened the

63. Andrei B. Nakov, *Malevich Ecrits*, Editions Champ Libre: Paris, 1975, p. 55.

Figure 18. Kasimir Malevich
Schneider, Allogismus, Aushang, c.1914-1915
Pencil on paper, 16.2 x 11 cm
Ludwig Museum, Cologne

Figure 19. Ivan A. Kudriashev
Design for the First Soviet Theater in Orenburg, 1920
Watercolor, gouache and paper collage on paper, 13.3 x 39 cm
Private collection

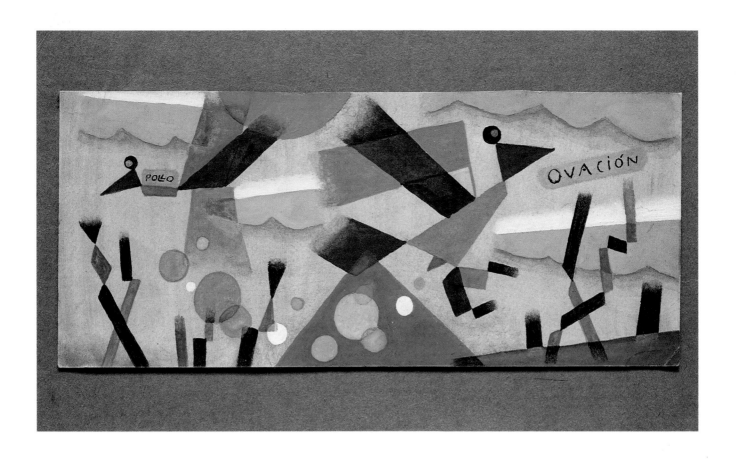

**46.** *Pollo* (*Chicken*), 1922
Watercolour on paper mounted on card,
image: 11 x 25.7 cm; card: 16.4 x 27.5 cm
Private collection, Buenos Aires

64. See for example *Watercolors by Kandinsky at the Guggenheim Museum*, with an essay by Susan B. Hirschfield, Guggenheim Museum: New York, 1991.

power of the images and conferred that transparency and levity that characterize them. Kandinsky used a similar procedure in his watercolours of that period.[64]

The expressive unity that Xul achieved working in that small scale is remarkable. The denomination chosen for this period in his painting -Expressionist-Plasticist- summarises the presence of Expressionist rooted components in the central motifs, for this is the way a realist painter, as Xul defined himself, proceeded, in the same way as the artistic purity was reflected in the play of geometric forms and bands that circle the motif and emphasized and invigorated it. In some paintings like the watercolour *Espero*, the lateral stripes invaded the coloured mounts, which in all cases were part of the image; it is a unique and suggestive vision.

Some of the texts Xul introduced into his watercolours have more hermetic meanings, and he employed neologisms written in *neocriollo*. These texts underlined the communicative force of the images, and functioned as symbols with an impact that reinforced the hidden meaning of his works.

In the case of Cubist painters, words tended to

*lighten, from an emotional point of view, the severe formal structures ... and also evoke the accents of daily life in abstract compositions,*[65]

65. H. Wescher, *La historia del collage. Del cubismo a la actualidad*, Editorial Gustavo Gili: Barcelona, 1976, p. 24.

66. *Cornac* in French is the name of the person who drives an elephant, and thus any guide. Viviane Cabannes from B.I.P. at the Centre Georges Pompidou in Paris informed me of this. It has the same meaning in Spanish.

Figure 20. Wizard and Dragon Terracotta, Si-Ngan-Fou ( Chen-Si ) Cleveland Museum of Art, Cleveland

Figure 21. Kasimir Malevich Dynamic Suprematism, 1916 Oil on canvas, 102.4 x 66.9 cm Ludwig Museum, Cologne

and thanks to Dadaism, they became symbols which brought unconscious meanings to the images. The Expressionist-Plasticist paintings done by Xul between 1921 and 1923 attained this degree of meaning. They were more accomplished works than his previous paintings because of the greater integration between text and image.

One of these works was *Fluctúa navesierpe por la extensión isucornake* (*The Serpent-ship Fluctuates through Space and its Guide*, plate 47), a good example of his **verbal paintings**, in which the pictorial image connects with a mysterious text that is hard to understand. A serpent is transfigured into a ship -*Navesierpe*-, like those Indian canoes, and is propelled by its own movement, and guided by a saintly character gripping rectangular paddles that act as oars.

The dislocations that the planes of the serpent's body experiences capture the essence of the ondulating and fluctuating movement of a reptile. Xul reiterated this representation later in his architectural structures. The serpent's head reminds us of the pure geometric shapes done by Malevich (figure 21). The stripes that extend over the supporting mount underlined and invigorated the image.

The affinity between *Fluctúa ...* and the ancient Chinese bas-relief illustrated in figure 20 confirms the link between Xul's visions and archetypal forms from the collective unconscious.

We will now attempt to decipher the meaning of the text in this painting which reads from right to left, and from above to below as:

FLUCTÚA NAVESIERPE POR LA EXTENSIÓN ISUCORNAKE

The first four terms are easy to translate as *The Serpent-ship fluctuates through space*, but the final bit can be broken into "*i su cornake*",[66] that is, *and his guide*. The complete text should now read:

*The Serpent-ship fluctuates through space and its guide.*

But there is more to this. Wouldn't Xul have suggested another meaning on a higher spiritual level that would take the symbolism of the imagery in its totality into account? Several solutions could be offered to solve this riddle. One suggests that its possible to take

**47.** *Fluctua navesierpe por la extensión
isucornake* (*The Serpent-ship Fluctuates
through Space and its Guide*), 1922
Watercolour on paper mounted on card,
17 x 29.5 cm
Private collection, Buenos Aires

advantage of the earth's energy to attain the desired transcendence as long as an illuminated guide is available, or that the observer is willing to follow the spiritual path.

Xul recorded other visions, and communicated other messages, as in *Pollo* (*Chicken*). The image shows flying chickens that while OVATIONing eject multi-coloured eggs in a reddish dusk. In this work Xul revealed a sense of humour that was both innocent and crafty, and that came from far-off places and exploded in the painting. The scene shows a process of gestation, but also warns about the possibility of massive destruction that the new birds, or airplanes, embody.

Meditation about myths and the content and teachings of religions attracted a mystic like Xul who did not acknowledge the comparative advantages of the important monotheistic religions over the polytheistic ones. It must be pointed out that Xul's own creative process did not lead him to use religious iconographic representations as if they were some archive of images which an artist consciously employs when searching for subject matter. Rather, Xul sought to obtain a better understanding of the mechanics of communication between his unconscious, his higher ego, with forms and spiritual beings that appeared in his meditations. And even if he had already painted themes with a Christian iconography like *San Francisco* (*Saint Francis*) and the *Anunciación* (*Annunciation*), I have a feeling that he must have done this for the mystical connections that he intuited rather than because he wanted to represent Christian mysticism.

There are references in his painting to other religions, especially those of ancient Egypt and the Aztecs, where the sun occupied the main place amongst the deities. Xul's attraction to the Sun must not be overlooked, given that it is located at the centre of his own cosmology.

In *Almas de Egipto* (*Souls of Egypt*, plate 47) and *Barca de Isis* (*Isis' Boat*, plate 48), Xul revealed two archetypal images. Osiris, dead, with his mitre and short beard, appeared in the first. He is both a god of fertility and the personification of the god of the underworld. Isis, sister and wife to Osiris, and mother of Horus, embodies the universe's feminine principle, and is the goddess of fertility, symbolised by the moon. Horus, the posthumous son of Osiris, is the king of Heaven, symbolised by the sun. Osiris, Isis and Horus form a trinity that profoundly influenced religions in the Mediterranean.

The boat guided by Isis transports Osiris's body under the

Figure 22. Funereal Papyrus from Touri. The Book of the Dead. (The Soul of the dead in Egypt leaves the body in the shape of a bird with a human head.) Louvre Museum, Paris

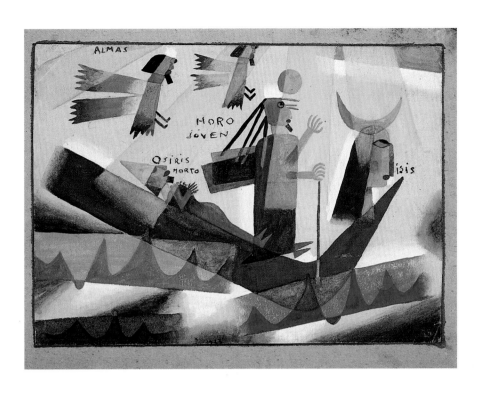

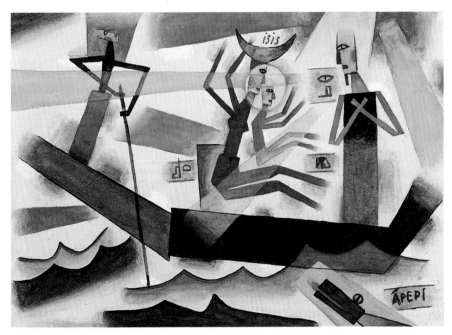

**48.** *Almas de Egipto ( Soul of Egypt)*, 1923
Watercolour on paper mounted on card,
image: 15.2 x 21.3 cm; card: 17.6 x 22.9 cm
Private collection, Caracas
Courtesy Rachel Adler Gallery

**49.** *Barco de Isis (Isis's Ship)*, 1922
Watercolour on paper, 15 x 21 cm
Private collection, Italy
Courtesy Rachel Adler Gallery

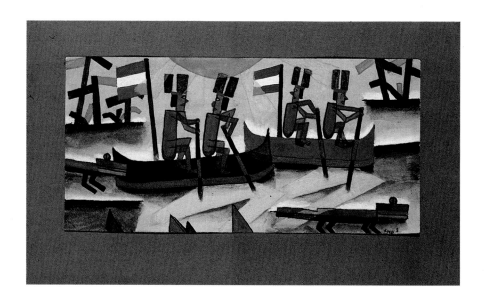

50. *Chaco* (*Chaco*), 1923
Watercolour on paper mounted on card,
image: 11.2 x 24.6 cm; card: 18 x 30.5 cm
Galería Rubbers, Buenos Aires

protection of Ra, the Sun god, and the King of Gods, while Horus grips an oar. The souls of the two dead are symbolized by birds with human faces, in accordance with Egyptian iconography (figure 22), and are flying over the scene.

In the second picture Isis can be observed, conducting little Horus away from the reach of Seth, the assassin of Osiris, and sailing in a boat in the company of a priest. Apepi, king of darkness, and eternal enemy of the sun, is symbolised by a marine serpent, and lies in wait for the royal vessel. Egyptian iconographic symbols can be seen over the sky.

The visual impact achieved with both paintings is a much more effective way of conveying information than any other form of narration. The inscriptions Xul added act as **educational** elements to facilitate an understanding of more hidden meanings, and to awaken the enthusiasm of the observer. I sense that Xul has not only recreated the mysteries of such an ancient religion, with an impeccable visual language, but has also pondered on the meaning of the symbolism of the Trinity, and the symbolism of the Mother and Child, beyond the significant differences that exist between Egyptian and Christian religions.

Although Xul had found Europe a marvellous continent *to see and learn new things*, he continually thought about his return home to his father. Nostalgia for his America is a typical way Xul visualized his role, and his position in the world he lived in.

A strong bond linked him to his Latin American roots as seen in *Tlaloc* and *Nanawatzin* (plates 67 and 68 ). Xul intuited that the best place to communicate his visions and the spirits inhabiting them was

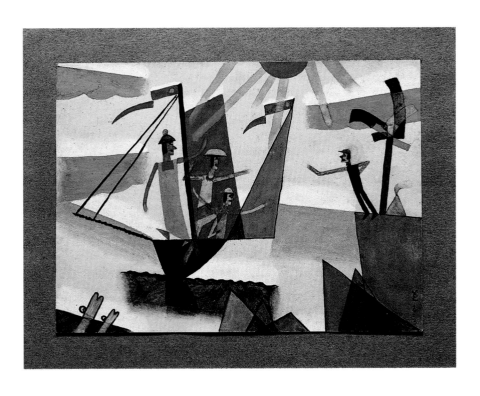

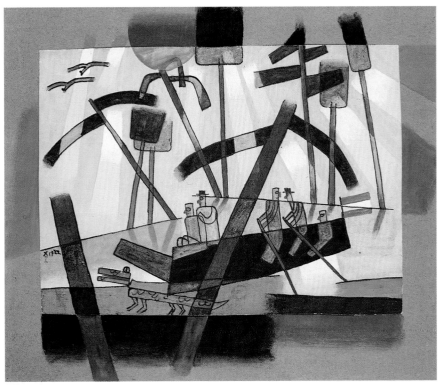

**51.** *Despedida (Farewell)*, 1923
Watercolour on paper mounted on card,
image: 17 x 21.7 cm; card: 22 x 26.5 cm
Manley-Riback Collection, New York

**52.** *Añoro patria (I Miss the Fatherland)*, 1922
Watercolour on paper mounted on card,
21.5 x 25.5 cm
Private collection, New York
Courtesy Rachel Adler Gallery

67. Pettoruti commented on a relationship between Xul and a young German woman in Munich: *a beauty of a girl, as tall and thin as he ...*, op. cit., p. 139.

68. The 3rd of July he wrote: *Dearest ones: for the last 3 or 4 days I have been here in Kelheim, a very pretty place. Rocks, woods, waters of a great river. I have been well looked-after, and spoilt...*

Figure 23. Paul Klee
Eros's Eyes, 1919/53
Pencil and ink on paper mounted on card,
13 x 22 cm. Private collection
© VG-BILD-KUNST, Bonn, 1994

Figure 24. Emilio Pettoruti
The Argentine Painter Xul Solar, 1920
Oil on board, 55 x 43 cm
Museo Municipal de Bellas Artes "Juan B. Castagnino", Rosario

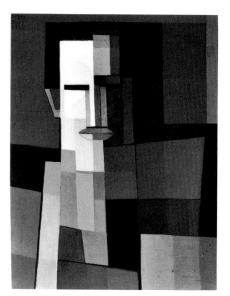

his own country, to which he was linked by ties that surpassed those of family affection. These links are obvious in *Despedida* (*Farewell*, plate 51) and *Añoro patria* (*I Miss my Fatherland*, plate 52).

There are other paintings that underline his interest in Argentina, but in *Mansilla 2936* (*2936 Mansilla Street*, plate 53) is where his irrepressible urge to return is most evident. The title refers to the number and street of his father's house in Buenos Aires. The image is suggestive with a man-bird painted in the centre, whose body is made up from the plans of his father's house. The face's profile is schematized into geometric shapes, and the extended wings also correspond to a geometric construction. This strange character is raised above a serpent which represents the earth, while other birds ascend towards heaven. The words that surround the central image read *The plan of the house on 2936 Mansilla Street, door, patio*, and do not require further commentary. The elongated face, the resolute look and the thick lips belong to the painter himself. Xul back in his father's house flying towards Buenos Aires is possibly an irrefutable proof of his will to return as much as a demonstration of tenderness and filial love.

If there is something absent in this kaleidoscope of images from the Plasticist-Expressionist period it concerns the way Xul reflects in his paintings his particular vision of human relationships, love, sensuality, eroticism, and his surprising humour. This leads us to inquire into his personal activities, and to try and know his friends. He has an extremely complex personality. Tall, handsome, with an innate capacity to make friends, he surely made many of them in the cultural circles he lived in, as those who knew him have testified.[67] In a note in a draft of a letter Xul mentioned Reichel, in fact, Hans Reichel (1892-1958), a German painter who lived in Munich.

In the numerous postcards Xul sent to his *mamás* and his father he only mentioned René, also a painter, whose mother lived in Stuttgart. Xul reported in almost telegraphic form on some marvellous holidays[68] spent between the summers of 1922 and 1923 in Kloster Trauntal in Kelheim, a locality on the Danube, in the vicinity of Regensburg, where he was invited by a lady and her mother. These are the only known references.

All that we can go by are his paintings, and his difficult texts. In his verbal painting *Tu fado kemelegiste como amada rósea icomoídolo oro i mui azul en altar vivo de tus homenajes itebendigo* (*You Fate that Chose Me as Pink Loved One and Golden Idol and Very Blue I Live in an Altar because of Your Homage and I Bless You*, plate 56) Xul revealed his interest in another lady of Oriental

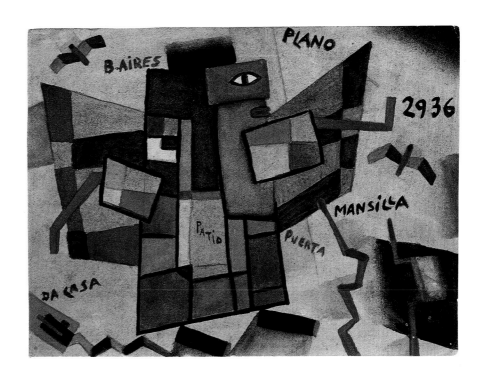

53. *Mansilla 2936 (2936 Mansilla Street)*, 1920
Watercolour on paper, 14 x 19 cm
Private collection, Mexico

origins, with make-up on. The translation of the title is straightforward. The image highlighted by a play of subtle colour planes integrated into the text suggests an enchanted approach to the theme of love.

*Axende encurvas miflama hasta el sol* (*My Flames Ascend in Curves to the Sun*, plate 57) is another of his works from the same series. The power of the colours as they move through yellows, greens, blues and oranges, matches the excitement that image and text express.

Further explicit works like *Las dos* (*The Two*, plate 54), *Hado* (*Fate*, plate 55), *Angel del carma* (*Karma Angel*, plate 69) and *Hipnotismo* (*Qero sisisi hipnotismo no no*) [*Hipnotism* (*Want yesyesyes Hipnotism no no*), plate 73] reflect, together with other works, Xul's particular vision of love.

A total expressive coherence and spiritual unity existed between the new works painted in Munich, and his previous ones such as *Caras*, *Fija la mente en prisiones eskemátikas* and *Troncos*. The year spent in Munich allowed Xul to perfect his expressive means. His abundant production was proof of a mature artist, in complete control of a subtle technique, painting works in small sizes that satisfied his urge to communicate.

Xul's preoccupation with the question of architecture, in the context of his vision of the world, strengthened in the new historical situation of postwar Europe. The combination of science and

71

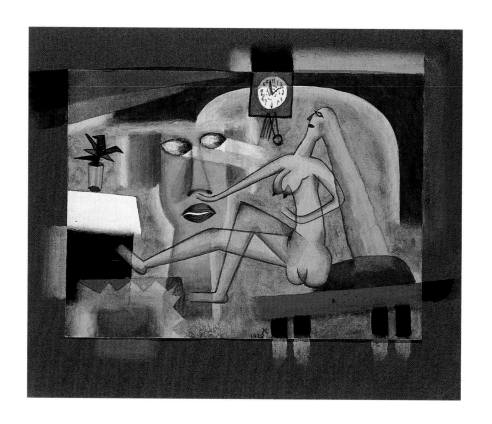

**54.** *Las dos* (*The Two*), 1923
Watercolour on paper mounted on card,
21.5 x 25.8 cm
Private collection, Buenos Aires

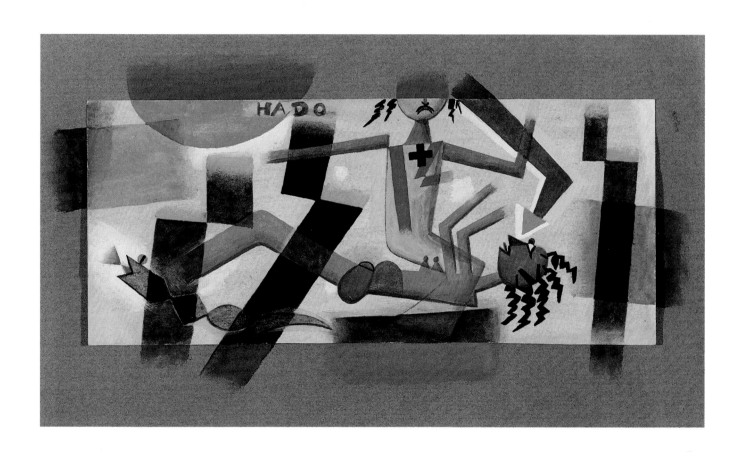

**55.** *Hado (Fate)*, 1922
Watercolour on paper mounted on card,
17.5 x 30.5 cm
Private collection, Buenos Aires

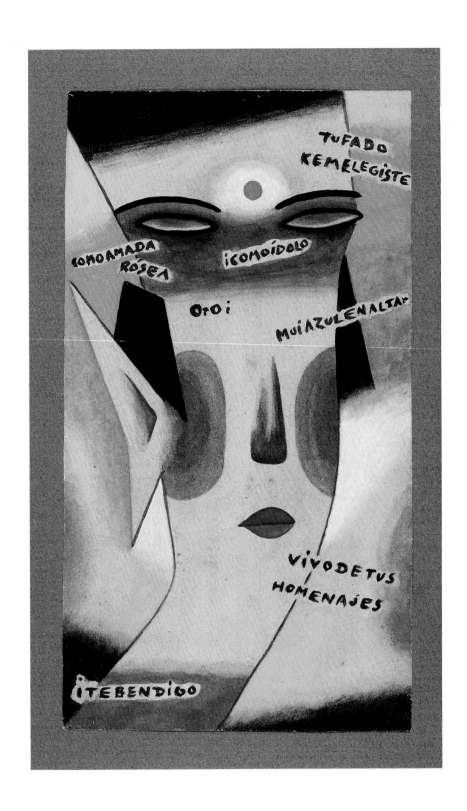

**56.** *Tu fado ke me elegiste...*
(*You Fate that Chose Me...*), 1922
Watercolour on paper mounted on card,
image: 19 x 12 cm; card: 30.6 x 18 cm
Private collection, Buenos Aires

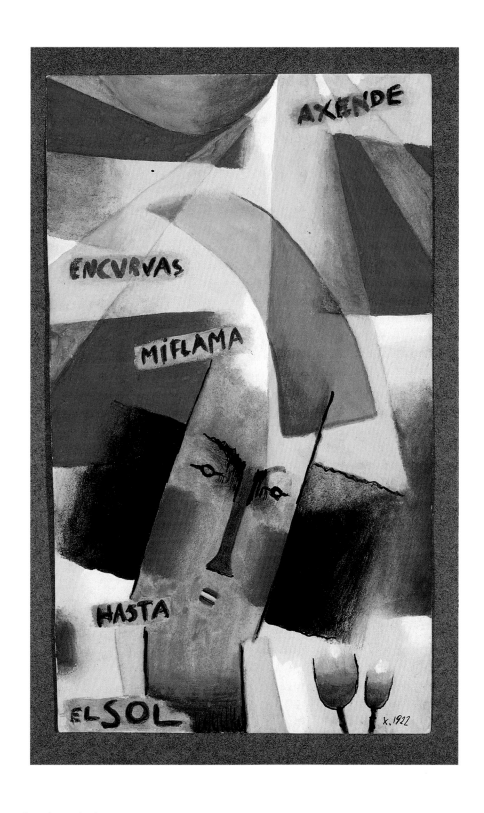

**57.** *Axende en curvas mi flama hasta el sol*
(*My Flame Ascend in Curves to the Sun*), 1922
Watercolour on paper mounted on card,
image: 21 x 12 cm; card: 30.6 x 18 cm
Private collection, Buenos Aires

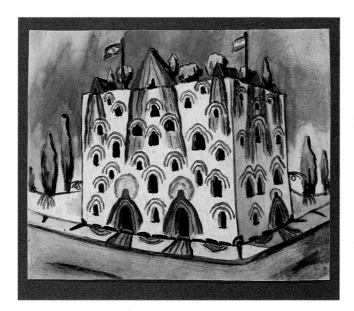

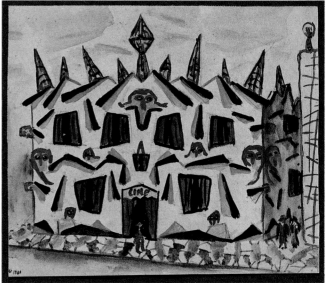

58. *Bau* (2) [*Building* (2)], 1920
Watercolour on paper mounted on card,
19 x 24 cm. Private collection

59. *Cine* (*Cinema*), 1921
Watercolour on paper mounted on card,
21.5 x 25.2 cm. Private collection

69. In this movement the purist tendencies of
De Stijl group, Le Corbusier's designs, and the
Russian Constructivists merge together,
although behind these rationalist tendencies
there lay a Utopian vision of the world.
70. Quoted in I. B. White, *Bruno Taut ...*, p. 227.

Figure 25. Lyonel Feininger
Cathedral of the Future, 1919
Woodcut published in the Bauhaus Manifesto

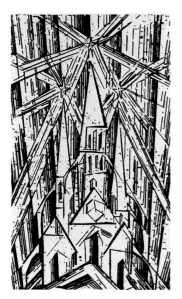

technology, the availability of capital, raw materials and labour, generated an extraordinary industrial leap-forward.

The new production demands, especially in architecture and industrial design, constrained spiritual leanings and utopian projects, and brought about a change in the attitude of business sectors who realized that the applications of designs created by avant-garde artists and designers could generate economic advantages that should not be put aside.

From the start of the 1920s, Gropius and the Taut brothers, and a few others, abandoned their activism, and mystical dreams. The Bauhaus created by Gropius in 1919 as an irradiating centre unifying the arts, crafts and architecture in the utopian context of the *Gesamtkunstwerk* (integrated work of art) and symbolised by Feininger's *Cathedral of the Future* (figure 25), a cathedral to socialism, changed direction from 1922, and turned into the emblematic school of Functionalism. For the decades to follow, it marked the aesthetics of Modernism.[69]

This sudden abandonment of the architect's and artist's cosmic vision in the world is seen in the following quotation from Mies van der Rohe:

*All the aspirations of our age are directed toward the profane. The efforts of the mystics will remain mere episodes.*[70]

Xul persevered with his architectural designs in this moment of change. In his works different styles appeared and coexisted. Xul

76

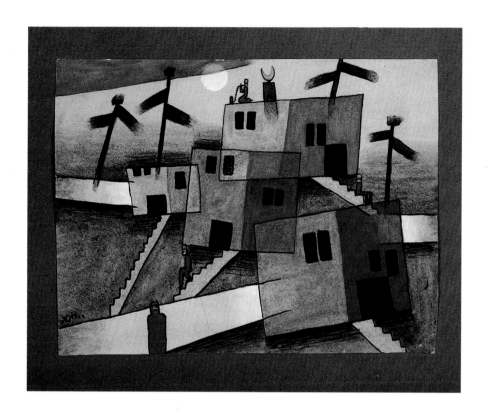

60. *Tres rúas* (*Three Roads*), 1922
Watercolour on paper mounted on card,
image: 14 x 18.5 cm; card: 17.5 x 21 cm
Private collection, Italy
Courtesy Rachel Adler Gallery

refused to take sides and in his attitudes there is a scorn for the
absolute, for what is dogmatic, for what is definitive. From his
isolated corner, Xul did not abandon his cosmic ideals, although he
understood the constructive advantages that the new Functionalism
in architecture and design revealed, as can be seen in the objects
reproduced in plates 43 and 44.

Good examples of Xul's concerns are a building in the shape of a
cube with obvious erotic implications[71] and where the Argentine and
Brazilian flags wave [*Bau(2)* (*Building(2)*, plate 58)], and a cinema
adorned with Expressionist features [*Cine* (*Cinema*, plate 59)]. The
expressive treatment of the walls breaks the smooth surface of the
buildings.

Xul established a counterpoint between expressive motifs and
pure shapes as carried out in his Expressionist-Plasticist paintings.
His architectonic designs also corresponded to a peculiar vision of
Modernism. Behind the humour that both designs reflected there was
possibly an early criticism of the whiteness and bare cleanliness of the
walls of Functionalist architecture.

Xul envisioned an ultramodern city of the future with
contemporary typologies that coincided in part with the Modern
Movement's concepts of that decade. *Dos rúas* (*Two Streets*), *Cinco
casas* (*Five Houses*) and *Tres rúas* (*Three Streets*) painted in 1922 and

71. Xul took up some of this material in his
series *países teti* (Teti Countries) painted
around 1950. See *Xul Solar Catalogue of...*,
op. cit., pp. 32 and 80.

77

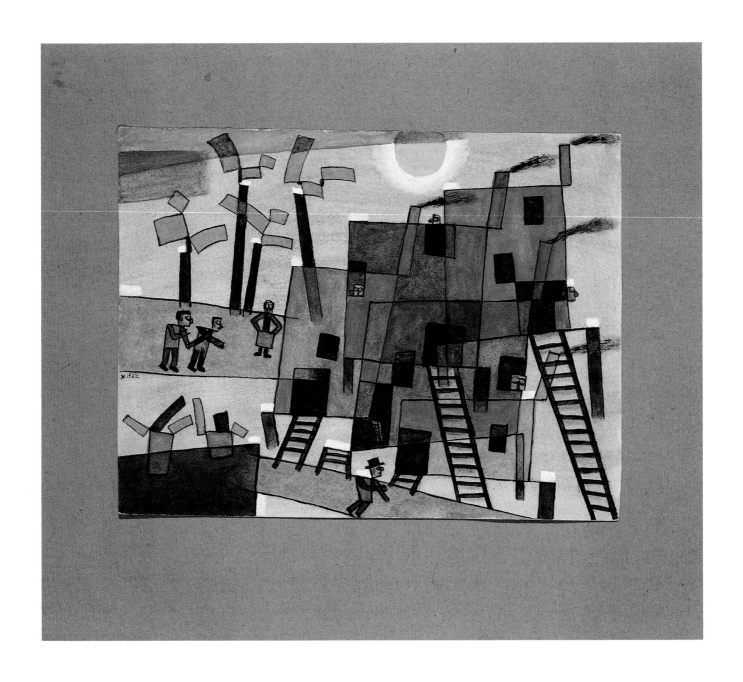

**61.** *Dos rúas* (*Two Roads*), 1922
Watercolour on paper mounted on card,
image: 13 x 18.5 cm; card: 22 x 25.6 cm
Private collection, Buenos Aires.

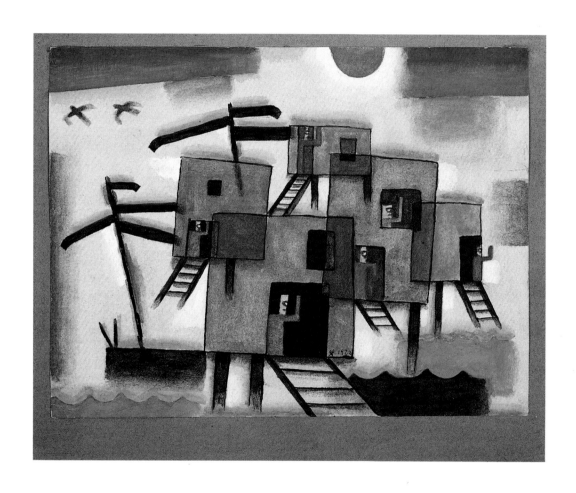

**62.** *Cinco casas (Five Houses)*, 1922
Watercolour on paper mounted on card,
image: 13.7 x 18.5 cm; card: 16.2 x 20 cm
Private collection, Buenos Aires

reproduced in plates 60, 61, and 62 illustrated the far-reaching ideas Xul developed for the construction of his new world.

The housing Xul designed was functional, fitting with the concept of box construction, painted in vivid colours, surrounded by trees, and lived in by people who merged with the architectures and the countries they inhabited. The houses had ample balconies and accessible roof-terraces and were supported from the ground or are raised on piles from dry ground or above water. This was the first reference to the Paraná Delta houses, close to San Fernando, his native town, and that he would later expand (see plates 161 to 164).

These idea-designs that emerged from his paintings were contemporary with the first Functionalist designs by European architects, and from what could be observed from the outside of *Dos rúas*, matched the proposal for a new architecture published by Le Corbusier[72] in 1926.

However, the problems involved required new artistic solutions in order to visualize them. Although the general pictoric process continued to be planar, the superposition of groups of parallel lines that symbolized the *rúas* (streets) seen from above granted his images a spatial feeling. This effect was recorded in the titles of the works. The folding over of planes superimposed on to the images gave Xul's pictoric space a personal quality, and this spatial play would become one of the central themes of his paintings from 1924 on.

# A world of reveries

72. I refer to *Les 5 points d'une architecture nouvelle* published by Le Corbusier in 1926. Xul was interested by Le Corbusier's aesthetic concepts and possessed the books: Le Corbusier-Saugnier, *Vers une architecture*, Crès: Paris, 1923, and *Urbanisme*, Crès: Paris, 1925, 7th edition.

73. On the 28th November 1922 he wrote to his father from Munich: *Dearest father: I will spend some time with the mamás. We'll have time to chat about you, about over there, and the great trip. I'll soon return to Germany where I have much to achieve. I'm sorry I did not come before. I promise not to let such a long time pass without writing to you while I am far away. Will you forgive me? Your son.*

74. Postcards sent to his *mamás* on the 10th, 14th and 17th March 1923.

Xul returned to Zoagli at the end of November 1922 to visit his *mamás*[73] and was back again in Munich in January 1923. He immediately began to prepare his return to Buenos Aires with Emilio Pettoruti towards the *end of the year, or at the beginning of the next*[74] with the aim to exhibit together. He ordered the frames for some sixty paintings in Germany where the phantom of inflation had set in, because in Buenos Aires that would be *very expensive*.

While he rushed on with his plans to return, he persevered with his works. In *Mensaje* (*Message*, plate 63) and *Una figura* (*A Figure*, plate 64) an attempt to soften the contrasting colours, and a greater subtlety in the use of watercolour, are noticeable. He also painted faces in the foreground like *Ojos azules* (*Blue Eyes*, plate 65) and *Yo*

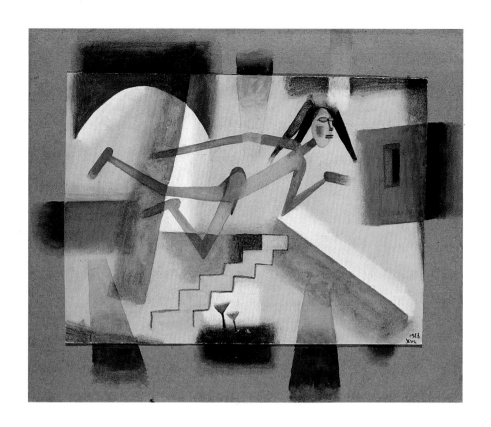

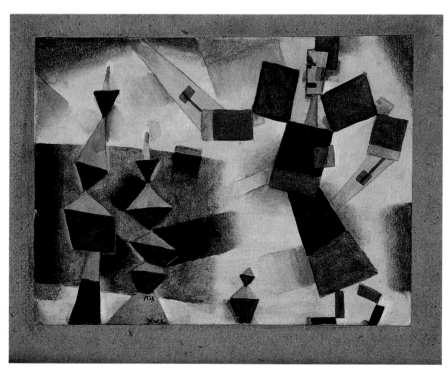

63. *Mensaje (Message)*, 1923
Watercolour on paper mounted on card,
image: 15 x 21 cm; card: 21.4 x 25.4 cm
Eduardo and Teresa Costantini Collection,
Buenos Aires

64. *Una figura (A Figure)*, 1923
Watercolour on paper mounted on card,
image: 15.4 x 19.2 cm; card: 17.4 x 21.7 cm
Private collection, Buenos Aires

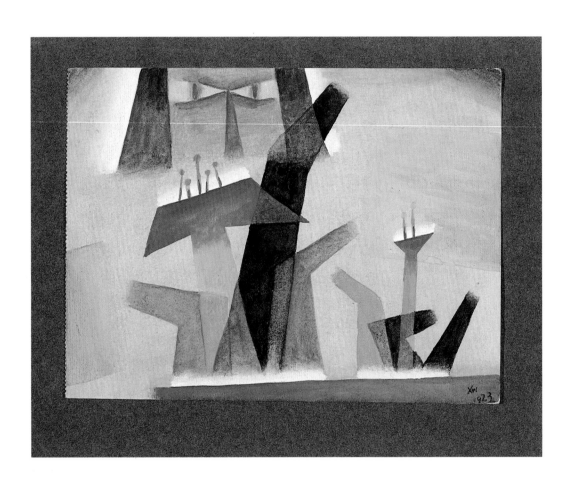

**65.** *Ojos azules (Blue Eyes)*, 1923
Watercolour on paper mounted on card,
image: 14.7 x 18.8 cm; card: 17.8 x 22.4 cm
Private collection, Buenos Aires

**66.** *Yo el 80 (I the 80)*, 1923
Watercolour on paper mounted on card,
image: 15.6 x 19.8 cm; card: 22 x 25.2 cm
Private collection, Buenos Aires

**67.** *Tlaloc* [*Tlaloc (Rain God)*], 1923
Watercolour on paper, 26 x 32 cm
Francisco Traba Collection, Buenos Aires

**68.** *Nana Watzin (Nana Watzin)*, 1923
Watercolour on paper, 25.5 x 31.5 cm
Galería Vermeer, Buenos Aires

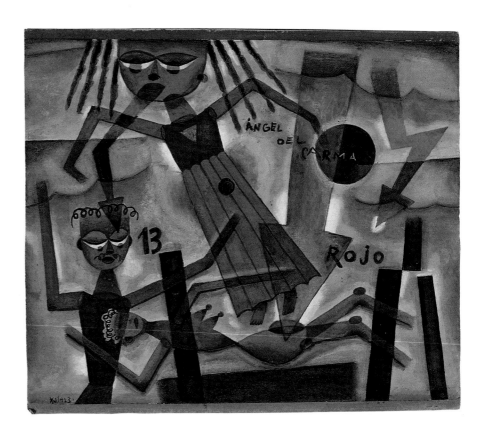

69. *Angel del carma (Karma Angel)*, 1923
Watercolour on paper mounted on card,
image: 27 x 33 cm; card: 28.3 x 33 cm
Private collection, New York
Courtesy Rachel Adler Gallery

el 80 (*I the 80*, plate 66). Although his chromatic intensity remained, Xul had lightened the planar structure around the central images. The velvety tonalities on the planes and the suggestive touches of white paint which delimited the shapes were techniques to highlight this.

The suggestive and hermetic message *Yo el 80* could have referred to his belonging to a generation of artists born in that decade, or to a self-portrait or to the esoteric connotation of the number. According to a numerological interpretation *the expression 2 times 40 equals one hundred or what is almost unnamable.*[75]

Xul was conscious of these changes in his painting between April and May:

> *I have already begun to paint slightly larger things and they're coming out well...,*[76] *I am progressing in my painting,*[77]... *When I finish some small pictures I will begin to paint large ones...*[78]

He also began to penetrate Aztec mythology. *Tlaloc (divo lluvi)* (*Rain God*, plate 67) represented the rain god. The serpents whose images were associated with other water deities, with water symbolism, and the presence of the Sun as supreme god, together with

75. Chevalier-Gheerbrant, op. cit., p. 793.

76. Postcard sent to *dearest old ones* on the 4th April 1923.

77. Postcard sent to *beloved old ones* on the 25th April 1923.

78. Postcard sent to *Dearest little old ones* on the 19th May 1923.

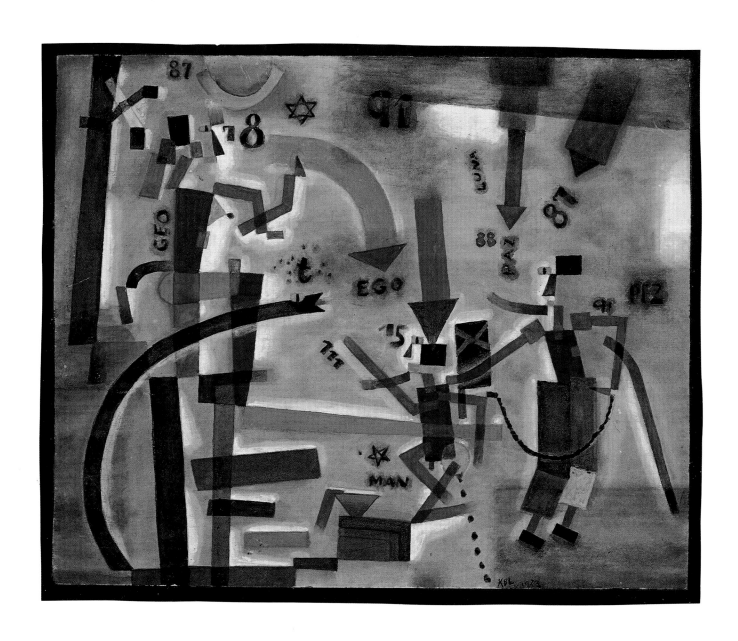

70. *Juzgue (Judge)*, 1923
Watercolour on paper, 26 x 32 cm
Museo Xul Solar, Buenos Aires

the words AGUA (water) and ATL which meant water in Nahualt, strengthened the visual unity of his work. An evocation of the meaning of sacrifice to attain redemption appeared in the watercolour *Nana Watzin*,[79] which is the name of an Aztec god who after sacrificing himself in a fire transformed into the sun.

Thus Xul began to paint his **reveries**, a name that coincided with the one suggested by Xul for his works grouped under the astrological sign of Pisces (fish): reveries, surrealism, subconscious.[80] In these works the dissociation between the central motif and the geometric shapes that encircled them, with the violent colour contrasts of his Expressionist-Plasticist paintings, has disappeared. His pictorial matter is lightened, and made more transparent, more velvety, at times shiny, even iridescent.

His images continued to be planar, but an incipient intention to create spatial sensations without resorting to perspective could be observed, as in the chairs in *Séptuplo* (*Septuple*, plate 88). The size of the works was somewhat larger than from his previous period but remained small. Perhaps the following passage from Lyonel Feininger offers the best explanation of why Xul preferred small sizes:

> *Force people to look close at our work to enter it. Nothing always more sickened me than to have acquaintances and well-wishers haul off at arms length in order to get as much away as possible from my drawings, in the mistaken idea that thereby they got the proper angle. Not one of us[81] is what might be termed a miniature painter. It is only that we have the inalterable focus in which to assimilate our visions. This focus depends on our own distance from the paper surface upon which we are putting line, runes and colors. Blow them up and where are they?[82]*

As an innate colourist Xul used a wider tonal range with light shadings which gave his work a unitary and poetic quality. There are multicoloured patterns with carmine, pinks, yellows, soft browns, purples, sky blues and light greens. The aura of his people, already suggested in *Ojos azules* and *Yo el 80* appeared more faded, and the pictorial matter acquired velvety characteristics. Multiple symbols were distributed around the plane as arrows, letters, words, and numbers. Although these responded to the painterly act by being integrated with the image, they also posited esoteric meanings that are still not completely revealed.

This pictorial richness and ambiguity in the use of space paralleled

79. Daniel E. Nelson offered an explanation of the mythological meaning of this watercolour in *Alejandro Xul Solar*, Latin American Art, Fall, 1991, p. 28.

80. Xul Solar, *Explica...*

81. Feininger was referring to Paul Klee, Mark Tobey and himself.

82. *Feininger and Tobey. Years of Friendship, 1944-1956. The Complete Correspondence*, Achim Moeller Fine Art: New York, 1991, p. 162.

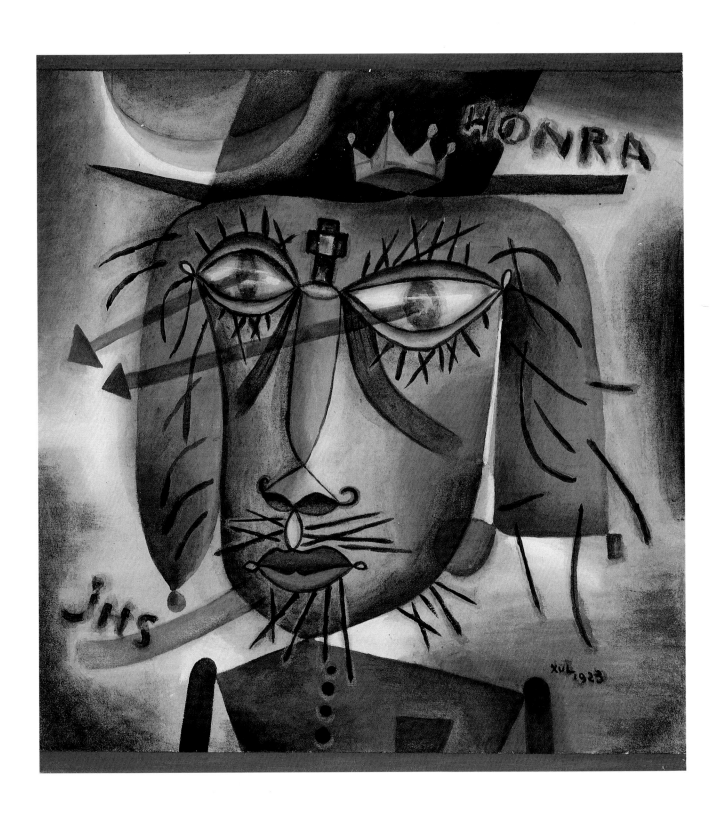

71. *Jefa honra* (*Female Chief Honours*), 1923
Watercolour on paper, 28 x 26 cm
George and Marion Helft Collection,
Buenos Aires

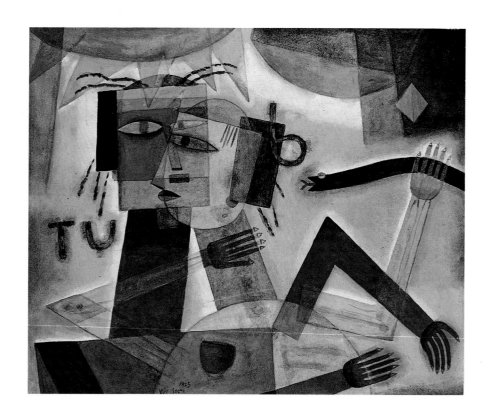

72. *Tu y yo (You and I)*, 1923
Watercolour on paper, 26 x 36 cm
Museo Xul Solar

83. Jorge Luis Borges, *Recuerdos de mi amigo Xul Solar* (text of a lecture), Comunicaciones 3, Fundación San Telmo: Buenos Aires, 1990.

Figure 26. Max Pechstein
And Do not Lead us into Temptation, 1921
Woodcut, 39.9 x 29.5 cm

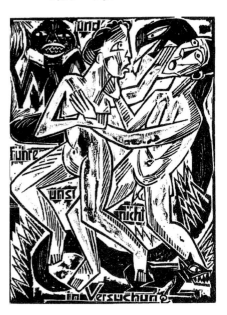

the hermetic themes. Within this series of works there was a first group painted in 1923 in which Xul linked human beings, serpents and dragons: *Juzgue* (*Judge*, plate 70), *Jefe de dragones* (*Chief of Dragons*, plate 75), *Homme das serpents* (*Man of Serpents*, plate 76), and *Jefe de sierpes* (*Chief of Serpents*, plate 77).

The images differed, but they responded to the same aesthetic factor. The recurrence of the images reflected the visions that moved the artist, that repeated themselves, and incited him to share them with the spectator. By liberating himself of his visions, Xul experienced a feeling of relief and happiness that penetrated his images and gave these reveries that *sort of radiant good fortune* pointed out by Jorge Luis Borges.[83]

Xul introduced into his paintings of that period numbers whose symbolic nature should be emphasized. Numbers have been used since ancient times as a means to express ideas, and to transmit messages to those who have been initiated. The rhythms and proportions that rule the geometric shapes are expressed by numbers. In the Cabbala, the game of rearranging letters and numerology plays an essential role.

The number 111 that appeared in three works could correspond to three times 1, which is at the same time the symbol of man, the symbol of the cosmological principle of creation, and the symbol of

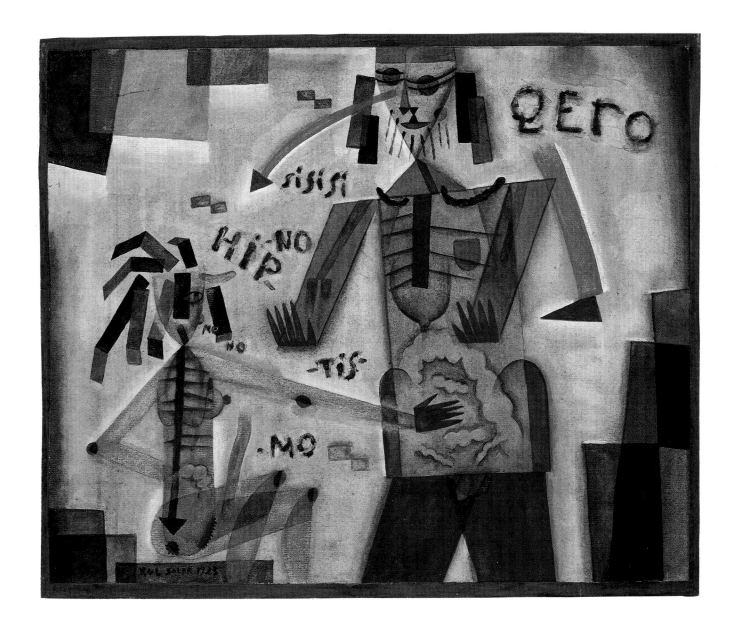

**73.** *Hipnotismo (Qero sisisi hipnotismo no no)*
[*Hypnotism (I want yesyesyes hypnotism no no)*],
1923
Watercolour on paper mounted on card,
image: 25.8 x 32.1 cm; card: 27.3 x 33.3 cm
Eduardo and Teresa Costantini Collection,
Buenos Aires

91

the spirit. What better than grouping together that trinity in one single unifying number that symbolizes human activity on earth!

The repeated appearance of the serpent in his paintings also lends itself to different interpretations. If in some cases the serpent is the archetype of terrestrial representations, and the powerful telluric forces that originate from there, and remain hidden there, then

*all possible serpents form together a unique primordial multiplicity, a primordial thing that cannot be dismembered, that does not cease to disentangle itself, disappearing and being reborn.*[84]

That primordial thing is the idea of life itself that encompasses the concepts of the cosmic serpent, the ancestral myth and healing and divinity.

The inclusion of the word DOMA ( taming) in *Homme das serpents*, one of the most beautiful works of that period, confirmed that human beings controlled the energies emanating from serpents through the numerical trinity (111) that links man and his spirit with the cosmological principle of creation. When vindicating the serpent in his paintings as one of the main archetypal symbols of the human soul, Xul was proposing to rehabilitate the serpent as symbol of creative freedom.

These interpretations are an attempt towards a greater openness in coming to terms with Xul's paintings. Years later Xul noted that his work had received

*in general favourable criticism from the plastic arts point of view but little understanding of its motifs and reasons.*[85]

If we have insisted in decodifying the meaning of his paintings, it is because we see Xul as a channel for communicating visions that he received from astral space and wished to pass on.

The multiplicity of interpretations that the reverie paintings offer depends on the sensitivity of the observer to their spiritual and universal contents. The greater the observer's meditative attitude, the greater is the aesthetic and spiritual pleasure obtained.

Because Xul's images lie in the collective unconscious they are archetypal, and thus universal and open to being interpreted and analysed. Through a symbolic reading it should prove possible to appreciate, if only partially, the structure of his thinking processes. This structure does not correspond to any particular school of

84. H. de Keyserling, *Méditations sud-américaines*, Paris, 1932; see Chevalier-Gheerbrant, op. cit., p. 868.

85. Taken from an autobiographic sketch, Archives of the Fundación Pan Klub Museo Xul Solar, Buenos Aires.

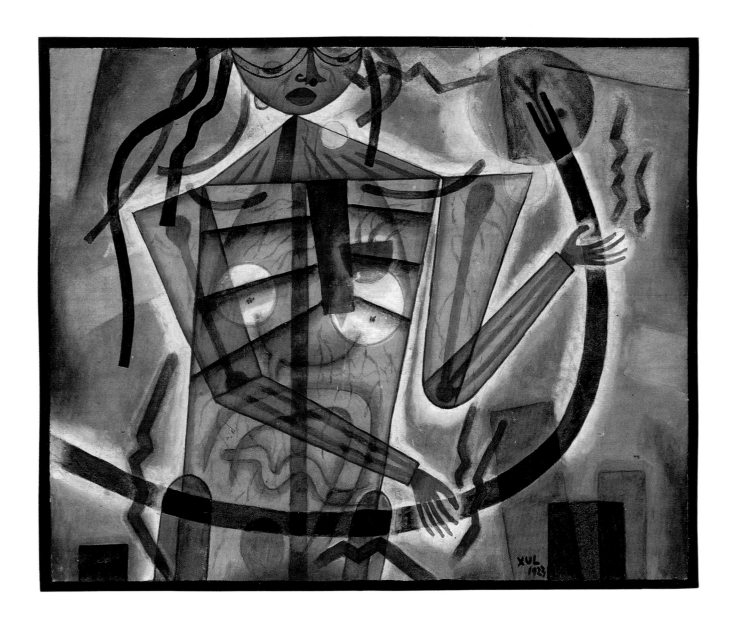

**74.** *Ña Diáfana* (*Lady Diaphonous*), 1923
Watercolour on paper mounted on card,
image: 26 x 32 cm; card: 26.7 x 32.7 cm
Museo Xul Solar

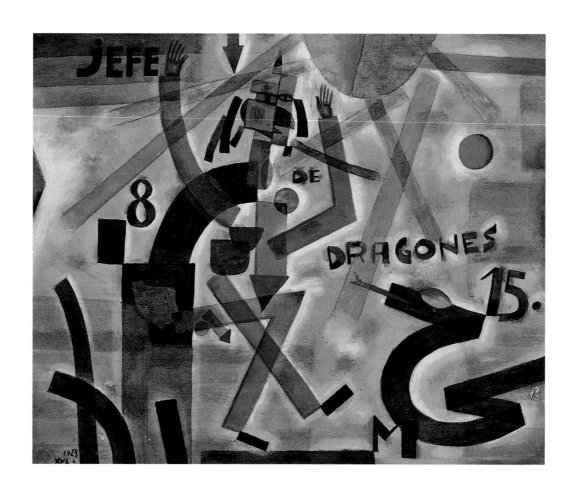

**75.** *Jefe de dragones* (*Chief of Dragons*), 1923
Watercolour on paper, 26 x 32 cm
Private collection, New York

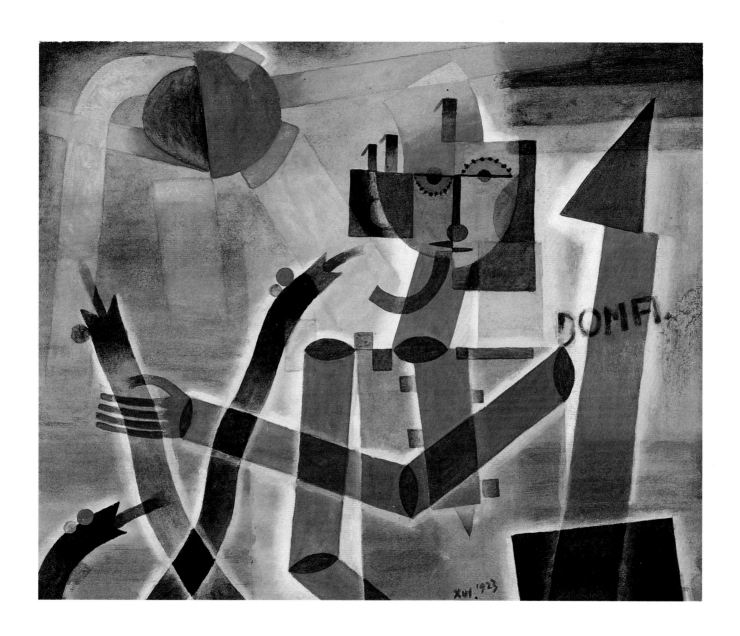

**76.** *Homme das serpentes*
(*Man of Serpents*), 1923
Watercolour on paper, 26 x 32 cm
Private collection, Buenos Aires

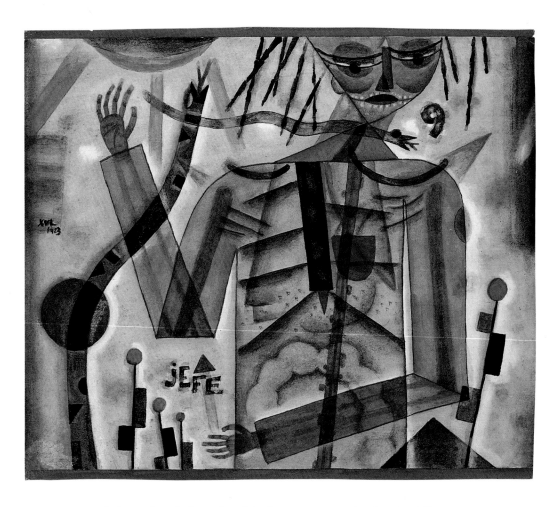

77. *Jefe de sierpes* (*Chief of Serpents*), 1923
Watercolour on paper mounted on card,
image: 26 x 32 cm; card: 27.2 x 32 cm
Eduardo and Teresa Costantini Collection,
Buenos Aires

philosophical thought. We discover in Xul a kind of fluctuating connection between his ideas, his thoughts, his paintings and his visions. It is as if his actions on the level of concrete achievements responded to the play of intellectual forces guided by his intelligence, his sense of social duty, his irreverent will to create and transmit.

All of this shapes a kind of **loose (fuzzy) logic** that rules Xul Solar's activities. By continuously modifying these rules he provoked astonishment and some dismissal as he directed it with a sort of negligent and ostensible simplicity, as if in passing, but that concealed a singular coherence.

If we take *Juzgue* (*Judge*), a first reading would show a prisoner chained to a guard, half kneeling on a kind of lectern in front of a feminine character seated on a platform, in the company of a serpent. The image responds to the painting's title. But there is more. Spread across the surface are written the words GEO, EGO, MAN, PEZ (fish), PAZ (peace), LUNA (moon), the numbers 7, 8 or 87?, 15, 78, 88, 91, 111, the letter **t** while a column with lights illuminates the scene. A sun, two stars and thick arrows complete the suggestive picture. The

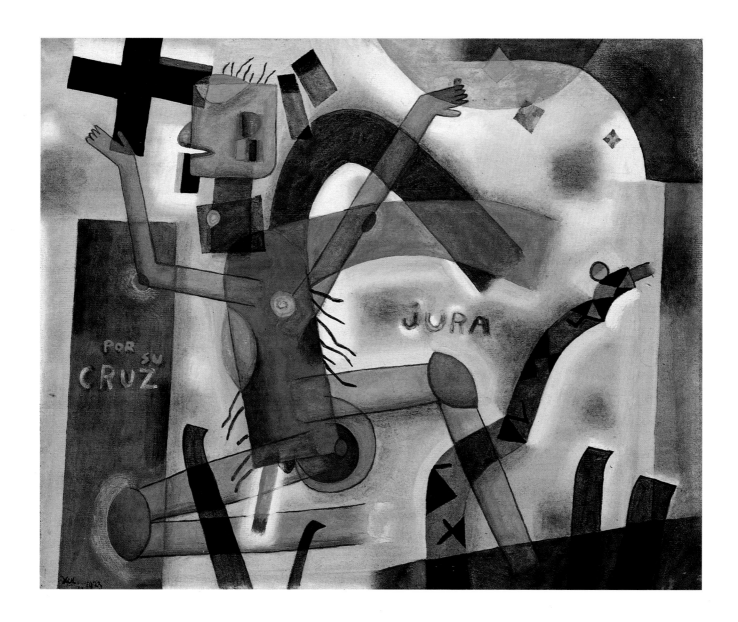

**78.** *Por su cruz jura*
(*By your Cross I Swear*), 1923
Watercolour on paper mounted on card,
25.8 x 32.2 cm
Eduardo and Teresa Costantini Collection,
Buenos Aires

organization of the characters through the play on geometric shapes, and the intensity of the whites around the figures, suggest a certain affinity with the paintings of his previous period. It is likely that *Juzgue* was one of his first reveries and that Xul reserved it for the Pan Klub collection, the Universal Club, his future museum.[86]

Let's attempt to interpret this work within the context already referred to. There are astral symbols: the idea of heaven is materialized by a sun that shows its two faces. There are numerical symbols; here the ground is slippery. Number 8 suggests the idea of balance, and symbolizes justice;[87] number 9 is a measure of gestation, of fruitful investigation, and of the crowning of the effort of creation; number 15 expresses an erotic value, and it also relate to the devil; 87 is possibly a reference to Xul's year of birth. There are symbols in the words. The inscription GEO next to the feminine character suggests the presence of an earthly female judge; the words EGO and MAN, placed near the prisoner, hint that what is being judged is man's egoism; the other words extend the meaning of the image. In other words, a **woman** judges the actions of **man** on earth.

In a detailed analysis, Lopez Anaya,[88] examined *Séptuplo*:

*An image that reveals and conceals its meaning, linked to the symbolism of numbers. The composition is formed by seven faces gathered in two groups; the first one formed by four profiles, and the second by three masks. It divides the group (septenary) into two sub-groups that correspond to number four and number three respectively.*
*The meaning of the septenary is well known and is considered to be a symbol of transformation and integration of all hierarchies into a totality. As far as the symbol of the complete order, of a cycle, it consists of a quaternary and a tertiary. The first is the earth symbol, of natural and spatial limits; the second expresses the spiritual synthesis ... In this painting further complementary graphic symbols appear including Venus, linked to love, Mars, related to action and destruction, and Saturn concerning duration and reserve ... It would seem, then, that the whole image is overloaded with symbolic elements, and might allude to the synthesis of opposites ...*

A face, divided into two halves, is placed in the centre of the image. Both halves, united, represent *Pareja* (*Couple*, plate 83), which is the entity through which the relationship between male and female is sustained in Western civilization. The couple is the unity of

86. The Xul Solar Museum is owned by the Fundación Pan Klub and was opened in May 1993 in Buenos Aires. Its located on Laprida 1212. The museum exhibits works originally selected by Xul, with the addition of some representative ones from all his periods.

87. Chevalier-Gheerbrant, op. cit., p. 511.

88. Jorge Lopez Anaya, Xul Solar, *Pintores argentinos del siglo XX*, Centro Editor de América Latina: Buenos Aires, 1980, p. 8. (This study was erroneously attributed to M. Taverna Irigoyen.)

Figure 27. Paul Klee, Black Magician, 1920/13 Watercolor over oil transfer on chalk-primed paper mounted on cardboard, 37 x 25.5 cm Bayerische Staatsgemäldesammlungen, Munich © VG-BILD-KUNST, Bonn, 1994

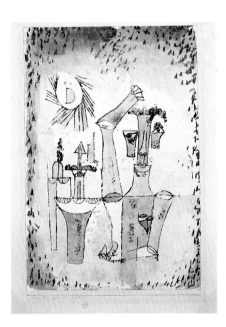

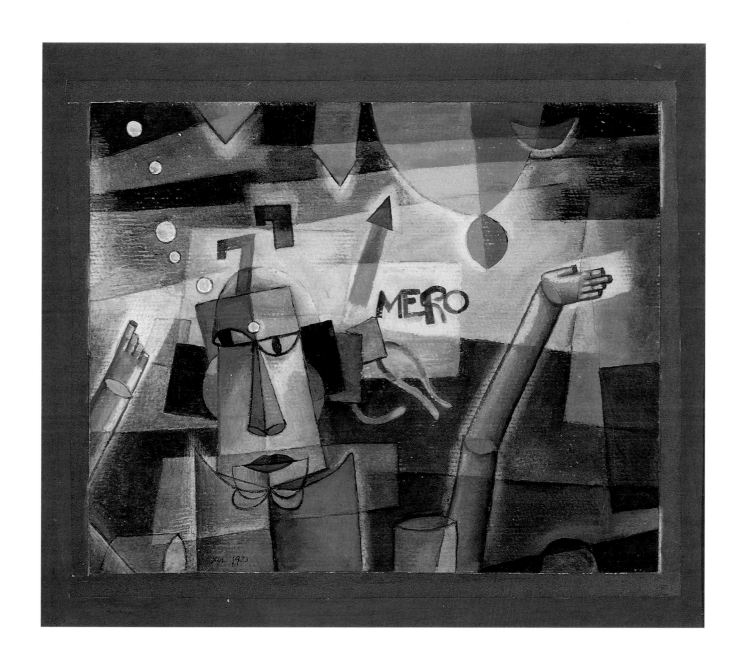

**79.** *Mero*, 1923
Watercolour on paper mounted on card,
image: 25.7 x 32 cm; card: 33 x 39 cm
Private collection, Buenos Aires

human relationships, and Xul painted it that way with a single neck on to which he superimposed a mandorla (shapes symbolising male and female). But there are also two faces. A blueish moon with a fire-like halo, sky-blue strips that make up the sky and the numerical trinity, give this work a planetary reference. Before him Chagall had painted a similar theme: *Homage to Apollinaire*, whose figure symbolised the birth of Adam and Eve who are *at the same time the primitive androgyne and the first couple*.[89] With that archetypal image, Xul recreated couples in their wholeness.

An extra-terrestrial being whose face is shaped by ribbons, observes us [*Cintas (Ribbons)*, plate 85]. Xul helps us understand that the universe does not end with the planet Earth, and that on other planets, under other skies, other beings watch us.

Xul's presence in Munich leads us to ask the question as to whether Xul ever met Paul Klee. When Xul arrived in Munich in October 1921 Klee had already left the city in order to take up his teaching post in the Bauhaus, directed at the time by Walter Gropius in Weimar. Apart from a trip to Stuttgart, no further journeys in Germany are recorded, so Xul probably did not go there. Klee was a recognized artist in Munich where the Golz New Art Gallery had given him an exhibition in 1920.[90]

By that time Xul had already joined the avant-garde, although he remained in a neutral corner without showing himself, as seen in his paintings from the period 1918-1921 that responded to his expressive needs. His visions were recorded in his watercolours where geometrical shapes coexisted with Expressionist motifs. The planar

89. Franz Meyer, *Marc Chagall*, Flammarion: Paris, 1964, p. 156.

90. Klee and his family lived in Munich from 1906. In January 1921 he took up his teaching post in the Bauhaus and periodically travelled to Weimar. In September 1921 his family joined him, and he installed himself there in October. Pettoruti stated that on a trip to Munich in the winter of 1921 to visit Xul he saw an exhibition of Klee's work in a bookshop, and met him through the owner. The artist made him climb up to his temporary lodgings above the bookshop and played him a violin concert (Pettoruti, p. 140). We could not verify this in the Paul Klee Foundation archives.

Figure 28. Paul Klee
Lovers, 1920/147
Gouache and pencil, 24.8 x 40.6 cm
Metropolitan Museum of Art,
the Berggruen Klee Collection, New York
© VG-BILD-KUNST, Bonn, 1994

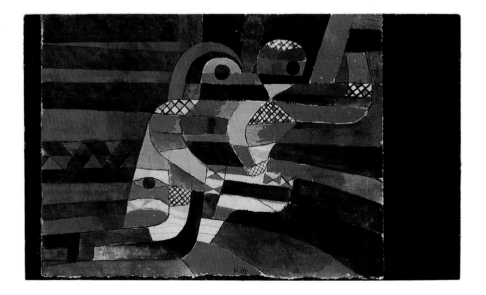

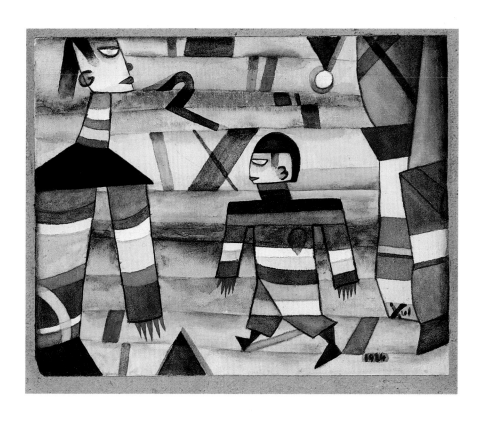

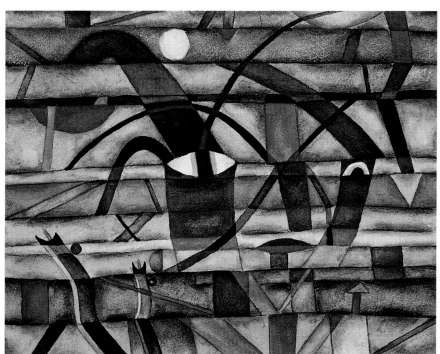

80. *Despareja* (*Un-couple*), 1924
Watercolour on paper mounted on card,
image: 19 x 24.1 cm; card: 21 x 25.6 cm
Eduardo and Teresa Costantini Collection,
Buenos Aires

81. *Una drola*, 1923
Watercolour on paper, 23 x 29.9 cm
Eduardo and Teresa Costantini Collection,
Buenos Aires

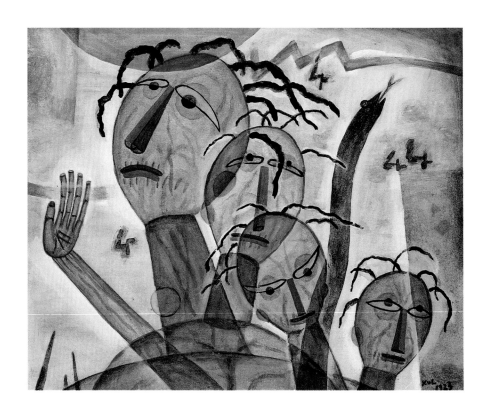

82. *Cuatro cholas (Four Indian Women)*, 1923
Watercolour on paper mounted on card,
25.8 x 32.1 cm
Eduardo and Teresa Costantini Collection,
Buenos Aires

91. Xul bought three books on Paul Klee in Munich: *Sturm Bilderbuch 3*, der Sturm: Berlin, 1918; Leopold Zahn, *Paul Klee: Leben, Wert, Geist*, Kiepenheuer: Postdam, 1920 and Wilhelm Hausenstein, *Kairuan, oder eine Geschichte vom Maler Klee und von der Kunst dieses Zeitalters*, Kurt Wolff: Munich, 1921.

forms are painted vigorously, as can be seen in *Cara*, *Troncos*, *Pupo* and *Tres y sierpe*. The critical success of his exhibition in Milan, where he had shown his Expressionist-Symbolist paintings, also confirmed this.

His encounter with Klee's works allowed him to verify how far he had advanced in the difficult world of painting, and reasserted the choice of path he had taken in 1914. Klee was the artist Xul most admired,[91] and with whom he shared an affinity in painting, in music, and in spirituality, and whose paintings were as attractive for their aesthetic qualities as they were small in size.

Certain coincidences can be noted in his first works where he had included inscriptions in *neocriollo* like *Man-tree*, and his diptychs (plates 10, 30 and 31), and in Klee's visual poems like *Once Emerged...*, (figure 17) carried out in the same period, but independently. Both artists were interested in exploring the artistic possibilities of introducing texts into painting (**verbal paintings**), which went back to Cubism, as well as how poems and texts could become paintings (**poems-visual texts**) which had already been anticipated by the Futurists with their "words in liberty" (figures 63 and 64), and by Apollinaire's "calligrammes".

It would be useful to emphasize the differences between **verbal painting**, rooted in Dada, especially in Duchamp and Picabia, where

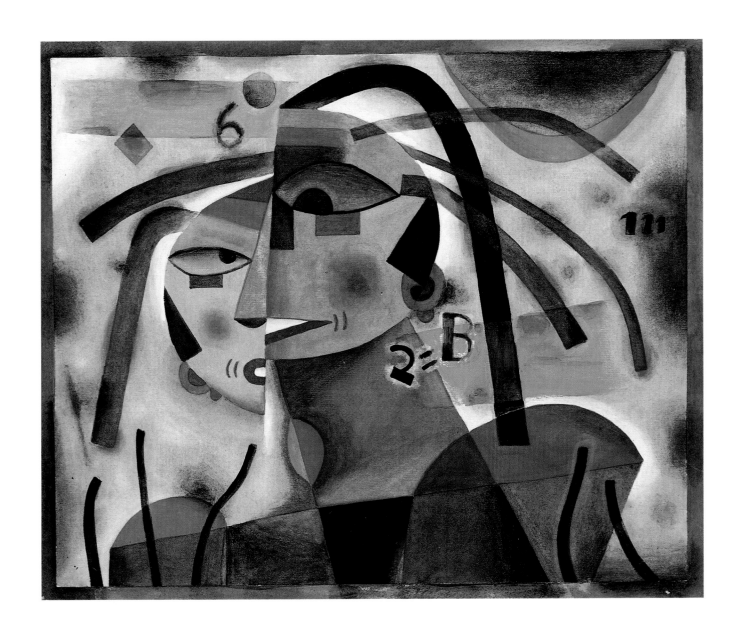

**83.** *Pareja (Couple)*, 1923
Watercolour on paper mounted on card,
image: 25.9 x 32 cm; card: 27.7 x 33.9 cm
Eduardo and Teresa Costantini Collection,
Buenos Aires

103

words reinforced or altered the meaning of the image, and the kind that Xul practiced with the **visual text**, where his pictorial treatment gave the text or poem a suggestive, artistic meaning, as in Klee's painting. Nevertheless, Xul added a new ingredient to his work which was his *neocriollo*, so that his verbal paintings became more hermetic thanks to that interpretative ambiguity.

Only in some of Xul's works from the 1923-1924 period is it possible to find thematic affinities and close similarities with Klee's work. In this way Xul expressed his admiration for Klee's work whose spiritual richness transcended its aesthetic qualities. Let's take *Las dos* (*The Two*, plate 54) from a series of works with erotic overtones. Its relationship with Klee's *Das Auge des Eros* (*Eros's Eye*, reproduced in Hausenstein's book and figure 23) is immediate. Xul reworked that refined and humorous eroticism into a more gestural and provocative image.

Klee was an extraordinary draftsman, and his ideas flowed through the lines of his drawings. This was one of the means he used in the making of his watercolours at that time. Xul, on the other hand, recorded images from visions that appeared to him almost spontaneously, fully composed like images that appear on the screens of high speed computers, and that Xul transferred to paper after lightly sketching them in pencil lines. This can be confirmed if *Schwarzmagier* (*Black Magician*, figure 27) is compared with the character from *Mero* (plate 79). In that scene there is a sort of repressed energy. The image of the magician emerges from the poetic outline, and it is hard to identify the relationship that exists between the title and the image. Xul, however, transformed the character using the same graphic elements into a more provocative, fairylike image, which catches the eye, and where the cosmic energy that falls on the character crowned by the magic number seven is perceptible.

Xul took up an idea that had been well worked on by Klee (figure 28) of elaborating the image in fields of horizontal lines on which he painted his scene (plates 80 and 81). The colours are luminous, but despite attempts to make the surface more dynamic with the insertion of slanting crosses, his images remained static. Soon after he painted *Dos parejas* (*Two couples*, plate 84), included now in the Pan Klub collection. One notices a complete dislocation of the horizontal line fields in this work. Disrupting the plane was a characteristic of his painting that Xul used in his later work, and it allowed him to recover the energy of his earlier work.

This is what differentiated the work of the two artists at the time. In Klee's watercolours and oils, the energy flows purely and

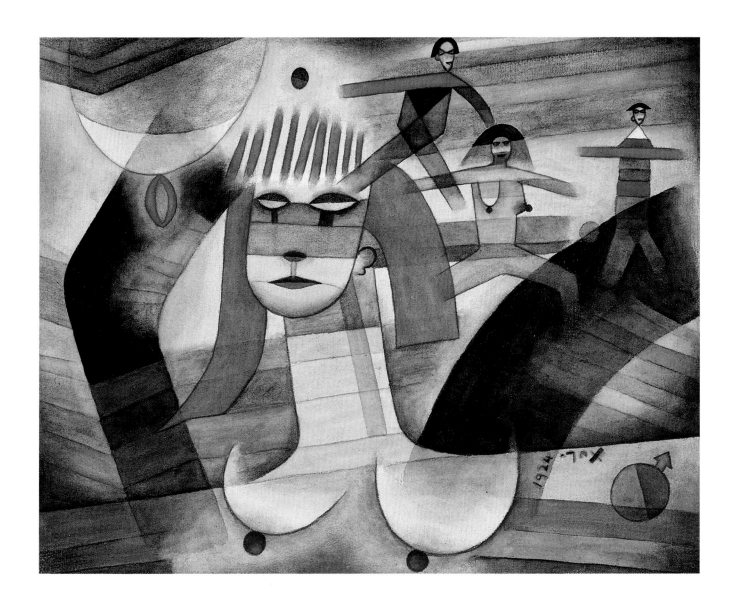

**84.** *Dos parejas (Two Couples)*, 1924
Watercolour on paper, 27.5 x 35 cm
Museo Xul Solar

organically, expressing itself in his subtle handling of colour, in the rhythm of his drawing, in the creation of many techniques, and in his sensual approach to nature. Paul Klee created a visionary, romantic and poetic version of his surrounding reality and also reached abstraction. Alternative processes ruled Xul Solar's works. There was a peculiar use of that energy that spread by impulses, like shock waves, that flowed towards the observer from special areas of the painting but that was integrated in the visual unity of the image.

With Klee what was lyrical, rhythmical, graphic, poetic and musical prevailed. Xul was dominated by an Expressionism that caught the eye, and at times overflowed. With his geometric shapes Xul generated fields of force in his paintings that energized the image, together with a hermetic world of signs and symbols. Xul Solar's works not only recovered visions from other worlds but transmitted an energy that lifted us to places, shapes, signs and thoughts beyond our time. What is more, his repeated references to *criollismo* (native Argentine culture) in his paintings and their connections with shapes from Pre-Columbian America underlined the different nature of his aesthetics.

Xul lived through German hyperinflation in an anxious mood, and continued to plan his journey. Informed about what was happening in Argentine life, he understood that a tough struggle awaited him. He wrote:

> *We are preparing the journey with Emilio. We'll hit out even if we are thrashed. Already in the Buenos Aires newspaper La Razón[92] they said that my art was unbalanced. We are happy to fight.[93]*

Towards the end of 1923, after dealing with tiresome bureaucratic matters to get his belongings sent back[94] from Munich, he returned to Zoagli. These include more than 200 books bought over 2 years including German books on Klee, Chagall, Picasso, Archipenko, Kokoschka, Cubism, Cézanne, Marc, Pechstein, Laurencin, Dada magazines, and books on Oriental art, architecture, some musical scores and a large collection of mystical, numerological and religious books by authors like Annie Besant, Erich Bischoff, Charles W. Leadbeater, Helena P. Blavatsky, Frederich Nietzsche, Eduoard Schuré, Rudolf Steiner, Deussen; as well as personal effects, painting equipment and

*roughly ninety-two paintings in different sized frames (and*

92. *Declinación del arte de nuestro tiempo*, La Razón, 17th August 1921.

93. Postcard sent to *Dearest old loved ones* in 1923, without a date.

94. In the Fundación Pan Klub's archives you can find the original declaration of the artist and writer Alejandro Schulz Solari's belongings approved by the Munich Department of Finances enabling them to be exported.

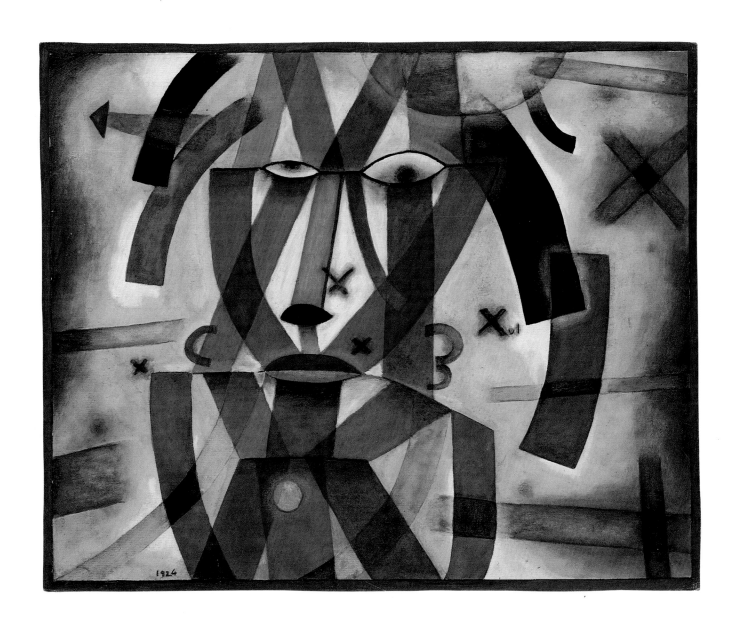

**85.** *Cintas (Ribbons)*, 1924
Watercolour on paper mounted on card,
image: 25.5 x 32.2 cm; card: 27.7 x 33.9 cm
Private collection, Buenos Aires

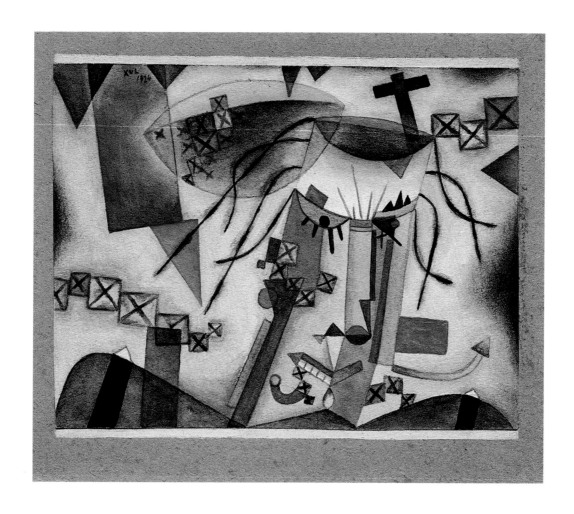

**86.** *Máscara con cruz* (*Mask with Cross*), 1924
Watercolour on paper mounted on card,
image: 17 x 22.5 cm; card: 21.4 x 25.3 cm
Private collection, Buenos Aires

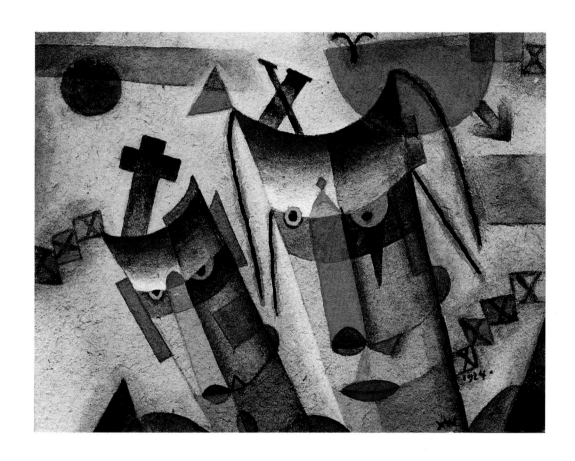

**87.** *Máscaras* (*Masks*), 1924
Watercolour on paper, 15 x 19.5 cm
Private collection, Mexico

*some 50 pieces of untouched card), (few are large, approx. 50 small measuring 22 x 17cm).*

Everything was ready for his return, as one of his sentences predicted: *I am more criollo (Argentine) than ever.* This quotation lacked any regional pride, rather it stressed Xul's desire to transcend the peculiarity of being Argentine within a more universal context.

This vocation for contributing to the development of a new culture in a country where the notion of an avant-garde had not really taken root can be related to the aspirations of other Latin American artists and writers, who after having taken part in European advanced movements, had decided to return to their own countries to try and change the existing structure of a postcolonial America which they had temporarily abandoned for more appealing horizons, searching for other masters.

Xul had concluded his European wanderings. He was 36 years old, and had confirmed himself as an artist. He had already realized his Quixotic dream of founding a new world which, though limited to his personal surroundings, answered his deepest desires.

He returned to his fatherland in July 1924 with his paintings, his writings, his notes and a very complete library, unique in its kind at that time, admired by Jorge Luis Borges. Xul hoped to fight a battle that he had refused to fight in a Europe that he admired and that had attracted him because it offered the chance to study and learn and where he had attained important successes, but that was alien to him. Europe for Xul was a world of others.

He would have to prove in that new milieu, a more cosmopolitan Buenos Aires in a process of modernizing and renovating itself, whether he would be able to extend his entourage so that his fellows would be able to join with him.

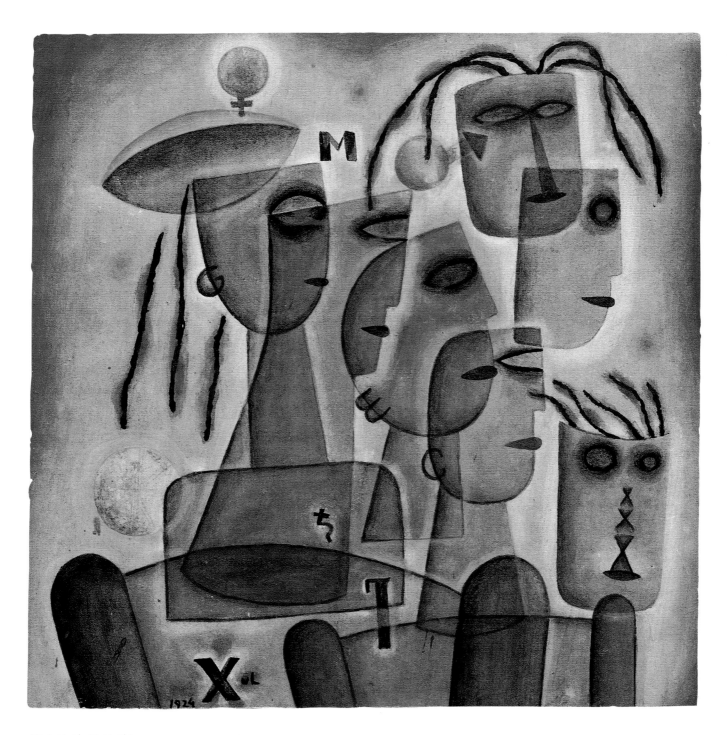

**88.** *Septuplo* (*Septuple*), 1924
Watercolour on paper mounted on card,
26 x 26 cm
Private collection, Buenos Aires

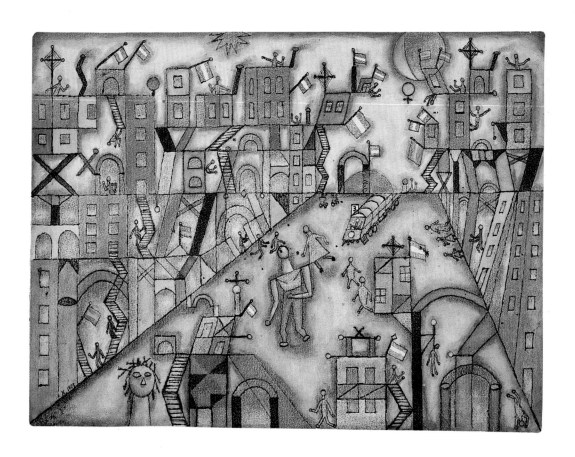

**89.** *Fecha patria (Fatherland Date)*, 1925
Ink and watercolour on paper, 27.8 x 37 cm
Private collection, Venezuela

# 3. Return to Buenos Aires

The return generated expectations in Xul. Buenos Aires had changed, and had grown bigger, and higher. The political and social structural changes that had been already felt in the Argentina celebrating its Centenary had created a different country. Electoral reform introduced by the Saenz Peña law had momentarily eradicated electoral fraud. The urban masses had voted a populist political party, called the Radical Party, into power. A few years later the university had been shaken by the so-called "University Reform" led by young students who wanted it to be in accord with the country's new reality.

The Argentina of the 1920s was on the boil. It was a society full of unresolved contradictions, still sunk in the past, and seeking the material changes that modern technology promised, but trapped by its inability to settle the social and cultural conflicts that this very modernization brought with it.

New intellectuals had been emerging from the more cultured classes, from the new bourgeoisie, and from the working classes. This explosive mixture of classes, of roots, this mess involving patrician values, native Argentine values, and immigration granted the Buenos Aires of the 1920s a cosmopolitan air, with an apparent and deceptive sense of progress. But in the background there was a sordid and perverse atmosphere that emanated from the mediocrities installed in the official cultural establishment who would not reveal themselves until conditions favoured them at the end of the decade.

At the time, Buenos Aires was a feast for writers. Literary magazines flourished with young writers and poets unable to identify with local archetypes, and who self-confidently threw themselves into the avant-garde, creating new myths.

A new event in the history of Argentine culture appeared: the arrival of a new, non-conformist generation that had abandoned the *fin de siècle* artistic canons for new experiences. This generation recognized the expressive possibilities offered by Futurism, Cubism and Expressionism, that had not received an echo from the earlier generation who still clung to the modernist values of Rubén Darío's *Prosas profanas*.

The cultural milieu was shaken by the avant-garde *ultraístas*

*(Ultraists)* with Jorge Luis Borges[95] as one of their main activists. With Xul Solar and Pettoruti's return, both who had belonged to the previous generation, the group that argued for novelty in art, poetry and literature, was complete.

Modern art had not yet affected the world of painting in Buenos Aires. Marcel Duchamp, during his stay in Buenos Aires from September 1918 to June 1919, tried to set up an exhibition of some 30 works by Cubists in a commercial gallery, as well as importing books on Cubism by Apollinaire, Gleizes and Metzinger to accompany the show. This first attempt to *Cubify* Buenos Aires was fruitless[96] and Duchamp took advantage of his time to work on one of his *Glasses* and to improve his playing of chess. His description of the Buenos Aires artistic world reveal the apathy of local artistic circles. Duchamp wrote:

> *The "painterly" tribe presents no interest. Zuloagas and Anglada Camarasas: both students, more or less. A few important galleries sell expensively and steadily. The few people I met have "heard" of Cubism but are totally ignorant of the significance of a modern movement. I immediately thought to organize an exhibition here next winter (that is, starting in May and June).*[97]

This was the reality that Xul and Pettoruti had to confront.

## Encouraging the Avant-garde

On their arrival in Buenos Aires the two painters joined the young avant-garde writers grouped around the magazine *Martín Fierro* which had been founded a second time by Evar Méndez in 1924. They were encouraged by the architect Alberto Prebisch[98] and the art critic Pedro Blake who also wrote for the magazine. The popular *Martín Fierro* had a large print run and shocked the Buenos Aires cultural world.

Pettoruti went his own way and exhibited in Florida street in October of that year in the Witcomb gallery. This act marked the appearance of avant-garde art in Argentina, and led to heated public debates[99] about Cubism, and about Futurism, still unheard of in

95. Borges returned to Buenos Aires in 1921 and founded the mural review *Prisma*, and later the magazine *Proa Revista de Renovación Literaria*. Its first period consisted in 3 numbers between August 1922 and July 1923. Borges then travelled back to Europe. On his return in August 1924 the second period of *Proa* began, edited by Borges, Brandán Caraffa, Ricardo Güiraldes and Pablo Rojas Paz.

96. Francis M. Naumann, *Affectueusement, Marcel: Ten Letters from Marcel Duchamp to Suzanne Duchamp and Jean Crotti*, Archives of American Art Journal, vol. 22, n. 4, 1982, p. 12

97. Francis M. Naumann, *Amicalement, Marcel: Fourteen Letters from Marcel Duchamp to Walter Pach*, Archives of American Art Journal, vol. 29, nos. 3 and 4, 1989, p. 42. I would like to thank Francis M. Naumann for these references.

98. The architect Alberto Prebisch (1899-1970) was one of the initiators of modern architecture in Argentina. After completing his studies he travelled to Paris, and on his return wrote on art and architecture in Martín Fierro.

99. E. Pettoruti, op. cit., p. 186.

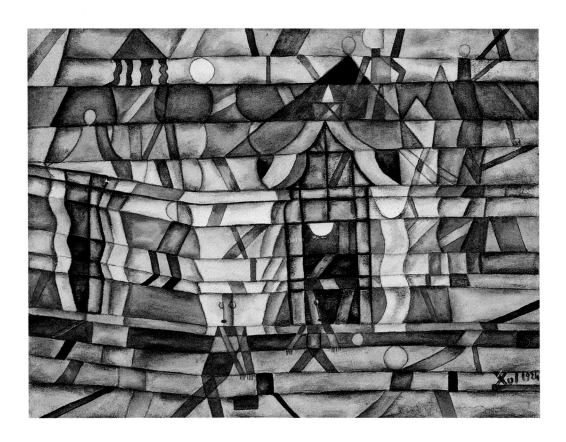

90. *Casa colonial (Colonial House)*, 1924
Watercolour on paper, 27.7 x 37.2 cm
Eduardo and Teresa Costantini Collection,
Buenos Aires

Buenos Aires. Xul commented on it in a long essay published in *Martín Fierro*.[100]

A short while later, and for the first time, Xul exhibited four paintings in the first "Salón Libre" (Free Salon) of Buenos Aires, which was a local and tardy version of the "Salon des Indépendants" in Paris. The acute critic Atalaya (Alfredo Chiabra Acosta) in a note on this Salon crudely described the prostrate state of art in Argentina and wrote:

> *The strangest and most unique contribution are the works of Xul Solar ... You would have to go back to the Count of Lautréamont to find a similarity in tune with Xul's mind. We would have to go back upstream to the sacred rivers of civilizations that existed in Asia to find something as complicated and as child-like as this painting...*[101]

100. Xul Solar, *Pettoruti*, Martín Fierro, Año I (second period), n. 10-11, September-October 1924.

101. Alfredo Chiabra Acosta (Atalaya), *1920-1932. Críticas de arte argentino*, M. Gleizer Editor: Buenos Aires, 1934, p. 8.

Life in Buenos Aires was not easy for Xul. He missed Europe, although in one of his letters to his *mamás* he pointed out that back home he had more chance of earning money than in Europe, and *later carry out or begin something from all the thinking I have been*

Figure 29. Xul Solar, 1926
Two vignettes for Jorge Luis Borges's book *El tamaño de mi esperanza ( The Size of my Hope)*

*doing.* If he was happy to have returned home, it was for the chance of being with his father again, who died unexpectedly in April 1925. His mother and aunt returned to Buenos Aires three months later.

Xul strove to get to know those Argentine intellectuals who shared his interest for culture and the new artistic tendencies. He struggled to show his paintings and make his research into *neocriollo* known. He frequently met Victoria Ocampo, Norah Lange, Oliverio Girondo, Evar Méndez, Macedonio Fernández -one of the most original thinkers of the time- and Jorge Luis Borges with whom he shared an interest in Johannes R. Becher, German Expressionism, Emanuel Swedenborg and William Blake.

The "Exhibition of Modern Painters" opened in Amigos del Arte[102] on the 17th June 1926 for three days to celebrate F. T. Marinetti's journey to Buenos Aires. Xul Solar participated with Norah Borges and Pettoruti, the architects Vautrier and Alberto Prebisch and the decorator Pedro Illari. A little later Xul exhibited again in the "Sala de Independientes", organized by the Comisión de Bellas Artes. What he sent to the Salón Florida, an art gallery, prompted a new critique from Atalaya

*We reach Xul Solar, **magnus** man and **magnus** intelligence. When we penetrate contemplatively Xul's pictorial work we unconsciously think of poets who have invented fairy tales. In his "terribilitá de bon enfant" there is so much freshness of spirit, a desire of such a childlike ability to be astounded and to enjoy himself -and astound us and divert us-, with the euphoria of his mental dreams that by contrast attain a pathetic quality, and from all this emanates a malicious sense of humour ...*
*But Xul, painter **per se**, according to his own confession, was a writer of a unique linguistic purity. His latest translation in Martín Fierro demonstrated this. In the Martín Fierro group, it is not Borges, nor any of the others, but Xul who is the writer with the purest accent and the most solid linguistic and universal cultural. He is the genius of the house.[103]*

Meanwhile, official culture and the main body of Argentine artists continued to ignore the new artistic movements. The following comment by Prebisch on the "Salón Nacional de Bellas Artes" in 1926 illustrates the intellectual level of these circles:

102. "Amigos del Arte" was one of the most prestigious private institutions in Buenos Aires, and was active from 1924 to 1946, run by Elena Sansinena de Elizalde.

103. Atalaya, *1920-1932*... op. cit., p. 267.

## MARTIN FIERRO

## "Martin Fierro" y Marinetti

Parte de los asistentes a la comida de fraternidad intelectual organizada por MARTIN FIERRO, que se dedicó a Marinetti, y en la que estuvieron representadas las revistas ''Inicial'', ''Revista de América'', ''Valoraciones'', ''Estudiantina''. Sentados: Guillermo Korn, Villareal, Sandro Piantanida, Sra. Delia del Carril, Marinetti, Héctor Pedro Blomberg, A. Mugnai, Petrone, Alietto, Ricardo Güiraldes, José de España, Leopoldo Marechal. De pie: Jorge Luis Borges, Roberto A. Ortelli, F. López Merino, Córdova Iturburu, Antonio Gullo, Lysandro Z. D. Galtier, Nicolás Olivari, Sra. Benedetta Cappa de Marinetti, Emilio Pettoruti, Sra. Adelina D. de Güiraldes, Piero Illari, Manuel Gálvez, Alberto Franco, Pelele, Bakhes, Sandro Volta, Antonio Mordini, Alfredo Bigatti, Pedro Blake, Xul Solal, N. N. Juan B. Tapia, Ing. Anfosi, Raúl Sosa, Absalón Rojas, Carlos A. Erro, Evar Méndez, Oliverio Girondo, Pablo Rojas Paz, Domingo Moreno, Francisco Luis Bernárdez

Figure 30. Banquet organized by the *Martín Fierro* group in honour of F.T. Marinetti, published in Martín Fierro, Año III (second period), nos. 30/31, 8th July 1926, p. 5. George and Marion Helft Collection, Buenos Aires

*After entering the exhibition the alert spectator notes that his sense of aesthetic categories is turned upside down. A breath of bad taste circulates in these rooms in which the ingenuous optimism of a few annually welcomes the mistaken fruits of the lamentable spring flowering ... Unfortunately this irremediable bad taste dominates this Salon and is not accompanied by any quality that might modify it, and make it tolerable. Our attentions slips over a mass of works of commonplace vulgarity. The ridiculous peasantish prudence of our painters keeps them ignorant of the problems shaking the contemporary artistic world for the last 20 years. Their minds have been kept chastely closed to all curiosity.*[104]

Xul, meanwhile, kept to his chosen path. His participation in the Martín Fierro group, where he had been well received, contributed to more openness. As well as his social activities, his interest in meeting people and showing his works, he worked intensely on his paintings. His Argentine paintings of this decade could be included in his period of reveries if the way he treated them is taken into account, although decisive changes could also be noted.

On the one hand Xul Solar dropped the problems concerning

104. Alberto Prebisch, *Salón Nacional de Bellas Artes de 1926*, Martín Fierro, Año III (second period), n. 35, 5th November 1926.

individuality or the couple, whose psychological connotations reflected his European isolation; on the other hand, his world expanded and new cosmogonies appeared in his visions with a new pictorial space that he integrated with his architectures.

Two paintings *Místicos* (*Mystics*, plate 91) and *Teatro* (*Theatre*, plate 92) illustrate this change. They can be dated 1924-1925 by the watercolour techniques. In *Místicos* Xul painted one of his ascension- towards-spirituality visions. The path begins in a house (God's) near the sea. After following a ramp, you climb up along a complex structure of columns and diagonal bars (Crosses of St. Andrew). It is a difficult path divided into stages, with resting places to meditate.

If you compare this extenuating path with the naive drawing of *Sube os alcanzaré, mais ke alas tengo,* and *Probémonos las alas también nos* it is noticeable how in a few years Xul had articulated his visions in more elaborate and hermetic artistic ways within the context of avant-garde art, and in his own, unique style. The ever-present sun, clouds, moons, and light colour modulations applied in vertical stripes, emphasize the feeling of ascending and reinforce the pictorial quality of the image, and its existential mystery.

A different atmosphere can be seen in *Teatro*. Xul created a complex stage design for an unknown piece of theatre, using a perspective with multiple vanishing points to represent the scene. The structural features used defied the forces of gravity. In watercolour Xul recreated the luminous and chiaroscuro effects of a magical, open-air stage, as suggested by the sun-moon and sky symbols across which the characters in the work, strange puppets, fly like Chagallian beings.

Here Xul employed a different technique. Instead of outlining the image in soft pencil as in *Místicos*, he drew the shapes with ink, using slightly broken strokes that define areas where he applied rich and transparent watercolours in iridescent tones. Diagonals, which act as a field of minor whirlwinds that slant across the pictorial plane, generate energies that make the image dynamic in an intense way not seen in previous works.

Both works marked the appearance of a new pictorial space in Xul's paintings that was at times ambiguous due to the subtle oppositions established between the general flatness of the image and the feeling of space offered by the soft colour gradations of the vertical frameworks, as in *Místicos*. At other times this space was converted into something fairy-like and mysterious by the advent of a three-dimensional segment that disturbed other parts of the

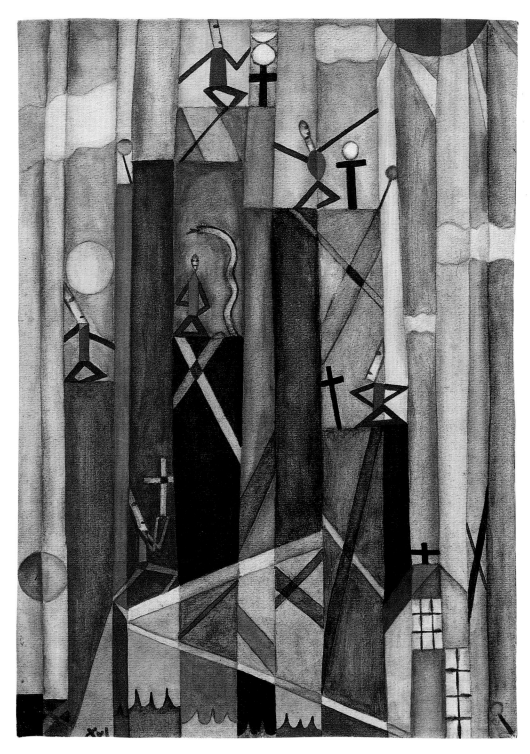

**91.** *Místicos (Mistics)*, 1924
Pencil and watercolour on paper, 36.5 x 26 cm
Private collection, Buenos Aires

image, through planar structures that appeared in the lateral segments of *Teatro* and in *Dos rúas* and *Tres rúas* (plates 60 and 61). This play of distortions multiplied the energy emanating from his paintings.

The essential characteristics of Xul's new pictorial space are the confrontation between the bi-dimensionality of the plane and the three-dimensional effect of perspective in the same image, the superposition of frontal planes and views from above, the play between planes and foreshortened lines, the opposition between the flatness of the image and the volumetric sense that his colour modulation achieved. This space is also built by juxtaposing partial images with different orientations within the pictorial plane. His series of *Rúas* represented the first antecedent that Xul perfected from his arrival in Buenos Aires. *Doce escaleras* (*Twelve Ladders*, plate 108) is an attractive example of this new organization of **juxtaposed spaces**.

New festive and joyous visions appeared that were related to his overt desire to dedicate himself to the reconstruction of his country's culture. It was no longer a question of dressing in regional clothes as he had in Paris when he walked the streets in a blue and white poncho. He also had to transform other qualities in order to attain universality. As he said:

> *Our (patriotism?) is to find the highest possible ideal of humanity, put it into practice and spread it around the world.*[105]

In this group of works you can find the series *Sandanza* (*Saintdance*) which present the celebration of a feast, or a rite.

105. Unpublished text by Xul Solar in the Museo Xul Solar.

Figure 31. Scene from a play based in G. K. Chesterton's novel *The Man Who Was Thursday*. Stage and clothes designed by Alexander Vesnin and George Yakulov

Figure 32. Scene from F. Crommelynck's play *The Magnanimous Cuckold*, Actor's Theatre, Moscow. Stages and clothes designed by Liubov Popova

**92.** *Teatro (Theater)*, 1924
Ink and watercolour on paper, 28 x 37.5 cm
Private collection, Buenos Aires

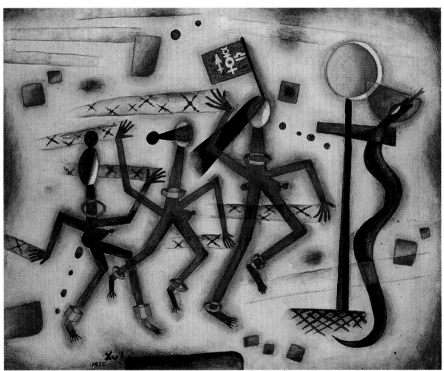

**93.** *Danza* (*Dance*), 1925
Watercolour on paper, 24.8 x 31 cm
Private collection, Italy
Courtesy Rachel Adler Gallery

**94.** *Sandanza(1)* [*Saintdance (1)*], 1925
Watercolour on paper, 23 x 31 cm
Museo Xul Solar

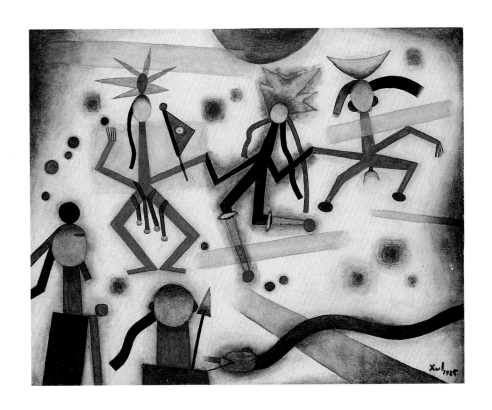

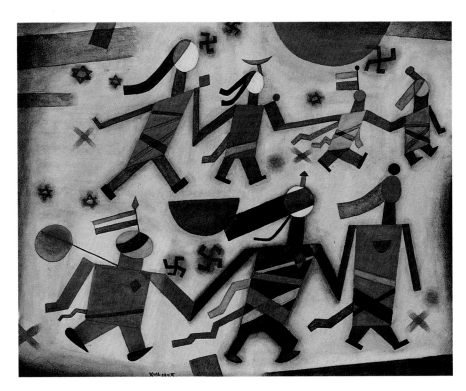

95. *Sandanza (Saintdance)*, 1925
Watercolour on paper, 23 x 31 cm
George and Marion Helft Collection,
Buenos Aires

96. *Ronda (Dancing in a Circle)*, 1925
Watercolour on paper mounted on card,
25 x 31 cm
Eduardo and Teresa Costantini Collection,
Buenos Aires

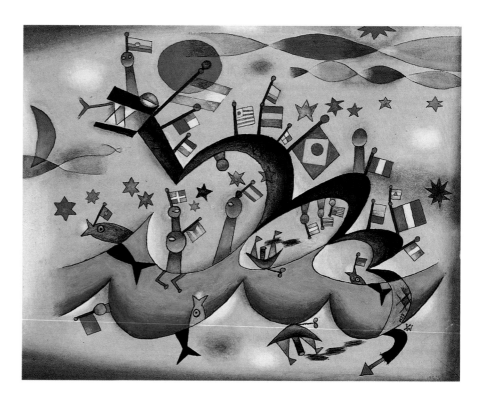

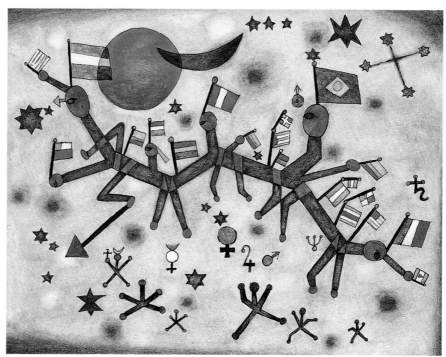

**97.** *Otro drago (Another Dragon)*, 1927
Watercolour on paper, 23 x 31 cm
Private collection, New York
Courtesy Rachel Adler Gallery

**98.** *País (Country)*, 1925
Watercolour on paper, 25.2 x 32.7 cm
Galería Rubbers, Buenos Aires

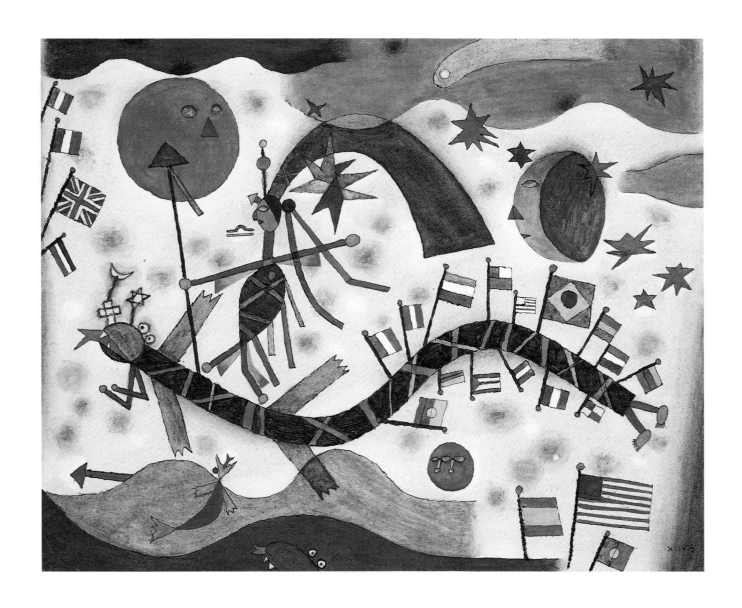

**99.** *Mundo (World)*, 1925
Watercolour on paper, 25.5 x 32.5 cm
Private collection, Mexico
Courtesy Rachel Adler Gallery

100. *Milicia (Militia)*, 1925
Watercolour on paper mounted on card,
image: 23 x 19 cm; card: 31 x 26 cm
Private collection, Buenos Aires

Figure 33. Front page of Martín Fierro, Año
III (second period), nos. 30-31, 8th July
1926, with Xul Solar's *Milicia*

There are happy dancers, accompanied by a flautist, and holding
hands, suspended in an ambiguous space that is more sky than
ground, between blue stripes and suns, as well as moons that
observe them (plate 93). These beings carry small Argentine flags.
Further, the presence of a field with St. Andrew's crosses, or the
letter X, is repeated on the flautist's head as another source of
energy. There are bejewelled women guided by a serpent from
whose hands enchanted haloes are loosened. One of them holds a
banner with astral symbols (plate 94). There are other beings
crowned with gleaming diadems who dance while watched by
guards (plate 95). There are characters who participate in two
groups, dressed in multicoloured clothes that recall the reticulated
structures of *Teatro* (plate 96).

126

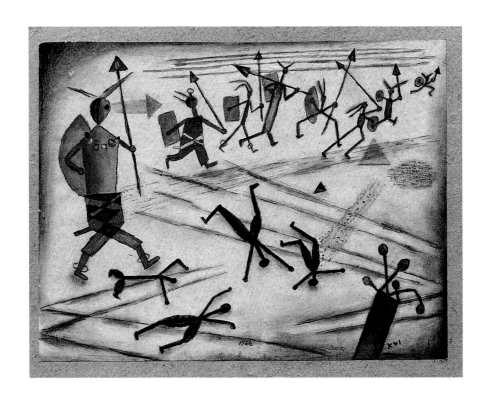

101. *Bárbaros (Barbarians)*, 1926
Watercolour on paper mounted on card,
image: 14.3 x 19.6 cm; card: 16 x 21 cm
Private collection, Buenos Aires

106. Martín Fierro, Año I (second period),
n. 4, 15th May 1924.

107. Like the *Prisma* proclamation (Buenos
Aires, 1921) and manifestos like the *Primer
Manifiesto Agú* (Chile 1920), the
*Estridentistas* (Mexico 1921, 1923 and
1925), the *Postumista* (San Domingo 1921),
the *Euforista* (San Juan, Puerto Rico, 1922),
partially go back to the manifestos published
in Chile by the poet Vicente Huidobro in
1914 and the *Manifesto for University
Reform* published in 1918 in Córdoba,
Argentina, collected by Nelson Osorio T.,
*Manifiestos, proclamas y polémicas de la
vanguardia hispanoamericana*, Biblioteca
Ayacucho: Caracas, 1988.

108. Beatriz Sarlo, *Una modernidad
periférica, Buenos Aires 1920 y 1930*,
Ediciones Nueva Visión: Buenos Aires, 1988,
p. 15.

Also occupying the scene are stars of David that symbolise the unity between matter and spirit, active and passive principles, evolution and involution, and swastikas, symbols of movement round a centre, of action, of continual regeneration. Xul applied the pictorial techniques of his reveries, and this constellation of forms with sky-blue stripes distributed on the plane endowed his images with a new dynamism.

In the meantime during this decade the young intellectuals in Latin America were transforming their official, immobile cultures by publishing magazines, manifestos and proclamations. This activity was happening in nearly all the countries and sometimes coincided with more radical political solutions. In this context the *Martín Fierro* manifesto,[106] published in 1924 shared many significant points with the first Futurist manifesto, although it reflected other proclamations.[107]

Buenos Aires occupied a privileged place in this internationalization of the modernizing Latin American movements as *the great Latin American stage of a culture of mixture*.[108] The review *Proa* published the founding of the "Unión Latino-Americana" amongst whose members figured Brandán Caraffa, Julio V. González, José Ingenieros, and Alfredo Palacios, the most outstanding socialist intellectuals in Argentina, who proposed to

127

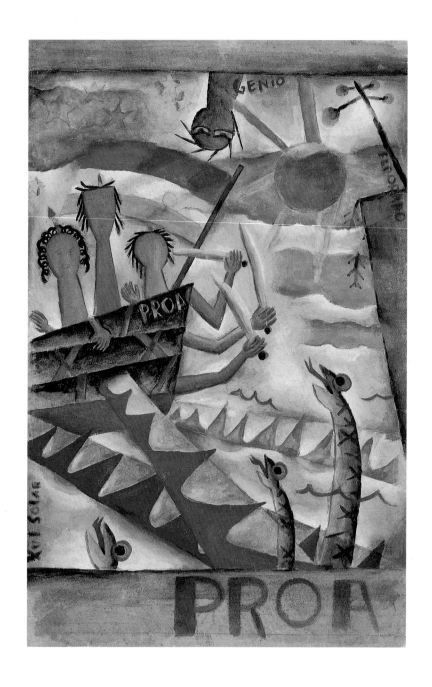

102. *Proa (Prow)*, c. 1926
Tempera on paper, 50 x 33 cm
Galería Rubbers, Buenos Aires

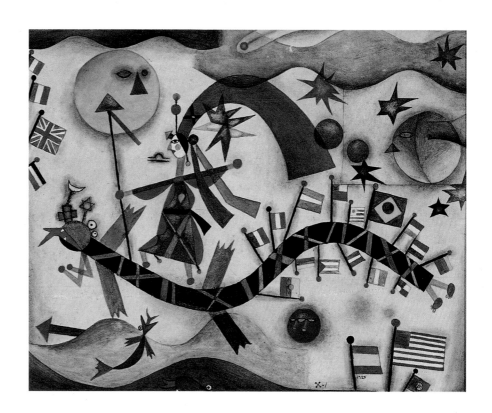

103. *Drago (Dragon)*, 1927
Watercolour on paper, 25.5 x 32 cm
Museo Xul Solar

generate a wider platform from where they could spread their ideas
for aesthetic and ideological change. Within a short time, Borges,
Caraffa and Güiraldes pointed out:

> *From the start we have wished that Proa would do justice to
> its name and be a concentration of struggle more through
> works than polemics. We work in the freest and hardest part
> of the boat, while the bourgeois of literature sleep in cabins.
> By our position they will have to pass behind us during the
> journey. Let them call us mad and extravagant. Deep down
> we are tame and will do anything except fight over the
> privilege of work and adventure.*[109]

Xul noted with interest how the objectives of the Latin American
avant-garde artists became internationalized. This effervescence
created favourable conditions for the development of a new culture.
Xul glimpsed the possibility of carrying out his designs, although he
did not relinquish the idea of returning to Europe. From this period
came the emblematic sketch called *Proa* (*Prow*, plate 102) as well
as a series of works that reflected the Latin American mood, like
*Mundo* (*World*, plate 99), and *Drago* (*Dragon*, plate 103).

109. Proa Revista de Renovación Literaria,
Año 2 (second period), n. 11, Buenos Aires
June 1925.

Figure 34. Cover of Revista de América, Año 2, No. 6, 1926, design by Xul Solar

In the foreground there is a defiant watchman, standing straight up, transported by a dragon-serpent that carries the symbols of the three main religions on his head. His body, adorned with flags from Latin American countries, slithers over the sea. Flags from Italy, France, Great Britain, Yugoslavia, Spain, The United States, and Portugal greet this messenger. The sun, moon, stars and a comet cross the sky, as in some representations of the Three Wise Men, and witness the mythical scene.

From the same period was *Otro horóscopo, Victoria (Ocampo)* [*Another Horoscope, Victoria (Ocampo)*, plate 104] which, apart from the woman's long face, reveals a globe with Latin America on it. If the date of this work (c.1927) is taken into account, doesn't this painting anticipate Victoria Ocampo's later Latin Americanist activities?[110]

Xul's aesthetic influences were soon recognized, and the philosopher Carlos Alberto Erro asked him to illustrate the cover of his *Revista de América* reproduced in figure 27. He also illustrated two of Jorge Luis Borges's books with vignettes.[111] These drawings referred to martial themes with soldiers and Argentine flags, and shared the mood of *Milicia* (*Militia*, plate 101) and *Bárbaros* (*Barbarians*, plate 101),to symbolize the writer and illustrator's will to fight for the new expressive possibilities of Spanish in America. Let us recall one of the last sentences in Xul's article on Pettoruti: *For our America the Wars of Independence are not yet over.*[112] It is within this context that Xul's vignettes and those works should be interpreted.

For Xul painting was only one of the mediums he worked in order to communicate, and he did not give up in his task as a writer and promoter of *neocriollo*. He concentrated in his meditations on the hexagrams of the "I Ching" and turned these visions into his language as *San Signos* (*Saint Signs*), which remain unpublished. He translated texts from the German Expressionist poet Christian Morgenstern's book *Stufen* into *neocriollo* and published them in *Martín Fierro*,[113] where he had also published -in neocriollo- a humorous note of farewell to the poet and writer Leopoldo Marechal.[114]

Macedonio Fernández, one of the most influential intellectuals of his time, offered the following portrait of Xul in *Papeles del Recienvenido* (*Papers of the Recently Arrived*):

*What is cyclical and what is circumstantial stand in the same proportion as spontaneous recurrence and the excited*

110. The first number of *Sur*, founded by Victoria Ocampo, appeared in 1931. See John King, *Sur. A Study of the Argentine Literary Journal and Its Role in the Development of a Culture, 1931-1970*, Cambridge University Press: Cambridge, 1986.

111. Jorge Luis Borges, *El tamaño de mi esperanza* (*The Size of my Hope*), Proa: Buenos Aires, 1926 (5 vignettes), and *El idioma de los argentinos* (*The Language of the Argentines*), M. Gleizer Editor: Buenos Aires, 1928 (6 vignettes).

112. Xul Solar, *Pettoruti...*, op. cit.

113. Xul Solar, *Morgenstern, Cristian, algunos piensos (pensamientos) cortos*, Martín Fierro, Año IV (second period), n. 41, 1927.

114. Xul Solar, *Despedida de Marechal*, Martín Fierro, Año IV (second period), n. 37, 1927.

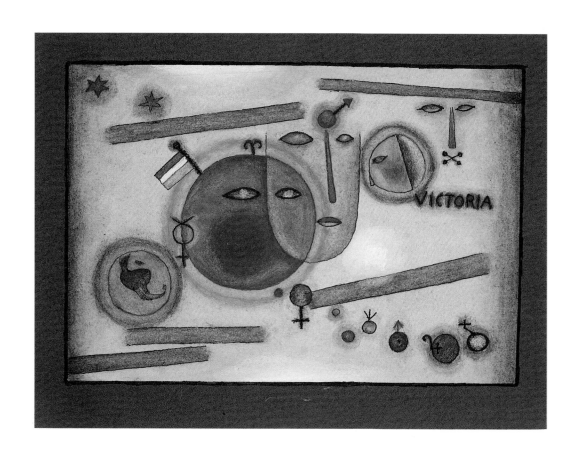

**104.** *Otro horóscopo Victoria (Ocampo)*
[*Another Horoscope Victoria (Ocampo)*], 1927
Watercolour on paper mounted on card,
image: 13.6 x 19.8 cm; card: 15.8 x 22.9 cm
Private collection, Italy
Courtesy Rachel Adler Gallery

Figure 35. Alejandro Xul Solar
Sketches with People and Shapes, c. 1925
Pencil on notebook
Museo Xul Solar

*recurrence of ideations: 90% of the facts of memory are provoked by actual circumstances. We would forget all the small daily details that we decided to do a minute ago if everything around us was not peopled with things and facts that function as reminders. I call this Circunstancio or Circunstancie, a word invented following Xul Solar's genial Lesson. He is a man who does not let languages speak badly, and would not grant them more defects than the one about "Always speaking". (Xul should not have died; he is not replaceable nor repeatable; is the most graceful Good Morning!, the lightest arrival, the one who left who we most wanted to stay, the person-character who least needs us and whom we miss several times a day. His short and never complicated visits make one think of someone who goes from the well to the garden with a small watering can that he has to continually refill, and leaves us splashed with a little water. Although we have the knockable character of pipes that refuse to light up, for him its all the same. His plauding character pops up in our domestic existence, sees us and says to himself: "Here you are, always in a temper!", applauds and leaves happy that we have not changed our defect. That's what he likes).*[115]

At the end of November 1928 Xul moved with his mother and aunt to the house at 1214 Laprida street, and a few months later held his first individual show in the salons of Amigos del Arte with 62 works, amongst which I would name *Ome i Sierpe (Man and Serpent)*, *Puerto periazul (Peri (sic) blue Port)*, *Tlaloc*, *Casa criolla (Creole House)*, *Sandanza (Saintdance)*, *Pareja (Couple)*, *Bárbaros (Barbarians)* and several *décoras* (decorative objects).

With this exhibition five years of ceaseless activity in Buenos Aires have concluded. The show awoke the interest of the most alert critics as well as of a nucleus of writer friends. Horacio Quiroga wrote a note praising his work in La Nación. E. M. Barreda interviewed him for the same newspaper[116] when Xul let him know about his first researches into reforming the writing of *neocriollo*, which he carried out years later in his *Grafías* (Ideographs), and in his project to reform musical writing.

115. Macedonio Fernández, *Papeles del Recienvenido*, Proa: Buenos Aires, 1929. Xul's copy dedicated by Macedonio was published by Losada: Buenos Aires, 1944, from which this quotation was taken, p. 270.

116. Ernesto Mario Barreda, *Por los reinos de la Cábala*, La Nación, 20th October 1929, p. 32.

# Articulation of the Architectures

The influence of Xul's art in Buenos Aires was limited to a narrow circle, unlike his creativity which allowed him to crystallize other paintings like *Fecha patria* (*Fatherland Date*, plate 89), *Puerto azul* (*Blue Harbour*, plate 105), *Pagoda*, plate 107, *Doce escaleras* (*Twelve Ladders*, plate 108), *Bau* (*Building*, plate 109), *Jol* (*Hall*, plate 111), which with *Místicos* and *Teatro* are essential to an understanding of how his integration with Argentine culture helped consolidate his universal aspirations.

*Fecha patria* records the image of a city, perhaps Buenos Aires, celebrating with Argentine and Spanish flags, with a wide avenue drawn in perspective. There are many people, a kind of tram, and curious architectonic styles that border the avenue. The structures located on the first plane hold up the buildings along the side, and thus subvert the classical ideas of perspective; this is one of the characteristics that identifies Xul's use of space.

Xul illustrated an unusual building called *Pagoda* using classical perspective. An ink drawing with watercoloury planes in soft tonalities shows people in a building without a roof, limited by walls with openings and ladders that lead to different levels, and a tower from which small people contemplate the scene. The clothes of the people, the typologies used in the architecture of the walls, and the palm trees, suggest that the scene is from some Oriental country. With few representational elements Xul created an architectonic space worthy of The Arabian Nights.

*Jol* shows a building of several floors on a corner, located opposite a small square with a statue typical of many in Buenos Aires. The slightly broken façade gives a sense of movement to the building. Painted in vivid colours, it establishes visual rhythms between the openings. Strategically placed posters read: JOL, BIE, UNION UNION, CASA RONCA (hoarse house) and PEN. What did Xul intend by such a festive building? I sense that *Jol* depicts the head office of a union of writers and poets given that PEN, which appears on a poster is the acronym for the well-known International Association of Poets, Playwrights, Essayists, Editors and Novelists, founded in 1922. The other posters reaffirm this interpretation. The presence of a large radio aerial indicates that voices and messages from intellectuals and artists are sent and received from the building. If I am right, *Jol* would be the icon of the gestation of a new Argentine culture extending to the world. Both Borges and Xul shared this aim.

Xul developed the basic elements of his new architectonic language in this group of paintings carried out between 1925 and 1927. His advanced ideas contradicted the preaching of the Modern Movement so influential at the time in Buenos Aires.[117] This language reaffirmed Xul's independent aesthetic position and his spirit of freedom, which resisted all dogma by not accepting all the paradigms established by Functionalist architecture whose utopian universalism sometimes distanced itself from unavoidable local realities.

An examination of this group of paintings permits three main lines in Xul's architectural thought to be discerned. The **first** was related to an anti-gravitational concept in building shapes which implied a reconsideration of the concepts of structural rationalism as a key element in design (plates 89, 105 and 106). The **second** proposed new open architectonic spaces utilizing a system of wall-screens integrated into nature (plates 107 and 108). The **third** reflects on the treatment of façades and use of colour in buildings (plates 109 and 111).

In the **first group** Xul abandoned the structural purity on which the architectural language was based right up to the middle of the century, and that he himself had partially used in his first designs. In Xul's works it is surprising to find this systematic subversion of the principle of the stability of constructive features, anticipated in the chimneys of the houses in *Dos rúas* and in the structures that support the lights in *Teatro*.

The architectonic features used in *Puerto Azul* are simple but subject first to the action of an energy field that slightly dislocates them, and breaks the order of visible appearances. These dislocations, like those undergone by the crystalline structures of metals, are not arbitrary because they obey the laws of physics which limit the infinite possibilities of movement, or, in engineering terminology, the system's degrees of freedom. To maintain their equilibrium, at a second stage, the elements support themselves subtly along the edges. This is impossible from the static point of view without further structural elements like struts and props as suggested by the Russian Constructivist architects in their early designs and currently put into practice by the Spanish architect and engineer Santiago Calatrava. Why shouldn't new energy fields be able to defeat gravity?

Behind these images, and evident in the context of these architectures, lies the imaginary existence of other fields of force and energies that seek to change the real world. Xul had already

117. For a thorough analysis of this theme see Katya García-Antón and Christopher Green, with Dawn Ades, *The Architectures of Alejandro Xul Solar* in *Xul Solar: the Architectures*, Courtauld Institute Galleries: London, 1994.

Figure 36. Alexander Rodchenko
Variant of a Drawing for a Newsstand, c. 1919

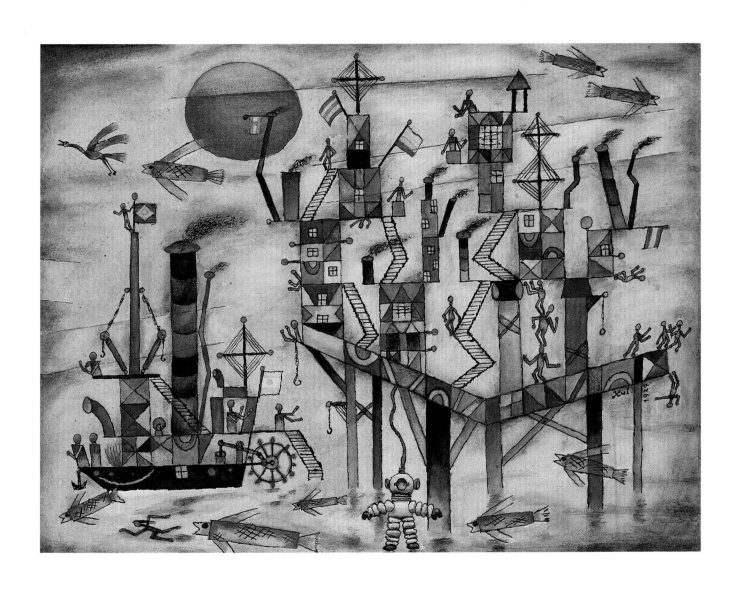

105. *Puerto azul* (*Blue Harbour*), 1927
Watercolour on paper, 28 x 37 cm
Museo Xul Solar

disarticulated planar forms in his Expressionist-Plasticist paintings, as seen in his subtle way of registering movement in the dislocated body of the serpent-ship in plate 47.

In *Palacio Almi* (*Almi's Palace*, plate 112) the palace walls are light advertising boards held up by posts which, though unstable, do not threaten the stability of the whole. These slightly skewed walls sometimes recall the wooden and parchment partitions in Japanese houses. Others have the texture of rocks, as in *San Monte lejos* (*San Monte Far-off*, plate 128) and *Bordes del San Monte* (*Edges of San Monte*, plate 127).

Characters raised on unsafe cylinders do not seem bothered with keeping their balance [*Místicos* (*Mystics*), plate 145]. They are squatting, standing on one leg, or kneeling. Only the practice of meditation could generate an energy that lasts through time and transforms that precarious stability into permanent balance. Xul's images insist on this possibility.

We should not be surprised by the affinity existing between this first line of Xul's architectonic thinking and the ideas and designs of Russian Constructivists like Alexander Rodchenko (figure 36) and Alexander Vesnin, developed between 1919 and 1921, and characterized by angular forms, dominated by diagonal features

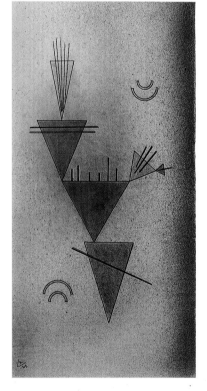

Figure 37. Paul Klee
Jerusalem, My Chief Joy, 1914 /161
Ink on paper, 19 x 18.3 cm
Private collection, Switzerland
© VG-BILD-KUNST, Bonn, 1994

Figure 38. Wasily Kandinsky
Little Game, June 1928
Watercolour and ink on paper, 34 x 17 cm
Solomon R. Guggenheim Museum,
New York

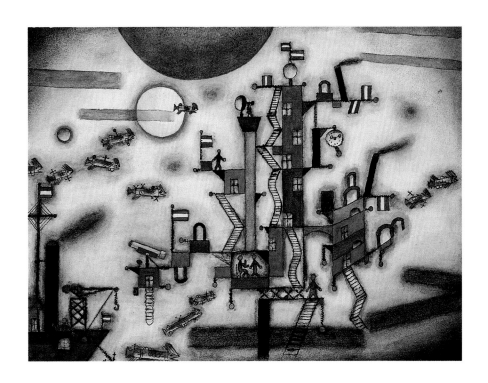

106. *Otro puerto* (*Another Harbour*), 1929
Ink and watercolour on paper, 27.5 x 37 cm
George and Marion Helft collection,
Buenos Aires

expressing a dynamic symbolism. In figures 31 and 32 scenes from Meyerhold's "The Magnanimous Cuckold" are shown with set designs by Liubov Popova in 1922, and from "The Man Who Was Thursday", designed a year later by Alexander Vesnin and George Yakulov. Early Constructivism, as much as Xul's Expressionism-Plasticism shared a dynamic use of geometric elements and rejected the concepts of order, harmony and stability. On the other hand, the pictorial space of *Teatro* was characterized by the deceitful incoherence of its perspective, and by the way it used the energy of forms which gave it that peculiar day-dreamy quality absent in the works of the Russian artists who in 1922 abandoned that dynamic syntax in order to underline the functionality of the new forms.[118]

It is worth recalling that Klee (figure 37) and later Kandinsky (figure 38) had designed architectures or shapes that were organized in unstable conditions, or were indifferent to balance, constructing delicate, utopian worlds of dream and poetry. It would be illusory to think that these shapes could remain in equilibrium for a long time, for the slightest jolt would disturb the balance and allow the system to collapse. Xul's language was different, and revealed his explicit desire to transgress the classical laws of mechanics, despite designs that seemed so solid and construable.

Xul's ideas could be related to the so-called concept of "Deconstructive Architecture" described by Mark Wigley:

118. S. M. Khan-Magomedov, *Alexandr Vesnin and Russian Constructivism*, Rizzoli: New York, 1986, p. 148.

*Deconstruction gains all its force by challenging the very values of harmony, unity and stability, and proposing instead a different view of structure: the view that the flaws are intrinsic to the structure. They cannot be removed without destroying it; they are, indeed, structural.*[119]

This definition may also be applied to Xul's works.

In the **second group** there are walls perforated by openings and placed on a polygonal base. They contain spaces that open to the sky, with a system of ladders to reach different levels, as in *Pagoda*, and in later paintings like *Muros biombos* (*Wall Screens*, plate 168) and in a series of architectonic drawings carried out in 1955.[120] This original language integrated architectonic spaces with nature and landscape, appropriate for mystical and spiritual purposes. They are limited solely by the ground, and by vertical planes that are prolonged to the sky or to infinity. This subverts the volumetric structuring of Functionalist architecture.

The treatment of the perimeter walls of Frank O. Gehry's house in Santa Monica, corresponds to a similar aesthetic concern. The observation post in Emilio Ambasz's design for the House of Spiritual Retreat in Córdoba, Spain, is mounted on the upper external part of a gigantic dihedron which is reached by two staircases located in its inside, as in Xul's example, and that appear to lead nowhere (figures 39 and 40). This corresponds in concept and mystical content to the ideas of open spaces advanced by Xul.

In the **third group** of architectures, Xul introduced the use of colour as one of the basic features that break the regularity of the façade's wall, and give it a rhythm and harmony that were reclaimed by Ferdinand Avenarius:

119. Mark Wigley, *Deconstructivist Architecture*, Museum of Modern Art: New York, 1988, p. 11.

120. These works were first exhibited at the Courtauld Institute Galleries, London, from the 5th January to the 27th February 1994.

Figures 39 and 40. Emilio Ambasz House for Spiritual Retreat, Córdoba

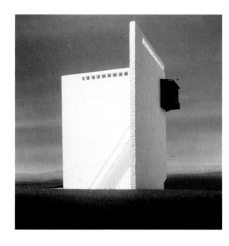
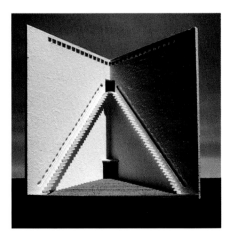

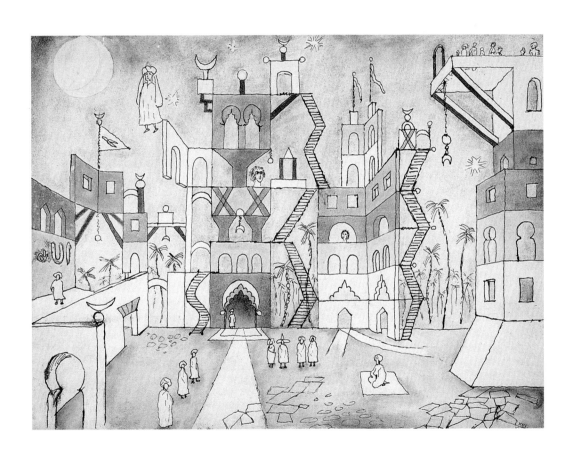

107. *Pagoda*, 1925
Ink and watercolour on paper, 28 x 37 cm
Private collection,
courtesy Rachel Adler Gallery

*Why do we not we paint our houses with colour? There is no simpler or cheaper way to make a plain building more welcoming, delightful, and even truly beautiful than a well-chosen coat of paint. It is far better to colour the entire outside wall rather than decorate it with such things as coloured relief or strapwork, or with figurative decoration... We shall repeat the call for coloured houses until it is heard.*[121]

This appeal was put into practice by Bruno Taut in his design for the garden city of Falkenberg. Xul shared the same concern as seen in *Jol* and *Bau* (*Building*, plate 109), and he added features with gentle rhythms to attain a visual balance that was in keeping with the needs of the inhabitants in the buildings, especially if these were collective, or obeyed repeated typologies.

*Bau* shows a house with three floors following a symmetrical axis. On the flat roof there is a chimney, the watertank with its metal ladder for access to cleaning, and what is needed for lighting. By its architectural plan, it is one of the typical single family houses that would be built in Buenos Aires from the 1920s on. The repetition of trapezoidal (key-stones) and rectangular shapes on the façade suggests an early application of prefabricated materials painted in Xul's range of colours. Because of its assessment of the wall as a vital constructional element, and also for its metaphysical connection with men and women from all cultures, *Bau* can be interpreted as the artist's subtle alternative to the white Functionalist houses that Modernist Argentine architects of the time were designing.

The use of the figure of the serpent and the woman as design features form part of Xul's visual play. I agree with García-Anton et. al. that the repetitive aspects of the constructional forms in *Bau* are

*highly conducive to connotative readings: there is more than a hint of that metonymical use of instantly recognizable architectural features within an aesthetic of bricolage, especially to be found more recently in the work of Michael Graves from the mid-seventies onwards,*[122]

amongst which I would point to the Plocek Residence (Warren, New Jersey) (figure 41) and the Walt Disney World Swan Hotel (Florida) (figure 42).

121. Ferdinand Avenarius, *Farbige Haüser*, Der Kunstwerk, XIII, n. 13, 1900, pp. 37-38, taken from Iain B. White, *Bruno Taut ...*, op. cit., p. 31.

122. K. García-Antón et al., *The Architectures of ...*, op. cit., p. 32.

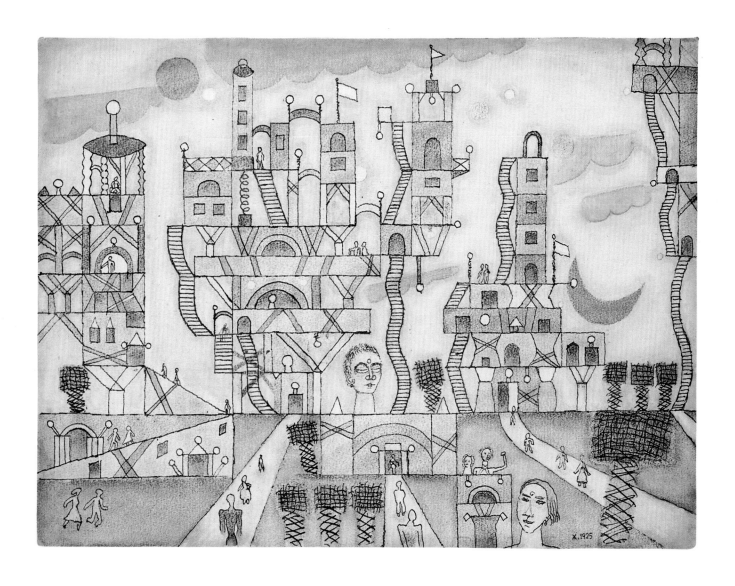

**108.** *Doce escaleras (Twelve ladders),* 1925
Ink and watercolour on paper, 27.5 x 37 cm
Galería Rubbers, Buenos Aires

Xul would apply this scheme to his buildings with façades and inscriptions, to his designs of buildings and cities constructed with pre-moulded elements [*Proyecto fachada para ciudá* (*Façade Project for City*, plate 155)], to his *Pan-tree* (*Universal Tree*, plate 147), and finally to his designs for façades on the picturesque Paraná river delta (Tigre), shown in plates 161 to 164.

From this moment, Xul had specified in Buenos Aires an architecture fit for his ambitions which were to integrate man, nature and the cosmos. He satisfied aims shared with German Expressionists like Adolf Behne. Later, he would add to this work after painfully meditating on the tragedy set off by the Second World War, another vision from the invisible aspects of things, as seen in such emblematic paintings as *Fiordo* (*Fiord*, plate 130) and *Valle Hondo* (*Deep Valley*, plate 131).

Figure 41. Michael Graves, 1982
Plocek Residence, Warren, New Jersey

Figure 42. Michael Graves, 1987
Walt Disney World Swan Hotel, Florida

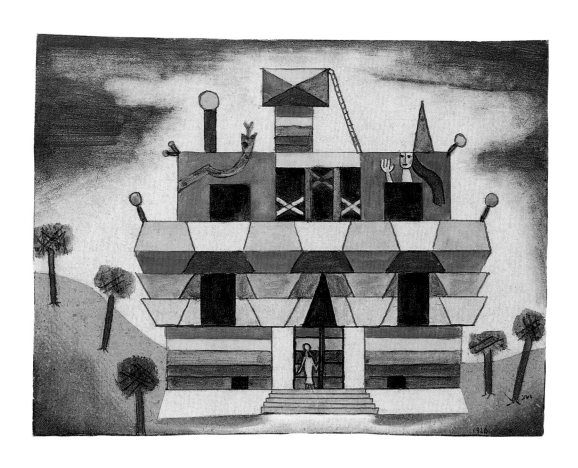

**109.** *Bau (Building)*, 1926
Watercolour on paper, 15.6 x 20.6 cm
Private collection, Buenos Aires

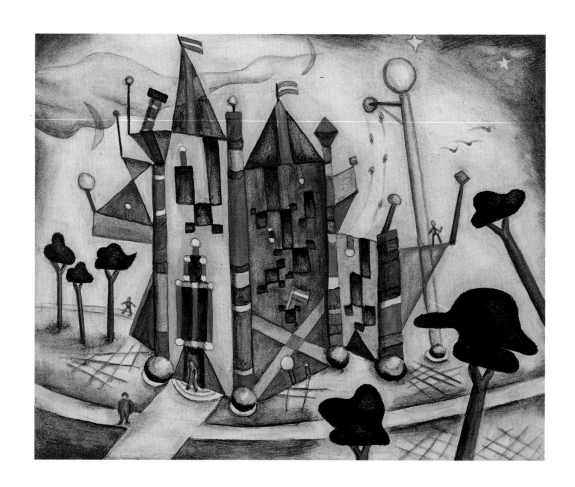

110. *Carpa festi* (*Tent Festival*), 1927
Watercolour on paper, 23.5 x 29 cm
Private collection, New York
Courtesy Rachel Adler Gallery

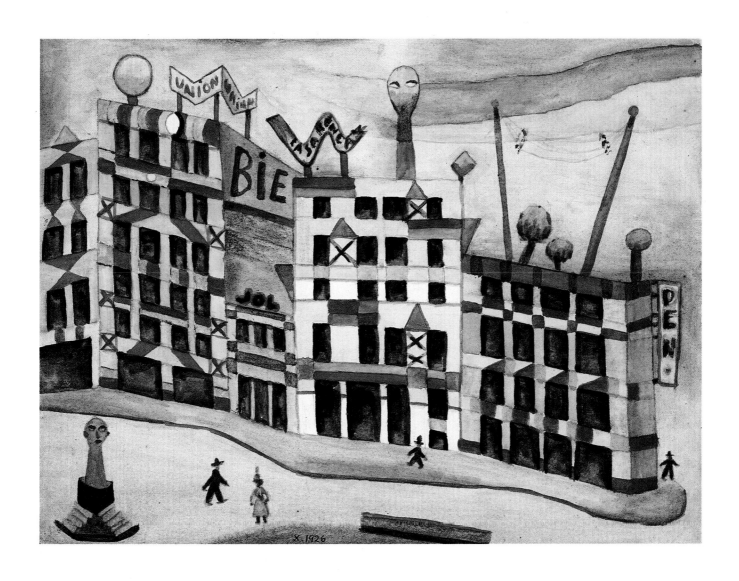

111. *Jol (Hall)*, 1926
Watercolour on paper, 22.5 x 30 cm
Private collection,
courtesy Rachel Adler Gallery

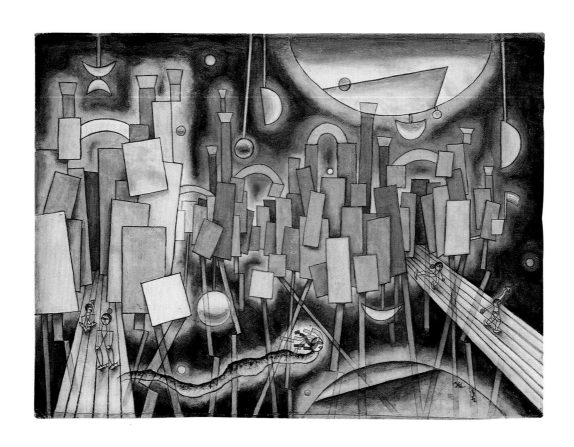

112. *Palacio almi (Almi's Palace)*, 1932
Watercolour on paper, 40 x 55 cm
Museo Xul Solar

# 4. Xul Solar's Universe

The 1920s had begun promisingly, but ended in September 1930 with the overthrow of President Yrigoyen by a military coup. This change in Argentine society started a process whose political, social and economic consequences would last for almost half a century.

If that decade had signalled an expansion of national culture, in the 1930s, known as the *infamous decade*, the conditions reverted and the country entered a period of darkness. The world economic crisis also affected Argentina, and all South American culture was affected by the consolidation of the totalitarian regimes in Europe, by the upsurge of racism, by the polarization of politics, and by fraud. This led to an increasing politicization of Argentine culture that spoilt part of what had been achieved.

To understand how a large section of Argentine society perceived Xul Solar's world view it is useful to turn to Roberto Arlt, an Argentine writer whose work merges realism with hallucinatory visions, social concerns and psychological fragmentation. Arlt knew about occultism and other beliefs prevalent in the cultural "underground" in Buenos Aires, and had dealt with these topics in his novels.[123] The following key-words occur in his work: astrologer,[124] mystic, inventor, visions, day-dreams, delirium, anguish, secret society, power, technology and madness. Couldn't the isolation that Xul suffered from this decade be linked to a typical Argentine tendency to pigeon-hole him as one of the feared characters from Arlt's world? It is also possible to assert, following an argument similar to those used by Macedonio Fernández, that these circumstances may have led to Xul's self-marginalization because it was imposed by the milieu, and he found no particular reason to contradict it.

123. See *El juguete rabioso*, *Los siete locos* (translated into English as *The Seven Madmen* by Naomi Lindstrom, Godine: Boston, 1984), *Los lanzallamas* in *Obras completas*, Carlos Lohlé: Buenos Aires, 1981.

124. A few years later Leopoldo Marechal personified Xul Solar as the astrologer Schulze in his novel *Adán Buenosayres*, Sudamericana: Buenos Aires, 1948, that chronicled the 1920s, and dedicated to his *Martinfierrista* avant-garde friends.

## Imaginary Countries

The brusque change in Argentine political and cultural life also had an effect on Xul's painting. From 1931 on he began to paint a new

series of visions. These are his **imaginary countries**, another face of the actual, mean and arbitrary country. In these countries -where Xul placed his architecture- it is easy to share dreams and illusions, and to create new spaces for games, knowledge and meditation. They are larger paintings, in tempera and watercolour on mounted, or glued boards; a refined technique that Xul mastered.

*País(Country*, plate 113) is one of the first works of this period. The architectonic structure of this painting is complex, and he used new constructive features. The entrance into this strange world is through three portals, flanked by four pillars made with rectangular shapes (wall-screens) that are slightly skewed to give a sense of volume. The pillars are held up by four slanting lines that also act as supports that lend the image the characteristic sense of space that appears in Xul's work. The three portals are crowned with a lintel, an arch, and a pediment on which an Argentine, a Spanish and three further flags flutter. Some of the walls are transformed into strange beings. A doubting visitor is faced with a mystery, while an articulated, mythological serpent reappears on the scene and hurls its eggs opposite the head of another person in the foreground. Where is this country of ambiguities and reveries?

Four palaces decked with flags make up *País celestial* (*Celestial Country*, plate 120), and are built on pyramids while strange beings descend stairways towards the main patio where the Argentine flag flutters. A serpent-goddess crosses in front of these bizarre tubular characters with shining haloes who watch over the scene. The slightly skewed walls, similar to those in *País*, suggest the presence of powerful forces that hold everything in balance, illumined by curious moons that hang from the sky.

The ambiguity between the architecture illuminated by the ever-present moons that constitute the basic landscape and the transparent paths and pyramids superimposed on them, with a counterpoint of warm and cold tones, as in his painting *Paisaje* (*Landscape*, plate 118), suggests a poetic space where all geometries and all orders are possible. Like the great Khan's atlas, *it reveals the shape of cities that as yet possess no shape or name.*[125]

In these paintings Xul used a new technique. He first sketched the shapes with pencil, as he did with the wall-screens, and then made them stand out with shading. The watercolour was applied in layers in parallel brush strokes. With this play of transparencies and adequate illumination he was able to define magical and surreal spaces. Once again, dreams and architectures went hand in hand in Xul's world.

125. Italo Calvino, *Las ciudades invisibles*, Ediciones Minotauro: Barcelona, 1983, p. 150 (*Invisible Cities*, translated by William Weaver, Secker and Warburg: London, 1974.)

148

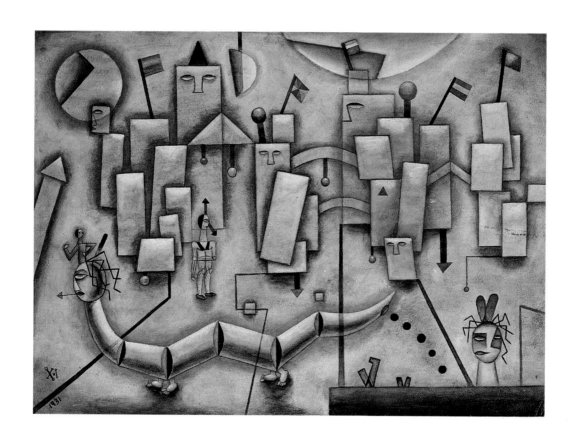

**113.** *País (Country),* 1931
Watercolour on paper mounted on board,
40 x 56 cm
Private collection, New York
Courtesy Rachel Adler Gallery

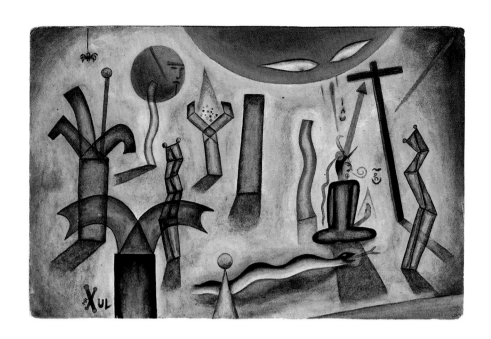

114. *Boske y yogui (Wood and Yogi)*, 1931
Watercolour on paper, 32 x 47 cm
Private collection, New York
Courtesy Rachel Adler Gallery

These imaginary landscapes invite afterthoughts. Xul introduces us into a cosmogony of cities with towers and pyramids, with bridges and paths. They are early materializations of Italo Calvino's invented, invisible and dreamt cities that inspire sudden and unsuspected urges to travel to higher planes of consciousness.

There are various way of attaining these states. The first one is to enter a labyrinth whose centre a traveller may reach after a tangle of paths and forks. According to Marcel Brion:

*The journey is difficult and the harder and more difficult the obstacles, the more the adept is transformed and acquires a new self during this initiatory itinerary.*[126]

A second possibility to reach illumination is by deep meditation. Its a question of embarking on a journey into the inner self, as practised by yogis, and as Xul has painted in *Boske y yogui* (*Wood and Yogi*, plate 114), and in *Yogui* (*Yogi*, plate 115).

A third way of reaching this state of supreme illumination is via ascension, as in *Místicos*. As you rise up you attain higher spiritual levels, or stages of a purer consciousness, and slowly cast off material and mental attachments.

There are further possibilities. These mysterious palaces with their magical ladders could be interpreted as great centres for meditation. In his paintings Xul underlined that ascension was one of the means to attain liberation, and spiritual understanding.

126. Chevalier-Gheerbrant, op. cit., p. 556.

150

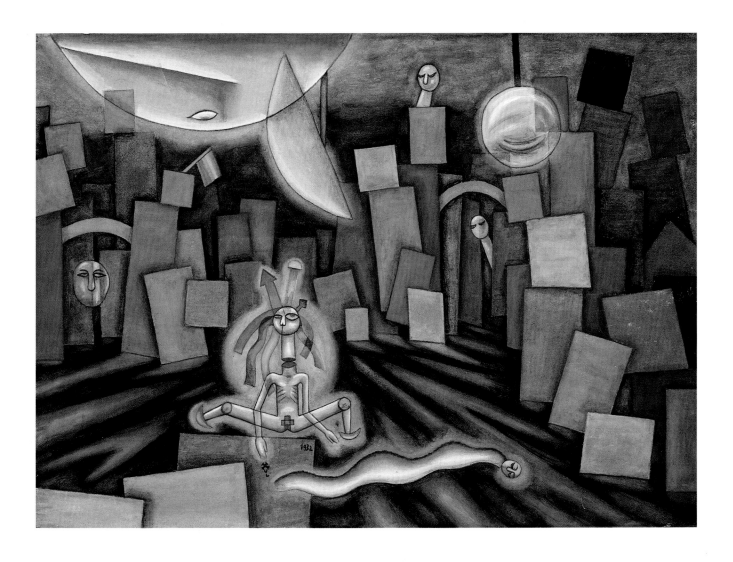

115. *Un yogui (A Yogi)*, 1932
Watercolour on paper, 40 x 55.5 cm
Museo Xul Solar

In Xul's world, ruled by its own order and logic, you reach this state of grace through an evolving process that establishes itself step by step, with partial reversals, but that quite clearly lead to a new state of consciousness that Xul symbolised in mountains and ladders. He had invented this in his first diptychs of 1918, and reaffirmed it in *Místicos*, and in his imaginary countries.

Xul continued with his task of studying religions, astrology, research into language, new methods of communication, developing his **pangame** (or astrological chess), his research into music and his theatre work with puppets. His house in Laprida street, where he had decided to build this world, was the focus of his activity.

You entered the house by climbing a steep staircase which was as magical as the ladders and staircases in his paintings. Inside there were two steep sections of thirteen steps separated by landings, and lighted by a skylight designed by Xul. On the second landing there

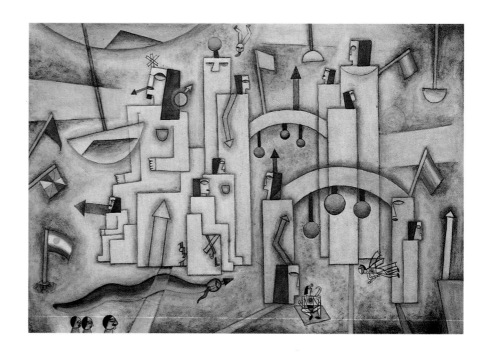

116. *Rey (King)*, 1931
Watercolour on paper, 38.1 x 54.8 cm
Private collection,
courtesy Rachel Adler Gallery

were two side doors. The one on the left led to a flat that was
rented out.[127] The one on the right led to his own flat, and one
enters to a central patio, closed off by a glass screen designed by
Xul. From there you reached the library, which connected with the
drawing room, dining room and bedroom. You climbed to the
studio, built by Xul in the attic, by another narrow and steep
wooden staircase that led off from the patio.

Xul gathered his friends for all-night sessions of meditation and
astrological study, and other spiritual matters, that would end at
dawn. Around 1936 he met Micaela Cadenas (Lita), and married
her years later. She went to his astrology classes and recalled:

> *At that time several astrologers often turned up, and they
> exchanged ideas about the different ways of interpreting or
> analysing the different phases and aspects, and what some
> authors thought about the different methods of interpretation.
> Sometimes they would analyse adverse aspects and how these
> corresponded with illnesses. Aided by Xul's great experience
> in the philosophical side of astrology, other topics included
> imagining the planets as great living beings with strong
> influences over humans, acting in accordance with the good
> or bad aspects of the horoscope of a given individual and
> dependent on the free will of each of his or her karma or
> spiritual experience, acquired by living this life.*[128]

127. Today this is an entrance to rooms of
the Museo Xul Solar.

128. Lita Xul Solar's handwritten notebook,
Museo Xul Solar, p. 30.

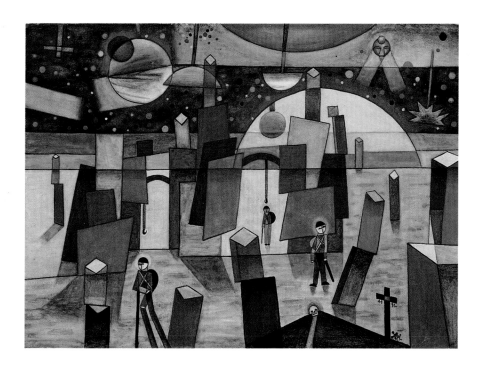

117. *Palacio bria (Bria Palace)*, 1932
Watercolour on paper mounted on board,
image: 40 x 56.7 cm; board: 41 x 56.7 cm
Museo Provincial de Bellas Artes, La Plata

129. See note 116.

130. There were artists like Norah Borges,
Domingo Candia, Raul Soldi, Alfredo
Guttero, Onofrio Pacenza, Juan Battle Planas,
Emilio Pettoruti, Carmelo Arden Quin, Sergio
de Castro, Tomás Maldonado, Joaquín
Torres García, the musician Juan Carlos Paz,
intellectuals like Alfredo Gonzalez Garaño,
Marcelo de Ridder, Julio Payró and Jorge
Romero Brest, and writers and poets like
Jorge Luis Borges, Ricardo Güiraldes,
Leopoldo Marechal, Adolfo Bioy Casares,
Victoria Ocampo, Ernesto Sábato, Luisa
Mercedes Levinson, Elvira de Alvear,
Macedonio Fernández, Adolfo de Obieta,
Pablo Rojas Paz, Ezequiel Martínez Estrada,
Jorge Calvetti, Raul Scalabrini Ortiz.

131. *Poema*, Imán, n. 1, Paris, 1931, p. 50.

132. *Apuntes de neocriollo (Notes on
neocriollo)*, Azul, n.2, November 1936, Azul,
p. 201.

133. Destiempo, Año I, n. 2, November 1936,
Buenos Aires, p. 4.

134. An unpublished text by Xul Solar in
Museo Xul Solar, already quoted from.

Anything to do with astrology made important sectors of Argentine society very suspicious. Xul had at that time already glimpsed its importance for psychological knowledge, and as a tool to characterize personalities.

When Xul met a new person, the first question was: *At what bornhour were you?* (**nacihora** in *neocriollo*, or time and date of birth)[129] so that he could make his/her chart. If you check the long list of astrological charts made by Xul in the archives of the Fundación Pan Klub you discover an outstanding group of artists,[130] intellectuals, writers and poets, many linked to the avant-garde magazine *Martín Fierro*. Noticeably absent were those who militated as traditional socialists, except for Leónidas Barletta, or fought for the left, as well as conservatives and right-wing nationalists.

Xul's concern to develop *neocriollo* did not cease. He published his poetic visions in this language in the magazines *Imán*[131]-edited in Paris by Elvira de Alvear- and in *Azul*.[132] He also published *Vision sobrel trilineo* in the second number of *Destiempo*,[133] a magazine edited by Borges and Bioy Casares in whose first number Xul published two vignettes. He also developed of his **panlengua**

*a universal language, based on numbers and logic, that seems to me to be the best solution to the problem after having studied 6 or 7 other known and imperfect propositions.*[134]

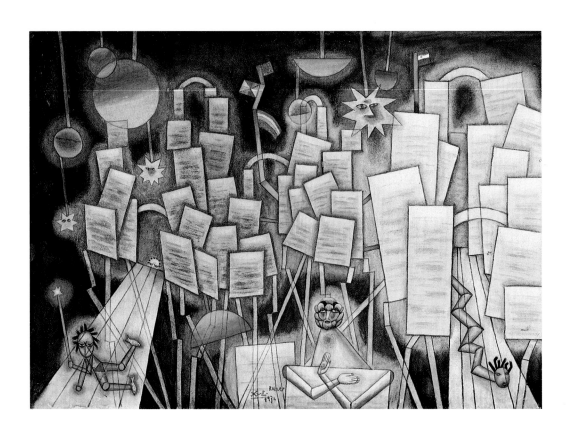

118. *Paisaje* (*Landscape*), 1932
Tempera on paper mounted on board,
39.7 x 56 cm
Private collection, Buenos Aires

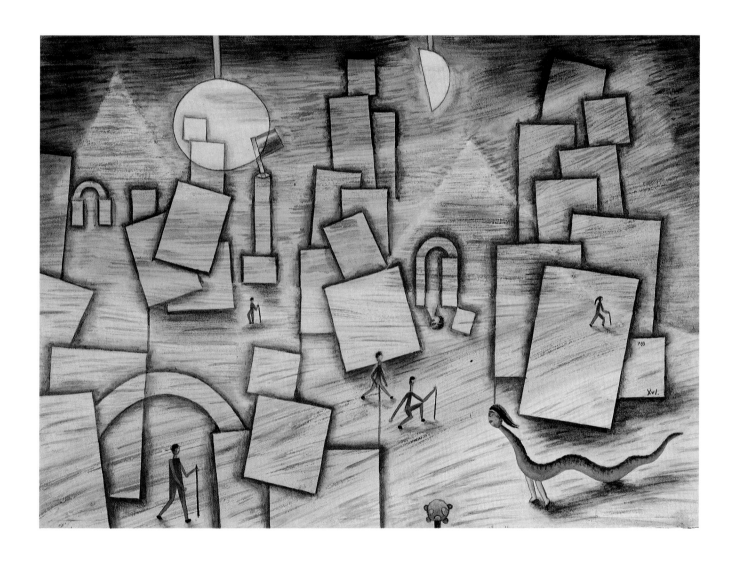

**119.** *Paisaje* (*Landscape*), 1933
Tempera on paper mounted on board,
40.6 x 56.3 cm
Private collection, Buenos Aires

Figure 43. Xul Solar, c. 1936
Vignette for *Destiempo* (Año I, n. 1, 1936)

135. For a study on his *neocriollo* see Naomi Lindstrom, *Xul Solar: Star-spangler of languages*, Review, 25/26, New York, p. 117 and A. Rubione, *Xul Solar: utopía y vanguardia*, Punto de Vista, Año X, n. 29, 1987, p. 37.

136. Cecilia Vicuña, *Palabrir*, Editorial Sudamericana: Buenos Aires, 1994.

137. See for example, María Esther Vázquez, *Borges, sus días y su tiempo*, Javier Vergara editor: Buenos Aires, 1984, pp. 82, 98, 102, 130, 210, 284; Jorge Luis Borges and Osvaldo Ferrari, *Diálogos*, Seix Barral: Barcelona, 1992, pp. 39, 191, 287, 290, 311; *Borges en la Escuela Freudiana de Buenos Aires*, Editorial Agalma: Buenos Aires, 1993, pp. 48, 49, 92.

Figure 44. Alejandro Xul Solar, August 1933
Text in his handwriting on Spanish and *graphisymbols*. Pencil and ink in a notebook. Museo Xul Solar

Xul was never short of reasons to insist on his *neocriollo*,[135] a curious hybrid of Spanish and Portuguese, with English and German words. In a notebook of August 1933 (figure 44) he outlined the three flaws that Spanish suffered as a language:

I) rhymes that are repeated and should be cut;
II) difficulty in combining words;
III) long, awkward words that should be replaced with English monosyllables.

A minor flaw was a dearth of many words to express ideas that were ready and clear in other languages like English or German.

A new generation of Latin American poets and artists have revindicated Xul's linguistic innovations like Jorge S. Perednik, an Argentine poet and editor of XUL, a poetry magazine in Buenos Aires which first appeared in 1980; Cecilia Vicuña, a Chilean poet and artist who includes a tribute to Xul in her forthcoming book[136] and Roberto Elía, Argentine artist who in a series of notebooks has created a symbiosis between images and words, with the following Cabbalistic text written on the 1st of December 1992 at 20.30:

AZUL
A ZUL
A XUL SOLAR
A XUL (LUX) SOLAR

## Xul and Borges

If the many references to Xul Solar in Borges's interviews of his last years[137] are taken into account, its obvious that his friendship with Xul had become almost legendary. Borges thought of him as an exceptional person, along with Rafael Cansinos-Asséns who initiated him into the literary life, and with Macedonio Fernández, his father's friend, and an intellectual in keeping with that cosmopolitan and contradictory Buenos Aires. Apart from known reciprocal contributions that included illustrations of books and vignettes in magazines, publication of texts, purchase of paintings, prologues for exhibition catalogues, and lectures, it is worth

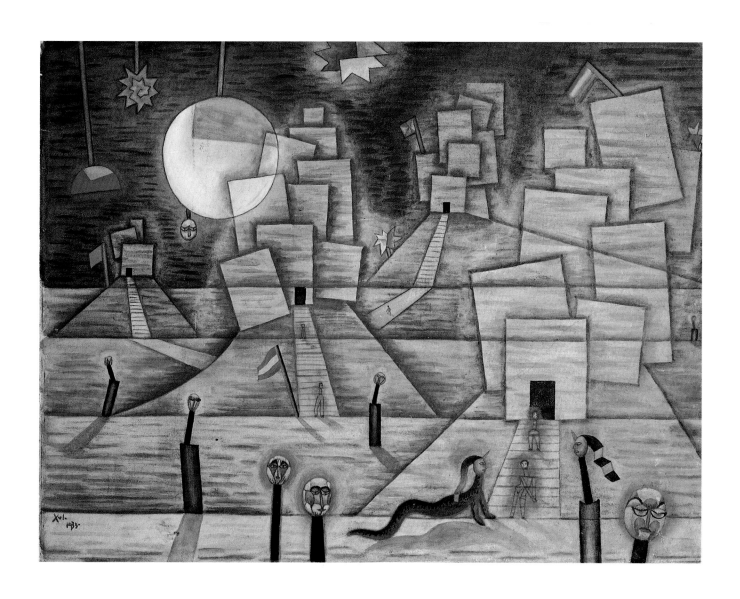

120. *Paisaje celestial*
(*Celestial Landscape*), 1933
Watercolour on paper mounted on board,
40.5 x 52.5 cm
Private collection, Buenos Aires

analysing how this warm human relationship was reflected at the creative level.

Both were in Europe at the same time,[138] and though they never met, their intellectual affinities began in that period. Borges studied German in Switzerland in order to study philosophy at the source. He read Schopenhauer and Nietzsche, and discovered the German Expressionist poets who exalted their feelings in images of tragic beauty, and immersed in an unending war, they demanded a new spiritual humanity. In Spain Borges published a review on *Die Aktion-Lyrik 1914-1916* about German Expressionist poetry in which he highlighted the poet Johannes R. Becher, who Xul was also reading. Years later when he referred to Expressionism Borges pointed out that it contained

> *all that was essential in later literature. I preferred it to Surrealism or to Dada, which seemed frivolous to me. Expressionism is more serious, and reflects serious concerns like magic, dreams, oriental religions and philosophies, and the longing for worldly brotherhood...*[139]

What Xul brought to Expressionism need not be repeated here, but this was their first link. There was also Swedenborg, whose world Xul painted, and whom Borges read.[140] Borges himself commented:

> *I talked a lot about Swedenborg with the Argentine painter and mystic Xul Solar. I was very friendly with Xul and went to his house on Laprida 1214 and we read Swedenborg, Blake, the German poets and the English poet Swinburne, and many others.*[141]

Figure 45. Alejandro Xul Solar, c. 1928. Drawings in pencil on loose sheet for the vignettes in J. L. Borges's book *El idioma de los argentinos* (*The Language of the Argentines*). The numbers (33), (40) and (44) correspond to the vignettes on pages 154, 92 and 121 of the book. On the other side of the paper there are further pencil drawings; three correspond to the remaining vignettes. Museo Xul Solar

138. Borges and his family lived in Switzerland between 1914 and 1919, and then in Majorca, Seville and Madrid. They returned to Buenos Aires in 1921. In 1923 they went back to Europe until the middle of 1924.

139. James Irby, *Entrevista con Borges*, Revista de la Universidad de México, vol. 16, n. 10, June 1962, in Emir Rodríguez Monegal, *Jorge Luis Borges. A Literary Biography*, E. P. Dutton: New York, 1978. (*Borges. Una biografía literaria*, Fondo de Cultura Económica: México, 1987, translated by H. Alsina Thevenet, p. 130.)

140. In Borges father's library there was a copy of Swedenborg's *Heaven and its Wonder and Hell*.

141. E. Swedenborg, *El cielo...* op. cit., p. 17.

Figure 46. J. L. Borges's dedication to Xul Solar in his book *El tamaño de mi esperanza*: *To Xul Solar, collaborator in these hopes, with gratitude Jorge Luis*. George and Marion Helft Collection, Buenos Aires

Figure 47. Xul Solar. Three vignettes for Borges's *El idioma de los argentinos*

142. See the postcard sent by Xul to his father in 1918 (figure 13).

143. Borges: *I have not known a more versatile or pleasurable library than his (Xul's). He let me know about Deussen's history of philosophy that does not begin like the others with Greece, but with India and China, and that devotes a chapter to Gilgamesh...* in *Obras completas, Parte 3ra.*, Emecé: Buenos Aires, 1989, p. 443, also published in *Atlas*, Sudamericana: Buenos Aires, 1984.

144. See *Martín Fierro*, 28th March 1927, p. 12.

145. Lita Xul Solar recalled one of these walks in the Barrio Sur with its pavements full with ditches, Handwritten notebook, op. cit., p. 24.

146. See Rodríguez Monegal, *Borges. Una biografía...* op. cit., p. 196.

147. In María Copani, *Ofrecer la utopía*, Clarín, Buenos Aires, 20th October 1988.

Both were fascinated by language problems. Borges and the other avant-garde poets called *Ultraists* planned to modify writing, for example, by replacing the letter **y** (and) with the vowel **i** (and), as manifested in *Prisma*, which Xul had been using since 1918.[142] Their meeting in Buenos Aires as part of the group around the magazine *Martín Fierro* must have been celebrated by both of them.

Xul, who belonged to the previous generation, represented for Borges the archetype of the artist and intellectual with a solid European and universal culture and was a master in the paradigms that Borges would later invent. Xul had a unique library[143] for Buenos Aires. Xul's mastery of languages, his linguistic researches into improving communication, his world vision, his knowledge about the Cabbala, his relevance as a painter, all make up a personality that would attract Borges to him.

Young Borges, who also mastered the main European languages, interested Xul thanks to the rigour of his logic, his love for the new poetry, his critical attitude to language and interest in developing the significant aspects of *criollismo*, or native Argentine art, with which Xul was identified in his paintings and sayings before the term acquired the sense that Borges gave it. Borges became the most eloquent person Xul talked with. This was the context in which mutual admiration and respect led to friendship.

Borges wrote the following half-rhyme:

*With Xul in the street called Mexico*
*We reformed the lexicon*[144]

which was published by Borges and his cousin Guillermo Juan, almost as a premonition. Thirty years later when Borges was appointed Director of the National Library located on Mexico street, Xul and his wife visited him and they walked together guided by Lita.[145]

Xul was not only a loyal friend, but his influence on Borges's work was considerable, even if not well studied, according to Rodríguez Monegal,[146] and confirmed by Perednik.[147] Borges's first explicit recognition was in his essay *El idioma infinito* (*The Infinite Language*) published in his book *El tamaño de mi esperanza* (*The Size of my Hope*) which ended: *I dedicate these notes to the great Xul Solar, for he is not free of guilt in their elaboration* and reaffirmed in Borges's dedication to Xul (figure 46).

The second reference appeared in a quotation by Borges from an imaginary text *Die Vernichtung der Rose. Nach dem arabischen*

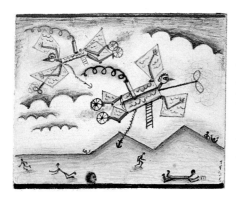

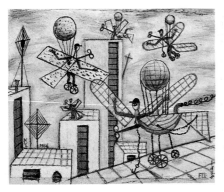

121. *Dos mestizos de avión y gente (Two Half-Breeds of Airplane and People)*, 1935
Coloured pencils on paper mounted on card
17.6 x 22.2 cm. Private collection

122. *Cuatro mestizos de avión y ciudad (Four Half-Breeds of Airplane and City)*, 1935
Coloured pencils on paper, 17.1 x 22.2 cm
Private collection, New York

148. Jorge Luis Borges, *Obras completas*, Emecé Editores: Buenos Aires, 1974, p. 324.
149. Borges, *Obras completas*, op. cit., p. 326.
150. Borges, *Obras completas*, op. cit., p. 327.
151. Borges told of this encounter with Xul: *I remember it was a hot day... in Buenos Aires in which you barely survive. I don't know how I reached his house at 1214 Laprida street, I climbed the steep staircase, on the right was the door. Xul was in and I asked him what he had been doing. Then I realized it was absurd asking someone what they might have done on such a day when to survive was enough. He said to me: "No, I didn't do anything". And then added, "Yes I founded twelve religions after eating. Twelve religions aftereats". These religions corresponded to the signs of the Zodiac. He believed, as in Japan for example, that all the religions are facets of one single truth (from Memories of my friend Xul Solar, op. cit.).*
152. Jorge Calvetti first alerted me to Xul Solar's interest in Crowley.

*Urtext uebertragen von Alexander Schulz. Leipzig, 1927* employed as an apocryphal source in the story *El tintorero enmascarado Hákim de Merv (The Masked Dyer Hakim de Merv)*.[148] This direct reference to Alex, as Xul was sometimes known, linked the plot to Xul's passion for religions and occultism.

The story narrates the history of the dyer Hákim who is transformed into a veiled prophet, hidden behind the white silk with which he covered himself after abandoning his brutal mask of a bull's head. Hákim fights his victorious battle in Nishapur with a prayer: *He studied meditation and peace; a harem of 114 blind women tried to placate the necessities of his divine body.*[149]

According to the heresies in *The Obscure Rose*, or *Hidden Rose* which are refuted in "The Annihilation of the Rose", the supposed book published by Schultz (Xul), Hákim has developed his cosmogony with a spectral God and his 999 conclaves with angels, authorities and thrones in the sky above and its symmetry in the sky below where:

> *Hákim's paradise and hell were no less desperate. "To those who deny the Word, to those who deny the Bejewelled Veil and the Face" (says a curse preserved in the Hidden Rose), "I promise you a marvellous Hell, for each one of you will reign over 999 empires of fire, and in each empire, 999 woods of fire, and in each wood, 999 towers of fire, and in each tower, 999 stories of fire, and in each story, 999 beds of fire, and in each bed he will be there and 999 shapes of fire (that will have your face and voice) and will torture you for ever".*[150]

It is tempting to link Xul's ability to invent new religions, which was well-known by Borges,[151] with Hákim's heresy. Further, in Europe Xul had met Aleister Crowley,[152] the English occult adept, who signed his letters with the number 666 -the Beast- and who corresponded with Xul. Although little known, this fact allows me to speculate that Xul commented on his contact with 666 to Borges. Now the quarrel about Hákim's origins can be solved. According to my hypothesis, Xul adduced the idea that religions can be invented to satisfy an individual's spiritual needs. The reference to Crowley led to the number 999, the Beast, the bull's mask, and to his sexual urges. More, one of Crowley's wives was called Rose. Behind Hákim's white veil was hidden a horrifying face, eaten by leprosy; behind the fantastic plot are hidden the keys to the story, which can be attributed to Xul.

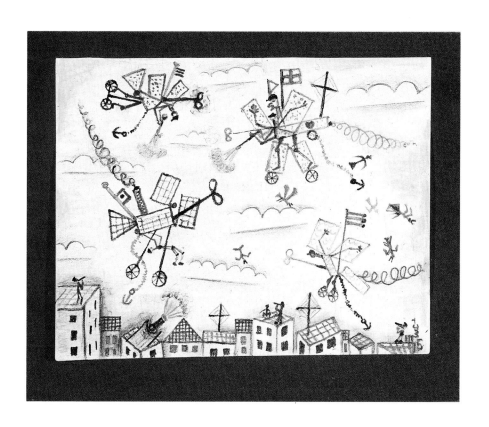

123. *Gente kin vuelras*
(*People Who Fly*), 1935
Coloured pencils on paper mounted on card,
image: 16.7 x 22 cm; card: 21.2 x 25.8 cm
Private collection, New York
Courtesy Rachel Adler Gallery

The following year Borges explained in *Las kenningar*, published in *Historia de la eternidad* (*History of Eternity*), that :

*So also, until our Xul-Solar's grammatical exhortations are not obeyed, lines like this from Rudyard Kipling:*

*"In the desert where the dung-fed camp-smoke curled"*

*or this other from Yeats:*

*"That dolphin-torn, that gong-tormented sea"*

*will be inimitable, and unthinkable in Spanish.*[153]

Further, Xul's influences have been noted by Rodríguez Monegal who wrote:

*Up to a certain point some of the strangest aspects of Pierre Menard's literary career may be due to Xul,*[154]

and mentions the language, a game of chess without castle's pawn

153. Borges, *Obras completas*, op. cit., p. 379.

154. Rodríguez Monegal, *Borges...*, op. cit., p. 196. He referred to *Pierre Menard, autor del Quijote* in *Ficciones*, Sur: Buenos Aires, 1944.

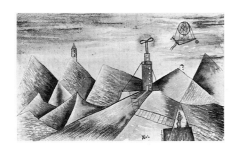

124. *Paisaje (Landscape)*, 1932
Pencil and ink on paper, 13 x 21.6 cm
Private collection, Buenos Aires

155. Borges, *Obras completas*, op. cit., p. 445.

156. Borges, *Obras completas*, op. cit., p. 435.

157. Isn't there a tongue-in-cheek reference to Alejandro Xul Solar's initials here?

158. Published in the magazine *Sur* in 1940. See Borges, *Obras completas*, op. cit., p. 441.

Figure 48. Georgi Krutikov, 1928. Flying City. Ink and pencil on photographic paper, 114.5 x 88 cm

which was *an innovation that Menard proposes, recommends, discusses and ends by rejecting,*[155] as well as interest in occult sciences, and let me add, a shared interest in symbolic logic.

In the story *Tlön, Uqbar, Orbis Tertius*, one of Borges's greatest contributions to fantastic literature, the explanation given by the author about Tlön's language is linked to a quotation in *neocriollo:*[156]

> *For example, there is no word that corresponds to the word "moon", but there is a verb in Spanish "lunecer" or "lunar". The moon rose above the river is said "hlör u fang axaxaxas*[157] *mlö", that is, in its order: above (upward) behind permanent-flow it mooned (Xul Solar translated tersely: upa tras perfluye lunó. "Upward, behind the onstreaming it mooned".)*

In the postscript to the story[158] there is a reference to Xul's flat in Laprida street where a compass, and the letters of the sphere that correspond to one of Tlön's alphabets, mysteriously appear. In the upper part of Xul's painting *Muros y escaleras* (*Walls and Ladders*, plate 132), dated 1944, there is a sector of a circle that looks like the face of a clock with signs like those of his *Grafías* (Ideographs) instead of numbers. Is this element another object belonging to Xul's hermetic world, a homage to his friend Borges's imagination, or further proof that Tlön exists in Buenos Aires?

## Visions and Landscapes

Between 1934 and 1942 Xul dedicated himself to his researches into visual communications, into his languages, and into astrology while he painted fundamental works. He dreamt of flying men, and cities with wings. The image of *Vuel Villa* (*Flying Villa*, plate 125) appeared. It was a popular theme at the time as seen in the Flash Gordon cartoons about space. This interest in flying cities was also shared by visionaries like the Russian architect Georgi Krutikov (figure 48). Wenzel Hablik had designed floating cities in 1908 and 1925, although they lacked the artistic beauty, the fairy-tale climate, and the degree of technological development of Xul's

**125.** *Vuel villa (Flying Villa)*, 1936
Watercolour on paper, 34 x 40 cm
Museo Xul Solar

**126.** *San Montes*, 1921
Watercolour on paper, 23 x 32 cm
Private collection

**127.** *Bordes del San Monte*
(*Edges of San Monte*), 1944
Tempera on paper mounted on board,
35 x 50 cm
Juan Alejo Soldati Collection, Buenos Aires

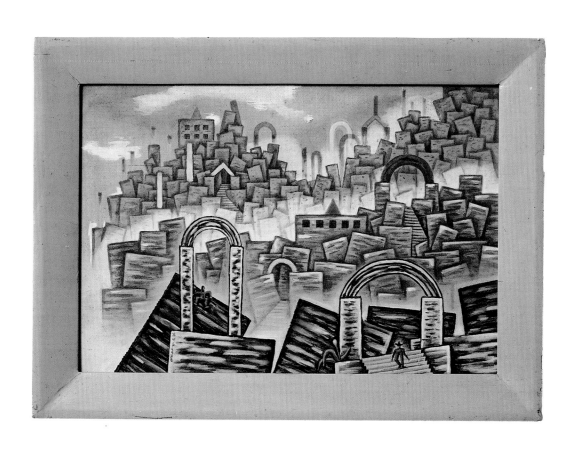

**128.** *San Monte lejos*
(*San Monte Far-Off*), 1938
Watercolour on paper mounted on board,
31.7 x 47 cm
Private collection, Buenos Aires

Figure 49. Xul Solar's astral chart

Figure 50. Xul Solar. Astral chart for the founding of the Pan Klub on the 27th of November 1939 at 12.25

design. Gyula Kosice took up this idea within the context of his *hydro-spatial city*.

Years later Xul wrote a still unpublished piece where he developed his idea of his town:

*Somebody in B. Aires had had for some time a rough design of a city, lets call it a town, that any day could appear on the horizon, and approach through the clouds, appear anywhere in the air where there had been nothing the day before, that is a town that floats, drifts and navigates through the air, a floating town, a Vuelvilla, that for brevity's sake we'll call V.V. To descend from the zenith, as it says in the Apocalypse, chapter XXI, 2: "And I John saw the holy city, new Jerusalem, coming down from God out of heaven, prepared as a bride adorned for her husband".*
*Its natural to want to see in this city a new publicity form that would reach nearly any place on earth, not excluding water and more quickly than slowly, though its hard to foresee where and how; but like a subsidiary subtown on wheels ought to accompany it, even if from time to time they're maybe too heavy to fly together, we will have to lower that almost. Better to consider it as a nucleus, a moving centre or capital of culture spread around, of various X branches, important and catalytic in unexpected perspectives.*

Xul also painted two magnificent landscapes: *San Monte lejos* (*San Monte Far-Off*, plate 128), and *Ciudá Lagui* (*The Lakeside City*, plate 129). In both of them Xul's use of juxtaposed spaces is evident. The vertical descent of the gardens occupy the forefront of the image, The multiple lines of the horizon can be seen behind the imposing towers. That way of setting up ladders with distorted foreshortenings that reach the sun, or the centre of his cosmology, like the rest, confers a multidimensional sense to *Ciudá Lagui*, never seen before in other urban landscapes. And pilgrims leave for new destinations from this magical city.

In *San Monte Lejos* a city built on hills makes its appearance. The light wall-screens of his *Palacios (Palaces)* have been transformed into ondulating breakwaters built of cyclopean walls. The perspective of the background, painted in a yellow between chestnut and ochre, and light touches of white, with its walls, arches, staircases and buildings, transports us to mystical cities lost in Tibet. Is this a new Shangri-la? The presence of elevated walls in

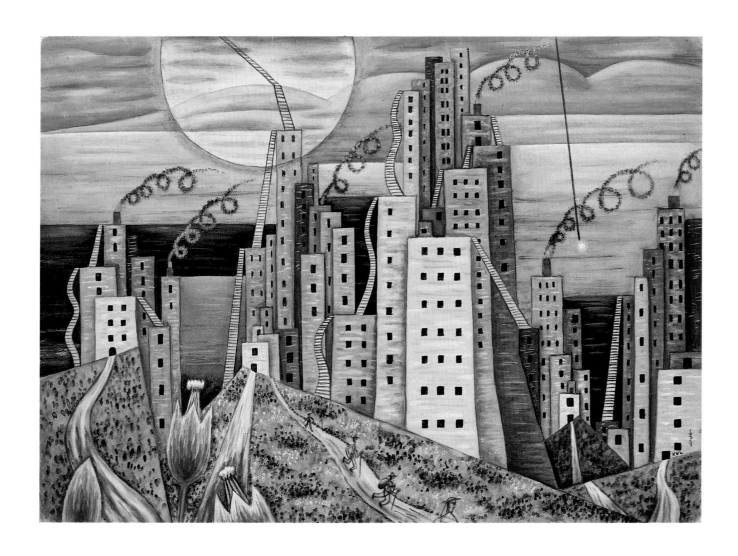

**129.** *Ciudad Lagui (Lakeside City)*, 1939
Watercolour on paper, 37.5 x 52 cm
Museo Xul Solar

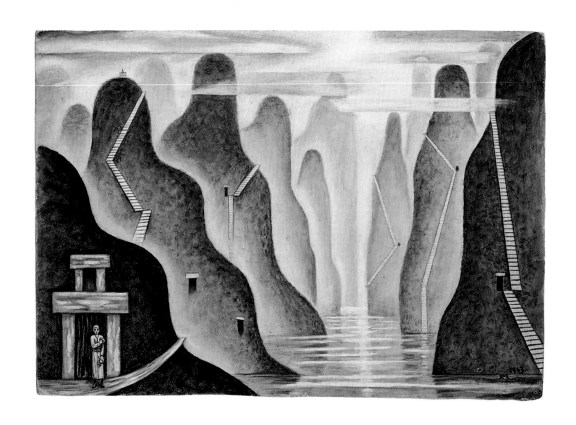

**130.** *Fiordo (Fiord)*, 1943
Tempera on paper mounted on board,
35 x 50 cm
Museo Xul Solar

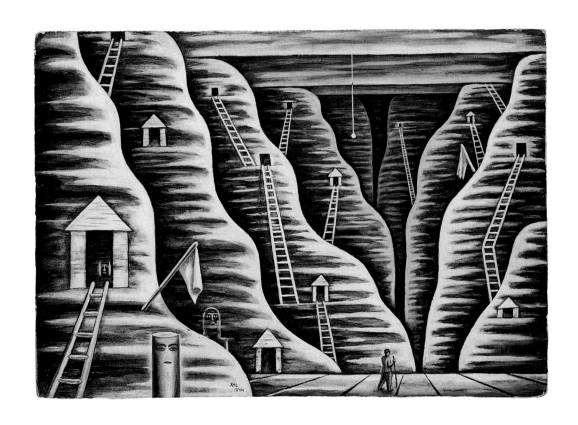

**131.** *Valle hondo (Deep Valley)*, 1944
Tempera on paper mounted on board,
35 x 50 cm
Private collection, Buenos Aires

159. In his lecture *Memories of my friend Xul Solar* Borges said: *Xul was the man most capable of friendship that I knew. I think I owe him the best hours of my life, reading and arguing, and above all, letting him teach me. I remember one of the first paychecks I received -some three hundred pesos-, which meant something. I thought: Xul has so many rich friends, and they haven't bought one painting. I am going to spend part of my first paycheck and buy a painting. I asked him the price of one of his works. He said: "One hundred pesos. I'll make a deal for a friend ... fifty pesos", and gave a larger work as a present.* Further, in his aunt Clorinda's notebook there's a note that confirms the operation.

Figure 51.
Cappadocian Landscape, Turkey

Figure 52
Guanlin Landscape, China

Figure 53. Ziggurat of the Moon Goddess Nanna in Ur (2200 BC)

the forefront of the painting, painted in colder tones, confirms that the way into this dreamy world is not free of obstacles. The link between this painting and *San Montes* (plate 126), painted in 1921 is obvious.

Xul exhibited individually again in Amigos del Arte in August 1940. Among the works shown were *Tlaloc* and *San Monte Lejos* bought by Borges,[159] and Xul's first *Grafías*.

Between 1943 and 1944 Xul painted a series of visions motivated by the critical situation in Europe. This momentary but very dangerous predominance of the Forces of Evil increased the possibilities of destroying contemporary society, and deeply affected him. These visions evoked Good and Evil, and man's condition on earth. They are extra-terrestrial worlds of dreams, whose geography is made up of strange mountains and bottomless pits where those frightening counter worlds that Borges invented in Hákim's cosmology might be glimpsed.

*Fiordo* (*Fiord*, plate 130) is the first of these works, and recalls the rocky landscapes of Guanlin on the Li river in China (figure 52). A little later Xul painted *Valle Hondo* (*Deep Valley*, plate 131) that seemed lifted from Cappadocia in Turkey (figure 51). Xul reached his highest point of artistic expressivity in these ascetic and disturbing paintings whose theme corresponded to that anguishing reality. The view in both works painted in black and white tempera is startling.

A detailed examination of these works shows their close connections. The image of *Valle Hondo* is the inverse of *Fiordo*. The mountain-fiords have turned into cavern-refuges. One is predominantly black, the other white. One has a surface of water, the other firm land. One has a gray and white sky with a luminosity spreading over the landscape, the other a hanging lamp illuminating the scene. One has a human-looking guard at the entrance, the

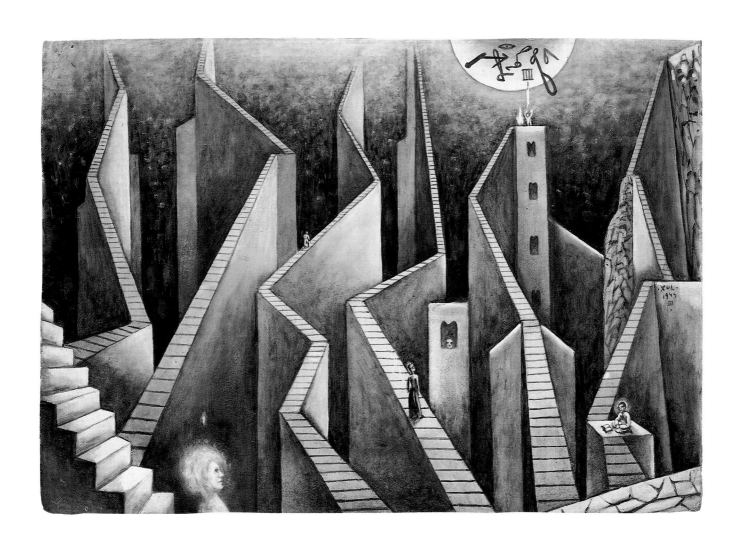

**132.** Muros y escaleras
(*Walls and Staircases*), 1944
Tempera on paper mounted on board,
35 x 50 cm
Galería Rubbers, Buenos Aires

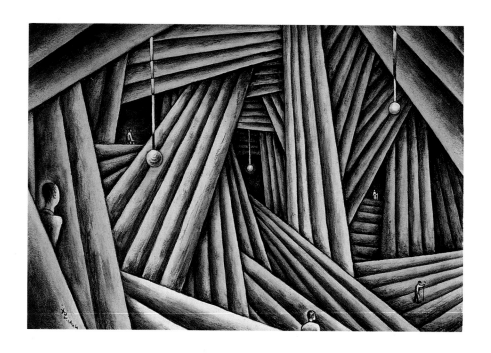

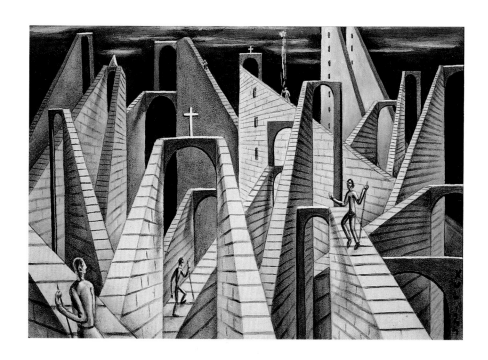

133. *Cavernas y troncos*
(*Caverns and Trunks*), 1944/III
Tempera on paper, 35 x 50 cm
Private collection, New York
Courtesy Rachel Adler Gallery

134. *Muros y escaleras*
(*Walls and Staircases*), 1944
Tempera on paper, 34 x 48.5 cm
George and Marion Helft collection,
Buenos Aires

**135.** *Ciudá y abismos*
(*City and Abysses*), 1946
Tempera on paper, 35 x 50 cm
Private collection, New York
Courtesy Rachel Adler Gallery

160. See Michel Foucault, *The Order of Things*, Vintage Books: New York, 1973, p. xvii. (I have applied this argument, developed by Foucault in analysing language, in the context of Xul's paintings.)

Figure 54. Xul Solar. Vignette published in Anales de Buenos Aires (Año II, n. 13, p. 24). Museo Xul Solar

Figure 55. Giovanni Battista Piranesi *Carceri* series. Etching, plate VII. Second edition (1761-1778)

other reveals strange transparent visions. One has a staircase cut out of rock, the other a ladder that can be folded away. One has the guard waiting for the arrival of a visitor, the other a pilgrim who seems to want to climb up from the deep valley of caves and fading light.

The path of spirituality is not free from dangers and ambushes, and from the other side the alluring forces of evil lie in wait. Evil must not be avoided. It is hard to distinguish in either of the two works where reality lies, and to which antagonistic worlds the staircases and ladders lead.

Again, ladders symbolize the ascent towards spirituality, but in these paintings there is the chance of descending into another world, or escaping from it. Without a ladder humanity would be forever condemned, without possibilities of attaining the light, or of descending to a world of shadows, nor of leaving it. That is why the ladder suggests the two possible meanings in these works by Xul. As symbol of ascension Xul had used it in his first diptychs, and in *Místicos*. Only Piranesi (figure 55) had achieved such a dramatic visual impact with the symbol of a staircase.

The ladder/staircase as symbol in the context of Xul's work attains the meaning of a **heterotopy**, or negative utopia, that *dissolves our myths, and sterilizes the lyricism*[160] of other paintings. The symbolic ambiguity of the ladders in these extraordinary paintings conveys sensations of tension and indefinable unease not yet seen in his work.

In *Bordes del San Monte* (*Edges of San Monte*, plate 127) a new cosmogonic version of the mountain in *San Monte lejos* appeared, and Xul takes us to its peaks. A complex network of steps and light ladders suggest a painful and difficult ascent to knowledge and transfiguration, whilst watchmen in trances meditate on solitary columns like resuscitated Parsees. In these works Xul used again a technique of parallel brush strokes. Subtly, he makes the forms stand out by highlighting the contours; it was the technique already employed in his paintings about imaginary countries.

Figure 56. Xul Solar. Vignette published in Anales de Buenos Aires (Año II, n. 13, p. 47). Museo Xul Solar

161. André Breton's first surrealist manifesto (*Manifiestos del surrealismo*, Ediciones Guadarrama: Madrid, 1969, p. 44).

Figure 57. Xul Solar, c. 1948-49. Automatic pencil drawings in notebook for the series of mystical landscapes. Museo Xul Solar

Narrow ramps or ladders crown slim walls, creating a feeling of vertigo for those who defy the precipices and yearn to ascend to absolute and eternal states, as in *Muros y Escaleras* (*Walls and Ladders*, plates 132 and 134), and evoke the myriad narrow ladders of the Sumerian ziggurats (figure 53).

Between 1948 and 1949 Xul carried out his series of **mystical landscapes**, numbering them according to the duodecimal system. The images rise up through superpositions of curved and straight lines in zigzags which define rhythmic visual fields and sectors that the artists then coloured. Hundreds of small sketches exist (figure 57), drawn in notebooks in which Xul constructed the base-landscape through automatic drawings (automatisms). On these hills, or sacred mountains, Xul placed his holy sites, like those colourful structures (*kioskos*) where invisible monks meditate (plates 136 to 139).

Once again Xul transports us, through magical associations, to an other-worldly Cappadocia where pilgrims ascend through stages towards knowledge, but this time to discover the dimensions of their inner being the ladders rise to the sky.

The use of unconscious mechanisms (automatisms) in these landscapes does not place Xul within surrealist orthodoxy. André Breton characterised Surrealism by its use of automatic writing manifested through a free association of words and images that rise up from the unconscious, and express

*the real functioning of thought. It is dictated by thought, without the regulating intervention of reason, alien to all aesthetic and moral considerations.*[161]

Although in these landscapes Xul based his method of painting on automatisms, his belonging to a spiritual world, his fascination with cosmic matters, with mysticism and hermetic thought, and his own optimistic vision of the role man and woman had to fulfil in this and

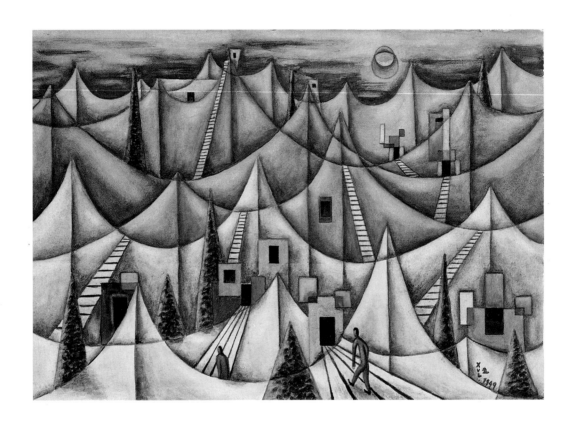

**136.** *Sierras* (*Mountains*), 1949/2
Tempera on paper mounted on board,
35 x 50 cm
Private collection, New York
Courtesy Rachel Adler Gallery

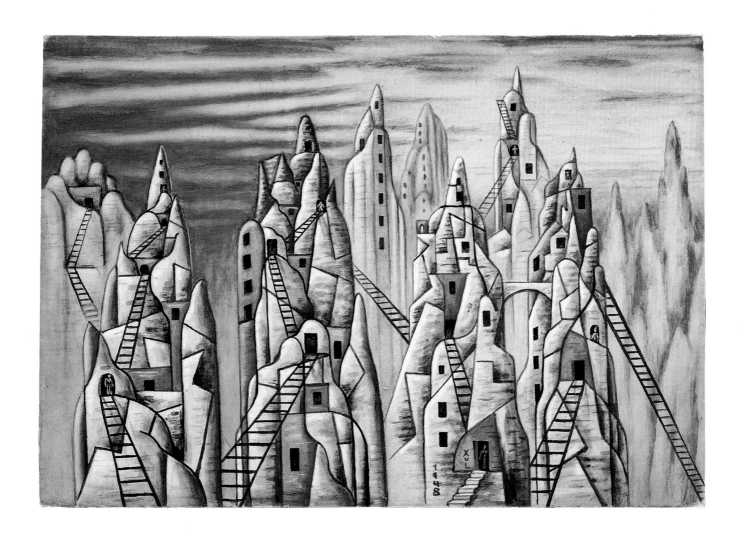

**137.** *Trogloditas (Troglodytes)*, 1948
Watercolour on paper mounted on board,
35 x 50 cm
John P. Axelrod Collection, Boston
Courtesy Rachel Adler Gallery

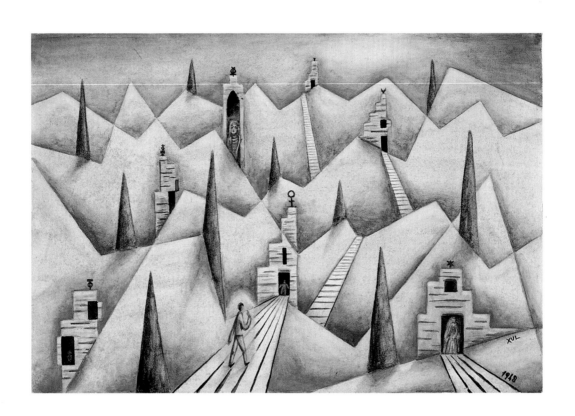

**138.** *Zigzag con kioskos*
(*Zizag with New-Stands*), 1948
Watercolour on paper mounted on board,
35 x 50 cm
Private collection,
courtesy Rachel Adler Gallery

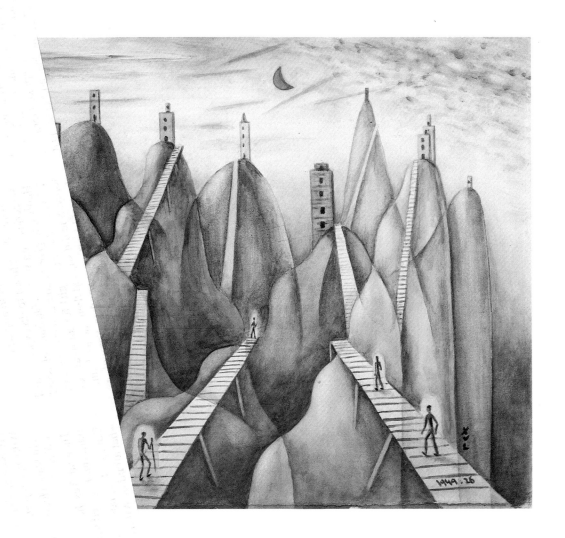

139. *Mo*
(*Mountai*
Watercolc
35 x 50 cn
Private coll
Courtesy Ra

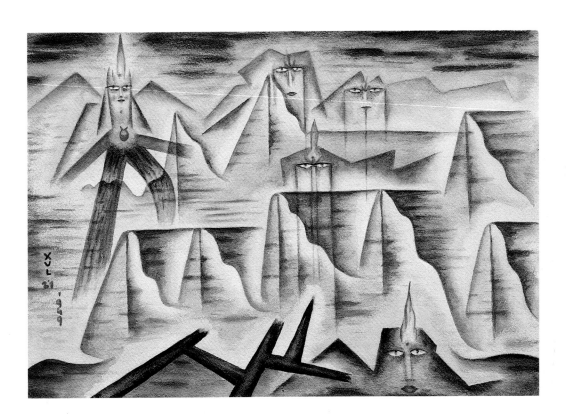

**140.** *Impromptu de Chopin*
(*Chopin's Impromptu*), 1949 /21
Watercolour on paper mounted on board,
35 x 50 cm
Private collection, Buenos Aires

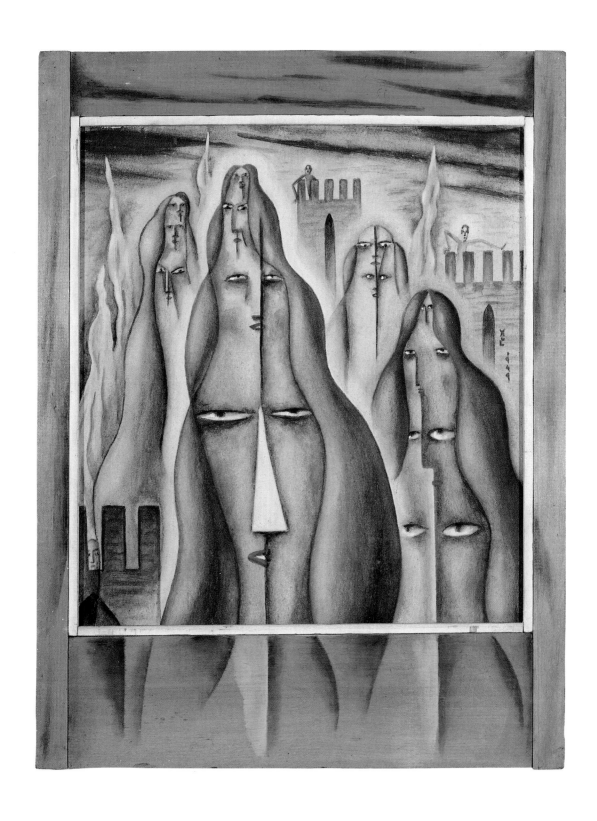

**141.** *Cuatro plurentes*
(*Four Multiple Entities*), 1949
Tempera on board and wood, 49.5 x 37.5 cm
Private collection, Buenos Aires

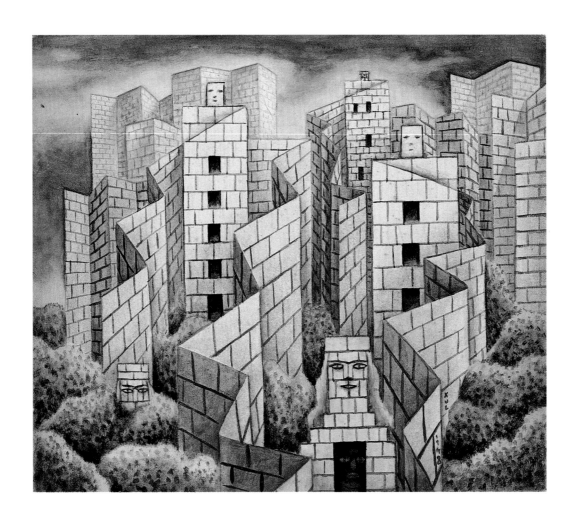

**142.** *Muros biombos (Walls Screens)*, 1948
Watercolour on paper, 34.5 x 40 cm
Museo Xul Solar

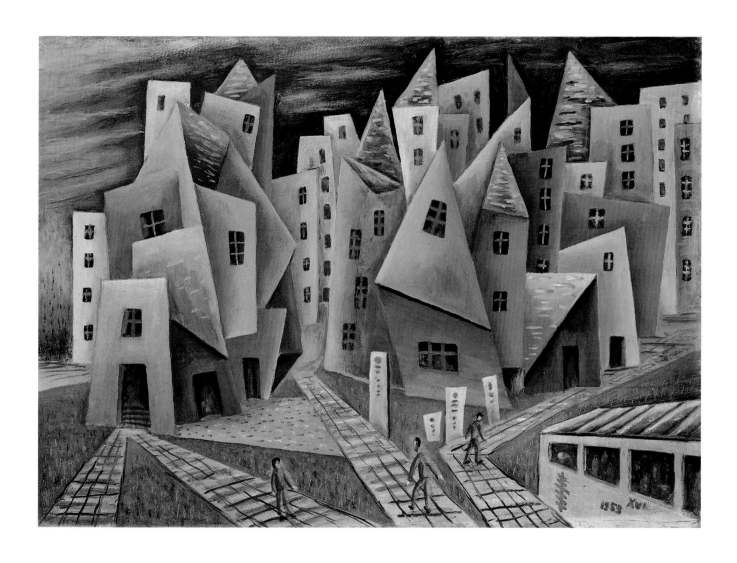

**143.** *Barrio (District)*, 1953
Tempera on paper, 40 x 56 cm
Museo Xul Solar

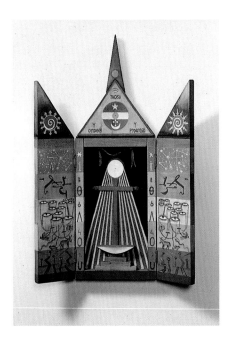

144. *Pan Altar Mundi*
Watercolour on wood, 65 x 46 cm
Museo Xul Solar

162. Lita Xul Solar's handwritten notebook,
p. 26.

Figure 58. Outline of the Cabbalistic Tree
with its ten "sefirot". Taken from Papus, *La
Cabbale, Tradition secrète de l'occident*,
Bibliothèque Chacornac: París, 1903.
Museo Xul Solar

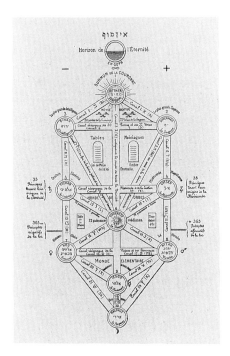

other worlds, implied an ethical, aesthetic and moral position that transcended that of the surrealists.

In these visions nature burst into brilliant colours, and these mountains turned into *Cuatro plurentes* (*Four Multiple Entities*, plate 141) or acquired musical rhythms as in *Impromptu de Chopin* (*Chopin's Impromptu*, plate 140). The use of frames prepared by Xul as an outer space for the images, reappeared in *Cuatro plurentes*, and this lightly painted wooden frame conveys a mysterious climate to the painting. Tempera, when applied with intense tones in which the colour of Swedenborg's angels recur, possesses a rich binding and texture that adds depth to the images.

This blooming of visions, colours and landscapes culminated in Xul's third one-man exhibition in July 1949 in the Samos gallery, with work from his latest period. In the prologue to Xul's first illustrated, 16 page catalogue, Borges wrote:

*A man versed in all the disciplines, curious about anything arcane, father of writings, of languages, of utopias, of mythologies, guest of hells and heavens, author of astrological chess, master of indulgent irony and generous in friendship, Xul Solar is one of the most surprising events of our time. There are minds that claim to have integrity, others show indiscriminate abundance; Xul Solar's copious inventiveness does not exclude honest rigour. His paintings document the world beyond the grave, the metaphysical world in which gods take on the shape of the imagination that dreams them. His passionate architecture, felicitous colours, the many circumstantial details, the labyrinths, the homunculi and angels unforgettably define this delicate and monumental art. Taste in our days hesitates between the merely pleasing lines, emotional transcription and realism in broad brush strokes. In an ambitious way that seeks to be modest Xul Solar renews the mystical painting of those who do not see with their actual eyes in the sacred company of Blake, Swedenborg, yogis and bards.*

According to Lita, when Xul Solar read this definitive text he got excited and said:

*I do not think that anyone in so few words could have said so much as Borges has and added: I do not merit, not merit, not deserve, not deserve, Saint thank you Borges.*[162]

# Hermetic Worlds

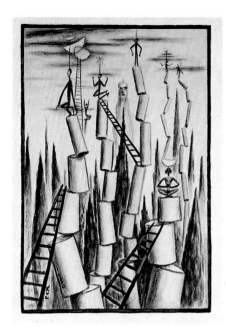

145. *Místicos (Mystics)*, 1950
Tempera on paper mounted on board,
45.5 x 30.5 cm
Private collection, Buenos Aires

Between 1951 and 1954 Xul found a way of using his painting as a medium to canalize his more esoteric visions, which can be related to his studying of the Cabbala,[163] astrology and religions that he combined together through his own creativity, his poetic imagination, and reasoning, seeking new religious systems more in keeping with his idea of universality.

Cabbala, as a means to attain the knowledge of God, the origin of the world, the diverse levels of being and the origin of evil, offered Xul Solar an almost infinite source of possibilities for re-elaboration. This vision of the world is represented by a symbolic structure called the "Tree of the Cabbala" or the "Tree of Life", formed by the ten *sefirot*, originally meaning numbers, that represent the divine emanations and attributes of God, and the absolute essence of being. The outline of the tree of the Cabbala can be seen in figure 58.

The passage from the realm of the absolute or absolute perfection to the material world is given in the Cabbala through conceptual thought, and creativity. This defines four worlds that are equally spread out. In the highest plane, which is the absolute plane, you can find the **crown** or **head** from which arise all the emanations, **wisdom** and **understanding**. In the second plane, the world of conception, of thought, and knowledge you can find **grace** (**love**), and **strength** (**judgement**) and both *sefirots* generate **beauty**. **Honour** (**glory**) and **victory** (**resistance**) are located on the third plane which is that of initiation and creation, and they generate the **foundation**. On the fourth plane, which is the earthly one, lies the **kingdom** (**royalty**), which reflects both the divine and absolute worlds as well as the lower world, the world of shadows. These ideas merely attempt to schematize this system of esoteric thought. Definitions vary according to the different interpretations of the "Zohar", the basic text for cabbalistic interpretations.

The ten *sefirot* are linked by twenty-two paths that correspond to the letters of the Hebrew alphabet. The different iconographic representations of the Tree of Life do not allow for literal readings, and only through an analysis of the sacred texts, and study of the doctrines, and meditations, can approximations to its meanings be accomplished.

Xul began with an atemporal symbolic scheme, usually represented by a man or by two or three columns, and transformed

163. The word Cabbala can be translated as the transmission of a tradition and is related to the esoteric Hebrew movement based on the interpretation of occult meanings in sacred texts. In the following analyses I have used Erich Bischoff's book *Die Elemente der Kabbalah*, Verlag Richard Schikowski: Berlin, republished in 1985. Xul Solar owned the first edition of this book, as he did of Papus, *La Cabbale. Tradition secrete de l'occident*, Bibliotheque Chacornac: Paris, 1903.

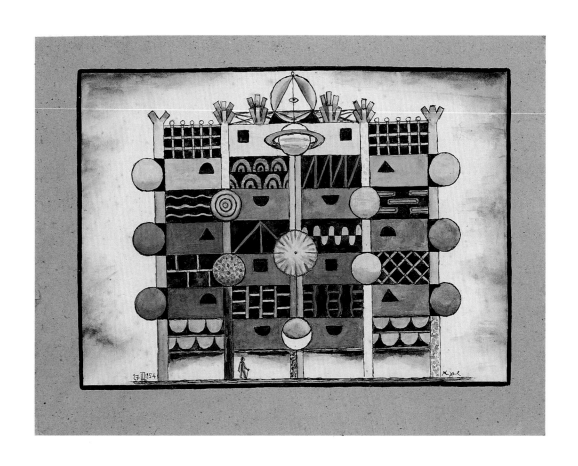

**146.** *Coecos fachada* [*Coecos (sic) façade*], 1953
Watercolour on paper mounted on card,
image: 24.2 x 34.4 cm; card: 31.8 x 41.6 cm
Private collection, Buenos Aires

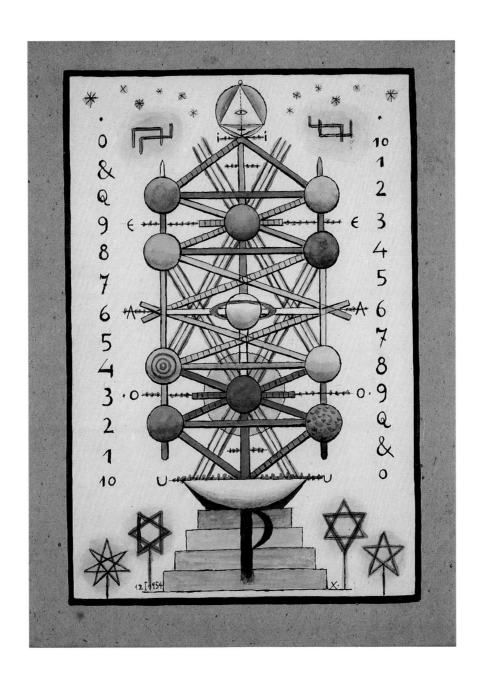

**147.** *Pan-tree (Universal Tree)*, 1954
Watercolour on paper mounted on card,
image: 35.5 x 24 cm; card: 42 x 32.3 cm
Museo de Arte Moderno, Buenos Aires

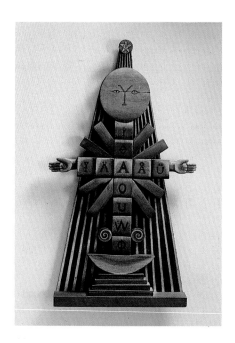

148. *Cruz* (*Cross*)
Watercolour on wood, 62 x 32.5 cm
Museo Xul Solar

164. In the representation of the tree of the Cabbala the left column is feminine, and the right column, masculine.

165. An ancient Tarot pack from Florence consisted of 97 cards, with 12 of them with signs from the Zodiac. Cf. Stuart R. Kaplan, *El Tarot*, Plaza de Janés: Barcelona, 1990, p. 40.

it into a physical structure: an architectonic form fixed on the ground. This is his *Pan-tree*, the **Universal Cabbalistic-astrological Tree** (plate 147), of which several versions exist. Thus the *tree* has transformed into a *Universal Temple*, and in this transformation from a mystical and ideal structure to a real one we once again come across the spirit of those first expressionist *Gesamtkunstwerken* (integrated works of art, plates 17 to 22).

Xul increased the number of *sefirots* to twelve in order to merge the concepts of Cabbala with his own astrological thinking. Although we do not have a concordance between the meaning of the planets incorporated by Xul and each *sefira*, we can note some affinities between **kingdom** and **Moon, foundation** and **Sun,** and **beauty** and **Saturn.**

The student ascends the tree of the Cabbala[164] slowly from earth towards the higher worlds, but not even the wisest can attain the highest levels. By proposing a new image as symbol of this suggestive mysticism, Xul perhaps had visualized new paths for spiritual growth, and more adequate ones for the actual human condition.

The façades of those buildings present harmonious designs and the ascent does not seem difficult, although even here it does not seem feasible to reach the crown, represented by a triangle enclosed in a circle with an eye that signifies the place from where all the emanations and infinity itself emerge.

In most of these paintings, colour follows a pre-established order. Xul chose white for the earthly kingdom, symbolised by the moon; red and yellow fire for the sun, and yellow, green and blue up to a violet shade for the highest level. These are the colours of decomposed light. Again **Xul** is **lux.**

Xul's fascination with esoteric matters can also be seen in a series of paintings based on the signs of the Zodiac and astrological portraits. In some of them esoteric and occult concerns prevail over the purely pictorial, and everything is more dense, opaque, with darkened backgrounds, so that the theme becomes hermetic. In others, Xul retains the transparency of his earlier paintings.

Possibly Xul's Tarot cards come from this period. He called them *Tarot con coecos astri* (Tarot with Astrological Correspondences),[165] and painted them by hand. This Tarot pack has 24 cards. The representations of the 12 cards (plate 150) that show the signs of the Zodiac, correspond to those used in his astrological painting (plate 149).

Each sign is linked to a number in the duodecimal system,

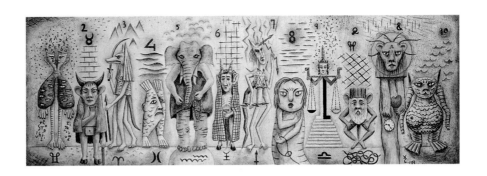

149. *Zodíaco (Zodiac)*, 1953
Watercolour on paper, 34 x 99 cm
Museo Xul Solar

beginning with Gemini, which is without a number, Taurus (2), Aries(3), Pisces (4), Aquarius (5), Capricorn (6) Sagittarius (7), Scorpio (8), Libra (9), Virgo (Q), Leo (&) and Cancer (10). The symbols Q, & and 10 of the duodecimal system represent the decimals 10,11 and 12 respectively. Several of the remaining images (plate 151), like *El Papa* (The Pope), *La rueda de la fortune* (The Wheel of Fortune), *El ahorcado* (The Hanged Man), *El mago* (The Magus), *La luna* (Moon), *El sol* (Sun), *El hermitaño* (The Hermit) and *La torre* (The Tower) answer to the symbolism of the great mysteries in the most known games. How Xul's cards relate to the traditional packs is not known.

Also from this period are Xul's works in wood like *Cruz* (*Cross*, plate 148) and *Pan Altar Mundi* (*Universal World Altar*, plate144), of a purely esoteric and ceremonial character, as well as a group of paintings on glass, a support used by naif artists in Baviera of the last century and later by Wasily Kandinsky.

## Pangame and other Inventions

One of the most original contributions of Xul's mind was his **Panchess** or **Pangame** (*Universal Game*), or **panjogo** (*Neocriollo Chess*), developed from the 1930s. Xul based it on chess, adding further elements from language, astrology and philosophy. In an unpublished text Xul offered some explanations for his game which reveals a true system within his artist's view of the world:

> *The motive and usefulness, that is what counts in this new game, is that it gathers together various means of expressions,*

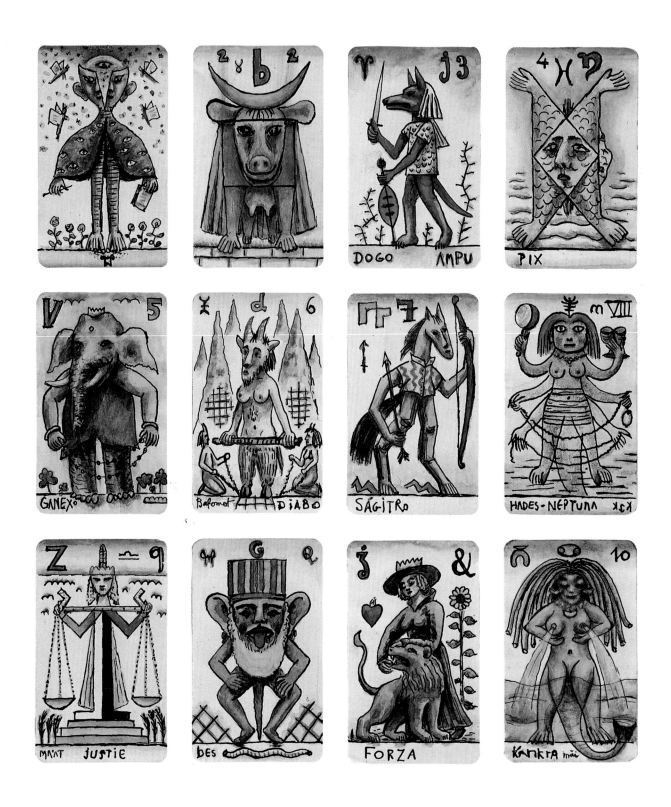

150. *12 cartas del Tarot*
(*Twelve Tarot Cards*)
Pencil and tempera on card
Measure of each card: 9.5 x 5.8 cm
Museo Xul Solar

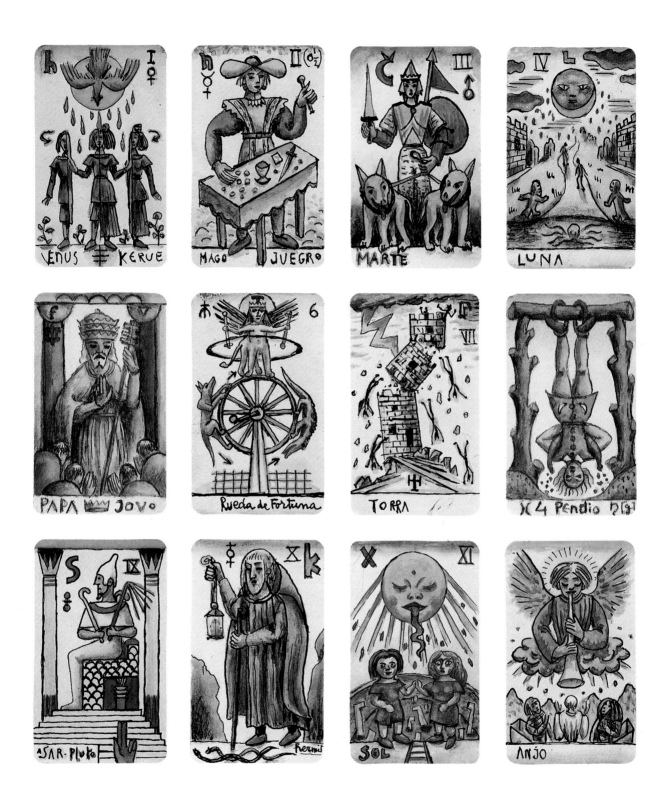

**151.** *12 cartas del Tarot*
(*Twelve Tarot Cards*)
Pencil and tempera on card
Measure of each card: 9.5 x 5.8 cm
Museo Xul Solar

Figure 59. Piano modified by Xul Solar in his flat. Museo Xul Solar

Figure 60. Puppets made by Xul Solar. From left to right: Taurus, Scorpio and Sagittarius

*that is, languages from various fields that correspond to each other on the same basis, which is the Zodiac, planets and the duodecimal system. This means there is coincidence between the phonetics of a language built on two polarities, the negative and positive, with a neutral middle term, and notes, chords and timbres of a free music, with the basic linear elements of abstract painting, which is also writing. The squares on the board, like degrees in a circle, coincide with the diurnal and nocturnal movement of the sky, with historical time, and its human drama expressed through the stars.*

*Each piece being characterized by a consonant (except for the pawns that equal numbers), means that any position on the board, marked by vowels or combinations of such, and always different, produces hundreds of thousands of different words, and several pieces together produce many millions. This means that the foundation of this game is a dictionary of a philosophical, a priori language, written with basic signs that correspond to sounds -a kind of triple-levelled shorthand of lines, forms and gestures described elsewhere- that forms all kinds of abstract drawings and musical combinations, implicit in the differing positions as the game advances. As each major piece also represents a planet where the board gives its positions in the sky, one can follow anniversaries over the years, that is, the influence or character, leaping across the board, as part of the march through historical time or through anything imaginary. Further correspondences make up a rational cabbalistic system, the most complete ever published.*

Xul further explained that the game is played on a flat, square board, divided into 13 x 13 lines of alternating dark and light squares which also represent fractions of time or of degree, sounds, numbers in the duodecimal system, and a multiplication table. Xul also used a board of 13 x 12 squares (figure 61). Apart from the pieces, also called chessmen, which come from traditional chess, there are new pieces called bi-rooks and bi-bishops. It can be played with the usual chess set or with the new pointed pieces, though Xul preferred them to be flat so that one could go on top of another, increasing the combinatory possibilities of the game. The chessmen were built by Xul himself, and were beautifully painted with signs and figures (figure 61).

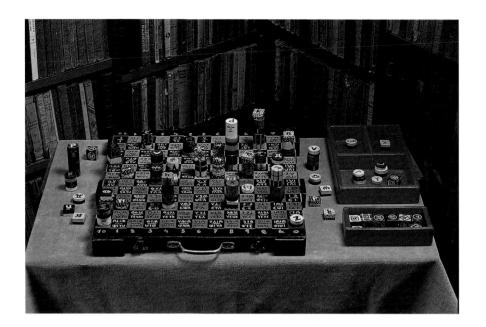

166. J. L. Borges, *Laprida 1214*, published in *Atlas*, op. cit.

167. Quoted by Leopoldo Marechal, *El panjuego de Xul Solar, un acto de amor*, Cuadernos de Mr. Crusoe, n.1, Buenos Aires, 1967, p. 168.

168. See note 116.

169. O. Svanascini, *Xul Solar*, op. cit., p. 35.

Figure 61. Xul Solar's Pangame with board of 13 x 12 squares. Museo Xul Solar

In his quest for perfection, Xul continuously modified his pangame, as Borges remembered.[166] Unfortunately Xul left no written rules so that the game can no longer be played. The basic idea was that each game formed part of a creative process with spiritual communications between the parts. According to Xul: *The game has the advantage that nobody loses and everyone wins.*[167] Xul's objective in inventing this universal game was to achieve a mysterious harmony between the players.

Xul's constant interest in music lead him to propose a modification of musical notation[168] which implied a substantial change in the piano's keyboard (figure 59) which Xul carried out with his own hands.

According to Svanascini:

*Xul claimed that the keyboard presented many difficulties so he adopted a hexatonic scale which allowed any piece to be played with more or less fingers in any tonality. To study this demanded, however, a third of his current time ... He busied himself also by making the keys uniform by rounding them, and even marking them so that they could be recognized by touch, preventing the fingers getting caught in the black keys ... These characteristics, he added, would allow a musical score without sharps and flats, in a system analogous to the current one, and at the same time, melodic diagrams which are in reality sketches. With practice one could draw musical movements with lines, possibly legible as music...*[169]

193

152. *Rejas (Iron Bars)*, 1955
Pencil and ink on paper mounted on board,
image: 16.8 x 22.2 cm; card: 22.5 x 28 cm
Private collection, Buenos Aires

153. *Plantas geométricas*
(*Geometric Plants*), 1955/41
Ink on paper mounted on board,
image: 17 x 22 cm; board: 22.5 x 28 cm
Private collection, Buenos Aires

170. Carol Lynn Blum in the catalogue *Xul Solar: a Collector's Vision*, Rachel Adler Gallery, New York, 1st of May to 30th June 1993.

171. O. Svanascini, *Xul Solar*, op. cit,, p. 36.

172. See note 48, p. 49.

The possibility of being able to play some of Xul's paintings on the piano is another advantage offered by his modified piano, according to Carol L. Blum.[170]

Xul had also prepared a puppet theatre to play works for adults, with mystical and esoteric themes. His puppets' masks were articulated (figure 60) and could be moved from below by simple means. These puppets can be seen in the Xul Solar museum. Svanascini records:

> *None of these creatures reflect reality. They are beings that live in infinite memory, on the edge of events, without this being decisive or premonitory. Their disquieting simplicity promises feasible destinies.*[171]

# A Return to Architecture

In 1954 Xul and Lita bought a small house in the picturesque Paraná river delta, on the Luján river, where Xul designed and built his studio. Xul spent many hours drawing and painting in the garden where he gave definitive shape to one of his greatest projects, his **Grafías** or **Ideographs**. This reconciliation with nature renewed his energy, and he recovered his interest in architecture.

His designs for colourful houses in the Paraná delta (plates 161 to 164), together with his designs for buildings and cities, revealed new forms and structures directly related to the buildings and monuments developed round his ideas on the Cabbala.

In his paintings Xul took up again his multicoloured façades with articulated shapes (plates 154 to 158), which represented one of the main components of his architectonic language.

It is useful to analyse his new constructions within his aesthetics. Some of these buildings are composed with elements in the form of letters of the alphabet, as in some of Carl Krayl's Dada building schemes,[172] and Fortunato Depero's pavilion (figure 62). In one of them you could read SAN VILLA ROXA DEL TEO REINO, and above the entrance HAUS LAR (plate 158). Others are made up with articulated geometric features , or by single, juxtaposed units. He even proposed buildings where the pillar is replaced by a totem pole (plate 160), thus re-establishing the pillar's original symbolism.

194

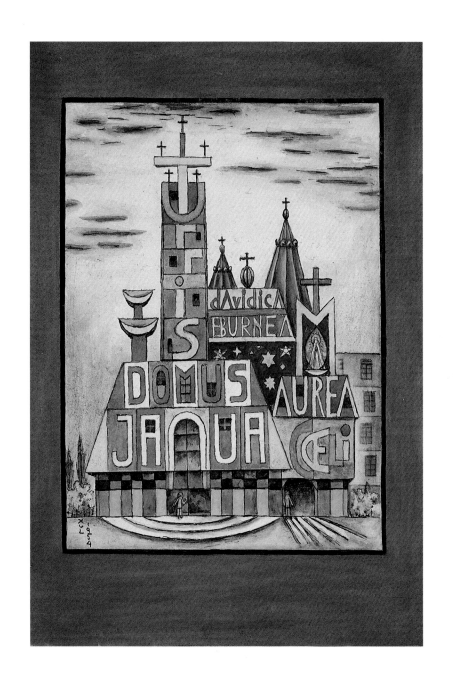

**154.** *Iglesia de María (María's Church)*, 1954
Watercolour on paper mounted on card,
image: 33.3 x 24.2 cm; card: 45.8 x 30.8 cm
Carlos and Martha Caprotti collection,
Buenos Aires

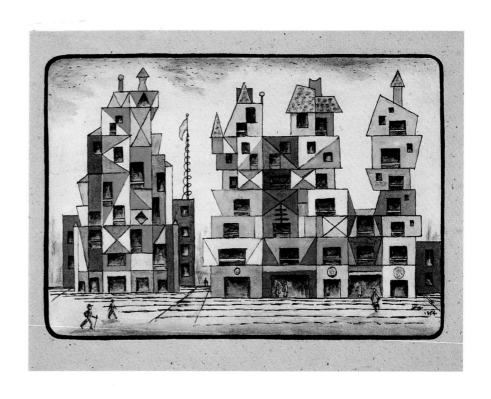

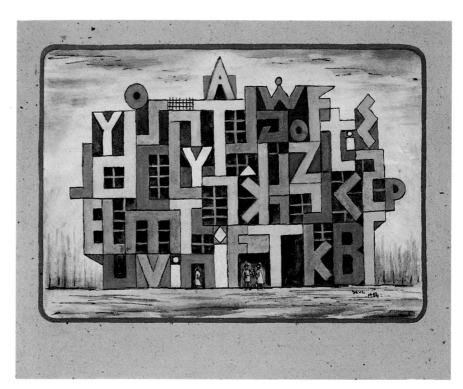

155. *Proyecto fachada para ciudad*
(*Façade-Project for City*), 1954
Watercolour on paper mounted on board,
image: 24.3 x 35.4 cm; board: 31 x 41.3 cm
Private collection, Buenos Aires
Courtesy Rachel Adler Gallery

156. *Proyecto fachada para ciudad*
(*Façade-Project for City*), 1954
Watercolour on paper mounted on board,
image: 25.4 x 36.5 cm; board: 33 x 41.5 cm
Private collection,
courtesy Rachel Adler Gallery

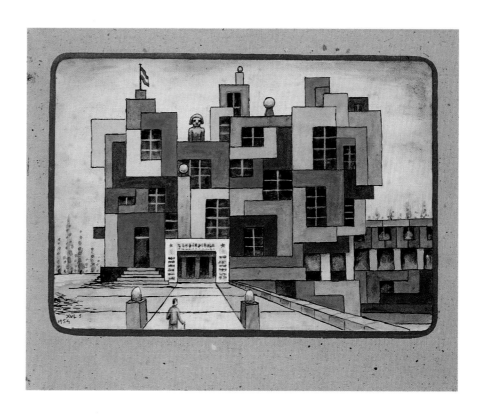

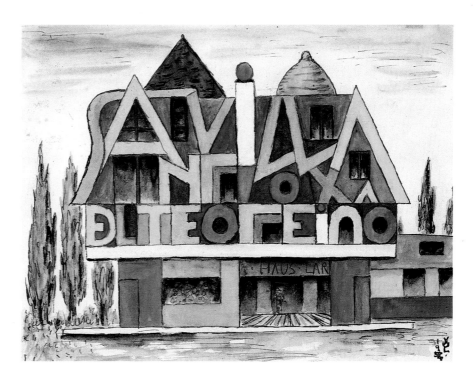

**157.** *Proyecto fachada para ciudad*
(*Façade-Project for City*), 1954
Watercolour on paper mounted on board,
image: 25.5 x 36.5 cm; board: 33 x 41.5 cm
Private collection. Buenos Aires

**158.** *Proyecto ciudá* (*San Villa*)
[*City Project* (*St. Villa*)],1954
Watercolour on paper, 25 x 33 cm
Private collection, Buenos Aires

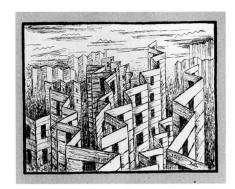

159. *Muros-biombo* (*Wall-Screen*), 1955
Ink on paper mounted on board,
image: 17 x 22 cm; board: 22.5 x 28 cm
Private collection, Buenos Aires

173. *Proyecto fachada para ciuda* (*Project for City Façades*, plate 156) was reproduced on the cover of the Journal of the American Planning Association, vol. 59, n. 3, 1993 to illustrate the article *Can Clinton Save our Cities?* by Robert F. Wagner Jr. and Julia Vitullo-Martin.

174. Christian Norberg-Schulz, *Michael Graves and the Language of Architecture* in *Michael Graves. Building and Projects, 1982-1989*, Princeton Architectural Press: New York, 1990, p. 7.

Figure 62. Fortunato Depero, Book Pavilion for Treves-Bestetti-Tuminelli, Biennale Internazionale di Arti Decorative, Monza, 1927

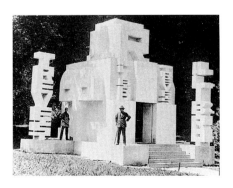

The disposition of the materials and the sense of colour confer a plastic quality sense to these buildings which have reminiscences of "De Stijl". The pieces which can be articulated amongst each other like old wooden, coloured toys retain the essential constructive features: columns, arches, beams etc. He designed them to be made with precast parts, utilizing industrial prefabrication technology, fully developed in the reconstruction of European cities, but not yet in use in Argentina.

Behind the kind of building designed by Xul, lay a visionary urban and social spirit opposed to the later functionalist designs imposed in the 1950s. They are happy, colourful buildings with a flexibility that allows for individuality, and symbolic contents that transcend the merely picturesque aspects of their façades.

It is not chance that lead Xul to take up again the ideas that lay behind *Bau* (plate 109). On the one hand, the explosive, disordered industrial growth in Argentina under Peronism during the decade 1945-1954 had produced a great concentration of precarious housing in Buenos Aires and its neighbourhoods called *villas miseria* (shanty towns). Xul's kind of architecture could have satisfied these necessities, and avoided the proliferation of anonymous buildings, and the social problems these created. On the other hand, modern techniques of prefabrication could have carried out his plans at low costs.

Most of the gigantic monoblocks of collective housing, built according to rationalist and pragmatic schemes in the large cities, today turn out to be uninhabitable thanks to the dire social consequences and have had to be destroyed (noted and lamented by sociologists and town planners). The schemes proposed by Xul were viable alternatives, and should be considered in this context.[173]

Xul also carried out an extensive series of architectonic drawings, mainly done while hospitalized in 1955. In this series he took up again his ideas on the balance of forms, and his architecture of open spaces.

It should not be forgotten that the language of these designs, typical in all Xul's work, revealed a profound linguistic and symbolic character, and made them very pleasing as means of visual communication. This was Xul's ultimate intention. The evaluation of the hierarchy of forms was already observed in his first designs, like *Estilos 3*. This first search to define styles fitting to his view of the world was embedded in the *linguistic conception of architecture*, as pointed out by Norberg-Schulz.[174]

For his part, Michael Graves makes a distinction between

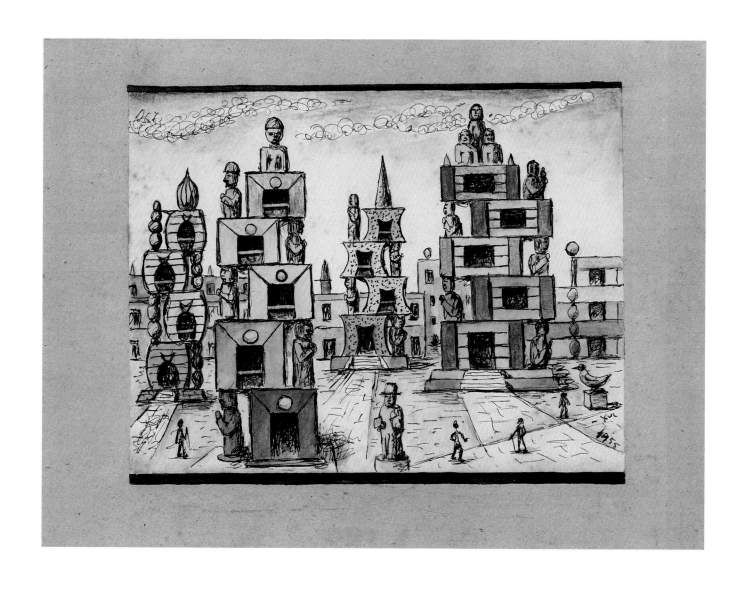

160. *Plaza* (2), 1955
Pencil and ink on paper mounted on board,
image: 16.2 x 22.2 cm; board: 22.6 x 30.2 cm
Private collection, Buenos Aires

199

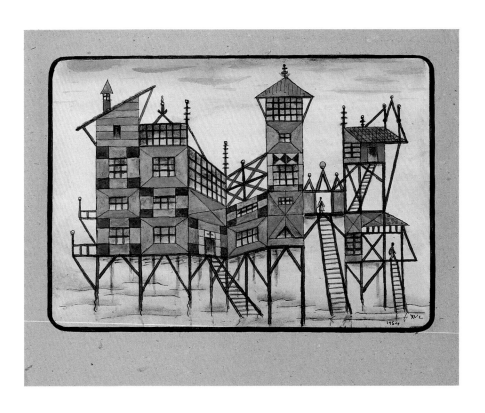

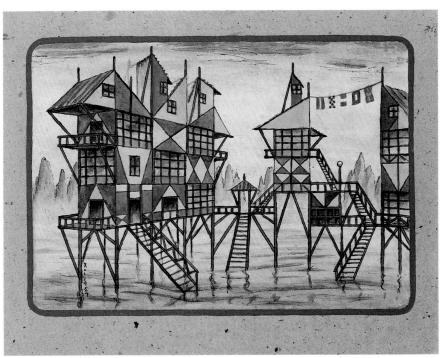

**161.** *Proyecto fachada Delta*
*(Façade-Project Delta)*, 1954
Watercolour on paper mounted on board,
image: 25,5 x 36,5 cm; board: 33 x 41.5 cm
Private collection, Buenos Aires

**162.** *Proyecto fachada Delta*
*(Façade-Project Delta)*, 1954
Watercolour on paper mounted on board,
image: 26 x 36 cm; board: 33 x 41.5 cm
Private collection, Buenos Aires

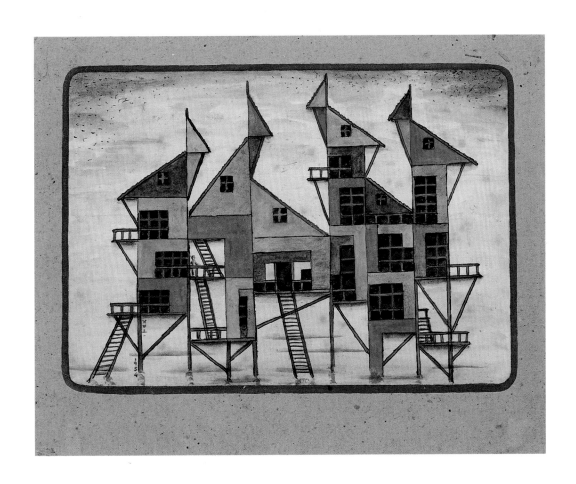

**163.** *Proyecto fachada Delta*
(*Façade-Project Delta*), 1954
Watercolour on paper mounted on board,
image: 25 x 36 cm; board: 33 x 41 cm
Private collection, Buenos Aires

"standard language" and "poetic language"; the architectonic conception of the latter is based on the evaluation of walls and façades as artistic features in their own right. Michel Graves wrote:

> *When applying this distinction of language to architecture, it could be said that the standard form of building is its common or internal language. The term internal language does not imply in this case that it is non-accessible, but rather that it is intrinsic to building in its most basic form - determined by pragmatic, constructional, and technical requirements. In contrast ..., poetic forms in architecture are sensitive to the figurative, associative, and anthropomorphic attitudes of a culture ... In its rejection of the human or anthropomorphic representation of previous architecture, the Modern Movement undermined the poetic form in favour of nonfigurative, abstract geometries.*[175]

Xul's work expresses ideas that are similar to that notion of poetic language, which helps us understand his solitary position in the Modern Movement.

Xul's architectonic designs, and his intellectual opposition to the extremes of Functionalism -he never fought his battles alone- corresponded with his own expressive needs and surpassed the pragmatism, the Functionalism, and utilitarianism of the Modern Movement. Similar to many ancient cultures like the Sumerian ziggurats, the Mayan pyramids, the Greek temples, and the Gothic cathedrals, Xul's designs were linked to forms that emerged from the collective unconscious as well as from his own experience and from his world that joyfully offered us.

175. Michael Graves, *A Case for Figurative Architecture* in *Michael Graves, Buildings and Projects, 1966-1981*, Rizzoli: New York, 1982, p. 11.

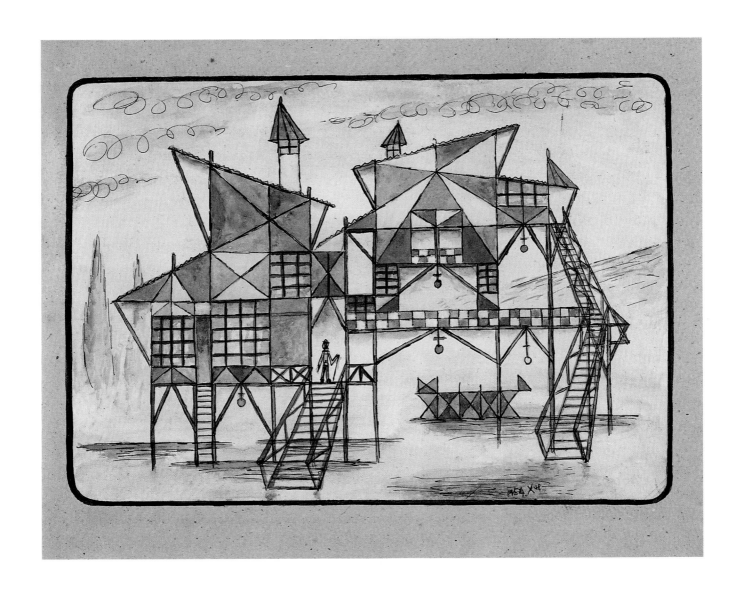

**164.** *Proyecto fachada Delta*
(*Façade-Project Delta*), 1954
Watercolour on paper mounted on board,
image: 25 x 36 cm; board: 33 x 41.5 cm
Private collection,
courtesy Rachel Adler Gallery

**165.** *Doña Lita (Mrs. Lita)*, 1958
Tempera on paper, 29 x 39 cm
Private collection, Buenos Aires

# 5. Xul, a Visual Communicator

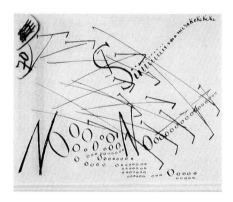

At the close of the 1950s Xul put his last and possibly most ambitious project into practice. It was to make his propositions, messages and useful mottoes visible through an original plastic writing written in *neocriollo*. It was a new attempt to use his art to better the world. Years after his first verbal paintings of 1918 to 1923, Xul decided to combine **verbal paintings** with **visual poems** in images that would unify **all** his texts and **all** his forms into what were his **thought-forms** which he called **pensiformas** in *neocriollo*, as well as **Grafías plastiútiles** or **Grafías (Ideographs)**.

This ambitious idea was to attain an integration of the messages transmitted by those texts whether poems, useful mottoes or proverbs, with symbolic geometric forms representing them. His aim was to create a plastic meta-language for visual communication. Each shape or symbol, or group of such, would correspond to a syllable, word or sentence, with the text covering the whole image.

A first glance at the notebook with Xul's notations shows that he began his researches into a visual communications system in the 1920s. He knew about Marinetti and the Italian Futurists' visual and typographical experiments with their "words in liberty" (figures 63 and 64), as well as Guillaume Apollinaire's visual poems or "calligrammes", Dadaist work, and the visual poems painted by artists like Paul Klee (figure 17) and Pavel Mansourov (figure 65). Xul had already experimented in his work with the interaction between words and images when he first gave expression to his anguished and complex creative process (diptychs) in 1918, and later in other Expressionist-Plasticist paintings.

Xul's researches were not solely based on this visual system but were also linked with his own linguistic interests and his immersion in his own cosmogony in which religions, astrology, occultism, mysticism and the sacred co-existed.

Xul's first attempts led him to develop a writing with stenographic type symbols. His first completed painting is dated 1935 (plate 166), and further works were carried out between 1938 and 1939. We do not know what verbal messages these paintings transmit.

Just as we are able to enjoy Chinese and Japonese ideograms without knowing their meaning, so the presence of a system of signs

that is hard to decipher does not hinder us from appreciating that vibrant organization of shapes that float like inter-relating objects, and make new patterns, painted in such surprising colours. Their recondite beauty is linked to ancient, still unknown civilizations that awaken unconscious fantasies; they are form-thoughts that have reached us from some distant country like Borges's Tlön.

Behind his visions of a world of mystical ascents and dangerous abysses, which reminds us how demanding it is to attain Goodness when faced with the insuperability of Evil, we find his sacred mountains, his work with esoteric and astrological meanings, and his researches into architectures, which also had linguistic connotations. Xul returned to his idea in 1958, and continued to develop it until his death. His work was unceasing, and in five years he produced a considerable number of *Grafías*, mostly painted in his house in the Delta.

At first it might seem that Xul's obsessive attitude was that of an artist who, having canalized his visionary world in paintings, then tried to visualize his thoughts in forms and shapes. A closer inspection that takes in Xul's concept of the world allows us to confirm that behind his stubborn search for shapes, aphorisms, portraits, and sentences, the artist had crystallized a new means of visual and textual communication that transcended the purely informative sense of the inscriptions in the painting.

In his *Grafías* Xul recovered the formal beauty, the soft shadings, and the refined colours and rhythm of his reverie paintings of the 1920s. Besides the almost permanent presence of the sun in these paintings reaffirmed Xul's fraternal gesture towards those who contemplate his work. Most of the *Grafías* painted between 1960 and 1962 were mounted by Xul on thick board. The paintings were framed with fine bands of colour, which amplified the works' visual field, repeating his flawless technique from his paintings of the 1920s, and his architectures of the 1950s.

A first examination of these works shows flat geometric, or lightly shaded figures distributed on the pictorial plane. There are also vegetable, anthropomorphic and zoomorphic shapes and structures that are articulated through the use of colour. These features float like microcosmic shapes on the picture's plane, and become integrated with the macrocosmic plane, which is the universal plane. As in his earlier visions the paintings appear as totalizers of its signs. Let us recall that Xul's paintings are not composed according to the rules of composition, but rise up simultaneously like images in a kaleidoscope.

Figure 65. Pavel Mansourov
The Wedding, c. 1920
Oil on wood, 135 x 57 cm
Ludwig Museum, Cologne

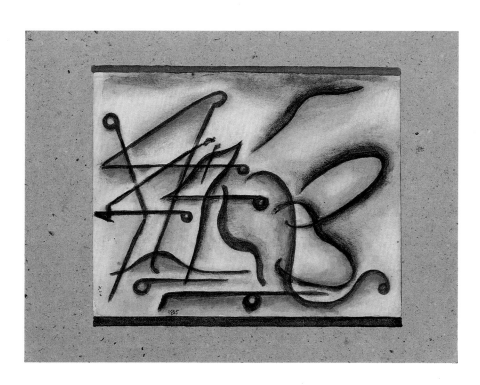

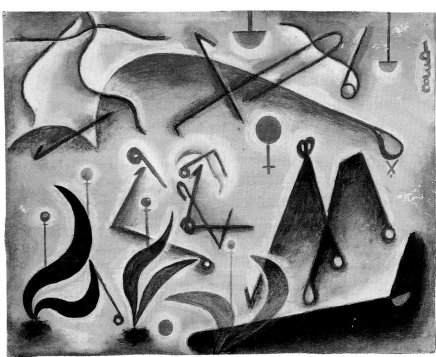

**166.** *Grafía (Ideograph)*, 1935
Tempera on paper mounted on board,
image: 16.5 x 21.6 cm; board: 22.3 x 30.8 cm
Private collection,
courtesy Rachel Adler Gallery

**167.** *Pri Grafía*, 1938
Tempera on paper mounted on board,
16.7 x 22 cm
Private collection,
courtesy Rachel Adler Gallery

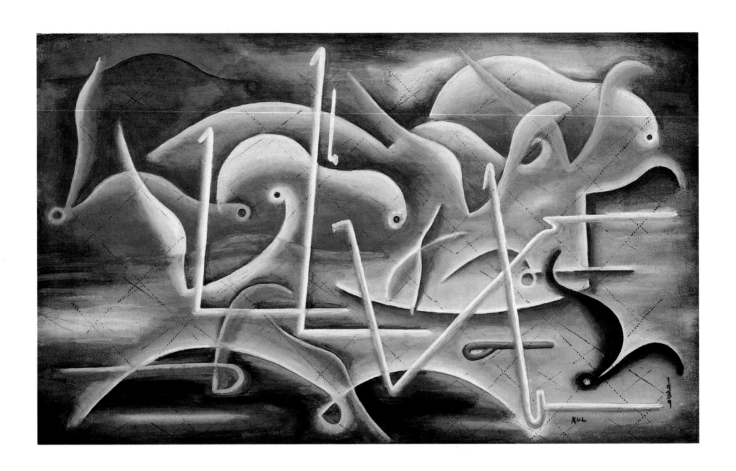

**168.** *Grafía antica* (*Ancient Ideograph*), 1939
Tempera on paper mounted on board,
34 x 55 cm
Eduardo and Teresa Costantini Collection,
Buenos Aires

208

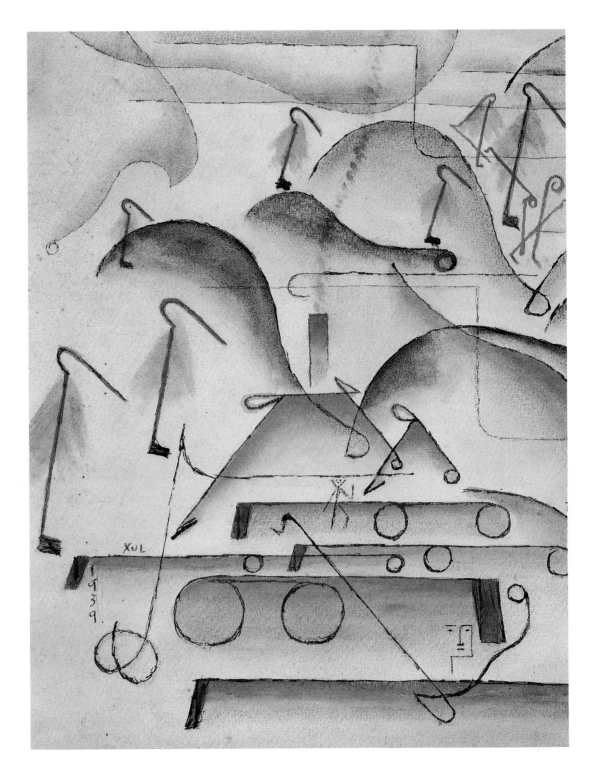

**169.** *Grafía (Ideograph)*, 1939
Watercolour on paper, 34 x 26 cm
Private collection, Buenos Aires

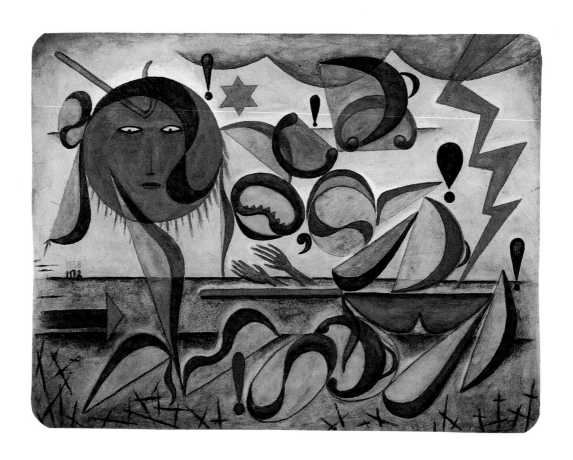

**170.** *Grafía (Ideograph)*, 1958
Watercolour on paper, 29 x 38.5 cm
John P. Axelrod Collection, Boston
Courtesy Rachel Adler Gallery

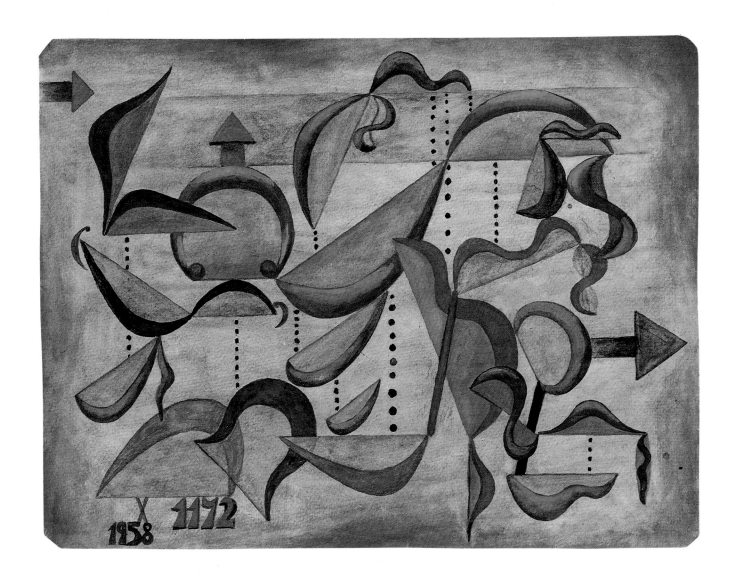

171. *Grafía (Ideograph)*, 1958
Tempera on paper, 28 x 38 cm
Private collection, Buenos Aires

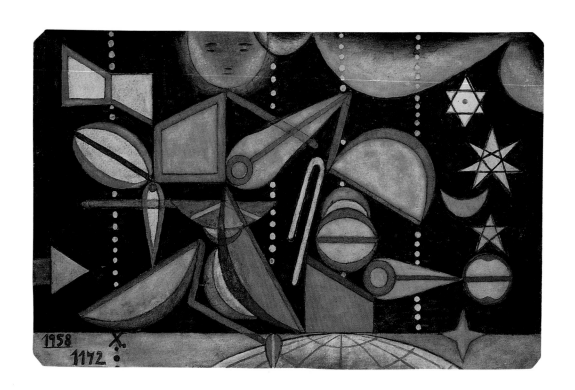

172. *Grafía (Ideograph)*, 1958
Tempera on paper, 25 x 38 cm
Private collection, Buenos Aires

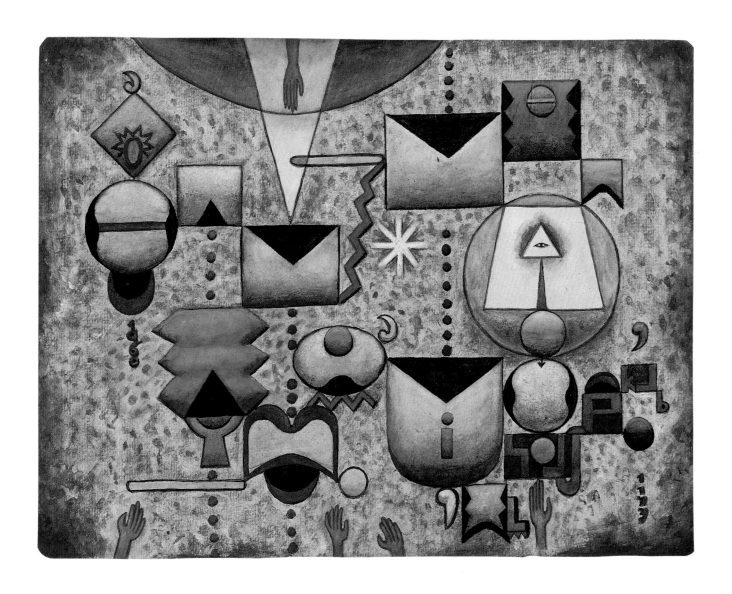

173. *Glor Santa María Madre de Dios*
(*Glorious Holy Mary Mother of God*), 1959
Tempera on paper, 28 x 38 cm
Private collection, New York
Courtesy Rachel Adler Gallery

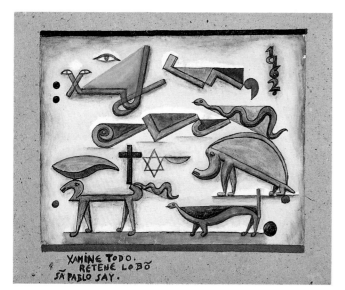

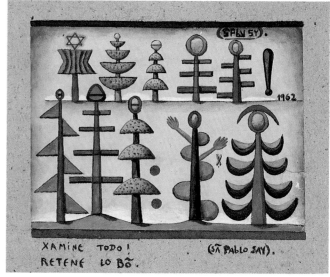

**174.** *Xamine todo. Retene lo bon...*
(*Examine all. Hold what is Good...*), 1962
Tempera on paper mounted on board,
image: 16.2 x 22 cm; board: 21.8 x 26.4 cm
Private collection, Buenos Aires
**175.** *Xamine todo ! retene lo bon*, 1962
Tempera on paper mounted on board,
image: 17 x 22 cm; board: 22.5 x 27.1 cm
Private collection, Buenos Aires
**176.** *¡Xamine todo retene lo bon!*, 1961
Tempera on paper mounted on board,
image: 17 x 23 cm; board: 22.2 x 27.8 cm
Private collection, Buenos Aires

176. Mario H. Gradowczyk, *Joaquín Torres
García*, Ediciones de Arte Gaglianone, Colección
Artistas de América n.1: Buenos Aires, 1985, p.
46. (English translation by Anne Twitty.)
177. Xul Solar prepared Torres García's
astrological chart probably when the Uruguayan
artist came to Buenos Aires in September 1942
for his exhibition in the Galería Muller and gave
a lecture. There is a small picture of Torres
García taken from some newspaper in one of
Xul's many clippings books.
178. Mario H. Gradowczyk, op. cit., p. 52.

His organization of space is very free, though there is an internal order that rules the plane, for nothing is left to chance. That is why these paintings have points in common with the pictograms painted by Joaquín Torres García called **free constructives**[176] in which the archetypal symbols float in the pictorial plane free of the grid (figure 66). This link with the paintings of the Uruguayan master[177] is not based on formal similarities between the works, but on a deeper link that is made comprehensible through Jung's collective unconscious. As I wrote earlier:

> *The use of elemental symbols in Torres García's paintings does not come solely from a conscious desire to synthesize and make abstract shapes, but is also the expression of the collective unconscious that is filled with archaic or archetypal symbols that surpass individual unconscious phenomena and lift us to a region where time and space and individuality are transcended.*[178]

Universal symbols, charged with energy, float in the collective unconscious, and Torres, after making contact with them, captures and inserts them into his pictorial plane. From this comes the energy that emanates from his Constructivist paintings, and makes them as attractive as the *Grafías*, with which they share convincing similarities. In Xul's case, the conjunction of his archetypal symbols with his thoughts and aphorisms spread out on the pictorial plane involves the observer who yearns to make contact with something cosmic. The *Grafías* interrelate symbolic shapes like the *fragments,*

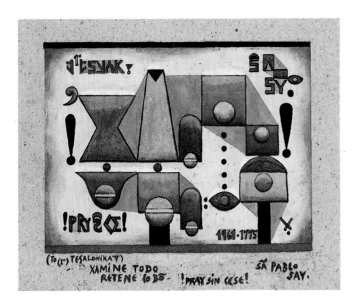

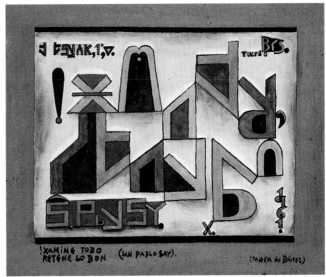

177. *Xamine todo retene lo bon...*, 1961
Tempera on paper mounted on board,
image: 15.5 x 22 cm; board: 21.5 x 26.7 cm
Private collection, Buenos Aires

178. *!Xamine todo retene lo bo...*, 1961
Tempera on paper mounted on board,
image: 17 x 23 cm; board: 22.4 x 27.5 cm
Private collection,
courtesy Rachel Adler Gallery

*interconnected shapes or colours* visualized by Kupka[179] in his
meditations, and turn them into a visual scheme that is also a text.

Each form or symbol represents a letter, a syllable, part of a
word or a word. The complete association of these elements
transforms them into words, which when grouped together make
up the image's text.

Xul created several alternative scripts that he sometimes applied
to the same aphorism. Six basic different scripts have been
identified:

1. **Geometric.** The letters, syllables or words are constructed in
flat geometric figures (plates 173, 177, 179, 184, 186, 189)
2. **Block Letters.** A modification of the Roman alphabet,
grouping the letters in blocks, although there are letters that do not
follow traditional writing (plates 178, 187, 188).
3. **Strips.** The repetition of geometric motifs in the shape of
strips or ribbons (plate 190).
4. **Shorthand.** A hieroglyphic or stenographic script (plates 176
and 185).
5. **Vegetable.** Consonants and syllables are represented by plants
(plate 175).
6. **Anthropomorphic and zoomorphic.** An amalgamation of the
geometric script and or without the shorthand script, and with
human or animal forms. These have the greatest esoteric content
(plate 174).

The combination of these six classes lead to new sub-classes

179. See the text cited on p. 38.

215

called **Mixed Grafías** (plate 191).

Xul enjoyed repeating his aphorisms utilizing his different scripts, as in *Xamine todo retene lo bon* (*Prove all Things; Hold fast That which is Good*), taken from the first Epistle of Paul to the Thessalonians, V, 21, reproduced in plates 174 (Zoomorpha), 175 (Vegetable), 176 (Shorthand), 177 (Geometric) and 178 (Block Letters). Some of these were painted in his studios in Buenos Aires and in the Delta.

It is possible to decipher the meaning of the texts in many of the *Grafías*, especially if you have Xul's or his wife Lita's translations from his *neocriollo* at hand. But Xul's logical thinking excluded, on principle, strict rules, and he continuously perfected his own rules of writing which sometimes made the translation difficult.

We have already pointed out that Xul's thinking corresponded to schemes of reasoning that were associative and adaptive, readjusting itself as it advanced. This established fluctuating connections of a probabilistic kind that did not cease being rational. There is no reason to think that Xul lacked the necessary scientific rigour to systematize a logic and unhesitatingly apply it. But just as he saw no advantages in monotheistic religions, so he refused to straight-jacket himself in Cartesian logic. These rules with variations led to Xul applying his peculiar **fuzzy logic** that admitted small fluctuations within a certain framework worthy of statistics, or of his own experience. Today this fuzzy logic is of interest in mathematics and technology, especially in relation to loose combinations. Xul, in his foresight, had applied this theory much earlier.

Is it possible to break the code of these scripts that are so ancient and so contemporary? Xul Solar or Lita have marked at the foot of each *Grafía*, or behind on the board, the painting's symbolised text in a large part of the works. This is the starting point to construct a system of decodification of the *Grafías*. The earliest attempt, made with Lita Xul Solar's help, can be found in Jorge García Romero's work,[180] though the limitations of Xul's logical system must be born in mind.

In each of the systems words must be built by syllables of two or three letters. The vowels **a**, **e** and **o** are represented in the geometric system by the signs

$$a = \triangle \qquad e = \ominus \qquad o = \bigcirc$$

180. Jorge O. García Romero, *Alejandro Xul Solar*, monograph presented at the Escuela Superior de Bellas Artes, Universidad Nacional de La Plata, August 1972.

Figure 66. Joaquín Torres García
Composition, 1938
Tempera on board, 81.3 x 104.2 cm
Solomon R. Guggenheim Museum, New York

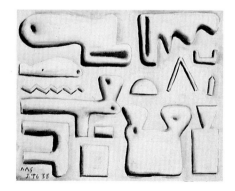

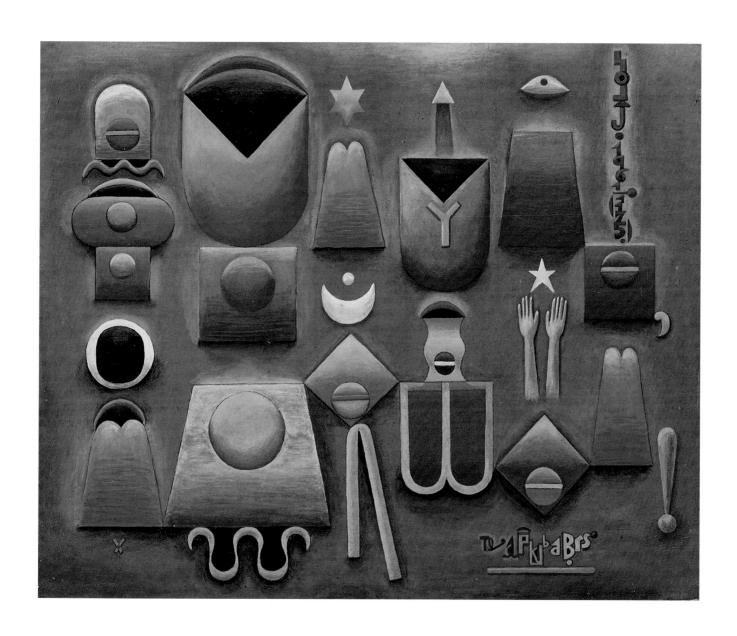

**179.** *Nel hondo mundo mi muy pide o min*
*Dios (lu plain wake mi)*, 1961
Tempera on paper mounted on board,
46 x 55.5 cm
Private collection, Buenos Aires

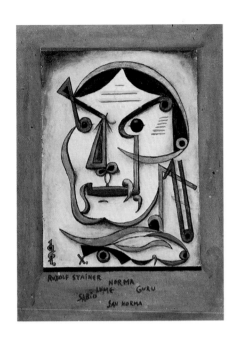

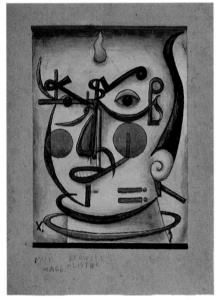

180. *Rudolf Stainer (Steiner)...*
[*Rudolf Stainer (Steiner)...*], 1961
Témpera on paper mounted on card,
30.5 x 21 cm
Private collection, New York
Courtesy Rachel Adler Gallery

181. *Muy mago Krowley Alistör (Crowley
Aleister) (Most Magician Krowley Alistör)*,
1961
Tempera on paper mounted on card,
image: 22.2 x 16.5 cm; card: 30.3 x 22.5 cm
Private collection, Buenos Aires

181. Jorge O. García Romero, p. 38.

and the consonants as indicated in Table 1, where the two letter syllables that form the basis of the geometric script have also been included. It should be noted that when the consonant shrinks in its upper part it combines with the **i**, and when it enlarges in its upper part it accompanies the **u**.

When the three-lettered syllables that terminate in the consonants **n** and **r** are formed the following signs[181] are used:

$$\text{n=} \quad \frown \qquad \text{r=} \quad \wedge\!\wedge\!\wedge \qquad \text{s=} \quad \sim\!\sim\!\sim$$

(Amongst these the author has added the one that corresponds to the one that terminates with the letter **s**). These symbols are placed above each syllable in the case of the **n**, or below each syllable for those that end with **r** or **s**.

Syllables with the letter **t** are above a virtual horizontal line while the letter **d** that answers to a similar sign lies under that line (see plate 179). In some cases the shape of the syllable **lu** corresponds to a mandorla with the two vertical lines indicated in Table 1, that we have completed so that it can be of use.

Generally the *Grafías* are read from the top down, and from left to right, but sometimes Xul inverted the sense, and indicated this with arrows.

We can now read some of the geometric *Grafías*, for example:

*Lu kene ten lu base nel nergie, sin nergie, lu kene no e kan*
(plate 184)

which means "Knowledge is based in energy, without energy knowledge is not possible". This invented aphorism is composed in two lines. As there is no counter indication, it should be read from the top left.

Bearing in mind what has been said, and using the symbols in the modified Table 1, the syllables and vowels are read in the following manner:

LU KE NE TEN LU BA SE NEL NER GIE;
SIN NER GIE, LU KE NE NO E KAN.

Another way of decoding this text is to write the syllables vertically:

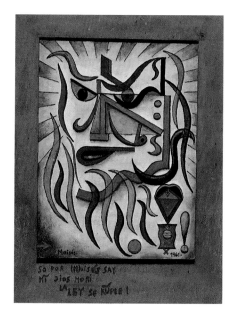

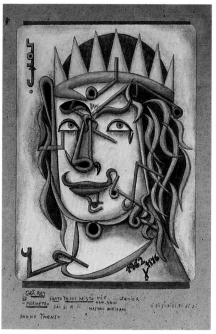

**182.** *Moisés (Moses)*, 1961
Tempera on paper mounted on card,
23 x 17 cm
Private collection, New York

**183.** *Gran Rey Santo Jesús Kristo*
(*Great Holy Jesus Christ*), 1962
Tempera on paper mounted on card,
40 x 28 cm
Private collection, New York

182. Jorge O. García Romero, op. cit.
183. See for example Francois Letaillieur, *Le demi-siècle lettriste*, Galerie 1900-2000, Marcel Fleiss: Paris, 1988.

| L | KN | T | L | BS | N | N G |
| U | E E | E | U | A E | E | E I |
|   |    | N |   |    | L | R E; |

| S | N G | L | KN | N | K |
| I | E I | U | E E | O | A |
| N | R E, |   |    | E | N. |

The painting is finished off with the inscription "Pan Klub" that shows that Xul had considered it for his Universal Club. It is signed with an initial X., and dated 1961, or 1175 in the duodecimal system. The place where it was painted was the Luján River.

Further *Grafías* can be deciphered in the same way, for which corresponding tables exist.[182] These will be useful for future researchers, bearing in mind the inevitable variations in Xul's codes.

Xul also painted the **Grafía-portraits** of Moses and Jesus (plates 182 and 183), and others linked to the history of religions like Rudolf Steiner and Aleister Crowley (plates 180 and 181). These obsessive and haunted images are made up with signs from the shorthand script which may also be decoded.

In his *Grafías* or thought-forms Xul combined the pictorial beauty and subtlety of these images, the spirituality of his aphorisms and the expressive possibilities of *neocriollo*. They constitute the metaphoric finale of his role as communicator, and open a complex spectrum of interpretative possibilities.

As a means of visual communication, the *Grafías* are linked to problems other contemporary artists working in this field have posed, especially the "Lettrist movement"[183] which was developed mainly in France by the Rumanian born artist Isidore Isou, and included the French Maurice Lemaître and François Letaillieur, and a group of North American artists including Barbara Kruger, Bruce Nauman and Jenny Holzer. These artists integrated words and texts with effective images that functioned aesthetically as much as social communication, using diverse expressive means from easle painting to photography and installations, with complex visual techniques operated by computers.

**Table 1**
Interpretative System for the Geometric
*Grafías* (Ideographs)

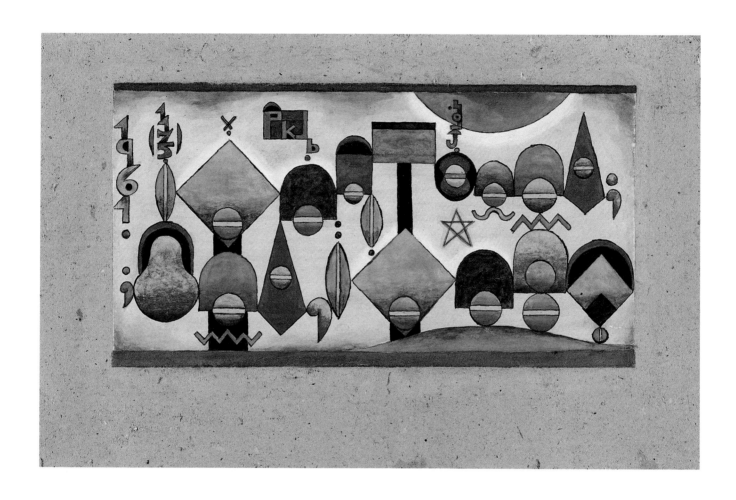

**184.** *Lu kene ten lu base nel nergie, sin nergie, lu kene no e kan* (*Knowledge is based in Energy, without Energy, Knowledge is not Possible*), 1961
Tempera on paper mounted on board,
image: 14.7 x 30.6 cm; board: 25.2 x 39.5 cm
Private collection, Buenos Aires

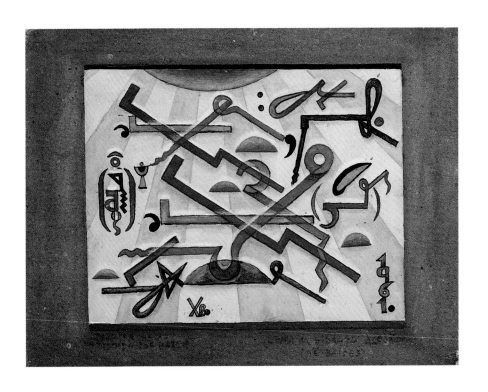

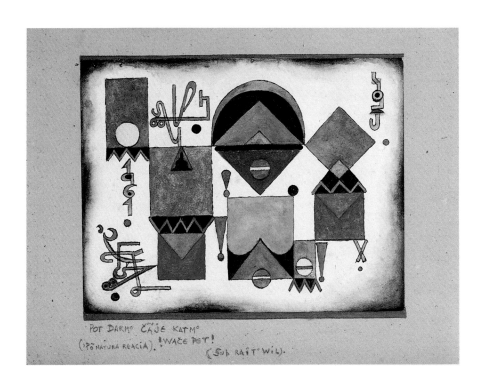

185. *Todo ta hecho...* ,1961
Tempera on paper mounted on board,
image: 16 x 22 cm; board: 22.6 x 30.4 cm
Private collection,
courtesy Rachel Adler Gallery

186. *Por darmo...* ,1961
Tempera on paper mounted on board,
image: 16.8 x 22 cm; board: 22.7 x 30.7 cm
Private collection,
courtesy Rachel Adler Gallery

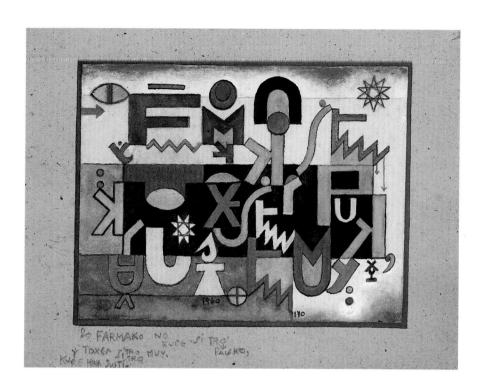

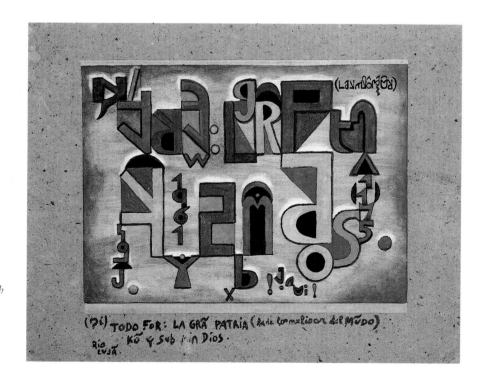

187. *Lo farmako no kure si tro pauko, y toxca si tro/ tro muy kure mwa juisti,* (*Pharmaceuticals do not Cure if there is too Little and Intoxicate if too...Much. Cure with what is Right*), 1960
Tempera on paper mounted on board, image: 16.5 x 22 cm; board: 22.9 x 30.2 cm
Private collection,
courtesy Rachel Adler Gallery

188. *Todo for la gran patria...*, 1961
Tempera on paper mounted on board, image: 17 x 22 cm; board: 22.7 x 29.9 cm
Private collection,
courtesy Rachel Adler Gallery

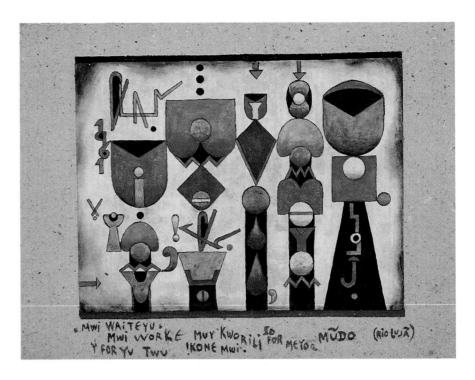

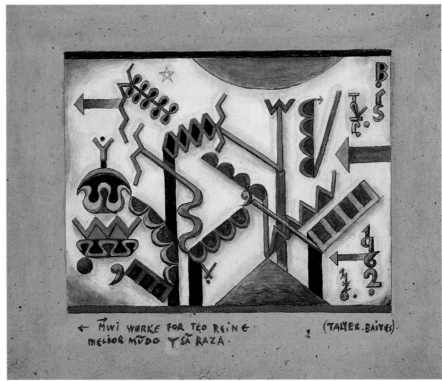

189. *Mwi waite yu...*, 1961
Tempera on paper mounted on board,
image: 17 x 22.3 cm; board: 22.9 x 30.5 cm
Private collection,
courtesy Rachel Adler Gallery

190. *Mwi worke for teo reino...*, 1962
Tempera on paper mounted on board,
image: 17 x 22 cm; board: 25 x 30 cm
Private collection,
courtesy Rachel Adler Gallery

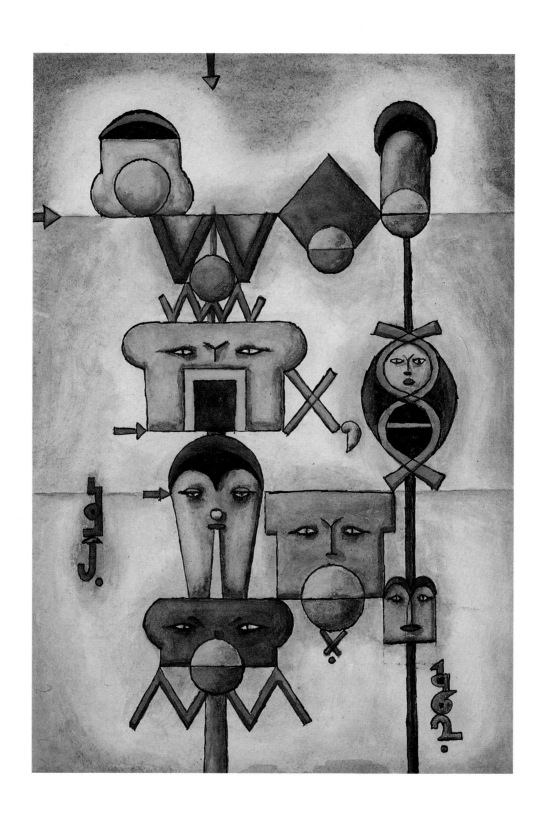

**191.** *Grafía (Ideograph)*, 1962
Tempera on paper mounted on board,
31.5 x 22.3 cm
Colección Galería Rubbers, Buenos Aires

Figure 67. View of the inside of the Xul Solar
museum. You can see the staircase which
leads to the artist's flat

# 6. A Final Comment

This panorama of Xul Solar's pictorial work began with a transcription of his first texts that revealed that from early on Xul had decided to create his own world for himself, and for his fellows. The path he followed for half a century was dedicated to canalizing his visions, and developing his expressive means. Painting, architecture, literature, language, music and other more personal mediums like astrology and religions, are distinct facets of an exceptional person. They also illustrate how his juvenile ambitions to create worlds have been satisfied.

Xul told those who spoke to him, in that blend of Dadaist and Eastern mystic that was so typical of the man, that his art would be understood in the year 2000. This claim reveals the lack of insights and interpretations that his work generated in local artistic circles. This is not a whimsical claim if you take into account the depth of his intellectual originality, and the range of what he did with a freedom from stylistic dogmas that was unthinkable in the ethnocentric development of the artistic movements of his times, especially in the European art of between-the-wars with which Xul had close spiritual ties.

In one of the interviews that appeared during his lifetime, and that usually exaggerated the anecdotal side to Xul's personality rather than inquiring into deeper motivations, Xul defined himself thus:

*I am world champion of a game that nobody yet knows called panchess. I am master of a script that nobody yet reads. I am creator of a technique, of a musical grafía that allows the piano to be studied in a third of the usual time that it takes today. I am director of a theatre that as yet has not begun working. I am creator of a universal language called panlingua based on numbers and astrology that will help people know each other better. I am creator of twelve painting techniques, some of them surrealist, and others that transpose a sensory, emotional world on to canvas, and that will produce in those that listen a Chopin suite, a Wagnerian prelude, or a stanza sung by Beniamino Gigli. I am the creator, and this is what most interests me at the moment,*

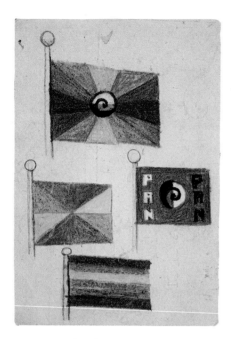

192. *Project for Flag for Pan Klub*, c. 1960
Coloured pencils and ink on card, 14 x 10 cm
Museo Xul Solar

184. Gregory Sheerwood, *Xul Solar, campeón mundial de panajedrez y el inquieto creador de la "panlingua"*, interview with Xul Solar in Mundo Argentino, Buenos Aires, 1st of August 1951.

*apart from the exhibition of painting that I am preparing, of a language that is desperately needed by Latin America.*[184]

This declaration was in keeping with what Xul thought about those who questioned him, and reveals the "mask" with which the artist protected himself and on to which his questioners projected their own views as to who Xul was. Xul was conscious of the coherence of his thought and of his role as communicator, and continued along the path that he had forged, without fussing about whether his deepest propositions were accepted or not, and convinced that new generations would better understand his work.

This completed work has been based on Xul's pictorial production, whose communicative power has facilitated a first approach to his complex world. We have tried to analize in which way the connections between individuality, collectivity, spirituality, mysticism, occultism, communication, language, cosmos and the collective unconscious have made such an original work possible. This study should be complemented with further works on Xul's languages, on his texts, on his visions, within the framework of his religious and spiritual preoccupations.

In each stage of his life, from his earliest and powerfully Expressionist oil paintings to his last *Grafías*, his work has corresponded to his visionary ambitions. Xul knew that these visions would be his contribution to universal culture, but sustained by both ancient and modern cultural affinities, as well as by the particularities of his Argentine origins, and his ancestral European roots. Xul's world was not directed to the Northern Hemisphere, nor to the Southern one, as Torres García had decided when he returned to Uruguay. To attain universality for Xul was but one component in his quest.

In his expressive means he was able to blend ancient Western cultures and the latest avant-garde thought, what was mystical and spiritual in Oriental cultures, unconscious substrata of Pre-Columbian culture and the incipient cultural expressions of a young country in a process of change. His way was extremely personal, with an idiosyncratic language that typified him.

When young, his artistic problems were situated in the context of Expressionism, to which he brought symbolist leanings in what could be called his Expressionist-Symbolist period. During this time he developed original artistic solutions, like his use of homotopies. When he amalgamated a freer geometric organization into his way of Expressionist painting: his Plasticist-Expressionist period, he

193. *Self-Portrait*, c. 1960
Ink on paper, 18.5 x 12 cm
Museo Xul Solar

became part of the European avant-garde. By mastering that new syntax Xul was able to refine his expressive traits with a more subtle use of watercolour in what became his reverie paintings.

His confrontation with a new Buenos Aires, with greater cultural inclinations, led Xul to create a new organization of juxtaposed spaces where man and woman, and cosmos and nature became unified. In this space perspective was subverted by planar forms, and imbalance triumphed over gravity. Multiple screens organized open architectural spaces, and colourful façades reinvigorated vertical walls.

His imaginary countries, his winged cities, his horizons that break apart, his worlds of good and evil, his mystical landscapes, his astrological paintings, and his pangame succeeded each other like images from a kaleidoscope.

Xul's creativity culminated with his *Grafías*, also called thought-forms, a paradigm for visual communication which once more triggered off a wide spectrum of interpretative possibilities.

I will conclude this study with a quotation from the epilogue to Borges's *El hacedor* (*The Maker*):

*A man set himself the task of drawing the world. Over the years he peopled a space with images of provinces, of mountains, of bays, of ships, of islands, of fish, of rooms, of instruments, of stars, of horses, and people. Just before dying he discovers that the patient labyrinth of lines traces out the image of his face.*[185]

To recall this passage by Borges is to look once again at Xul in his work.

185. J. L. Borges, *Obras completas*, op. cit., p. 854.

Alejandro Schulz Solari. Museo Xul Solar

# 7. Chronology

**1887**
Oscar Agustín Alejandro Schulz Solari (Xul Solar) is born on the 14th of December at 11.20 in San Fernando, a town near Buenos Aires.
His father, Emilio Schulz Riga, German, was born in Riga in 1853, and arrived in Buenos Aires in 1873.
His mother Agustina Solari, Italian, was born in 1865 in San Pietro de Rovereto, near Genoa, and travelled to Buenos Aires in 1882 with her younger sister Clorinda to rejoin their father who had emigrated to

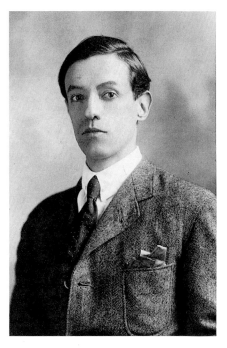

Young Alejandro Schulz Solari.
Museo Xul Solar

Argentina and lived in the city of San Fernando.
**1889**
Baptized on his birthday.
**1891**
On 12th May his younger sister Sara is born.
**1893**
Ill with typhus.
**1894**
On 28th January his sister Sara dies. In March he enters the state school Galarza, situated in Tigre, a town near Buenos Aires facing the Delta of the Paraná river.

**1895**
His parents move, and he changes to the French School Fremy.
**1898**
In June Dr. Segura operates on his nose.
**1900**
He enters the Colegio Inglés (English College) and begins studying the violin which he has to stop after falling from a horse and dislocating his arm.
**1901**
In April begins his secondary schooling in the Colegio Nacional -Sección Norte- (National College-Northern Section) and in June moves to Buenos Aires at 1480 Juncal street.
**1902**
New change of address to 628 Beruti street. In April enters the private Colegio del Plata (La Plata College). In August they move to 636 (today 2936) Mansilla street.
**1903**
In March rejoins the Colegio Nacional. Two throat operations.
**1905**
In October begins working for the first time in the Penitenciaría Nacional (National Prison) where his father has been mechanical engineer since 1903. He earns 80 pesos a month.
**1906**
In March leaves his job to enrol in the Faculty of Exact Sciences to study architecture. Joins the Club de Gimnasia (Gymnasium Club) and buys a piano.
**1907**
In November gives up studying.
**1908**
Xul works in the Municipalidad de Buenos Aires (Buenos Aires Municipality) earning one hundred and fifty pesos. He gives up the job soon after because there is no work to do. A friend of his who did not mind this situation took over.
**1910**
He repeatedly tries and fails to get a good job. In October he begins writing some texts and poems that deal with his life conflicts, and his desire to create new worlds. He loves music and goes to concerts. He befriends Juan de Dios Filiberto, a well-known composer of tangos. Xul initiates him into symphonic music.

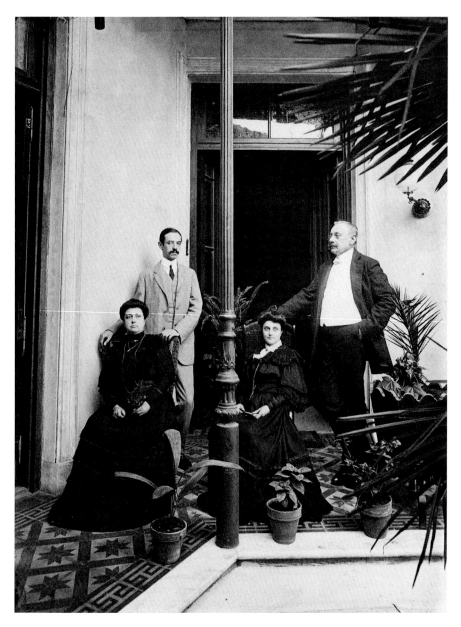

Family Photograph. Standing: Alejandro and don Emilio Schulz Riga. Sitting from left to right Clorinda Solari (aunt of the artist) and his mother Agustina Solari de Schulz (January 1907). Museo Xul Solar

**1911**
In January he plans a journey to Australia with his writer friend Diego Luis Molinari. He tries fruitlessly to get a pension. He complains of poor health, and suffers from anaemia. In November he writes *My first paintings. 12 at least and my dramatic and musical poem will be my obsession all the time...* These works may have been lost.

**1912**
He begins to plan a journey to Europe *with enough money to last a month...* On the 5th April he embarks for Hong Kong, working his passage on the English ship "England Carrier", which

disappointingly takes him to London at the end of April. In May he travels to Turin. He buys the almanac *Der Blaue Reiter*. In a letter written in Italian and received in Buenos Aires on the 8th November he comments on his progress in painting and shows a sketch for his painting *Entierro (Burial)*.

**1913**
In March Xul travels to Paris. In April he moves to London to wait for his mother and aunt Clorinda who arrive on the 28th April with the aim of accompanying him in Europe. They remain in London until the 9th May in the Court Hotel in Lincoln's Inn Field. They spend 10 days together in Paris where Xul enthuses over the Russian Ballet and its music. They leave for Italy on the 20th May. Xul stays in Turin until the 26th May and returns to Rovereto with his mother and aunt who remain for a while in Zoagli, near Rovereto. The three are supported financially by Don Emilio who continues to work in Buenos AIres. He travels several times to Turin between June and September. He returns to Paris on the 9th October and remains until Christmas, then returns to his *mamás*. The dates of his trips to Paris coincide with the dates of the *Salon d'Automne* and the *Salon des Indepéndants* where avant-garde artists are showing.

**1914**
From the 9th March he lives again in Paris, but war forces him back to Italy. He passes through Tours, and ends up in Marseille. He is back in Italy by the end of October. He paints Expressionist landscapes in oil and tempera on small boards. He paints the first version of *Entierro (Burial)*, one of the major works of his first period called **Expressionist-Symbolist**.

**1915**
On the 15th January Xul travels back to Paris where he lives until the 22nd October. He tries to get work as a nurse on the war front, but has to pay a high sum for the training and decides not to go ahead with it.

**1916**
On the 7th July Xul moves to Florence and meets the Argentine painter Emilio Pettoruti. In his autobiography *Un pintor frente al espejo (A Painter in Front of the Mirror)*, Pettoruti recounts this meeting. He begins to sign his work **Xul Solar**, an emblematic name which can be read as **solar intensity**. The painting *Man-tree*, today in the

Alejandro Schulz Solari on the day of his departure for Europe in 1912. Museo Xul Solar

Photograph of part of Emilio Schulz Riga's room in the Penitenciaría Nacional which don Emilio sent Xul on the 12th December 1914. In the centre you can see a photo of the child Alejandro in the place of honour. Museo Xul Solar

Emilio Pettoruti with Xul Solar and relations in Italy. Museo Xul Solar

Xul Solar museum, registers his first use of his new language *neocriollo*.

**1917**
In March he returns to Zoagli. In September he travels to Milan and works for two months in the Argentine Consulate.

**1918**
Xul begins a new stage with profound changes in his images. He abandons the more esoteric Symbolist features, and includes freer geometric shapes. He paints his first diptych that deals with his conflicts. In Milan he paints his first architectures. He returns to Zoagli where he continues in his new style, and in his paintings includes written texts in *neocriollo* or neocreol, an invented language used as a medium to facilitate communication between the American countries. In December ill with influenza.

**1919**
Several short stays in Milan. On the 6th November Xul leaves for London, and remains for several months. He undergoes existential conflicts, evident in his writing of the time.

**1920**
On the 10th May he is back from London, and on the 26th travels to Milan and then Venice to attend the *XII International Art Exhibition* where as well as Italian artists he sees work by Archipenko, Gontcharova, Larionov and Survage in the Russian pavilion. In Milan on the 27th November his first joint show opens with sculptures by Arturo Martini (1889-1947) at Mario Buggelli's Galleria Arte. He shows 46 watercolours, 4 temperas and 20 oils, including his architectural projects and design motifs. The catalogue is written by Pettoruti. Criticism in Italy is positive. Pettoruti paints his portrait in oil which can be seen in the Museo Nacional de Bellas Artes "Juan B. Castagnino" in Rosario. His friend Piero Marussig (1879-1937), a *Novecento* painter, also paints his portrait in oil which Xul exchanges for a watercolour.

**1921**
He visits Rome possibly to see the *First Rome Biennale*. On the 14th October he decides to install himself in Munich, and attends the Münchener Kunstwerkstätten, a school for the applied arts founded by von Debschitz, which before the war had been esteemed for its progressive educational methods. A first negative article on Xul

appears in the Buenos Aires newspaper La Razón.

**1922**
He asserts his **Expressionist-Plasticist** paintings in which a central motif of Expressionist characteristics is surrounded by a set of geometric shapes that frame it. He writes to his *mamás I am painting fantastic things.* He is invited to spend his summer holidays in Kloster Trauntal, formerly an ancient Franciscan monastery turned into a hotel, on the Danube, near Kelheim. In August he returns to Zoagli to spend some time with his family, and plans to return to Germany. He meets the German painter Hans Reichel.

**1923**
On the 22nd January he returns to Munich and lodges in the house of Mrs. Alberti, wife of the writer Herbert Alberti on 11a Keferstrasse. Xul and Pettoruti decide to return to Argentina at the end of the year. Xul prepares a prologue for Pettoruti's catalogue at the Der Sturm gallery in Berlin - *so that my name will wander around there with his paintings.* The prologue for Pettoruti's show is not published because *nobody could translate it. I'm now working on a book on him*; which did not happen either, though Alberto M. Candioti, Argentine consul in

Berlin, and one of the early Pettoruti collectors, did write one.

Xul begins to prepare the frames for his show in Buenos Aires that both artists plan to hold on Florida street. At the end of March he moves to Stuttgart to attend a Congress on Education for the Young where *I learnt many new things.* He is happy to return home. Referring to artists in Buenos Aires he writes: *I read something about things over there, and saw some photographs. They are very pompier* [conventional]. *Its better like that, we will have a greater impact...* In May he begins to paint larger works of great beauty: his **reveries**. He dispenses with the violent contrasts of his earlier paintings in work that is more translucent and velvety. Xul returns to Kloster Trauntal in June for his holidays. In August hyperinflation breaks out in Germany. In a postcard to his father in German he writes: *You must be glad to be so far from the horror which is expected here in this mad Europe.* On the 15th December he returns to Zoagli. He brings with him from Germany boxes of more than two hundred books on philosophy, history of religions, esoteric sciences, contemporary art, and art from Europe, America, Asia and Africa, his musical pieces and *some 92 paintings in different sized frames (and some 50 pieces of untouched*

card), *(few are large, approx. 50 small measuring 22 x 17cm)*, as well as his personal effects.

**1924**
On the 29th April he travels to Paris. Meets the Englishman Aleister Crowley, master of the occult. He hangs three paintings in a show of Latin American artists in the Musée

Front and back of a postcard sent by Xul Solar to his mother and aunt in August 1922 from Kelheim. On the back is Kloster Trauntal where Xul spent his holidays. Museo Xul Solar

Banquet in honour of the poet Jules Supervielle. Standing: XX., Raúl González Tuñón, Arch. Alberto Prebisch, Eng. Eduardo Girondo, Dr. Brandán Caraffa, Alberto Girondo, Pablo Rojas Paz, Evar Méndez, Alvaro Melián Lafinur, D. Salguero De la Hanty, Sandro Piantanida, A. Xul Solar, Jules Supervielle, Ernesto Palacio, Mrs. Delia del Carril and Ricardo Güiraldes. Sitting: Dr. Sergio Piñero, Arch. Juan Carlos Figari Castro, Dr. Pedro Figari, Mrs. de Supervielle and Mrs. Adelina Del Carril de Güiraldes, Martín Fierro, Año I (second period), nos. 12/13, 20th November 1924, p. 9. George and Marion Helft Collection, Buenos Aires

## La fiesta de "Don Segundo Sombra"

Grupo de algunos de los numerosos asistentes a la demostración en honor de Ricardo Güiraldes, festejando el éxito de "Don Segundo Sombra", fiesta a la que prestaron su concurso la "jazz" y orquesta típica del Real Cine dirigidas por los maestros Verona y Guido, y el dúo Magaldi-Noda, siendo celebradísimos. Sentados Sres.: Nicolás Olivari, Enrique González Tuñón, Dr. Manuel Gálvez, Juan Pablo Echagüe, Ricardo Güiraldes, Dr. Adolfo Korn, Ing. Eduardo Girondo, Sra. y Sr. Julio V. Rodríguez; de pie: Evar Méndez, Dr. Nerio Rojas, Roberto Mariani, Francisco A. Colombo, Ruth Lange, Juan B. Tapia, Leopoldo Marchal, Dr. Absalón Rojas, Nora Lange, Ernesto Palacio, Jorge Luis Borges, Luis M. Onetti, Xul Solal, Luisa y Molly Boggione, Oliverio Girondo, Raúl González Tuñón, Eduardo A. Mallea, Pondal Ríos, Rosa Boggione, Geo Mergault, Margarita Ricco, Pedro V. Blake, Lamberti Sorrentino. Estaban además: Dres. Eduardo y Enrique Bullrich, Dr. Sergio Piñero (h.), Rafael Girondo, Germán de Elizalde, Luis F. de Elizalde, Macedonio Fernández, Jacobo Fijman, y Raúl Scalabrini Ortiz

The party for "Don Segundo Sombra" in honour of Ricardo Güiraldes, Martín Fierro, Año III (second period), n. 36, 12th December 1926, p. 2. George and Marion Helft Collection, Buenos Aires

Galliéra, organized by La Maison de l'Amérique Latine and the Académie Internationale des Beaux-Arts. On the 20th June he leaves France for Hamburg where the Argentine Consul Raul Oyanharte helps him and Pettoruti to obtain tickets. They embark on the ship "Vigo" and reach Buenos Aires on the 23rd July 1924. Xul immediately joins the young avant-garde group based on the popular magazine *Martín Fierro*, founded by Evar Méndez.

Pettoruti prefers to exhibit in Florida street on his own, and Xul writes a long article on the show for *Martín Fierro*: *Lets us admit, then, that amongst us, still concealed, can be found all the germs for an art of the future, and not in strange museums, nor in the homes of overseas dealers. Let us honour our rare rebels who like this artist assert themselves rather than deny others, and let us be constructive rather than destructive. Let us honour those who struggle so that the soul of our country may be more beautiful. For the wars of Independence are not yet over. In art, one of the strongest champions is the painter Emilio Pettoruti.*

He exhibits 4 paintings for the first time in the *Primer Salón Libre* in Buenos Aires, a local version of the *Salon des Indépendants*.

The acute critic Atalaya (Alfredo Chiabra Acosta) picks on Xul's works as *the most curious contribution and strangely odd...*

### 1925
On the 21st April don Emilio Schulz Riga dies while living in the Penitenciaría Nacional. Xul writes to his *mamás* to summon them home. They arrive on the 29th July. Life in Buenos Aires is difficult. He misses Europe, but in one letter writes: *Since I have been here I have earned very little money with a few badly paid drawings. With time this will improve, I'll do designs, etc. I am doing a poster that I have sold, and I am promised money for paintings. Although things will get slowly better, and that after when I am well known with more friends than the few I have, I hope that there is always the chance of something, money, a job, commissions, etc. For me life is incomparably more useful in Europe than here. Over there there are many people with similar ideas who can teach me a lot, ultramodern artists who excite and stimulate me, here nothing, many intelligent people but dated in their ideas and without faith or passions. However here is the possibility of earning money (although a little more than in Europe) and later the chance to carry out, or begin to carry out, some of the many ideas that I have thought about. I am still unprepared, and some two years in Paris or London, and some months in Germany will help me so much. At the moment I have to stay here for a few months to find things out and meet all the important people...*

If Xul is happy to be back it is because he has the chance of being with his father again fulfilling a promise often repeated in letters.

Xul Solar

Nos alegraría mucho
que viniera esta tarde
a las 5 a tomar el té.
Lo saludamos Norah y Georg

JORGE LUIS BORGES

no solamente a tomar el té; a
tomar las almas (neo-acriollables)
de don Ricardo Güiraldes y otros que
estarán i sacrifiquen por la patria y
venga!
Av. Quintana 222

Postcard sent to Xul by Norah Borges and Jorge Luis Borges. Museo Xul Solar

He introduces his idea of **juxtaposed spaces** into his paintings. He sends 4 works to the *Salón de los Independientes*.

**1926**

He actively gets to know Argentine intellectuals and struggles to exhibit his work. His linguistic researches are received with curiosity and interest. He frequents Victoria Ocampo, Norah Lange and Oliverio Girondo, Macedonio Fernández, and especially Jorge Luis Borges with whom he shares an interest in Johannes Becher, Emanuel Swedenborg and William Blake.

To mark the visit by Marinetti in Buenos Aires, Amigos del Arte, the most prestigious cultural centre in the city run by Elena Sansinena de Elizalde, holds an *Exhibition of Modern Painters* on the 17th June for three days where Xul hangs 11 watercolours next to work by Norah Borges, Pettoruti, the architects Vautier and Alberto Prebisch and the designer Pedro Illari. In these halls Marinetti gives daily lectures on avant-garde art. Xul sends his watercolours to the *Sala de Independientes* organized by the Commission for Fine Arts (3 watercolours) and to *La Peña* in the Café Tortoni (3 watercolours). His friendship with Borges strengthens and he illustrates his book *El tamaño de mi esperanza* (*The Size of my Hope*) with five small vignettes, published by Proa. Borges dedicates his essay *El idioma infinito* (*The Infinite Language*) from this book to Xul.

In his paintings three different lines of architectonic thought can be seen: a break with the functionalist idea of equilibrium; an architecture of open spaces; and coloured façades with rhythmic, repetitive features.

**1927**

Works actively with his linguistic researches and translates from German into *neocriollo Algunos piensos cortos* (*Small Short Thoughts*) by the German Expressionist Christian Morgenstern,

taken from his book *Stufen* and publishes them in *Martín Fierro* where he had previously published a short humorous note bidding farewell to the poet and writer Leopoldo Marechal. He takes part in the first permanent exhibition of Argentine art organized by the Salón Florida- Art Dealers, with Basaldúa, Norah Borges, del Prete, Figari and Thibon de Libián. In October he exhibits in Boliche de Arte: *Great Fair of Young Painters*. The philosopher Carlos Alberto Erro chooses one of Xul's work for the cover of *Revista de América*. His paintings reflect his interest in Latin American culture. He lives in Cabildo 4417 with his mother and aunt.

**1928**

Xul produces 6 illustrations for Borges's new book *El idioma de los argentinos* (*The Language of the Argentines*). During this period Xul concentrates on meditations on the I Ching hexagrams, and turns these into

Xul Solar's house on Laprida street 1212-1214-1216. Museo Xul Solar

neocriollo as the visions called *San Signos*, still unpublished. In November the three move to the house on Laprida 1212-1214-1216, a building from the last century with four flats. Two are on the ground floor which you enter through number 1212 and 1216. The other two on the first floor are entered through 1214. Xul and his family lived in the first floor.

**1929**
Macedonio Fernández, one of the most influential intellectuals of the time, acknowledges Xul's original thought in his book *Papeles del Recienvenido* (Papers of the Recently Arrived). Xul has his first one-man show on the 15th May in Amigos del Arte on Florida 659, with 62 paintings. He also exhibits in the *Nuevo Salón*. His works elicits good reviews from the more alert

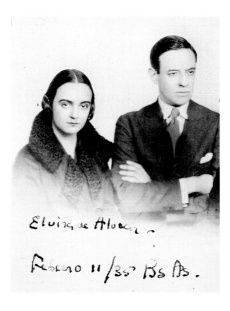

critics and writers. Horacio Quiroga praises his work, and E. M. Barreda interviews him, in La Nación. Xul shows his first works on reforms in writing, research that leads him to his *Grafías* (Ideographs).
Aleister Crowley writes to Xul on the 11th December: *Your register as the best visionary that I have ever examined still subsists today, and I would like to have this group of visions* [he refers to the *San Signos* based on the I Ching symbols] *as a model.*

**1930**
He again exhibits in October in the *Salón de Pintores y Escultores Modernos* held in Amigos del Arte with

9 works. He also sends works to La Plata, Rosario and the *Salón Centenario* in Montevideo under the auspices of the Grupo Independiente de Artistas Uruguayos. He buys a piano.

**1931**
Xul continues writing in *neocriollo*, and publishes *Poema* in the literary review *Imán*, edited in Paris by Elvira de Alvear, and one of his visions *Apuntes de neocriollo* in the magazine *Azul*. In May Xul again exhibits in the *Salón Centenario* in Montevideo and in the *Salón de Pintores Modernos* in Buenos Aires which opens on the 18th September in the presence of the French writer Paul Morand. He begins his series of **imaginary countries**.

**1932**
Takes part in the exhibition *Fifty Years of La Plata* in the Museo Provincial de Bellas Artes which buys his watercolour *Palacio Bría* (*Bria Palace*), one of the pictures of a new series which confirms the continuity of his architectural thinking. He shows in the Signo gallery in Buenos Aires, in Mendoza, and in Misiones. He joins the Corporación de Artistas Plásticos (Artists Association) and donates a work to be auctioned to help the daughter of the critic Atalaya who had recently died.

**1933**
Xul deepens his research into astrology, but is more interested in its philosophy than in predictions and in the connections between planets and the spiritual experiences of human beings. He also works on his neocriollo and a new language called *panlengua* (universal language). In the archives of the Fundación Pan Klub there are horoscopes done by Xul of many leading Argentines from the worlds of art, science and politics. He teaches, and gathers his friends in sessions that last until dawn and he translates for the magazine *El Hogar*, instigated by Borges, and for the Saturday section *Revista Multicolor* of the newspaper *Crítica*, also run by Borges. He publishes *Cuentos del Amazonas, de los Mosetenes y Guaruyús*, and signs it *Alejandro Schulz*. He participates in the *Salón de Pintores y Escultores Modernos* in Amigos del Arte.

**1934**
Xul sends two works to the *Salón de Dibujos, Acuarelas y Grabados* which opens on the 18th January. In May he has two works in the *Salón de Pintores*

Elvira de Alvear and Xul Solar (inscribed by Xul). (The photo belonged to Borges.) Georges and Marion Helft Collection, Buenos Aires

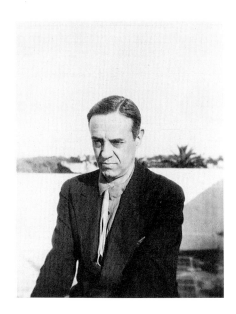

Alejandro Xul Solar on the terrace of his house on Laprida street. Museo Xul Solar

*Modernos*. He sells his piano, and obtains a "Dulcitone" for 200 pesos.

**1935**

As part of his desire to develop a system of visual communication linked to his neocriollo language Xul paints his first *Grafía* (Ideograph). Its meaning has yet not been decoded.

**1936**

Xul contributes two vignettes to the first number in October of the magazine *Destiempo*, edited by Adolfo Bioy Casares and Jorge Luis Borges, with E. Pissavini as secretary, who was the porter at Bioy's house (a typical example of the editors' kind of joking). In the following November number Xul publishes *Visión sobrel Trilineo* in neocriollo. He meets Micaela Cadenas, his future wife. Though he spends most of his time experimenting, and teaching astrology, he paints the magnificent *Vuel Villa* (*Flying City*). In November he exhibits three works in the Moody Gallery.

**1937-39**

In this decade he develops his *panjuego* (*pangame*)(universal game or panchess), a kind of chess based on astrology played with a board of 13 squares each way (or 13 by 12), with rules that Xul continuously changes. Xul invites his friends to play it. Borges and Marechal have written about this. On the 27th November 1939 as 12.25 Xul founds his **Pan Klub** (Universal Club) which he has been dreaming about since his youth.

[This key idea lead to the founding of the Pan Klub which became legally established in 1987 with the unconditional support of Micaela Cadenas de Schulz Solari (Lita Xul Solar, 1902-1988), and the other founding members: Natalio Jorge Povarché, Carlos Norberto Caprotti, Martha Lucía Rastelli de Caprotti, Juan José y Pablo Tomás Beitía and Elena Amanda Montero Lacasa de Povarché. The Xul Solar museum was opened in May 1993, and takes up three of the four flats in the house on Laprida 1212, preserving the flat

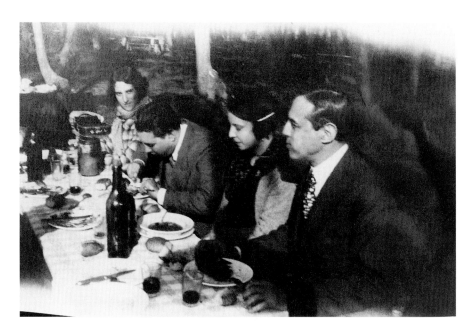

Borges and Xul Solar having lunch with two young ladies at the seaside resort of Quilmes. Museo Xul Solar

occupied by Xul and his family, with his studio and library. It was designed by the architect Pablo T. Beitía, and based on Xul's ideas.]

**1940**
In July Xul has another one-man show in the Sala II of Amigos del Arte, with 25 works, including *Tlaloc*, and *San Monte Lejos* which are bought by Borges, and two *Grafías*. Jorge Romero Brest writes about him in *Argentina Libre*. The critic and Academician José León Pagano completes his monumental work *El arte de los argentinos* (*The Art of the Argentines*), but ignores Xul.

**1941-43**
In 1941 Xul gives a lecture *Algunos aspectos de astrología* in the bar Baba-Yaga in San Isidro. Two years later takes part in the *Curso elemental de astrología* at the Universidad Espiritualista Americana in Rosario offering three topics: *Conceptos generales* (20th March), *Bhavo Chakro* and *Práctica del horóscopo* (18th and 19th September).

**1944-1947**
Paints a series of visions in white and black tempera, with yellow tones between ochre and chestnut suggesting Xul's anguished visions of Good and Evil. Jorge Calvetti publishes his poem *El forastero* in 1944, dedicated to Xul. Exhibition in the Galería Compte in 1944. On the 13th August 1946 Xul marries Micaela Cadenas (Lita Xul Solar). They travel the next day to Córdoba.

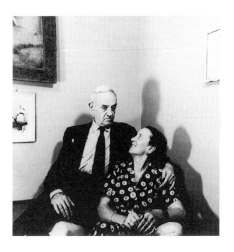

He starts to modify her piano, using the hexatonic range and a reduced keyboard. Illustrates *Un modelo para la muerte*, written by B. Suarez Lynch (pseudonym for Bioy Casares and Borges), as well as vignettes for the magazine *Los Anales de Buenos Aires*, edited by Borges.

Xul paints his **mystical landscapes** using automatist techniques. He takes part in 1948 in the *Salón de Acuarelistas* in Witcomb. On the 18th July 1949 he has a one-man show in the Samos gallery with 37 mystical landscapes painted between 1933 and 1949. The 16 paged catalogue (his first illustrated catalogue) carries a text by Borges. He also exhibits in the Salón Florida gallery and the Galería Cavallotti. On the 20th September gives a lecture in the Sala Velásquez on

Xul Solar and his wife Micaela Cadenas (Lita). Museo Xul Solar

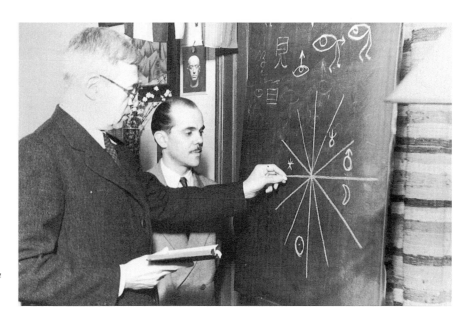

Xul preparing an astrological chart with the journalist Carlos Marín, and published in *Coche a la vista*. October 1950. Museo Xul Solar. ( On the wall is the painting *Zigzag con kioskos* (*Zigzag with News-stands*). Museo Xul Solar

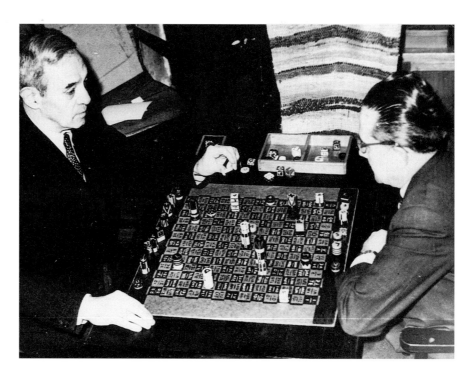

Alejandro Xul Solar in his house playing *pangame* with Carlos A. Foglia.
Museo Xul Solar

*Usos norbuddihistas adaptables a nuestra mentalidad* (Norbuddhist uses adaptable to our mentality).

**1950**
On the 11th February Xul travels to Montevideo invited to a congress on the *Guaraní* language.[1] On the 28th February Xul legalises the purchase of the house on Laprida 1212-1214-1216 from his aunt Clorinda at 65.000 pesos. In an interview published in a magazine on racing cars *Coche a la vista* Xul predicts Juan Manuel Fangio's fame through his astrological chart (in 1951 Fangio won his first world championship).

**1951**
He completes the mortgage on his house. Between the 3rd and 15th of September he exhibits at the Galería Guión in Buenos Aires with 24 works, and takes part in a show at the Galería Bonino.

1. Tupian Indian language spoken in Paraguay, southern Brazil and northeastern Argentina. Guaraní is sometimes considered the national language of Paraguay.

Xul and Lita's Tigre house, with his studio on the first floor. Museo Xul Solar

**1952**
Takes part in the show *Pintura y escultura de este siglo* in the Museo Nacional de Bellas Artes in Buenos Aires.

**1953**
On the 22nd September Xul opens his one-man show in the Galería Van Riel-Sala V. In the catalogue he publishes *Explica* (Explains) where he astrologically classifies twelve schools of painting. Between 1950 and 1953 his paintings reveal deep esoteric meanings linked to astrology. He makes puppets for adults, altars in wood, and a 24-card Tarot pack. He paints the portrait-horoscope of the Guatemalan writer Miguel Angel Asturias, a friend.
He begins to paint his cabbalistic monuments: *Pan-tree*.

**1954**
He buys a house in the Tigre delta, on the Luján river, at Los Ciruelos dock. He installs his workshop there, specially designed by himself. He crystallises his concept of architecture as a language, paints a series of architectures with letters to be built with pre-fabricated elements, and his coloured Delta houses (façades). Takes part in the *Exposición de pintura, escultura y arquitectura de nuestro tiempo* in Buenos Aires.

**1955**
On the 10th June Xul is operated in the

View of the interior of the Xul Solar museum.

Hospital Fernández. During convalescence he continues with his architectonic drawings and figures, mostly in ink on small sheets of paper and then mounted on board.

**1956-57**

He does not show his work. He writes *Propuestas para más vida futura. Algo semitécnico sobre mejoras anatómicas y entes nuevos (Proposal for more future life. Something semitechnical on anatomical improvements and new*

beings), published in the magazine *Lyra* and *Autómatas en la historia chica* (*Automatons in local history*) in the magazine *Mirador*.

**1958-1962**

Xul writes *Una vieja forma paranoica de publicidad, el Portlach (An old paranoiac form of advertising, the Potlatch)* in the magazine *Publicidad Argentina*. His mother dies in 1959. Xul paints his *grafías* and *grafía-portraits*, mainly done in his Delta house.

In 1960 he is invited to take part with two works in the show *150 años de Arte Argentino* in the Museo Nacional de Bellas Artes under its new Director Jorge Romero Brest, who wants to stimulate national art. He is also invited to show in the Museu de Arte Moderna in Rio (1961), and in the Musée National de l'Art Moderne in Paris (1962) with one work. In December 1961 the Board of the Argentine PEN Club invites him to join as an active member.

**1963**

On the 9th April he dies in his house on the Delta after a stroke, accompanied by his wife Lita who recounted the details to Borges.[2]

2. Jorge Luis Borges, *Recuerdos de mi amigo Xul Solar*, op. cit.

Xul playing the piano with Lita.
Museo Xul Solar

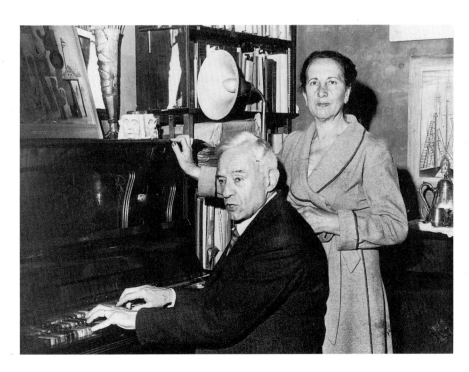

Partial view of the hall in Xul's house. On the
left you can see the painting *Desarrollo del I
Ching* (*Development of the I Ching*). Xul's
work table can be seen at the back.

# 8. Exhibitions, Bibliographies and Videos

## Principal Exhibitions

**1920**
Galleria Arte, *Xul Solar and the sculptor Arturo Martini* (46 watercolours, 4 temperas y 20 oils). Prologue by Emilio Pettoruti, Milan, 27th November to 16th December.

**1924**
Musée Gallièra, *Exposition d'Art Américain - Latin*, París (3 works), 15th March to 15th April.

*Primer Salón Libre*, Witcomb, Buenos Aires (4 works).

**1925**
*Salón de los Independientes*, Buenos Aires (4 works).

**1926**
Amigos del Arte, *Exposición de Pintores Modernos*, with Norah Borges and Emilio Pettoruti (11 works).

*Sala de los Independientes*, Comisión de Bellas Artes (3 watercolours), June.

Exposición en *La Peña*, Café Tortoni, Buenos Aires (4 watercolours).

**1927**
Salón Florida, Buenos Aires, with Norah Borges, del Prete and Basaldúa (2 watercolours).

**1929**
Amigos del Arte, *Xul Solar*, Buenos Aires (62 works), May.

**1930**
Amigos del Arte, *Salón de Pintores y Escultores Modernos*, with Norah Borges, Pettoruti, Victorica and others, Buenos Aires (9 works), October.

**1931**
Amigos del Arte, *Salón de Pintores Modernos*, Buenos Aires (7 works).

*Salón Centenario*, Montevideo, Uruguay September.

**1932**
Museo Provincial de Bellas Artes, *50 años de La Plata*, La Plata, Buenos Aires Province.

**1933-1939**
He takes part in collective exhibitions in Amigos del Arte, Buenos Aires, and in the *Salón del Arte de La Plata*, Buenos Aires Province.

**1940**
Amigos del Arte, Buenos Aires (1 work).

Amigos del Arte, *Xul Solar*, Buenos Aires (25 works).

**1949**
Galería Samos, *Xul Solar*, Buenos Aires (22 watercolours y 3 drawings). Prologue by Jorge Luis Borges.

Salón Florida, Buenos Aires (2 works).

Galería Cavallotti, Buenos Aires (3 works).

**1951**
Galería Guión, *Xul Solar*, Buenos Aires (24 works).

*Salón de Artes Plásticas de Mar del Plata*, Buenos Aires Province (2 works).

**1952**
Museo Nacional de Bellas Artes, *Pintura y escultura argentina de este siglo*, Buenos Aires.

**1953**
Galería Van Riel, Sala V, *Xul Solar*, Buenos Aires, (37 works). Prologue by Xul Solar: *Explica (He explains)*.

**1954**
*Exposición de pintura, escultura y arquitectura de nuestro tiempo*, Buenos Aires (5 works).

**1960**
Museo Nacional de Bellas Artes, *150 años de Arte Argentino*, Buenos Aires (2 works), with texts by Córdova Iturburu, José León Pagano, Enrique Azcoaga,

243

Lorenzo Varela, Ernesto B. Rodríguez and Samuel Paz.

**1961**
Museu de Arte Moderna, Río de Janeiro, *Arte Argentino, Brasil, 1961* (1 work), sponsored by the Argentine Embassy. Texts by Carlos Manuel Muñiz and Jorge Romero Brest.

**1962**
Musée Nationale d'Art Moderne, *Art àrgentin actuel*, Paris (1 work).

**1963**
Galería de Arte Riobóo, *Exposición homenaje*, Buenos Aires. Prologue by Osvaldo Svanascini.

Museo Nacional de Bellas Artes, *Homenaje a Xul Solar*, Buenos Aires (93 works). Prologue by Jorge Luis Borges, October.

**1964**
Galería Serra, *Surrealismo Imaginación*, Buenos Aires (6 works).

**1965**
Librería Galería de las Artes, *Exposición homenaje a Ignacio Acquarone*, Buenos Aires (1 work).

Galería Diálogos, *Homenaje a Xul Solar*, Olivos, Buenos Aires Province (22 works). Presented by Jorge Luis Borges.

Galería Dédalo, *Magia e Imaginación en la Pintura*, Buenos Aires (5 works).

Teatro Candilejas, *Homenaje a Xul Solar*, Buenos Aires (11 works).

Galería Proar, *Xul Solar, Exposición retrospectiva*, Buenos Aires (41 works). Catalogue with an authobiographic note and texts by Raúl Soldi, Juan Battle Planas, Adolfo de Obieta. 23th August to 11th September.

Museo de Artes Plásticas Eduardo Sívori, *Argentina en el mundo de las artes visuales 1*, Buenos Aires (2 works). Prologue by Ignacio Pirovano.

**1966**
Museo Provincial de Bellas Artes - Emilio Caraffa, *III Bienal Americana de Arte, Homenaje a Xul Solar* - guest of honour, Córdoba (50 works).

Sociedad Hebraica Argentina, *Homenaje al sesquicentenario de la Independencia Argentina*, Buenos Aires (1 work).

**1967**
Museo Provincial de Bellas Artes - Rosa Galisteo de Rodríguez, *Homenaje a Xul Solar*, Santa Fe (65 works). Prologue by Aldo Pellegrini.

Centro de Artes Visuales del Instituto Torcuato Di Tella, *Surrealismo en la Argentina*, Buenos Aires (9 works). Exhibition organized with the support of the Rubbers and Van Riel Galleries. Prologue and texts by J. Romero Brest and Aldo Pellegrini.

**1968**
Museo Provincial de Bellas Artes, *Homenaje a Xul Solar*, La Plata, Buenos Aires Province (80 works). Catalogue with prologue by Jorge Luis Borges, 17th July to 11th August.

**1969**
Galería de Arte Javier, *Xul Solar (homenaje)*, Buenos Aires (9 works). Prologue by J. L. Borges, 1949 (catalogue of Galería Samos).

Fundación Lorenzutti, *Panorama de la Pintura Argentina 1*, Salas Nacionales de Exposición, Buenos Aires (3 works).

**1970**
Galería Rubbers, *Xul Solar, Obras 1915-1962*, Buenos Aires (53 works). Prologue by Natalio Jorge Povarché, 19th May to 6th June.

Fundación Lorenzutti, *Pintura Argentina-Promoción Internacional*, Museo Nacional de Bellas Artes, Buenos Aires (2 works).

**1971**
Mediator Dei y Galería Rubbers, *IX Salón de Arte Sagrado*, Buenos Aires (1 work).

Galería Bonino, Buenos Aires (1 work).

Fundación Lorenzutti, *Pintura Argentina-Promoción Internacional*, Museo de Bellas Artes, Santiago, Chile (3 works).

**1972**
Fundación Lorenzutti, *Obras Maestras de la Pintura Argentina 1*, Salas Nacionales de Exposición, Buenos Aires (9 works).

**1974**
*Centenario Mar del Plata, homenaje de los Plásticos Argentinos*. Mar del Plata, Buenos Aires Province.

**1975**
Universidad de Buenos Aires, *Maestros de la Pintura Argentina*, Dirección de Cultura, Buenos Aires (1 work).

Galería Rubbers, *Xul Solar*, Buenos Aires (26 works). Prologue by Rafael Squirru, May.

**1976**
Galería Rubbers, *Xul Solar*, Buenos Aires (29 works). Prologue by Vicente Caride, August.

**1977**
Musée d'Art Moderne de la Ville, *Xul Solar*, Paris (61 works). Catalogue with texts by Jacques Lassaigne, Jorge Luis Borges and Aldo Pellegrini, 20th October to 27th November.

**1978**
Galería Rubbers, *Pintores Argentinos*, Buenos Aires (1 work).

FIAC 78" Grand Palais, *Xul Solar* (presented by Galería Rubbers), 20-29th October, París.

Galería Rubbers, *Xul Solar*, Buenos Aires (61 works). Prologue by Jacques Lassaigne with some critics that were published in Paris in 1977.

**1979**
Galería Rubbers, *Xul Solar*, Buenos Aires (24 works).

**1980**
Galería Rubbers, *Xul Solar*, Buenos Aires (24 works). Prologue by J. L. Borges, 1949 (Galería Samos).

**1982**
Galería Rubbers, *Homenaje a Xul Solar - 25 años de Rubbers*, Buenos Aires (25 works), 13th May to 1st June.

Galería Vermeer, *Los Raros*, Buenos Aires (6 works). Catalogue with text by Osiris Chierico, December.

**1983**
Galería Ruth Benzacar, *El anti-rinoceronte. Periódico Martín Fierro: las primeras vanguardias*, Buenos Aires (7 works). Introduction by Samuel Oliver, October - November.

**1984**
Galería Rubbers, *Xul Solar*, Buenos Aires (21 works). Prologue by J. L. Borges, October 1963.

**1985**
Galería Rubbers, *Xul Solar*, Buenos Aires (17 works). Prologue by Angel Bonomini, May-June.

**1986**
CAYC, *Xul Solar, exposición en ocasión de la reunión del ICOM*, Buenos Aires (30 works).

**1987-1988**
Galería Rubbers, *Xul Solar*, Buenos Aires (22 works). Prologue by Bengt Oldenburg.

*Art of the Fantastic Latin America, 1920-1987* (8 works), Indianapolis Museum of Art: June-September 1987. The Queens Museum, Flushing, Nueva York: October-December 1987. Center for the Fine Arts, Miami: January-March 1988. Catalogue by Holliday T. Day and Hollister Sturges with texts by E. Lucie-Smith, D. Bayón, F. Fevre and others. Indianapolis Museum of Art and Indiana University Press, 1987.

CAYC, *Cultura de lo Surreal*, Buenos Aires (12 works).

Galería Kramer, *Xul Solar*, Buenos Aires (25 works). With the support of Galería Rubbers. Prologue by Mario H. Gradowczyk.

**1989**
Galería Rubbers, *Grafías*, Buenos Aires (21 works). Prologue by Pierre Mazars (Le Figaro, 15th November 1977).

*Art in Latin American. The Modern Era 1820-1980* (5 works). The Hayward Gallery, Londres: May-August 1989, National Museum and Museum of Modern Art, Stockholm: September-November 1989 and Palacio de Velázquez, Madrid: December 1989 to March 1990. Catalogue by Dawn Ades with texts by Guy Brett, Stanton Catlin and Rosemary O'Neill. The South Bank Center and Yale University Press, 1989.

**1990**
Museo de Arte Americano de Maldonado, *Alejandro Xul Solar*, Uruguay (20 works). Prologue by Mario H. Gradowczyk, January-February.

**1991**
Rachel Adler Gallery, *Alejandro Xul Solar*, Nueva York (35 works). Prologue by Mario H. Gradowczyk, 2nd May to 8 th June.

**1992**
Guillermo de Osma Galería, *Xul Solar*, Madrid (23 works). Texts by Jorge Luis Borges (Galería Samos), Jacques Lassaigne (Musée d'Art Moderne de la Ville, Paris ) and Mario H. Gradowczyk, 13th February to 3rd April.

Estación Plaza de Armas, *Artistas Latinoamericanos del siglo XX*, Sevilla (14 works). Exhibition organized with the support of the Museum of Modern Art of New York by Waldo Rasmussen with essay by Edward J. Sullivan, 11th August to 12th October.

Musée Nationale d'Art Moderne, Centre Georges Pompidou, *Art d'Amérique latine 1911-1968*, Paris (10 works). Exhibition organized with the support of the Museum of Modern Art of New York, with texts by D. Bozo, W. Rasmussen, Alain Sayag, Mario H. Gradowczyk and others, 12th November to 11th January 1993.

Royal Museum of Fine Arts, *America-Bride of the Sun*, Antwerp (5 works). With texts by Paul Vandenbroeck, Mario H. Gradowczyk, and others, Imschoot Books: Ghent, 1992.

**1993**
Rachel Adler Gallery, *Xul Solar, A Collector's Vision*, New York (41 works). Prologue by Carol L. Blum.

Ludwig Museum, Cologne, *Lateinamerikanische Kunst in 20. Jahrhundert*, Exhibition organized with the support of the Museum of Modern Art of New York by Waldo Rasmussen with texts by Edward J. Sullivan and others, 9 th February to 25th April. Prestel: Munich, 1993.

Museum of Modern Art, *Latin American Artists of the Twentieth Century*, New York (7 works). Exhibition organized by Waldo Rasmussen with texts by Edward J. Sullivan, Daniel E. Nelson and others, 6th June to 7th September. Harry N. Abrams, Inc.: New York, 1993

**1994**
Courtauld Institute Galleries, *Xul Solar: the Architectures*, London (59 works). Catalogue edited by Christopher Green with texts by Dawn Ades, Katya García-Antón, Mario H. Gradowczyk, Christopher Green and John King.

## Writings by Xul Solar

**1924**
*Pettoruti*, Martín Fierro, Año 1 (second period), n. 10-11, September-October, Buenos Aires.

**1927**
*Morgenstern, Cristian, Algunos piensos cortos*, translation from German into *neocriollo*, Xul Solar, Martín Fierro, Año IV (second period), n. 41, Buenos Aires, 28th May.

*Despedida de Marechal*, Martín Fierro, Año IV (second period), n. 37, Buenos Aires, 20th January.

**1931**
*Poema*, Imán, n. 1, París, April, p. 50.

*Apuntes de neocriollo*, Azul, Año II , n. 11, Azul, August, p. 201.

**1933**
*Cuentos del Amazonas, de los Mosetenes y Guaruyús*, Revista Multicolor de los Sábados, Crítica, Año I, n. 2, 19th August.

**1953**
*Explica*, prologue to the catalogue of his show in Galería Van Riel.

**1957**
*Propuestas para más vida futura. Algo semitécnico sobre mejoras anatómicas y entes nuevos*, Lyra, Año XV, n. 5, Buenos Aires, pp. 164-166.

*Autómatas en la historia chica*, Mirador, n. 2, Buenos Aires, June.

**1958**
*Una vieja forma paranoica de publicidad, el "Portlach"*, Publicidad Argentina, Año II, n. 11, Buenos Aires, October, p. 34.

**1981**
*Poema*, with an etching by Martha Ripoll, Ediciones Dos Amigos: Buenos Aires, February (numbered edition of 50 copies.)

**1985**
Alejandro Schulz Solari, *Tres mitos aborígenes. Cuento del Amazonas, La cadena de flechas (cuento de los guaruyús del este boliviano), La Gran Serpiente (leyenda mosetene, norte de Bolivia)*, Tiempo Argentino, Buenos

Aires, 17th March. (First published in
Revista Multicolor de los Sábados,
Crítica, 1933.)

## Books Illustrated by Xul Solar

1926
Jorge Luis Borges, *El tamaño de mi
esperanza*, Proa: Buenos Aires
(5 vignettes).

1928
Jorge Luis Borges, *El idioma de los
argentinos*, M. Gleizer Editor: Buenos
Aires (6 vignettes).

1946
B. Suárez Lynch (pen-name of Adolfo
Bioy Casares and Jorge Luis Borges),
*Un modelo para la muerte*, Oportet &
Haereses: Buenos Aires (7 vignettes)
(Numbered edition of 300 copies.)

## Books and Monographs on
## Xul Solar

1962
Svanascini, Osvaldo, *Xul Solar*,
Ediciones Culturales Argentinas: Buenos
Aires.

1967
Pellegrini, Aldo, *Xul Solar*, Viscontea
Editora, Vol. I, n. 9, Buenos Aires.

1980
López Anaya, Jorge, *Xul Solar, Pintores
Argentinos del siglo XX*, Fascículo n. 27,
Centro Editor de América Latina:
Buenos Aires. (Erroneously attributed to
J. M. Taverna Irigoyen.)

1988
Gradowczyk, Mario H., *Alejandro Xul
Solar*, Ediciones Anzilotti: Buenos Aires,
with texts and poems by J. L. Borges, J.
Calvetti, C. Morgenstern, Xul Solar, R.
Aizenberg, J. Battle Planas, F. L.
Bernárdez, P. Mazars and R. Soldi.

1990
*Xul Solar, Collection of the Art Works
in the Museum* with texts by Natalio J.
Povarché, Jorge Luis Borges, Jacques
Lassaigne, Aldo Pellegrini y Rafael
Squirru, edited by Mario H.
Gradowczyk. Pan Klub Foundation Xul
Solar Museum: Buenos Aires

## Videos

1987
*Xul Solar*, text by María Esther Vázquez,
directed by Hipólito R. Míguez, Elsa
Gaffuri production: Buenos Aires.

1988
*Xul Solar*, text and direction by María
Ofelia Escasany, Fundación María Ofelia
Escasany: Buenos Aires.

## Articles and Essays on Xul Solar

1920
M. G. S. *Martini, Xul, Galli e Villani*, Il
Popolo d'Italia, 27th November.

*Xul e Martini Alla Galleria Arte*, La
Sera, Milan, 27th November.

1921
*Decadencia del Arte en la Época Actual*,
La Razón, Buenos Aires, 17th January.

1924
R. de Souza, *Xul Solar*, La Prensa,
Buenos Aires, 14th July.

*Xul Solar*, La Razón, Buenos Aires,
17th August.

1925
*Salón de los Independientes*, La
Argentina, Buenos Aires,
27th November.

1926
Blake, Pedro, *Exposición de pintura y
escultura en La Peña*, Martín Fierro,
Año III (second period), nos. 30-31,
Buenos Aires, 8th July.

Prebisch, Alberto, *Marinetti en los
"Amigos del Arte"*, Martín Fierro,
Año III (second period), nos. 30-31,
Buenos Aires, 8th July.

1928
Pettoruti, Emilio, *Alejandro Xul Solar*,
Espiral, Año II, n. 24, Bahía Blanca.

1929
*Amigos del Arte*, La Razón, Buenos
Aires, 22th May.

Quiroga, Horacio, *Al margen de la
Pintura - Xul Solar*, La Nación, Buenos

Aires, 24th May.
*Exposiciones de Xul Solar y Antonio
Berni*, La Prensa, Buenos Aires,
27th May.

*Argentina en el Arte*, Nuevo Año, Vol. 1,
n. 14, Buenos Aires, p. 217.

Zia, Lisardo, *Los Amigos del Arte*, La
Fronda, Buenos Aires, 20th September.

*Exposición Xul Solar*, La Prensa, Buenos
Aires, 1st October.

Barreda, Ernesto Mario, *Por los Reinos
de la Cábala -Xul Solar*, La Nación,
Buenos Aires, 20th October, p. 32.

1930
*Amigos del Arte*, El Argentino, La Plata,
Pcia. de Buenos Aires, 16th January.

*Argentina*, Revista de Arte y Crítica, La
Razón, Buenos Aires, 30th November.

De Torre, Guillermo, La nueva pintura
argentina, *La Gaceta Literaria*, Madrid,
Tomo 4, n. 95, 1st December.

1932
*Dos Acuarelas de Xul Solar*, Crítica,
Buenos Aires, 27th November.

1933
*Dibujos de escritores*, El Mundo, Buenos
Aires, 24th April.

Pettoruti, Emilio, *Xul Solar*, Crisol,
Buenos Aires, 27th July.

*Del Primer Salón de la Plata*, La Nación,
Buenos Aires, 29th August.

1934
*Xul Solar*, La Nación, Buenos Aires,
April.

*Amigos del Arte*, La Nación,
Buenos Aires, 30th May.

*2º Salón de La Plata*, La Prensa, Buenos
Aires, 14th June.

Chiabra Acosta, Alfredo (Atalaya),
*1920-1932 Críticas de Arte Argentino*,
M. Gleizer Editor: Buenos Aires.

1935
*Xul Solar*, La Nación, Buenos Aires,
21st March.

1940
*Exposiciones en "Amigos del Arte"*, La

Nación, Buenos Aires, 29th July.
Romero Brest, Jorge, *Xul Solar en Amigos del Arte*, Argentina Libre, Buenos Aires, 8th August.

*Universidad Espiritualista Americana*, La Acción, Rosario, Santa Fe Province, 9th August.

**1944**
Calvetti, Jorge, *El forastero*, poem dedicated to Xul Solar, Comisión Nacional de Cultura, Buenos Aires.

**1947**
Indart, Héctor N., *Xul Solar, creador del Panajedrez*, Él, Buenos Aires, Año 1, n. 1, January.

**1949**
*Exposiciones Xul Solar*, Noticias Gráficas, Buenos Aires, July.

V. de L. T., *Xul Solar*, El Mundo, Buenos Aires, 24th July.

*Acuarelas y dibujos de Xul Solar*, Clarín, Buenos Aires, 24th July.

*Exposición Xul Solar*, La Prensa, Buenos Aires, 28th July.

*Acuarelas y dibujos de Xul Solar*, Mundo Argentino, Buenos Aires, 10th August.

Borges, Jorge Luis, *Xul Solar y su arte*, Continente, Buenos Aires, n. 31, October.

*Xul Solar*, Continente, Buenos Aires, n. 32, November, p. 76.

**1950**
Sekelj, Tibor, *Jugar con las estrellas - Xul Solar*, Leoplán, Buenos Aires.

Marín, Carlos. *Los Astros señalan a Juan Manuel Fangio, como a un hombre de grandes destinos (Xul Solar)*, Coche a la vista, Buenos Aires, October.

**1951**
Marechal, Elbia Rosbaco de, *En el país de Xul*, poem, Buenos Aires.

Sheerwood, Gregory, *Xul Solar Campeón Mundial del Panajedrez y Panlingua*, Mundo Argentino, Buenos Aires, 1st August.

Córdova Iturburu, Cayetano, *Xul Solar*, Clarín, Buenos Aires, 9th September.

Berrante, Fabio, *Exposiciones: Xul Solar*, El Líder, Buenos Aires, 28th October.

**1953**
Foglia, Carlos A., *Xul Solar pintor de símbolos efectivos*, El Hogar, Buenos Aires, Año XLIX, n. 2288, 18th September, p. 49.

*Xul Solar*, El Mundo, Buenos Aires, 3th October.

Dolika, *Xul Solar, Peintre, Astrologue et Mystique*, Le Quotidien, Buenos Aires, 9th October.

E. B. R., *Xul Solar*, Letra y Línea, Buenos Aires, November.

**1957**
Córdova Iturburu, C., *Xul Solar y el Reino de la Fantasía*, Clarín, Buenos Aires, 17th February.

**1961**
De la Torre, Dora, *Xul Solar, el hombre increíble*, El Mundo, Buenos Aires, 20th October.

San Martín, María Laura, *Pintura Argentina Contemporánea*, Buenos Aires: La Mandrágora.

**1963**
*Xul Solar, en una muestra póstuma*, La Nación, Buenos Aires, 25th April.

R. G. T. *Xul Solar*, Clarín, Buenos Aires, 20th May.

Taverna Irigoyen, J. M., *Xul Solar y la irrealidad*, El Litoral, Santa Fe, 28th July.

*Un homenaje al pintor Xul Solar*, Clarín, Buenos Aires, 10th October.

*Un homenaje a Xul Solar y su extraño mundo*, La Nación, Buenos Aires, 25th October.

Fraga, Alfredo, *Vigencia patafísica de un mago*, La Nación, Buenos Aires, 24th November.

*Xul Solar pintor, astrólogo y creador de Panlengua*, Clarín, Buenos Aires, 12th December.

Córdova Iturburu, C., *Magia y originalidad de Xul Solar*, El Mundo, Buenos Aires, 22th December.

**1965**
*Muestra en memoria de Xul Solar*, La Prensa, Buenos Aires, 3th May.

*Homenaje a Xul Solar*, La Nación, Buenos Aires, 30th May.

E. R., *Artes Plásticas - Xul Solar*, La Prensa, Buenos Aires, 6th June.

*Xul Solar*, La Prensa, Buenos Aires, 6th July.

*Xul Solar: El Guardián del Fuego*, Primera Plana, Buenos Aires, 10th August.

*Tendencias Xul Solar*, La Razón, Buenos Aires, 28th August.

Córdova Iturburu, C., *Xul Solar*, El Mundo, Buenos Aires, 29th August.

Blum, Sigwald, *Xul Solar*, Argentinisches Tageblatt, Buenos Aires, 5th September.

Aparicio, M. A., *Los Grandes Valores*, El Orden, Buenos Aires, 17th October.

*Argentina en el Mundo Artes Visuales 1- Xul Solar*, Ministerio de Relaciones Exteriores y Culto, Buenos Aires, 15th December.

Brughetti, Romualdo, *Historia del Arte en la Argentina*, Pomarca, México.

**1966**
Pereda Valdéz, Ildefonso, *Borges y Xul Solar*, El País, Montevideo, Uruguay, 8th February.

Rodríguez, Ernesto B., *Visiones del Arte en la Argentina*, Femirama, Buenos Aires, March.

*Xul Solar y Artistas Cordobeses en el Museo Caraffa*, Comercio y Justicia, Córdoba, 14th October.

*Muestra Xul Solar en el Museo Provincial de Bellas Artes, Emilio Caraffa, Córdoba*. La Nación, Buenos Aires, 15th October.

*Xul Solar en el Museo Caraffa - Córdoba*. La Nación, Buenos Aires, 18th October.

Coconier, G., *Xul Solar*, La Colmena, Año LIX, n. 592, Buenos Aires, 15th November.

**1967**
Pellegrini, Aldo, *Panorama de la Pintura Argentina Contemporánea*, Paidós: Buenos Aires, pp. 17, 24-26 and 119.

Derbecq, Germaine, *Los Precursores*, Karina, Buenos Aires, January.

Marechal, Leopoldo, *El Panjuego de Xul Solar, un acto de amor*, Cuadernos de Mr. Crusoe, Buenos Aires, p. 166.

*Xul Solar - Surrealismo*, Panorama, Buenos Aires, June.

Córdova Iturburu, C., *Surrealismo en nuestro país*, El Mundo, Buenos Aires, 9th July.

**1968**
*Bienal de Córdoba, Homenaje a Xul Solar*, La Nación, Buenos Aires, 15th July.

Pettoruti, Emilio, *Un pintor frente al espejo*, Solar-Hachette: Buenos Aires.

*Xul Solar en La Plata*, La Prensa, Buenos Aires, 17th July.

*Muestra de homenaje al pintor Xul Solar*, El Día, La Plata, Buenos Aires Province, 17th July.

*Bellas Artes - homenaje a Xul Solar*, La Nación, Buenos Aires, 23th July.

*Un misterio llamado Xul Solar*, El Día, La Plata, Buenos Aires Province, 21st August.

**1969**
Bernárdez, Francisco Luis, *Xul Solar*, Clarín, Buenos Aires, 30th January.

Svanascini, Osvaldo, *Alejandro Xul Solar*, Panorama de la Pintura Argentina 1, Buenos Aires.

*Pintura y Realidad - Xul Solar*, Análisis, Año IX, n. 430, Buenos Aires, 3rd June.
*Xul Solar*, Clarín, Buenos Aires, 12th June.

Boots, Mim, *Palabras / Porteño - Xul Solar*. The Bulletin Board American Women's Club, Vol. 34, n. 5, Buenos Aires, August, p. 10.

*Xul Solar - un habitante del misterio*, Revista 2001, Año 2, n. 13, Buenos Aires, August, p. 54.

**1970**
*Centenario de La Nación, Xul Solar*, La Nación, Buenos Aires, 4th January.

Barrios, Américo, *Fascinante sorpresa - Xul Solar*, Crónica, Buenos Aires, 1st February.

*Retrospectiva de Xul Solar*, La Nación, Buenos Aires, 23th May.

*Xul Solar*, Periscopio, Buenos Aires, 26th May.

*Dueño del misterio*, Confirmado, Buenos Aires, 27th May, p. 68.

Hernández Rosselot, *Xul Solar, un precursor de lo insólito*, La Razón, Buenos Aires, 30th May.

*Xul Solar - Pinturas*, Decoralia, n. 52, Buenos Aires, August, p. 117.

**1971**
Taverna Irigoyen, J. M., *Xul Solar y la Irrealidad*, La Capital, Rosario, Pcia. de Santa Fe, 21st March.

Demaría, Fernando, *Xul Solar y Paul Klee*, Lyra, Año 28, nos. 216-218, Buenos Aires.

Perazzo, Nelly, *Xul Solar*, Lyra, Año 28, nos. 216-218, Buenos Aires.

Svanascini, Osvaldo, *Los Panoramas de la Pintura Argentina en una experiencia de la Fundación Lorenzutti*, Lyra, Año 28, nos. 216-218, Buenos Aires.

*Dos exposiciones en Rubbers: Xul Solar-Roberto Aizenberg*, Lyra, Año 28, nos. 216-218, Buenos Aires.

*El Surrealismo en la Argentina (Xul Solar)*, Clarín, Buenos Aires, 31st October.

Safons, Horacio, *Breve historia del pincel*, Primera Plana, n. 461, Buenos Aires, 30th November.

Monzón, Hugo, *Plástica - Xul Solar*, La Opinión, Buenos Aires, 29th December.

**1972**
Molina, Antonio, *El misterioso artista Xul Solar*, Traza y Baza, España, n. 2.

**1973**
Trípoli, Vicente, *Xul Solar, entre la tierra y el espacio*, Clarín, Buenos Aires, 2nd July.

**1974**
*Una exposición que revela a la ciudad - Xul Solar* (Centenario de Mar del Plata), La Nación, Buenos Aires, 1st February.

**1975**
Arcidiácono, Carlos, *La Aventura de la Imaginación - Xul Solar*, Mercado, Buenos Aires, 22nd May.

Graham Yooll, Micaela, *Xul Solar*, Buenos Aires Herald, Buenos Aires, 24th May.

*Xul Solar*, La Opinión, Buenos Aires, 31st May.

Haedo, Oscar F., *Pettoruti, Curatella Manes, Xul Solar, la apertura estética de 1924*, Mayoría, n. 23, Buenos Aires, p. 12.

*Xul Solar*, La Opinión, Buenos Aires, 1st June.

*Xul Solar*, El Cronista Comercial, Buenos Aires, 5th June.

Bajarlía, Juan Jacobo, *Xul Solar, el hombre que leía las estrellas*, Clarín, Buenos Aires, 5th June.

*Xul Solar*, Síntesis de la Industria, Buenos Aires, 9th June.

*Xul Solar*, La Nación, Buenos Aires, 9th June.

Pellegrini, Aldo, *Todos los cielos de Xul Solar*, La Opinión, Buenos Aires, 15th June.

Zito Lema, Vicente, *La cuidadora de ese mensaje*, La Opinión, Buenos Aires, 15th June.

Calvetti, Jorge, Obieta, Adolfo, Mosquera Eastman, Ricardo, *Otras aproximaciones*, La Opinión, Buenos Aires, 15th June.

*Borges y Borges (Xul Solar)*, Plaza Magazine, n. 2, Buenos Aires, September.

*Borges - Xul*, La Razón, Buenos Aires, 3rd September.

**1976**
*Rubbers - Xul Solar*, La Nación, Buenos Aires, 20th March.

Graham - Yooll, Micaela, *Xul Solar*,

Buenos Aires Herald, Buenos Aires, 27th May.

*Xul Solar*, Guía de Arte, Buenos Aires, May.

*Xul Solar Symbolische Bildwelt*, Argentinisches Tageblatt, Buenos Aires, 30th May.

Marini, Orlando, *Xul Solar*, Pregón, San Salvador de Jujuy, 30th May.

Bonomini, Angel, *Xul Solar - Rubbers*, La Nación, Buenos Aires, 6th June.

*Borges y Xul Solar*, Supplement of Crítica, Buenos Aires, May-June.

Rivera, Jorge B., *Xul Solar o la creación cósmica*, Clarín Revista, Buenos Aires, 12th August.

**1977**
Bini, Rafael A., *Los Mundos de Xul Solar*, Expreso Imaginario, n. 7, Buenos Aires, February.

Pazos, Luis, *Xul Solar, sesenta años después lo reconocen en París*, Somos, n. 40, Buenos Aires, 24th June.

*Xul Solar's Expositions*, Aurore, Paris, 18th October.

*Jorge L. Borges (Xul Solar)*, Le Figaro, Paris, 20th October.

*Jorge L. Borges (Xul Solar)*, L'Humanité, Paris, 21st October.

*Distinction*, Aurore, Paris, 21st October.

*Xul Solar*, Connaissance des Arts, Paris, November.

*Exposition Solar*, Centre Presse Portiers, Paris, 3rd November.

Mazars, Pierre, *Le cas Solar*, Le Figaro, Paris, 15th November.

*Xul Solar*, Panorama du Medecin, Paris, 5th November.

G. P. *La magie de Xul Solar*, Quotidien de Paris, 3th November.

Discazany, André, *Rehabilitación en París de un precoz Surrealismo Argentino*, Correo de Arte, Año 1, n. 4, Buenos Aires, 13th November, p. 130.

*Xul Solar en París*, La Opinión, Buenos Aires, 13th November.

*Nouvelles Argentines -Un Peintre Surréaliste- 100 idées*, La Maison, Paris, December.

*Xul Solar, un pintor visionario*, Siete Días, Buenos Aires, 14th December.

**1978**
*Xul Solar*, La Nación, Buenos Aires, 24th May.

*Las grafías de Xul Solar*, Correo de Arte, Año 2, n. 5, Buenos Aires, May, p. 37.

Conrad de Behar, Thelia, *Solar Creative Visionary*, Buenos Aires Herald, Buenos Aires, 1st June.

Galli, Aldo, *Xul Solar*, La Prensa, Buenos Aires, 3rd June.

Monzón, Hugo, *Las sesenta y una piezas (de Xul Solar) que se exhibieron en París*, La Opinión, 3rd June.

Calvetti, Jorge, *La Realidad*, poem, La Prensa, Buenos Aires, 3rd September.

Bello, Luis, *Xul Solar en París*, La Nación, Buenos Aires, 4th September.

Perrone, Alberto M., *Xul Solar, el Mago*, La Nación, Buenos Aires, 17th September.

Córdova Iturburu, C., *Ochenta años de Pintura Argentina - del preimpresionismo a la novísima figuración*, Librería de la Ciudad: Buenos Aires.

*FIAC 78 - Xul Solar*, Periscope, n. 543, Paris, 18th October, p. 109.

**1979**
Nanni, Martha, *Xul Solar, FIAC 78, París*, Horizonte, Revista de Arte, Año 2, n. 3, Buenos Aires, p. 33.

*Obras de Xul Solar en Galería Rubbers*, La Opinión, Buenos Aires, 17th May.

Benarós, León, *Obra inédita de Xul Solar - rara originalidad*, Clarín, Buenos Aires, 19th May.

*Xul Solar (Malerei) Galería Rubbers*, Argentinisches Tageblatt, Buenos Aires, 20th May.

Conrad de Behar, Thelia, *Xul Solar*, Buenos Aires Herald, Buenos Aires, 24th May.

*Xul Solar*, Clarín, Buenos Aires, 26th May.

Alva Negri, Tomás, *Xul Solar, hombre y pintor insólito*, La Opinión, Buenos Aires, 26th May.

Galli, Aldo, *Xul Solar*, La Prensa, Buenos Aires, 28th May.

*Los espejos de un místico (Xul Solar)*, Siete Días, Buenos Aires, 30th May.

Andrés, Alfredo, *Piezas de Xul Solar en Galería Rubbers*, La Opinión, Buenos Aires, 31st May.

Pérez, Elba, *Xul Solar*, Convicción, Buenos Aires, 1st June.

*Xul Solar*, El Economista, Buenos Aires, 1st June.

Pazos, Luis, *Xul Solar, el primer adelantado*, Somos, Buenos Aires, 1st June, p. 42.

*Xul Solar - Esoterismo, Surrealismo y otras expresiones*, La Nación, Buenos Aires, 2nd June.

**1980**
Brughetti, Romualdo, *El mundo esotérico de Xul Solar*, Clarín, Buenos Aires, 6th April.

Byron, Silvestre, *Xul Solar, el amigo de Jorge L. Borges*, Magazine, Año 2, n. 19, Buenos Aires, April.

Galli, Aldo, *Las acuarelas de Xul Solar. Una expresión desmesurada*, La Prensa, Buenos Aires, 5th May.

*Xul Solar*, La Nación, Buenos Aires, 10th May.

Conrad de Behar, Thelia, *Creative Concepts*, Buenos Aires Herald, Buenos Aires, 15th May.

Squirru, Rafael, *Pintura moderna de los argentinos*, Siete Días, Año XIV, n. 699, Buenos Aires, 5th November, p. 51.

**1981**
*Xul - Revista de Poesía*, La Nación, Buenos Aires, 11th January.

**1982**
Pérez, Elba, *Magia y misterio del inefable Xul Solar* and *Sólo los Dioses benévolos juegan, y un mensaje que en el 2000 se verá*, Tiempo Argentino, Buenos Aires, 10th April.

*Xul Solar*, La Prensa, Buenos Aires, 17th May.

Conrad de Behar, Thelia, *Metaphysics and Reality in Painting*, Buenos Aires Herald, Buenos Aires, 23th May.

*El Múltiple Xul Solar, y una herencia que aún debemos descifrar*, La Gaceta de Hoy, Buenos Aires, 17th June, p. 3.

*Martín Fierro. La vanguardia presente*, Artinf Arte Informa, Año 7, n. 42, Buenos Aires, July-August.

*Iglesia de María de Xul Solar*, Somos, Año 6, n. 313, Buenos Aires, 17th September, p. 31.

**1984**
Diéguez Videla, Albino, *Xul Solar, una muestra y los recuerdos de Lita*, La Prensa, Buenos Aires, 22nd April.

Borges, Jorge Luis, *Laprida 1214* in *Atlas*, Sudamericana: Buenos Aires, p. 77.

*Xul Solar*, Primera Plana, Buenos Aires, 27th April.

*Obras de Xul Solar*, La Nación, Buenos Aires, 5th May.

Pérez, Elba, *Aquel viejo mago de la Tribu, que se llamaba Xul Solar*, Tiempo Argentino, Buenos Aires, 11th May.

*Ganchegui y Xul Solar: Dos generaciones en plástica*, Somos, Buenos Aires, 11th May.

Galli, Aldo, *Xul Solar: Pintura y esoterismo*, La Prensa, Buenos Aires, 13th May.

Rivera, Jorge B., *Invicto de juego inexistente Xul Solar*, Tiempo Argentino, Buenos Aires, 17th May.

*Xul Solar, Rubbers festeja medio millar de exposiciones. La primera muestra de Galería Rubbers, cuando inauguró en 1957, incluía obras de Xul Solar*, La Razón, Buenos Aires, 28th May.

Galli, Aldo, *Del Arte Enigmático de Xul Solar al esteticismo de Teresio Fara*, La Nación, Buenos Aires, 8the June.

Pérez, Elba, *Xul Solar, ese enigma que vivió entre nosotros*, Tiempo Argentino, Buenos Aires, 10th June.

Galea, Héctor A., *Xul Solar, un anticipo surrealista*, Clarín, Buenos Aires, 9th September.

Borges, Jorge Luis and Ferrari, Osvaldo, *Borges evoca dos misterios: el de la luz y el de la sombra*, Tiempo Argentino, Buenos Aires, 3th October.

Benarós, León, *Símbolo, número, magia en Xul Solar*, Artinf Arte Informa, Año 10, n. 52-53, Buenos Aires, September-December, p. 12.

*Washington desea un Xul Solar*, Rogelio Novey, 1986 , Óleo y Mármol, Año 1, n. 2, Buenos Aires, June.

**1987**
*Intento de equilibrio (Xul Solar), los 15 mejores cuadros de la Pintura Argentina*, Gente, Año 19, n. 1128, Buenos Aires, 5th March, p. 42.

Galli, Aldo, *Xul Solar*, La Nación, Buenos Aires, 16th May.

Rubione, Alfredo, *Xul Solar: utopía y vanguardia*, Punto de Vista, Año X, n. 29, Buenos Aires, p. 37.

Gradowczyk, M. H., *Xul Solar, el umbral de otros cosmos*, Artinf Arte Informa, Año 12, nos. 64-65, Buenos Aires, p. 16.

Brill, Rosa, *Xul Solar*, Clarín, Buenos Aires, 25th July.

López Anaya, Jorge, *Xul Solar y Horacio Butler en dos reveladores videos*, La Nación, December.

Fevre, Fermín, *Alejandro Xul Solar*, in *Art of the Fantastic: Latin America, 1920-1987*, Indianapolis Museum of Art: Indianápolis, p. 230.

**1988**
Vázquez, María Esther, *Xul Solar y Borges*, La Nación, Buenos Aires, 7th February.

López Anaya, Jorge, *Obras de brillantes autores en una muestra surrealista*, La Nación, Buenos Aires, 26th March.

Aulicino, Jorge, *Xul Solar. El criollo que abrió las puertas del universo*, Clarín, Buenos Aires, 22th May.

Benarós, León, *Xul Solar y la criptomagia*, Artinf Arte Informa, Año 13, nos. 72-73, Buenos Aires, p. 34.

Fevre, Fermín, *Recordando a Xul Solar*, Criterio, Año LXI, n. 2013, 25th August.

Copani, María, *Xul Solar y Borges*, (Selection from a Conference by Jorge Perednik), Clarín, Buenos Aires, 20th October.

Herrera, Matilde, *Xul Solar*, Página 12, Buenos Aires, 15th November.

Brughetti, Romualdo, *Entre la realidad y la ficción: Xul Solar*, by M. H. Gradowczyk, La Nación, Buenos Aires, 27th November.

Driben, Leila, *Xul Solar. Edición a cargo de Mario H. Gradowczyk*, Babel, Año 1, n. 5, November, p. 31.

De Arteaga, Alicia, *Xul Solar*, La Nación, Buenos Aires, 25th November.

**1989**
J. G. M., *Xul Solar*, Nuevo Sur, Buenos Aires, 9th June.

Diéguez Videla, Albino, *Xul Solar*, La Prensa, Buenos Aires, 11th June.

Galli, Aldo, *Xul Solar*, La Nación, Buenos Aires, 12th June.

Magrini, César, *Xul Solar*, El Cronista Comercial, Buenos Aires, 15th June.

Diéguez Videla, Albino, *Video Fundación Escasany*, La Prensa, Buenos Aires, 19th July.

*Xul Solar en Video*, by María Ofelia Escasany and Federico Aldao, El Cronista Comercial, Buenos Aires, 25th July.

**1990**
Haber, Alicia, *Sumas y Restas del Panorama Veraniego*, Punta del Este. El País, Montevideo, 12th February.

Vázquez, María Esther, *De Pettoruti al condominio de los medios de comunicación*, La Nación, Buenos Aires, 1st July, 4° section, p. 4.

Jorge Luis Borges, *Recuerdos de mi amigo Xul Solar*, (text of a lecture given at the Fundación San Telmo), Comunicaciones 3, Fundación San Telmo: Buenos Aires.

López Anaya, Jorge, *Xul Solar, un creador modernista y visionario*, La Nación, Buenos Aires, 7th July, 3rd section, p. 5.

Diéguez Videla, Albino, *De Xul Solar a un enfoque velazqueño*, La Prensa (Semanario de Artes Visuales), Buenos Aires, 8th July, p. 5.

*Homenaje teatral a Xul Solar un artista con interrogantes*, El Cronista, Buenos Aires, 14th September, p. 26.

Peyrori, Oscar, *Una apariencia de locura*, La Voz del Interior, Córdoba, 14th September.

Squirru, Rafael, *Xul Solar, esoteric glimpses*, in *Xul Solar, Collection of the Art Works in the Museum*, Pan Klub Foundation Xul Solar Museum: Buenos Aires, p. 43.

**1991**
Gualdoni Basualdo, Adrián, *La Feria de los Dealers, Lo mejor del arte en Nueva York*, Clarín, Buenos Aires, 3rd March, p. 6.

*Xul Solar*, The Antique Collector, New York, May, p. 59.

*Alejandro Xul Solar*, Noticias de Arte, Año XVI, New York, May.

Nelson, Daniel, *Alejandro Xul Solar*, Latin American Art, Autumn number, p. 28.

Brenson, Michael, *Alejandro Xul Solar*, The New York Times, 7th June.

Ferrer, Elizabeth, *Alejandro Xul Solar*, Art Nexus, Colombia, n.2, October, pp. 136/137.

*Homenaje del arte a la ciencia*, Clarín - Artes y Antigüedades, 27th October, p. 8.

*El Antropólogo Schultze*, La Maga, Buenos Aires, 12th December, p. 30.

Adams, Brooks, *Alejandro Xul Solar at Rachel Adler*, Art in America, New York, December, p. 110.

**1992**
*La Fundación Pan Klub...*, La Nación, Buenos Aires, 30th March.
Ameijeiras, Hernán, *El Museo Xul Solar podría estar terminado en pocos meses más*, La Maga, Buenos Aires, 8th April.

Arias, Ana, *Un 9 de abril*, Clarín - Sociedad, Buenos Aires, 9th April, p. 70.

Gradowczyk Mario H., *An Approach to Xul Solar, America Bride of the Sun*, Imschoot Books: Ghent, 1992, pp. 424 / 427

Benarós, León, *Síntesis*, Clarín - Artes Visuales, Buenos Aires, 5th September. p. 39.

*El escritor de la puerta de al lado*, Clarín, 2nd. section, Buenos Aires, 13th September, p. 20.

De Arteaga, Alicia, *Resultados del efecto Quinto Centenario*, La Nación - Economía, Buenos Aires, 12th October, p. 13.

*Los Surrealistas no quieren rendirse*, Página 12 - Cultura, Buenos Aires, 25th October.

*El Tigre y el Delta*, *Xul Solar*, La Guía Pirelli Turismo, pp. 136, 356 and 357.

**1993**
Castro, Fernando, *Primera Muestra individual del pintor Xul Solar en España*, Diario 16, Madrid, 15th February.

Barnatan, Marcos R., *La vida de Xul Solar - Un artista versado en todas las disciplinas*, Metrópolis, n. 144, Madrid, 26th February.

Fietta Jarque, *Xul Solar en la Galería Guillermo de Osma - Ocultismo Luminoso*, Guía El País, n. 170, Madrid, 26th February, p. 10.

*Xul Solar 1887-1963*, Casa y Jardín, Madrid, n. 206, February-March, p. 16.

*Xul Solar*, Galería Guillermo de Osma, Galería Anticuaria, n. 104, Madrid, March, p. 18.

Huici, Fernando, *El sueño de Xul Solar*, El País, Madrid, 8th March.

Bonet, Juan Manuel, *Xul Solar,*

*ciudadano del cosmos*, Blanco y Negro - Arte, n. 3846, 14th March, pp. 61/63.

Pagano, José Luis, *Fantasmas en un Museo, Xul Solar uno de los pintores argentinos más importantes muestra su obra*, Somos, Año 14, n.868, Buenos Aires, 17th March, pp. 44/45.

Cantor, Alejandro Gabriel, *El Museo Xul Solar conserva un vanguardismo revolucionario*, El Cronista - Cultura, Buenos Aires, 19th March, p. 3.

Martínez Quijano, Ana, *Vertiginosa escalada mundial de Xul Solar*, Ámbito Financiero, Buenos Aires, 22th March, p. 2.

Ameijeiras, Hernán, *Inaugurarán el Museo Xul Solar con 86 obras que el autor dejó para que sean "comprendidas" en el año 2000*, La Maga, Buenos Aires, 24th March.

Gallego, Julián, *Xul Solar y Un Museo para Xul Solar*, Artinf, Año 17, n. 84, Autumn, pp. 23 and 46.

Diéguez Videla, Albino, *Un regalo permanente de Xul y Lita*, La Prensa -Artes Visuales, 4th section, Buenos Aires, 4th April, p. 5.

Xurxo, Ignacio, *Anticambalache 2000*, La Nación - Revista, Buenos Aires, 2th May, pp. 34/36.

Fevre, Fermín, *Xul Solar ya tiene museo*, Clarín, Buenos Aires, 6th May.

*La Fundación Pan Klub*, La Prensa, Buenos Aires, 9th May.

Lebenglik, Fabián, *Un nuevo Museo en Buenos Aires: El Solar de Xul Solar*, Página 12 - Plástica, Buenos Aires, 11th May.

Ballester, Alejandra R., *El Universo de Xul Solar, creador múltiple*, El Cronista - Cultura, Buenos Aires, 11th May, p. 2.

Feinsilber, Laura, *Abren un museo para admirar a Xul Solar*, Ámbito Financiero, Buenos Aires, 13th May.

Gambarotta, Pablo, *Xul Solar: Until the end of time*, Buenos Aires Herald - Art, Buenos Aires, 16th May.

De Arteaga, Alicia, *Movida latina en Nueva York y Xul Solar en su casa y*

*para todos*, La Nación - economía, Buenos Aires, 17th May, p. 16.

*Museo Xul Solar*, Gente, Año 27, n. 1452, Buenos Aires, 20th May.

Glusberg, Jorge, *Xul Solar*, Espacio de Arte, Año 1, n. 2, Buenos Aires, May, pp. 26/30.

Verlichak, Victoria, *Para Xul Solar*, Noticias -Arte, Año XV, n. 857, Buenos Aires, 30th May, p. 20.

Martínez Quijano, Ana, *Xul Solar - El Mago Blanco del Arte*, First, Año 7, n. 81, Buenos Aires, June, pp. 3 and 28/37.

Hoexter, Corinne K., *A Heat Wave from Down South*, Spotlight, New York, June, pp. 48/49.

Seselowsky, Alejandro, *El fuego creador de Xul Solar, la extravagancia de un verdadero creador*, Barrio Norte Express, Año 2, n. 14, Buenos Aires, June.

Levit, Horacio G., *Arte y espacio; por fin juntos*, La Nación -Arquitectura, 3rd section, Buenos Aires, 2nd June, p. 6.

Talmer, Jerry, *Those Latin Looks*, New York Post, 4th June.

B. y B., *Xul Solar y su museo*, Arte al Día Informa, Año II, n. 3, Buenos Aires, 15th June, pp. 3/4.

Gociol, Judith, *Una caminata por la ciudad de Buenos Aires rinde homenaje al mundo creado por Jorge Luis Borges*, La Maga, Buenos Aires, June.

*Un paseo borgeano*, Clarín, Buenos Aires, 27th June.

*Xul Solar, vencedor de este y otros mundos*, Lys, June.

Araujo, Susana, *Xul Solar: el único cosmopolita*, Qué hacemos?, Año 14, n. 156, June, pp. 4 and 26/29.

Perazzo, Nelly, *La imaginación desenfrenada de Xul Solar*, Art Nexus (international edition of *Arte en Colombia*), April-June, pp. 86/100.

Diéguez Videla, Albino, *Xul Solar se internacionaliza*, La Prensa, Buenos Aires, 4th July.

González Montaner, Berto, *Silvina Arango y la arquitectura colombiana de paso por Buenos Aires*, Clarín - Arquitectura, Buenos Aires, 10th July, pp. 1/2.

Verlichak, Victoria, *Latinos en el MOMA*, Noticias, Buenos Aires, 11th July, p. 20.

Nelson, Daniel E., *Xul Solar: World Maker, Latin American Artists of the Twentieth Century*, The Museum of Modern Art, New York, 1993, pp. 46/51.

Gradowczyk, Mario H., *Xul Solar, una aproximación*, Arte y Antigüedades, Año 6, n. 18, Buenos Aires, August, p. 46.

Salas, Andrés, *Museo Xul Solar en Capital Federal*, Época, 2° sección, Corrientes, 13th August, pp. 1/2.

*Xul Solar y su museo del año dos mil*, Arte al Día Internacional, Año 14, August, pp. 32/33 and 48.

Castelar, Diana, *Xul Solar*, Bonjour, Año 6, n. 35, August, pp. 38/39.

*Discépolo 1993: Fundación Pan Klub*, Bonjour, Año 6, n. 35, August, p. 46.

Arenes, Carolina, *De la mano de Borges, la ciudad no es ningún cuento*, La Nación, Buenos Aires, 15th August.

De Ambrosini, Silvia, *Xul Solar y sus enigmas pictóricos*, Artinf, Año 17, n. 85.

Márquez, Mercedes, *Xul Solar, D & D - Diseño y Decoración en la Argentina*, n. 26, October.

Sainz, Carola, *Xul Solar el artista esotérico*, Plena, Año 2, n. 25, October, pp. 40/42.

Haber, Alicia, *El museo de un pintor esotérico*, El País Cultural, Año IV, n. 205, Montevideo, 9th October, pp. 6/7.

Pschepirca, Pablo arq., *Xul Solar -entre formas suspendidas*, Clarín- Arquitectura, Buenos Aires, 9th October, pp. 1/3.

Pacheco, Marcelo, *La figura de Xul Solar cobra cada vez más importancia en el mundo*, La Maga, Buenos Aires, 20th October, pp. 38/39.

Irigoyen, Adriana, *Esencias y entrañas. En el museo con Pablo Beitía*, Summa 3, October, pp. 18/35.

**1994**
Russell Taylor, John, *Visions from the human melting Pot*, The Times- the Arts, London, 8th January, p. 14.

*Las utopías arquitectónicas de Xul Solar en Inglaterra*, La Nación, Buenos Aires, 8th January.

*Obras de Xul Solar en Londres*, Clarín, Buenos Aires, 15th January, p. 11.

Areán, Carlos, *Xul Solar. Surrealista argentino*, Cuadernos hispanoamericanos, ICAIC, 524, Madrid, February, pp. 71/84.

# 9. List of plates

## Photographic Credits

Museo Xul Solar: plates 1, 4, 8, 10, 12, 70, 72, 74, 84, 94, 103, 105, 112, 115, 125, 126, 129, 130, 142, 143, 144, 148, 149.

Rachel Adler Gallery: plates 6, 13, 33, 36, 37, 41, 48, 49, 52, 60, 69, 75, 89, 93, 97, 99, 104, 107, 110, 113, 114, 116, 122, 123, 133, 135, 136, 137, 138, 139, 155, 156, 164, 166, 167, 170, 173, 174, 175, 176, 178, 180, 181, 182, 183, 185, 186, 188, 187 and figures 63 and 64.

Sotheby's: plate 87.

Museum der bildenen Künste, Leipzig: figure 3.

Kröller-Müller Museum, Otterlo: figure 4.

Solomon R. Guggenheim Museum, New York: figures 10, 38 and 66.

Kunstmuseum, Bern: figure 17.

Rheinisches Bildarchiv, Cologne: figures 18, 21 and 65.

Fundación Pettoruti: figure 24.

Bayerische Staatsgemäldesammlungen, Munich: figure 27.

Metropolitan Museum of Art, New York: figure 28.

Emilio Ambasz: figures 39 and 40.

Michael Graves: figures 41 and 42.

Facundo de Zuviría: pages 226 and 241.

The rest of the photographic material was taken by Caldarella & Banchero for the Fundación Bunge y Born.

This book was printed
in the month of July 1994
at Lucini officina d'arte grafica,
Milan, Italy.